Owls of the United States and Canada

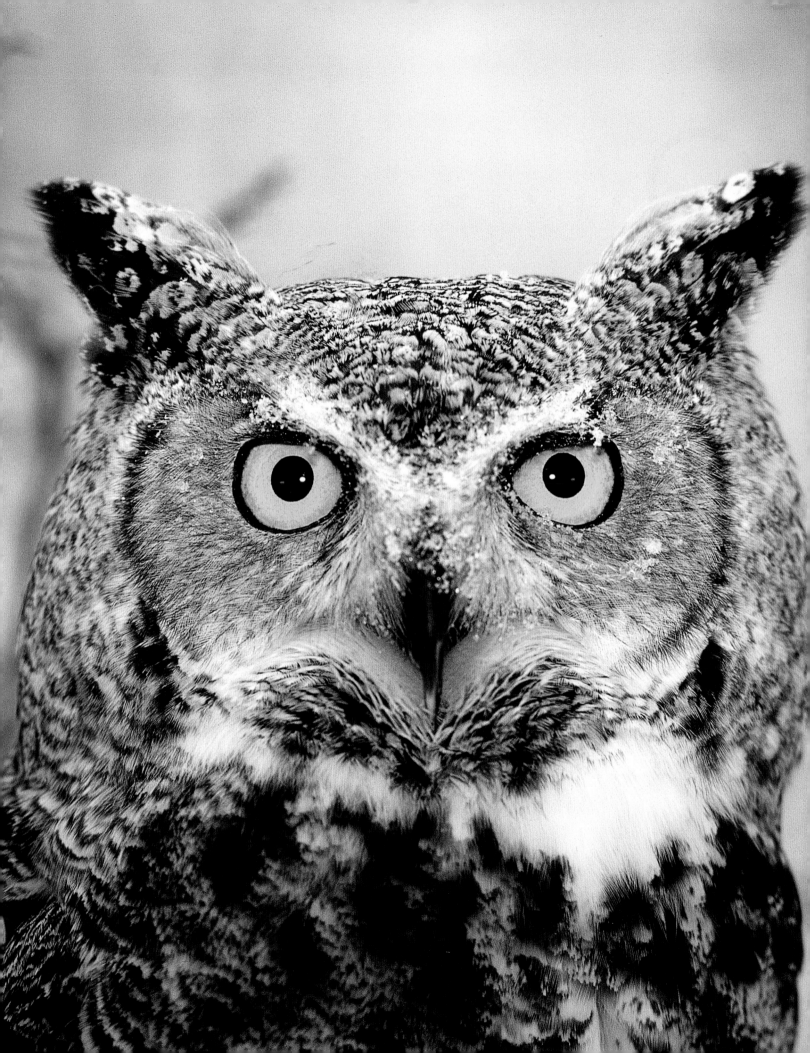

Owls

of the United States and Canada

A *Complete Guide to Their Biology and Behavior*

Text and Photographs by Wayne Lynch

THE JOHNS HOPKINS UNIVERSITY PRESS BALTIMORE

The Johns Hopkins University Press
2715 North Charles Street
Baltimore, Maryland 21218-4363
www.press.jhu.edu

Library of Congress Cataloging-in-Publication Data

Lynch, Wayne.
 Owls of the United States and Canada : a com-
plete guide to their biology and behavior / text and
photographs by Wayne Lynch.
 p. cm.
 Includes bibliographical references.
 ISBN-13: 978-0-8018-8687-4 (hardcover : alk.
paper)
 ISBN-10: 0-8018-8687-2 (hardcover : alk. paper)
1. Owls—United States. 2. Owls—Canada.
3. Owls—Behavior—United States. 4. Owls—
Behavior—Canada. I. Title.
 QL696.S8L96 2007
 598.9'7097--dc22 2007014624

A catalog record for this book is available from the
British Library.

The photograph of the ferruginous pygmy-owl on
page 33 is by Brian E. Small; used with permission.

Frontispiece: The great horned owl is primarily a
nocturnal hunter, but in the depths of a northern
winter it will hunt in the half-light of dusk and
dawn.

Special discounts are available for bulk purchases of this
book. For more information, please contact Special Sales
at 410-516-6936 or specialsales@press.jhu.edu.

The Johns Hopkins University Press uses environ-
mentally friendly book materials, including recycled
text paper that is composed of at least 30 percent
post-consumer waste, whenever possible. All of
our book papers are acid-free, and our jackets and
covers are printed on paper with recycled content.

For my wife, Aubrey, who always believed in me
and for my owling buddy Dr. Gordon Court, a good friend

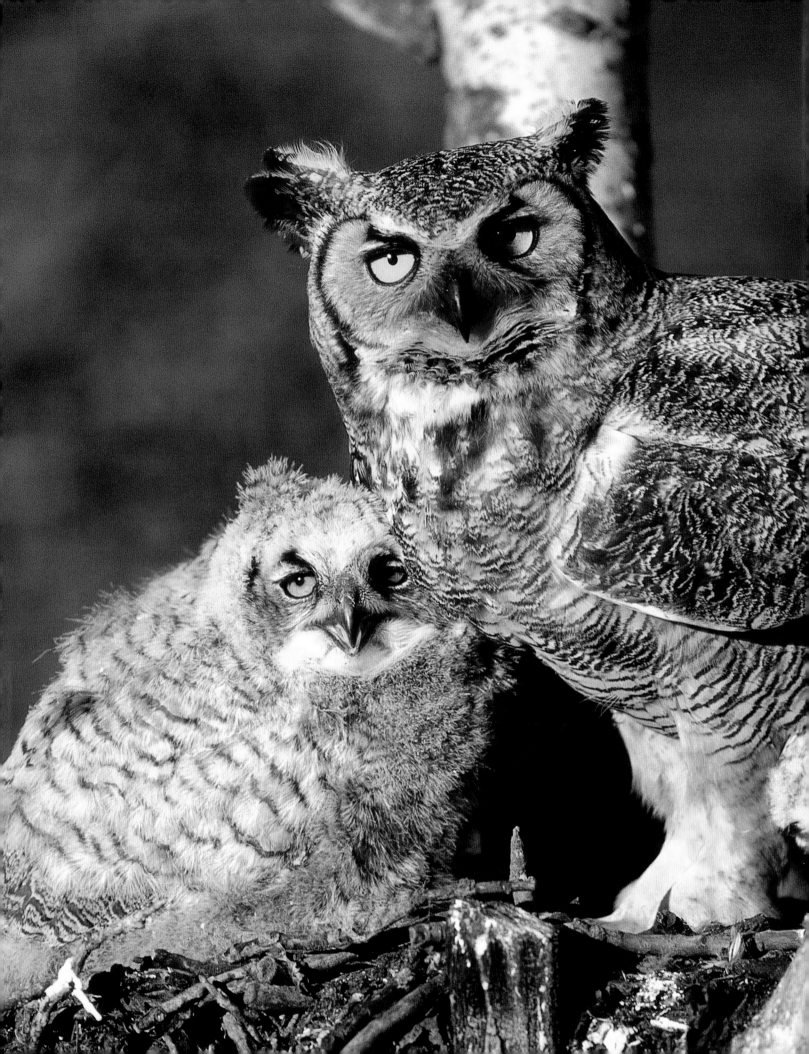

CONTENTS

(*opposite*) The large and powerful great horned owl is the most common and widespread owl in the United States and Canada.

ACKNOWLEDGMENTS

I would not have been able to produce this book without the friendly assistance, cooperation, and encouragement of many people. My sincere thanks go to owlers Graham Booth, Bruce and Bonnie Caywood, Ray Cromie, Jeff and Angela Gottfred, Al MacKeigan, and Trevor Roper. I am also indebted to many professional biologists who offered me valuable time with them in the field. I acknowledge Dr. Frederick and Nancy Gehlbach who taught me about tree cavities and desert owls, Sheridan Stone who introduced me to Arizona's spotted owls, Dick Cannings who took me to see my first flammulated owls, Doug Collister who taught me how to whistle for northern pygmy-owls, and Rick Martin and Robert Sissons who showed me burrowing owls in Alberta. Discussions with other scientists gave me valuable insight into the world of owls, and I am thankful to the veteran owl researcher Denver Holt, bird banders Dr. Stuart Houston and Norman Smith, spotted owl biologist Kent Livezey, invertebrate biologists Drs. James Philips and Heather Proctor, raptor researcher Cindy Platt, and bird biologist Lisa Takats-Priestley, all of whom were enthusiastic, congenial, and helpful.

Professional photographers are notoriously secretive about where wildlife can be successfully photographed. Six of them were not and each gave me valuable tips where I could locate owls. My heartfelt thanks go out to Rick and Nora Bowers, Dr. Gordon Court, Bobby Harrison, Jared Hobbs, and Brian Small.

Two friends were especially important in bringing this book to fruition. The biologist Jared Hobbs is a great field person and a damn good photographer; his enthusiasm is contagious and his energy enviable. I greatly enjoyed our many trips together and thank him for tolerating his "geezer" companion. The biologist Dr. Gordon Court has been a valued friend for more than a decade. Without his help this book would never have happened. His advice, encouragement, experience, and assistance in the field were more helpful that he can possibly imagine, and I treasure the many happy hours we spent together searching for owls and photographing them.

The Alberta Foundation for the Arts provided generous funding to help pay the bills while I buried myself in the library. I thank them for their support and belief in the project. I also thank the librarians at the University of Calgary and at the Calgary Public Library who tracked down obscure references for me.

Once the book was written, I surrendered the text to six brave souls for technical review. It is a daunting task to carefully read an entire

manuscript with enough attention to make constructive criticisms, and I am grateful to my reviewers for finding the time to undertake this valuable yet onerous task. My thanks go out to the Alberta endangered species biologist and raptor specialist Dr. Gordon Court, author and research scientist Dr. James Duncan, researcher and professor of biology Dr. Frederick Gehlbach, senior government research scientist Dr. Geoff Holroyd, British professor of biology Dr. Graham Martin, and author and retired government research scientist Dr. Robert Nero. All were thorough and methodical in their reviews and insightful with their criticisms. I thank them all for their candor, attention to detail, and helpful suggestions. Of course, I alone accept all responsibility for any errors that may have crept into the text.

This is my first book with the Johns Hopkins University Press and I am thrilled to be working with such a prestigious publisher. The many people I met from various departments at the Press were encouraging and generous with their comments. I especially thank life science editor Dr. Vincent Burke, who devoted himself to the quality of this book. He skillfully and graciously guided me along, easing the process throughout. I found him to be knowledgeable, helpful, and creative. His professionalism was unmatched in my 27 years of working with editors. I am also thankful to the managing editor, Juliana McCarthy; copy editor, Anne R. Gibbons; and designer, Glen Burris, for their creative involvement.

Last, and most important, I thank my wife, Aubrey Lang, to whom this book, and every other book I've ever written, is dedicated. After 33 years of marriage I still find her the most stimulating, delightful, and unselfish person I have ever met. Her skill as an editor, her toughness as a field companion, and her creativity as a business partner are just three of the many reasons I love her dearly. She made the magic happen.

Acknowledgments

INTRODUCTION: Owl Addiction

Perhaps I was destined to write a book about owls. I have been a critter junkie since I was a child, and owls have been an important part of many significant events in my past. When I was 11, the chance discovery of a boreal owl roosting near my home in Ottawa, Ontario, greatly accelerated my interest in natural history. I felt I had been given a privileged glimpse of a mythical creature. This lucky sighting led me to my local library where I read all the owl books I could find. It wasn't long before my interest in wildlife expanded to anything with a beating heart. Later, when I was a young man in medical school, it was a barred owl that launched my passionate pursuit of photography. One afternoon, during a break between lectures, I was gabbing with a classmate about the unwary barred owl that was wintering on the campus and how easily the secretive bird could be seen. A week later the classmate gave me an 8 × 10 inch glossy black-and-white closeup photograph of the owl as a thank you. Within days, I had bought my first camera, and the rest, as they say, is history.

An owl also played a role during the courtship of my wife. On one of our earliest dates, I took her to see an eastern screech-owl that I knew was roosting in the woods near her home. Aubrey, a sweet, charming, French Canadian, "big-city girl," had no idea such fascinating creatures of the night lived nearby and could be seen so easily as they warmed themselves in the midwinter sunshine. I later joked with her that an afternoon owl outing was a good way to minimize courtship expenses and also demonstrate what a sensitive guy I was. Thirty-three years later, we still chuckle about that afternoon, and the photographs I took on that cold January day are among my most treasured.

In September 1979, four years after we were married, I took a leap of faith and abandoned my career as an emergency physician to work as a freelance science writer and wildlife photographer. A book on the ecology of the prairie grasslands was to be my maiden voyage into the uncertain waters of my newly chosen career. With this first book I hoped to prove to family and friends that I wasn't just a foolish nature nerd who had left a secure and lucrative profession for a vision that only I could see.

I began my grasslands project on a cattle ranch on the Saskatchewan-Montana border in the heart of what would become Canada's Grasslands National Park. That summer, a pair of burrowing owls rescued me when I needed it most.

Near the ranch was a large black-tailed prairie dog colony, and sev-

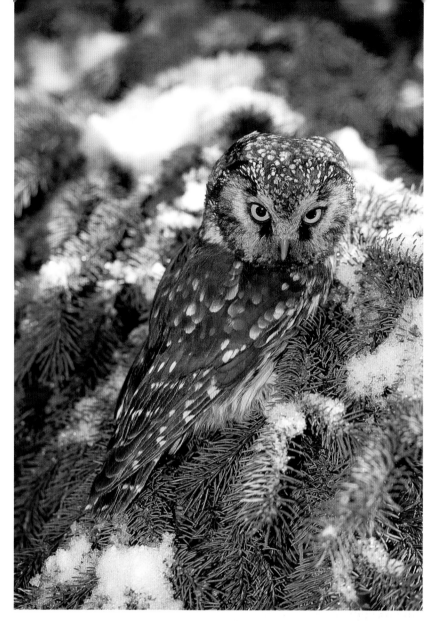

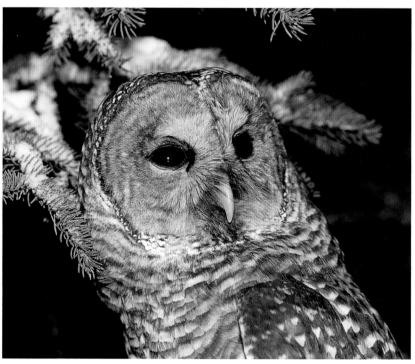

(*top*) The boreal owl ranges the farthest north of any of the small owls in North America, extending to the boundary between the boreal forest and the arctic tundra at a latitude of 67° north in Alaska. (*bottom*) Of the 19 species of owls in the United States and Canada, the barred owl is one of 4 species with dark eyes. The other dark-eyed owls are the barn owl, flammulated owl, and spotted owl. All the other owls have yellow eyes.

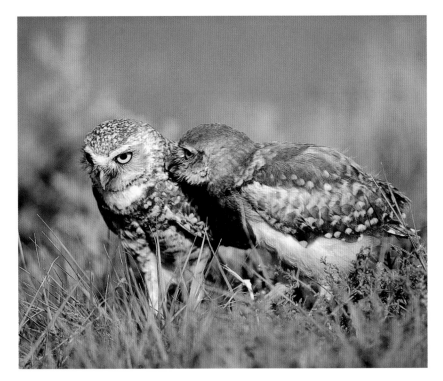

A young burrowing owl may sometimes preen the feathers on its parents' head and neck. It may also preen its nestmates.

eral pairs of burrowing owls lived alongside the plump, tawny rodents. There was a drought that year and the skies were featureless and hazy, the prairie parched and brittle. I feared I had made a terrible mistake. Was I pursuing an impossible dream? I erected a canvas photo blind about 50 feet (15 m) from one of the nesting pairs of owls, and for several weeks I spent hours every day cramped inside, peeking at the world through a porthole and a camera lens. In the quiet solitude of that desiccated prairie, I frequently wavered in my resolve to alter the direction of my life. The owls, of course, were oblivious to my mental struggle, yet they unknowingly buoyed my spirits, time and again, with intimate glimpses into their private lives. I watched them gently preen each other's face and neck, boldly scold and mob an American magpie, and hide in fear as the shadow of a golden eagle traced a course near their burrow. Sometimes, when I was hidden inside the blind I would simply rest my head in my hands and listen to the gentle coo of the owls and the soothing whisper of the wind in full conversation with the prairie. That summer, the owls were my salvation.

In the 27 years that have passed since that first summer on the prairies, owls have repeatedly brought immeasurable joy to my life and left me with many cherished memories. One of those memories was the summer Aubrey and I camped alone in the Canadian High Arctic surrounded by herds of musk oxen, inquisitive arctic foxes, and courting king eiders to capture the regal beauty of nesting snowy owls. It was a summer I will never forget. In other parts of the world, owls were sometimes welcome surprises. In the grasslands of Brazil, while searching for giant anteaters, I was delighted every day to see burrowing owls perched atop innumerable termite mounds. In the legendary enchanted islands of the Galápagos archipelago, I was enthralled by the liquid flight of a short-eared owl boldly hunting wedge-rumped storm petrels in the wan-

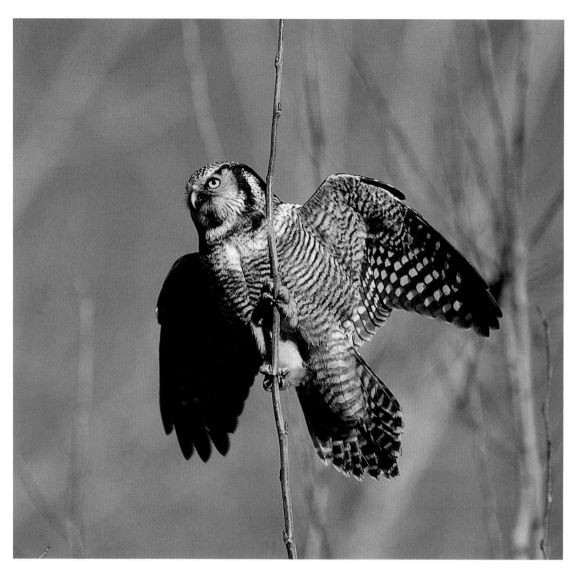

The long tail on the northern hawk owl gives the bird greater maneuverability in forested environments where it sometimes hunts fast-flying songbirds. The hawk owl resembles the *Accipiter* hawks in its diurnal habits and hunting style.

ing light of dusk. In 2005, my love of wildlife led me to Trinidad, where I photographed magnificent leatherback sea turtles nesting at night on the moonlit tropical beaches and ferruginous pygmy-owls hunting in the sunlight and shadows of the rain forest during the day. In the mid-1800s, the American luminary Henry David Thoreau encapsulated my feelings when he penned these words: "I rejoice that there are owls."

I am not alone in my fascination with owls. Sightings of northern owls are on the wish list of many bird-watchers and nature enthusiasts. In a survey done in the 1990s by the highly respected American Birding Association, 3 northern owls, the secretive boreal owl, the ghostly great gray owl, and the rapacious northern hawk owl, were among the top 10 birds that members in the United States and Canada most wanted to see.

In 1997, when I attended the Second International Owl Symposium, one of the most entertaining presentations was one on "owlaholics." It seems that incurable owlaholics sleep on pillowcases embroidered with the images of owls, shower behind a bathroom curtain with owls peering in, keep their hand soap in an owl-shaped tray, dry their dishes with owl-embossed tea towels, use oven mitts with owls on them, and season their food with a requisite set of salt and pepper shakers molded in the

shape of their favorite bird. Of course, they also wear clothing and jewelry, both tasteful and tacky, embellished with owlish designs and patterns. According to the presenter, the respected European owl expert Dr. Heimo Mikkola, there are thousands of owlaholics all over the world, but the majority live in the United States, England, and Australia. At that time, the United States topped the list with 109 International Owl Collectors Clubs, more than twice as many as either of its two rivals. Worldwide, only about 20 percent of owlaholics are males, but they own the largest collections, some with more than 5,000 owlish items. Apparently, people who work the graveyard shift, or stay up at night, are often the ones who become addicted to owls. Others become hooked after they inherit a collection and then begin to add to it. I wondered if anything had changed in 10 years so I went to eBay and typed in the word "owl." Up popped 7,196 items for sale, including earrings and brooches, ornamental boxes, key rings, letter openers, and figurines, even one carved from fossil mammoth ivory. For less than 25 dollars I could have bought my two favorite items: a set of owl-shaped golf club covers and a leather cell phone case. The latter seemed like a real bargain considering that the eyes of the owl adorning the case jiggled when you shook it.

Our attraction to owls begins at an early age. A first-grade teacher told me that owls are among the first birds that children learn to recognize. Owls, along with penguins, are the two most popular birds used to make stuffed toys. No doubt there are many things that endear us to owls, not the least of which are their solemn, seemingly contemplative demeanor, upright stance, large heads, and flat, oval faces. Owls also have exceptionally large eyes that are often bright yellow, making them all the more conspicuous. Anyone who has taken an introductory course in human psychology understands the primal reaction humans have to any animal with a relatively big head and large eyes. These are the juvenile traits common to many young animals, including human infants, and they elicit in us an innate tendency to nurture. In 1928, the legendary cartoonist Walt Disney understood this human reaction well and he used it to enhance the appeal of his trademark character Mickey Mouse. A normal house mouse has thin legs, small beady eyes, a long nose, and a relatively small head. When Mickey stepped off the drawing board he had short thick legs, large eyes, a big head, and a blunt snout. Over the years, Mickey's juvenile traits have been exaggerated even further, presumably to make him more likeable.

Humankind's interest in owls goes back a long time, perhaps since we first began to reflect on the world and the earthly forces that control and determine our fate. In Paleolithic Europe, Ice Age artists squeezed inside lightless caves with flaming torches and covered the walls with charcoal and ochre drawings depicting the wild animals that were important in their lives. Predators and prey were the most common creatures depicted. Some drawings may have been supplications for successful hunts, others a celebratory record of hunts that went well. Birds, in particular owls, are not a common subject in cave art. Until the early 1990s, a drawing, perhaps 15,000 to 20,000 years old, of a snowy owl

and its chicks was thought to be the oldest bird species recognizable in prehistoric art. Found in a cave, Les Trois Frères (the Three Brothers), in Ariège, France, it was drawn at a time when France was covered by arctic tundra and much colder than it is today.

In 1994, one week before Christmas, three French speleologists found a limestone cave that made headlines around the world. The Chauvet Cave overlooks the Ardèche River in southern France, and its subterranean gallery of masterfully drawn lions, cave bears, ibex, bison, mammoths, and woolly rhinoceroses are now believed to be the oldest known paintings in the world, radiocarbon dated at between 30,000 and 32,000 years of age. On a rock overhang, the intrepid French trio found the solitary image of an owl. The painting, which has conspicuous ear-tufts and a heavily streaked breast, bears a strong resemblance to the Eurasian eagle owl—the largest owl in the world.

Owls appear in Egyptian hieroglyphics, on ancient Grecian coins, and on treasured Roman vases. Later, they adorned Byzantine sculptures, Renaissance silverware, and Victorian jewelry. In North America, owls and rock art have a much shorter history. The oldest owl depiction that I am aware of is believed to have been drawn by the Fremont Indians of southern Utah, between 800 and 1,500 years ago. The famous owl panel, located near the town of Moab, features a large bird about 2 feet (61 cm) tall, with oversized feet and long ear-tufts, most likely representing a great horned owl whose dangerous talons would have been widely recognized and respected by the native people.

Farther south, in Mexico, the Aztecs believed the owl was a potent symbol of the dark and mysterious underworld. During human sacrifices, stone containers, decorated with the images of owls, were used by the priests to hold the still-beating hearts of their unfortunate victims. As part of the sanguineous ceremonies, a shaman set the tempo by beating a drum on which the face of an owl had been carved.

Since the dawn of recorded history, the owl has been a powerful symbol for humans. In 77 AD, Pliny the Elder, the Roman statesman and scholar, wrote that the owl was "the very monster of the night... when it appears it foretells nothing but evil." The superstitious Pliny believed that this malevolent creature also possessed potent curative and magical powers. His remedy for an earache was a slurry of owl's brain mixed with oil, then injected into the ear canal. If you were afflicted with rheumatism, ingesting the ashes of a burnt owl feather would bring certain relief. He also claimed that the heart or eye of an owl was the most reliable way to discover a secret. If you placed the magic body part on a person's chest while he or she slept, upon awakening the person would disclose all his or her deepest secrets, especially those relating to infidelity and treachery.

The human imagination has always been fertile ground for myths and fabrications. We long to understand the unexplained and control the uncontrollable. The world around us is often beset with puzzling tragedies and disasters. Over the ages, humankind plumbed the depths of its collective imagination and repeatedly invented omnipotent celestial powers that could be worshipped and placated. With supplica-

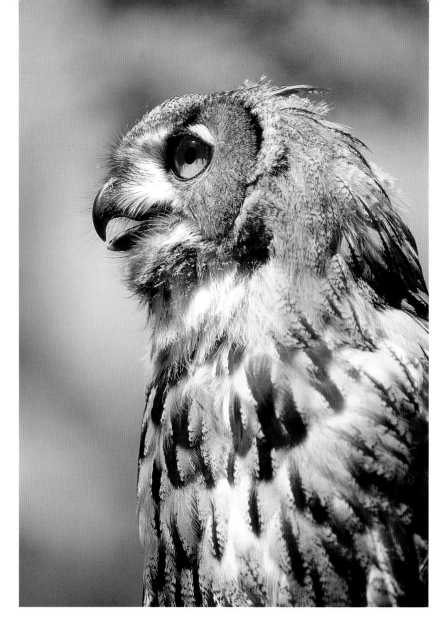

The Eurasian eagle owl is the heaviest owl in the world. Females from Norway can weigh up to 9.25 pounds (4,196 gm), almost twice the maximum weight of an adult female snowy owl, which is the heaviest owl in North America.

tion, prayer, and complicated rituals, we strove to please the powers that we believed determined our fate, curry their favor, and perhaps regain control to alter our destiny. This prospect for control is the essence of hope, and it has always been a powerful force that could rescue us from despair. So it is with all myths; they are humanity's desperate need to understand, explain, and control.

In the mortal mind, death and darkness have often been linked. Not surprisingly then, the owl, which for many is the consummate bird of darkness, was frequently considered a messenger of tragedy and doom. It is said that the death of the great Roman emperor Julius Caesar was foretold by the hooting of an owl. During the Middle Ages in Europe, the owl was thought to be an accomplice of sorcerers and witches, assisting these villainous souls in casting their evil spells. In later times, the owl could protect you from evil. If you nailed a dead owl over your front door it would ward off dreaded diseases. Kill a second owl and hang its lifeless body on your barn to guard your property and crops against damage from torrential rains, hail, and lightning fires. In keeping with its association with evil, the French name for the barn owl is *effraie*, which comes from the verb *effrayer,* meaning to frighten, or fill with dread.

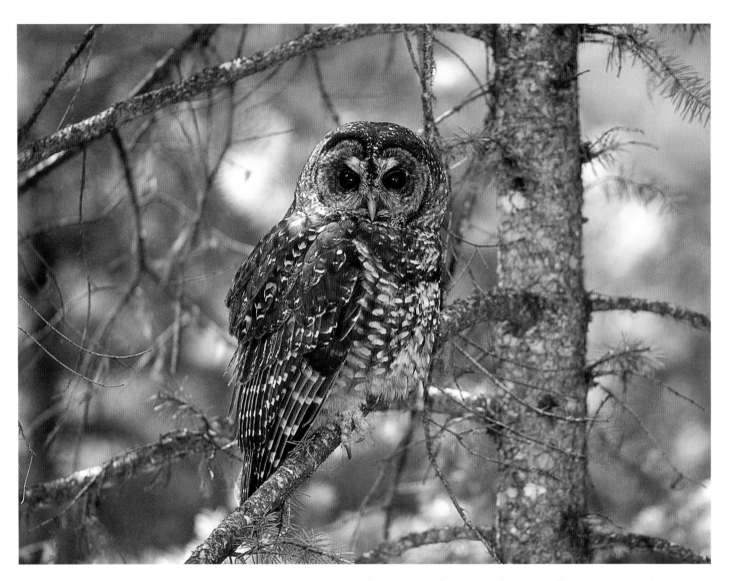

The Haida culture of southeastern Alaska and coastal British Columbia sometimes carved the image of an owl on their ceremonial totem poles because the bird had special meaning in their world. Usually the great horned owl was the species depicted, but sometimes they carved the image of the elusive northern spotted owl, pictured here.

In North America, the owl had an equally prominent place in the myths and beliefs of the indigenous peoples, and the birds were often associated with magic. The Cherokee Indians of the southern Appalachian Mountains would bathe a newborn baby's eyes with water in which an owl's feather had been soaked to improve the child's night vision. The Seminoles of Florida would whistle when they heard the call of a barred owl. It was good luck if the owl answered back, a bad omen if it didn't. Shamans in the Haida culture of coastal British Columbia wore amulets made from the remains of owls or elaborate masks fashioned from their feathers.

In the New World, as in the Old World, the owl was cast, at various times, as a messenger from the afterworld, the vengeful soul of a dead warrior, the bearer of bad news, a wicked servant of the deceased, or a feathered witch who could forecast the weather, warn of death, or kidnap naughty children. The Kiowa of the southern Great Plains thought powerful shamans were transformed into owls when they died. The Pueblo Indians of Arizona and New Mexico associated the owl with Skeleton Man, the god of death, and the fearsome Apaches whose fa-

mous warrior chiefs included Cochise and Geronimo, feared the owl more than any other creature in their world.

In my first year of medical practice, I worked in a small community in northern Ontario and many of my patients were Ojibwa people. A woman elder who had fallen and broken her arm told me she was not surprised by the accident. She believed that owls brought a person bad luck and the previous day she had accidentally flushed an owl in the forest.

Native peoples were often astute observers of the natural world with an intimate knowledge of animal behavior. Many admired the owl's courageous defense of its young and its ability to attack swiftly and silently in the blackness of the night. The Tlingit people of the Pacific coast appealed to the spirit of the owl to give them courage in warfare, and they would rush into battle hooting like owls. The Oglala Sioux of the northern Great Plains revered the large, powerful snowy owl above all other birds of prey. Warriors who had fought well in combat wore a headdress of the owl's feathers as a conspicuous badge of their bravery.

The owl has been credited with a greater breadth of character traits and powers than any other bird in history. By some it was worshipped; by others, feared and hated. Although owls were perceived by many as denizens of darkness, the native Hawaiians had great affection for the short-eared owl, the only species native to the archipelago, and they saw it as a protector.

In modern North America, the owl's reputation has undergone a transformation better than any publicist could orchestrate. From the black depths of witchery and wickedness, owls have risen to become the most beloved group of birds on the continent. None have embraced them more than the community of Cape Coral in southwest Florida, which has a burrowing owl as its municipal mascot. Roughly 2,000 of these endearing diminutive owls live in the city and surrounding areas. They nest in people's yards and in scattered vacant lots. Some residents even dig "starter burrows" in their manicured lawns to encourage the owls to stick around. One year, when I was in Florida for the Christmas holidays, I drove to Cape Coral to see the owls for myself. The locals were protective and tolerant of the birds. It was heartwarming to see and a memorable way to celebrate Christmas. Each year, in February, the residents also proudly host a Burrowing Owl Festival (www.ccfriendsof wildlife.org) to promote further protection for the birds and to encourage concern for other local wildlife.

On the other side of the continental United States another group has embraced an owl as their emblem. Washington's Olympic National Park is home to at least 40 nesting pairs of northern spotted owls, and the controversial owl is the official avian emblem of this protected tract of verdant temperate rain forest.

Canadians, perhaps more than others, are enamored with owls. A snowy owl adorned the country's 50-dollar note beginning in 1988. Sadly, it was replaced in 2006 by the grinning countenance of yet another dead Canadian politician. On a more encouraging front, 3 of the

For more than 30 years, the great horned owl has been the provincial bird of Alberta. This adaptable owl lives in every habitat within the province: prairie grasslands, aspen parkland, boreal forest, and the Rocky Mountains.

nation's 10 provinces have owls as their avian emblems. Quebec has the snowy owl; Manitoba adopted the great gray owl; and Alberta chose the great horned owl. In 1972, the residents of Alberta were given a list of 50 birds to consider. In the end, children from 1,600 schools, as well as thousands of newspaper readers, cast their votes and the owl was selected by 23 percent of them. The runner-up was the mountain bluebird (*Sialia currucoides*) with 18 percent of the votes. The mountain bluebird, by the way, is the official state bird of Idaho and Nevada, but regrettably, no species of owl has achieved a similar status in any state.

In the early 1970s, when Alberta was selecting its provincial bird, environmental sensitivity was awakening all across Canada and the United States. A few decades earlier, the only good bird of prey was one you could bury. Even within the sanctuary of national parks, eagles, hawks, and owls were frequently shot on sight, and it was park rangers who wielded the weapons. Today, raptors, in particular owls, are the celebrities of the avian world. For many people, the chance sighting of an owl on an afternoon outing instantly elevates the mundane to the magical. For me, owls are aesthetically beautiful, scientifically fascinating, and emotionally soothing. I photograph and study owls and the natural world not simply to earn a living but also to maintain a necessary connection with the continuum of life and to comfort my soul. The Sami reindeer herders of Lapland have a saying about nature that mirrors my sentiments: "If ever you are lost in life, put your ear to the earth and listen to the beat of her heart."

Owls of the United States and Canada

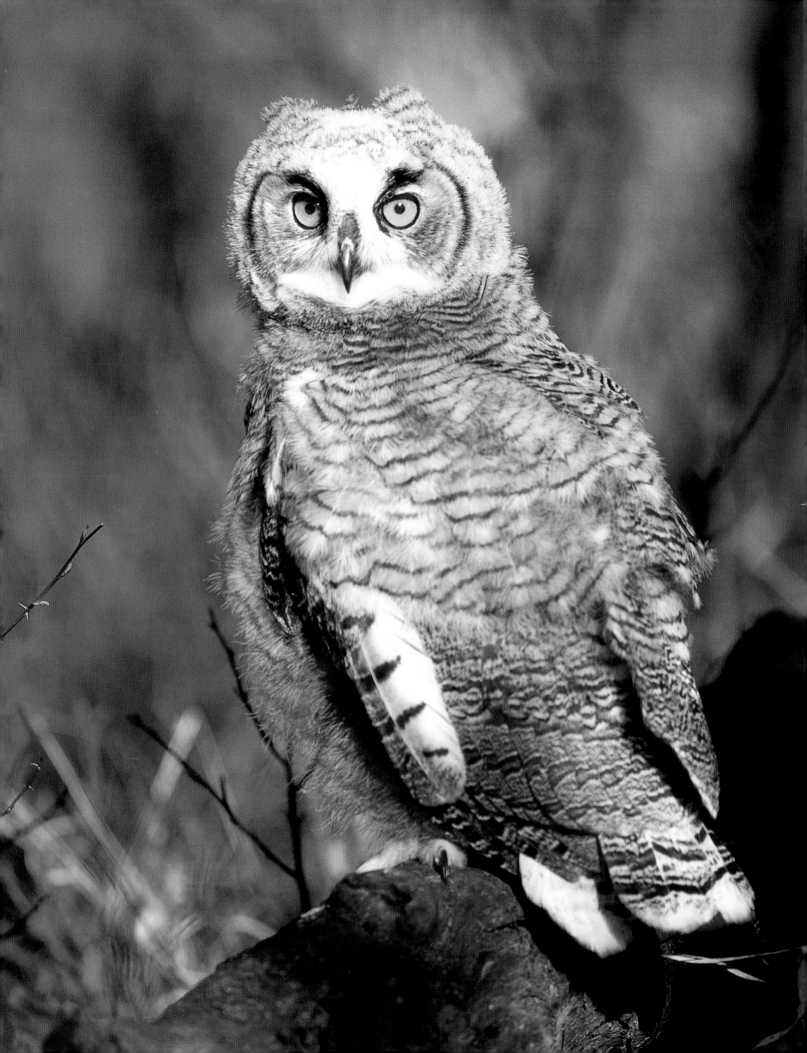

Anatomy of an Owl

AS A SCIENTIST I am patient, but as a wildlife photographer, I am stubbornly patient. After hours of tedium, cramped inside a photo blind, I'm naturally tempted to quit and leave. It's only the hope that perhaps five more minutes of waiting may yield a great photograph or a spectacular sighting that makes me persevere. This strategy has been successful for me time and again. Once when I was watching an incubating snowy owl on Prince of Wales Island in the Canadian arctic, I wrote in my journal:

> I've been inside the blind for nearly five hours now. It's almost midnight and the landscape is bathed in soft amber light. The female owl is facing into the sun, her eyes shielded behind black squinting lids. Five mosquitoes are clinging to the feathers along the side of her beak. In the past hour, she has barely budged. I busy myself listening to the familiar sounds of the tundra world around me: the melodious babble of a courting long-tailed duck, the raspy rattle of a red-throated loon flying overhead, and the faint bugle of a distant sandhill crane, accompanied by the delicate tinkle of candle ice collapsing in the summer heat. Out the rear of the blind I can see the male owl resting on the ice of a nearby lake, perhaps to cool himself and escape the hordes of bloodthirsty mosquitoes, many of which seem trapped inside the blind with me. Suddenly the female leaves the nest and flies over to the male who has now landed on the tundra with a collared lemming in his beak. The male arches his wings and rocks back and forth, strutting in one place and holding the lemming high in the air. His brilliant white plumage glares in the golden sunshine. He drops the rodent and the female quickly retrieves it and gulps it down. Without further fanfare she silently glides back to the nest and covers the six white eggs with her feathery bulk.

(*opposite*) This young great horned owl is roughly two months old. Although it can fly, it still has many of the downy feathers it had as a small chick.

This photograph of an incubating female snowy owl was taken at 3:00 a.m. Throughout much of the species' breeding range, the sun does not set at any time during the summer nesting season.

The whole incident took less than a couple of minutes and I captured none of it on film because the distance was too great. Nonetheless, I was thrilled by what I had seen. Witnessing such a precious moment of animal behavior was ample reward for the wait.

Paleocene Origins

Originally, the evolutionary history of animals, and the relationship between species, was determined by methodically comparing the minute details of their anatomy and behavior. Using this method, early taxonomists (the people who classify organisms) concluded, for example, that the 7 species of New World vultures must be closely related to the 15 species of Old World vultures because they look alike and they probably also share a common ancestor. We now know that the two groups of vultures are not closely related at all. The New World group, which includes the familiar turkey vulture, shares a common ancestry with the storks, whereas the Old World birds arose from an ancestral bird of prey. The two groups came to resemble each other simply because their lifestyles were similar—both are large carrion-feeding specialists. Biologists call this process *convergent evolution.* It occurs when two unrelated groups of animals evolve to resemble each other in response to similar challenges and pressures in their respective environments. In the world of birds, there are many examples of convergent evolution: fish and krill–eating penguins in Antarctica and auks in the arctic; nectar-sipping sunbirds in Africa and hummingbirds in North and South America; fruit-eating hornbills in Asia and toucans in Central and South America.

In 1758, when the Swedish botanist and physician Carolus Linnaeus categorized wild species in *Systema Naturae,* he understandably concluded that owls were related to hawks, eagles, and falcons and lumped them

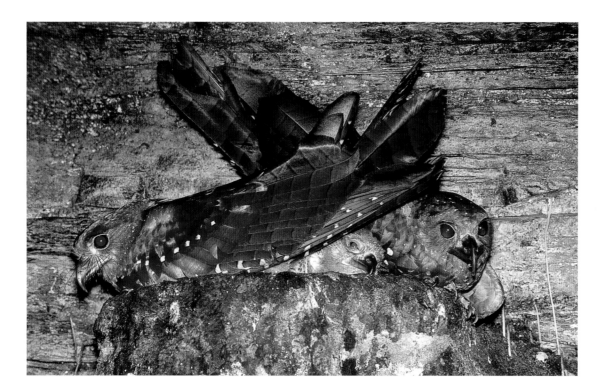

Oilbirds belong to the order Caprimulgiformes, whose members are the closest living relatives of owls. There were 162 oilbirds nesting in this Trinidad cave. Because the birds feed on fruit, their chicks grow slowly and do not fledge until they are about 110 days old.

together in the order Accipitres. After all, owls are carnivorous predators with dangerous hooked beaks and lethal talons resembling those of hawks and eagles, so the two groups must be closely linked. Dissenters argued that owls seemed more closely allied with the nightjars because both groups were nocturnal and had large eyes and soft billowy plumage, which surely suggested a close relationship. The debate lasted for more than 200 years until the controversy was finally settled in the early 1990s. Today we know that owls are close relatives of the nightjars, oilbirds, and potoos. Some authorities currently lump the owls and nightjars together in the order Strigiformes, while others still keep the nightjars and their kin in a separate order of their own, the Caprimulgiformes. That's the good news at the end of the story, but let's start back at the beginning.

Many of the bones in a bird's skeleton are hollow and thin walled, and they disintegrate rapidly. As a result, fossil bird bones are hard to find compared to the frequently discovered fossils of reptiles and mammals. This may explain why there are large gaps in the avian fossil record. The oldest bird fossils are those of *Archaeopteryx lithographica,* which date from the late Jurassic period, roughly 150 million years ago. The earliest fossils that can positively be identified as those of an owl come from the Paleocene epoch around 60 million years ago.

Palaeontologists call this early owl *Ogygoptynx wetmorei.* It was unearthed near Tiffany, Colorado, in 1916. Based on the structure of the bones in the bird's ankle and foot, some have speculated that this ancestral Paleocene owl had similar habits to our modern-day burrowing owl. It may have hunted insects, centipedes, and scorpions since small mammals were uncommon at the time. In the following Eocene epoch, around 50 million years ago, owls underwent a dramatic diversification, and many new species appeared—most of them similar to the modern-day barn

owls. A second pulse of owl diversification occurred later in the Miocene epoch between 22 and 24 million years ago. The Miocene was a time of increasing global aridity. Grasslands expanded as a consequence, and as they did, an abundance of small seed-eating mammals evolved. This may have been the impetus needed for this second wave of owl speciation.

By the time the Ice Age arrived, 2 to 3 million years ago, the largest owl that has ever lived was hunting in the forests of Cuba. *Ornimegalonyx oteroi* is estimated to have stood more than 3 feet (1 m) tall, making it almost twice the size of the present-day great horned owl. There were no large mammalian predators living on Cuba at that time, so *Ornimegalonyx*'s main competition came from other predatory birds, namely, three giant barn owls, a vulture the size of an Andean condor, and an eagle larger than any known today. Palaeontologists believe *Ornimegalonyx* was a weak flier, and that it may have killed its prey on foot. The remains of at least 200 small ground sloths were found inside a cave in Cuba. *Ornimegalonyx* may have dragged them there before devouring them. This giant owl may have also preyed on a large rodent the size of the present-day capybara, which weighs up to 110 pounds (50 kg). Julio de la Torre imagines Pleistocene Cuba as a frightening world where giant eagles and vultures loitered outside the owl's cave, while inside West Indian boa constrictors slithered in the shadows and hordes of squealing vampire bats clung to the dark, dank ceiling.

In 1857, Charles Darwin, the eminent British naturalist and revolutionary thinker, predicted that "the time will come, I believe, though I shall not live to see it, when we shall have fairly true genealogical trees of each kingdom of nature." Today, 150 years later, Darwin's prophetic words have been proven correct, and the evolutionary relationships and lines of descent between nearly every group of organisms is largely understood. The development of molecular biology in the 1980s provided the needed clarity for critical analysis. For birds, it culminated in 1991 with the publication of *Phylogeny and Classification of Birds: A Study of Molecular Evolution* by Charles Sibley and Jon Ahlquist, and this book is still the benchmark used to determine avian family relationships.

The power of molecular evolution rests on the belief that genes change over time at a predictable rate, and if you compare the structure of a particular gene in one bird with the same gene in another bird, you can calculate how closely related they are and how long they have been separated from a common ancestor. A gene is simply a strand of DNA that programs the assembly of a single particular protein. The most common gene used for this kind of analysis is the one that controls the production of the protein cytochrome *b*. Advocates of this method claim that a 2 percent difference in the DNA formula of the cytochrome gene when comparing two birds is crudely equivalent to 1 million years of separation. Furthermore, for owls, if the difference is greater than 1.5 percent, the two birds should be accepted as separate species.

What can all this high-powered DNA science teach us about the evolution and classification of the owl species living today? Everyone agrees that there are two separate families of owls: the barn and bay owls, which are lumped together in the family Tytonidae, and the true owls,

(*opposite*) There are three species of screech-owls in the United States, including this eastern screech-owl from Florida. Worldwide, there are perhaps 60 related species but their classification is currently under revision.

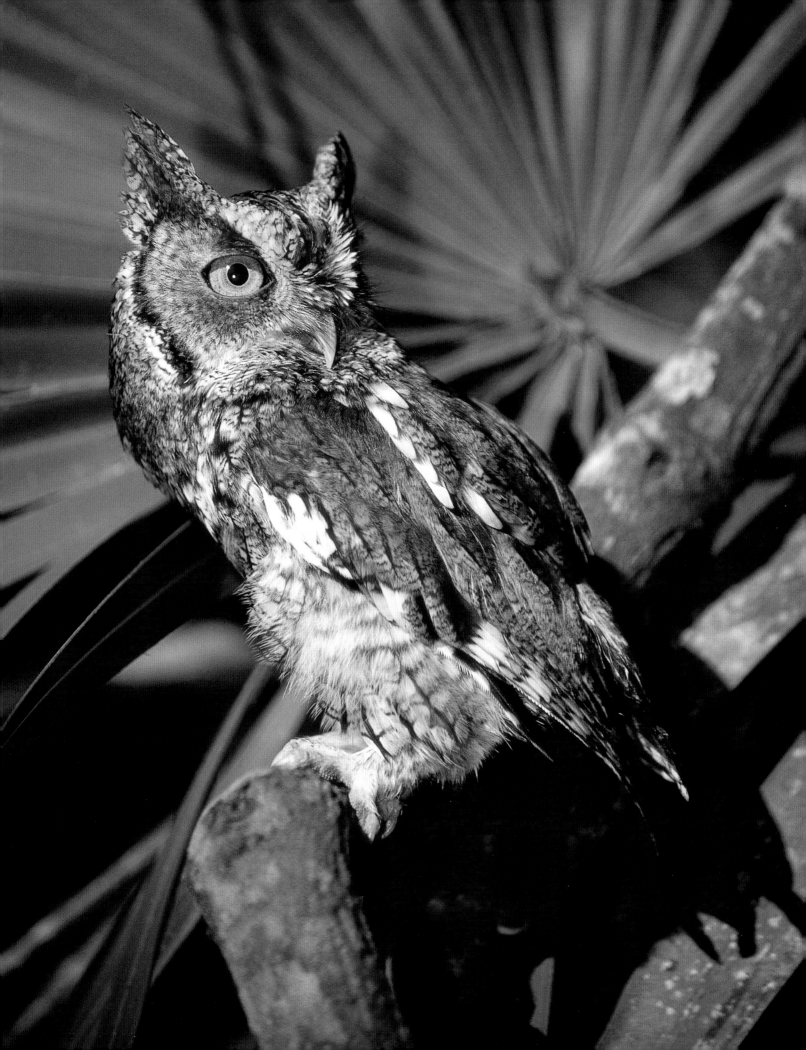

Weights and Wingspans

Species	Scientific name	Average body weight	Average wingspan
Snowy owl	*Bubo scandiacus*	4 lb (1,814 gm)	52 in (1.32 m)
Great horned owl	*Bubo virginianus*	3.2 lb (1,452 gm)	44 in (1.1 m)
Great gray owl	*Strix nebulosa*	2.4 lb (1,089 gm)	52 in (1.3 m)
Barred owl	*Strix varia*	1.6 lb (726 gm)	42 in (1.1 m)
Spotted owl	*Strix occidentalis*	1.3 lb (590 gm)	40 in (1.0 m)
Barn owl	*Tyto alba*	1 lb (454 gm)	43 in (1.1 m)
Short-eared owl	*Asio flammeus*	12 oz (340 gm)	38 in (97 cm)
Northern hawk owl	*Surnia ulula*	11 oz (312 gm)	28 in (71 cm)
Long-eared owl	*Asio otus*	9 oz (255 gm)	36 in (91 cm)
Eastern screech-owl	*Megascops asio*	6 oz (170 gm)	20 in (51 cm)
Burrowing owl	*Athene cunicularia*	5 oz (142 gm)	21 in (53 cm)
Western screech-owl	*Megascops kennicottii*	5 oz (142 gm)	20 in (51 cm)
Boreal owl	*Aegolius funereus*	4.7 oz (133 gm)	21 in (53 cm)
Whiskered screech-owl	*Megascops trichopsis*	3.2 oz (91 gm)	17.5 in (44 cm)
Northern saw-whet owl	*Aegolius acadicus*	2.8 oz (79 gm)	17 in (43 cm)
Northern pygmy-owl	*Glaucidium gnoma*	2.5 oz (71 gm)	12 in (30 cm)
Ferruginous pygmy-owl	*Glaucidium brasilianum*	2.5 oz (71 gm)	12 in (30 cm)
Flammulated owl	*Otus flammeolus*	2.1 oz (60 gm)	16 in (41 cm)
Elf owl	*Micrathene whitneyi*	1.4 oz (40 gm)	13 in (33 cm)

Notes: The species are arranged by decreasing body weight. The scientific names follow the current AOU checklist. A DNA analysis of the ferruginous pygmy-owl in the United States by G. A. Proudfoot, R. L. Honeycutt, and R. D. Slack (2006) in *Conservation Genetics* proposed that the owl was a new species, the Mexican ferruginous pygmy-owl (*Glaucidium ridgewayi*), but the proposed designation has not yet been accepted by the AOU. Average body weights and wingspans are for adult males and females combined.

which comprise the family Strigidae. The tytonids appeared earlier and date their beginnings from around 50 million years ago. The strigids branched off from the tytonids during the Miocene epoch during the period of aridity I spoke about earlier. Although authorities agree on the existence of two families of owls, they disagree on the total number of species in each. The problem boils down to what constitutes a species, and currently the worldwide classification of pygmy-owls (*Glaucidium* spp.) and screech-owls (*Otus* spp.), in particular, is in a state of uncertainty. The owl specialist James Duncan, in his book *Owls of the World: Their Lives, Behavior, and Survival,* claims there are 204 species—16 tytonids and 188 strigids—and I use this number as the accepted total.

Owls represent barely 2 percent of the world's birds, yet they are found on every continent, except Antarctica, and on many remote island groups, including the Hawaiian Islands. More than half of the world's owls live in the neotropics and sub-Saharan Africa. According to the esteemed AOU (American Ornithologists' Union), there are only 19 species of owls in the United States and Canada. They range from the sparrow-size elf owl, the smallest owl in the world, to the large and powerful snowy owl, which is roughly 46 times heavier. The snowy owl

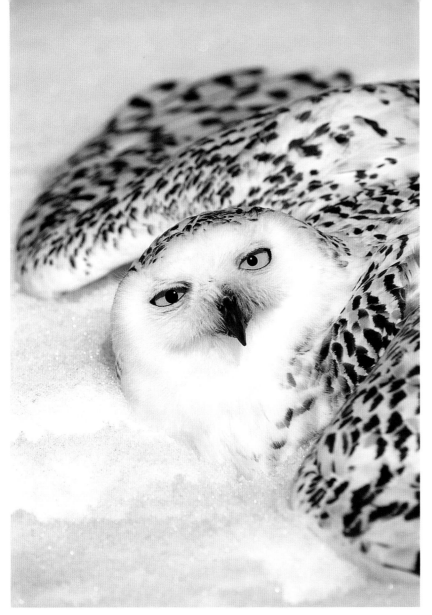

This female snowy owl is huddled over prey in a guarding behavior called mantling that is common to many birds of prey.

ranks number two in the world for weight. Only the Eurasian eagle owl is heavier. Although these 19 species represent only a small sample of the world's owls, scientists know more about their ecology and biology than about all the other owl species combined. From this wealth of insight and information I hope to weave a detailed and fascinating tale.

WMDs: Weapons of Mouse Destruction

The great horned owl has been called "the tiger of the skies" for good reason. In defense of its eggs or young the bird may attack with incredible savagery. As Allan Eckert warned in his book *The Owls of North America,* "There are scores of well-authenticated cases on record where men have been blinded and suffered severe injuries to head, throat, chest, back, and groin by enraged attacking great horned owls. The attacks are bold, slashing, and very dangerous, made even more so by the total unexpectedness with which they strike." A nature photographer in Saskatchewan learned this lesson the hard way when an angry great horned owl knocked him out of a tree. In the fall, he fractured his pelvis and had to drag himself to the road to be rescued. I knew these facts

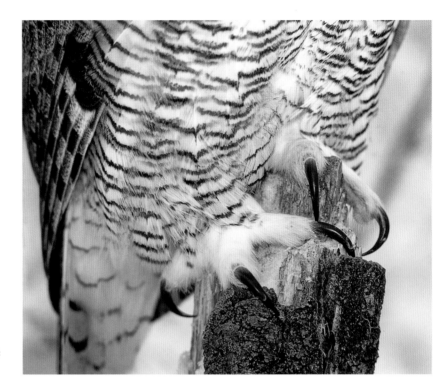

The great horned owl has evolved strong, heavy talons to restrain large, muscular prey such as the snowshoe hare.

well when, in the spring of 2002, I decided to photograph a nesting pair of these owls from a tree stand 30 feet (9 m) off the ground and about the same distance from their nest. Each time I climbed to my roost, I wore a hockey helmet with a full face mask and a heavy leather jacket to protect myself against an attack. I also strapped myself to the tree with a safety harness so if the tree stand collapsed or the owl decided to strike, I wouldn't plummet to the ground and go thump. Luckily for me, not all great horned owls are created equal, and this pair never displayed a single moment of aggression in the three months I was around them.

Owls have dangerous talons and sharp beaks to protect themselves and their offspring. And, being birds of prey, they also need such instruments to capture, kill, and dismember their victims. The downward-curving beak in most owls is largely hidden inside their facial feathers, so it appears deceptively short and unimpressive, when actually, it is quite strong, sturdy, and sharply hooked. The curved upper beak on an adult great horned owl can measure nearly 1.5 inches (3.8 cm) in length. On an adult snowy owl it can be nearly 2 inches (5 cm) long. As in all raptors, the edges of an owl's beak are necessarily sharp for dismembering prey.

The facial feathers on an owl, especially those surrounding the beak, tend to be modified into simple bristles or semibristles, and it is these that conceal most of the bill. There may be a biological reason for this. A bristly feather may be easier to keep clean than a conventional feather with a wide vane. This feather trend reaches an extreme in the carrion-feeding vultures, many of whom have bare heads with only a few scattered bristles.

The facial bristles on an owl could also be a residual trait retained from their common ancestry with the nightjars, many of whom have well-developed bristles surrounding their mouth. In nightjars, such as

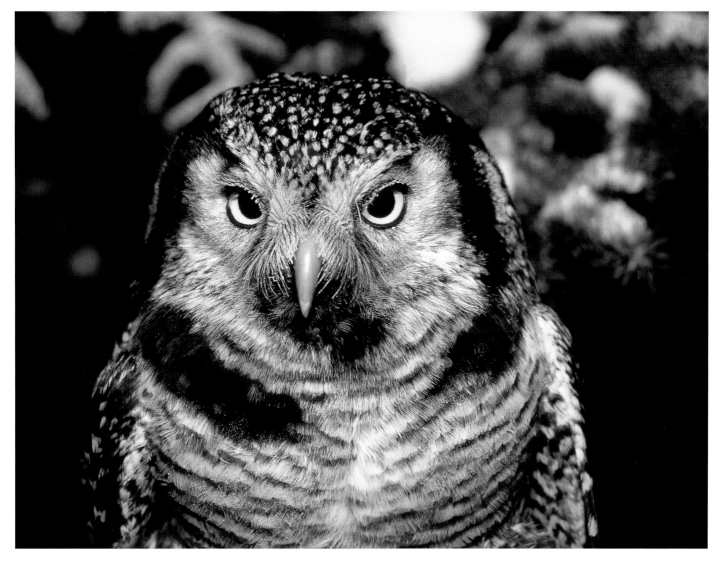

It was −31°F (−35°C) when I took this photograph of a northern hawk owl with frost-encrusted facial bristles. The bird's nostrils are buried beneath the bristles, which help warm the air it breathes.

the whip-poor-will, the bristles may serve a tactile function, helping them target the tiny mouths of their young in the darkness at night. This might also be the case in owls, but such a benefit has not been studied. Furthermore, in nightjars, the bristles may function like a net to increase the area covered by the birds' gape and help them capture erratically moving prey on the wing. Only the small insectivorous owls, such as the flammulated owl, actually capture prey with their beaks while they are flying, but their facial bristles are too short to benefit them in this way.

The feet and talons of an owl are its principal weapons of attack and capture. All owls have four toes, and the outside toe is reversible so that it can face forward or backward, depending on the needs of the bird. All other birds of prey have three toes pointing forward and one backward, except for the fish-eating osprey, which has two toes facing forward and two facing backward. Why owls should be different is not known, but like the osprey, their toes and talons may be used primarily to secure a firm grip on their prey rather than to kill. Even if talon penetration is not the main way an owl usually kills its prey, talon size increases with the average size of prey that is tackled. The great gray owl ranks number

three in body size, yet it has relatively small feet and slender talons, a reflection of the small mammalian prey it normally hunts. The great horned owl, on the other hand, has thick, heavy feet and massive talons up to 1.5 inches (3.8 cm) long that can penetrate heavy leather gloves— a lesson learned quickly by anyone trying to band these powerful birds. A common prey of the great horned owl, in the Canadian portion of its range, is the 3-pound (1.4-kg) snowshoe hare, a muscular animal that frequently equals the owl in weight. A harried hare is surely hard to hold and requires the heaviest of strigid weaponry to overpower.

On Wings That Whisper

The wing shape of a bird is not random. Through the process of evolution, the wings of every species have been honed by natural selection to an optimal design. Body size, habitat, and lifestyle combine to determine which wing shape a bird will have. Among the nearly 10,000 species of birds worldwide, wing shapes vary greatly, but ornithologists recognize four basic styles. *Elliptical wings* are short and broad—a common wing design in the perching birds, grouse, pheasants, and quail. These wings facilitate fast takeoffs and rapid maneuvering in thick vegetation. *High-speed wings* are narrow, pointed, and medium-size in length, and the usual wing design of falcons, shorebirds, swallows, and swifts. This type of wing evolved for rapid flight in open, unobstructed habitats. The third style of wing is the *high-aspect-ratio wing*. These are exceptionally long and narrow and are well suited to high-speed gliding in strong, gusty winds. Albatrosses and shearwaters, perhaps the most accomplished aeronauts on the planet, use such wings to wander the trackless expanses of the open seas. Last, there are *high-lift wings*. These are ideally suited for low-speed flight, soaring, and gliding. Vultures,

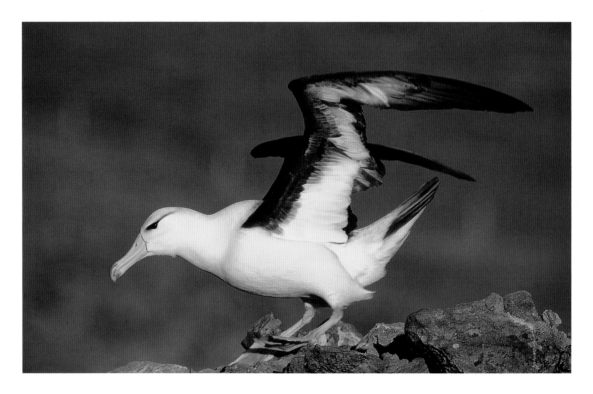

The black-browed albatross has an 8-foot (2.4-m) wingspan and plies the windy latitudes of the roaring forties and furious fifties in the Southern Hemisphere.

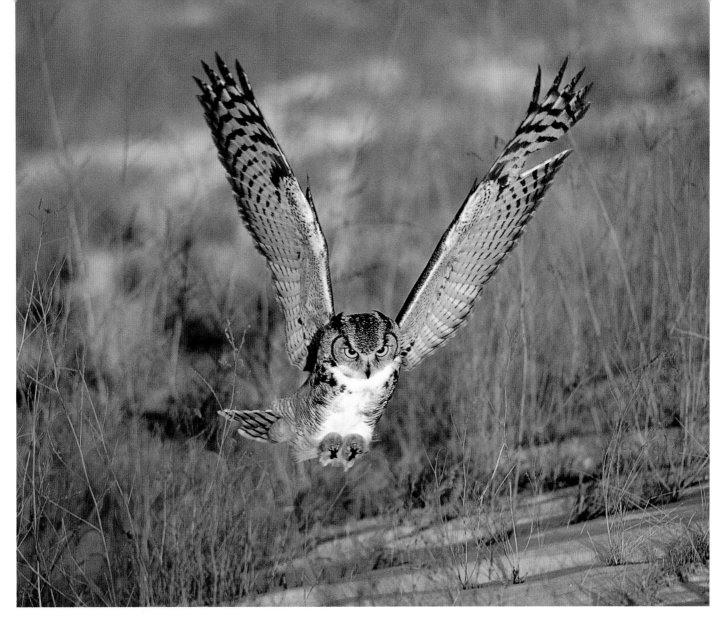

eagles, pelicans, storks, and owls have wings of this type, which are big and rounded, with a large surface area. The large primary feathers on the tips of high-lift wings also flare and separate, creating slots, which further enhance lift.

David Johnson traced the wings of 12 species of North American owls to calculate the combined surface area of their two wings. He then compared his results with values from other studies. Not surprisingly, the three heaviest owls, the snowy, great horned, and great gray, had the largest wings. Great grays were number one, with a total wing surface area ranging from 437 to 508 square inches (2,819–3,277 sq cm). To give you a frame of reference, a standard sheet of typing paper is 93 square inches (600 sq cm) in area. The snowy owl ranked second with a total wing area of 399 square inches (2,574 sq cm), and the great horned owl's wings were slightly smaller, measuring an average 388 square inches (2,503 sq cm). The relevance of these measurements becomes clear when you consider the body weight of the bird they are keeping aloft and what consequences this has for flight performance. For example, the wings of some of the great grays in Johnson's study were 25 percent larger than those of the snowy owl, yet the snowy owl is roughly 25 per-

The separation of the large primary feathers on the tips of a great horned owl's wings are called slots. These enhance lift and maneuverability. The large gap in the owl's left wing is the result of an injury.

An Owl's Skeleton

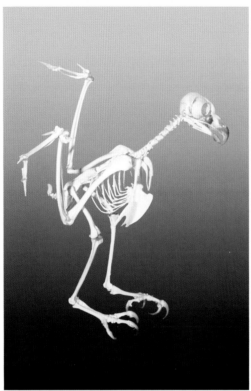

This skeleton of a great horned owl reveals how long the bird's neck actually is even though the owl appears to have a short neck when it is covered with feathers.

As in all birds, the skeleton of the owl evolved to provide maximum strength with minimum weight. To achieve this, the large limb bones in owls are hollow, air-filled, and lightweight. They are reinforced with internal struts to give them added structural strength to withstand the forces generated by the large muscles of the owl's wings and legs. Even so, the skeletal weight of an eastern screech-owl comprises only 7.5 percent of its total body weight. A principle of biophysics dictates that as any vertebrate animal gets larger it needs a heavier skeleton to support its bulk. Thus, a great horned owl's skeleton is heavier than that of a screech-owl and comprises 8.5 percent of its total body weight. Even so, the owl's skeleton weighs relatively little. In fact, an owl's feathers typically weigh twice as much as its bones. In comparison, the skeleton of an adult human comprises about 11 to 12 percent of its body weight.

cent heavier. This introduces the concept of wing loading—the amount of body weight carried by each unit of wing area and the impact this has on the way a bird flies.

When you combine low body weight with a large wing surface area, as you have in owls, wing loading is low. This means that each square inch of wing needs to lift a relatively small amount of body weight. Johnson calculated that the wing loading was lowest in the northern saw-whet, flammulated, and long-eared owls, and all had a value of 0.05 ounces per square inch (0.21 gm/sq cm). The snowy owl had the heaviest wing loading, 0.13 ounces per square inch (0.55 gm/sq cm), which was roughly a threefold increase over the smaller species. Even with such a relatively heavy wing loading, the snowy owl is still much better off than loons, grebes, auks, rails, grouse, waterfowl, and songbirds, to name just a few. The wing loading in loons is probably the highest in the avian world with a value of 2.5 ounces per square inch (1.8 gm/sq cm) for the common loon.

Low wing loading influences two aspects of owl flight: speed and noise. Because each small area of wing is supporting a low amount of body weight, the bird can fly slowly without stalling. This allows the

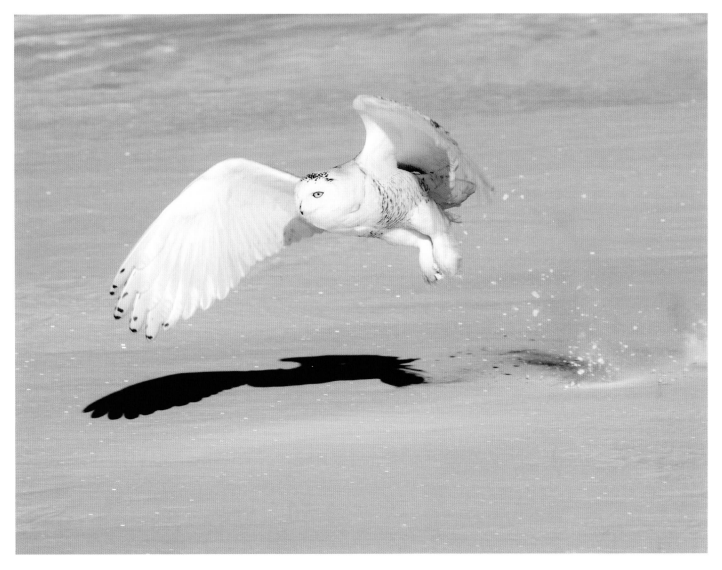

owl to spend a greater amount of time searching the ground beneath it for potential prey. Flying slowly also reduces the wind noise from air flowing over the wings. By flying quietly an owl is more likely to detect the faint sounds of hidden prey and less likely to betray its approach to any prey with sharp hearing. Desert rodents, such as kangaroo rats, for example, have evolved enlarged middle ear chambers that improve their detection of low frequency sounds, and they escape the talons of long-eared owls more frequently than do other rodents without such auditory adaptations; making silent flight a beneficial trait.

In some owls, the structure of their wing feathers has been modified to further dampen the noise of flight. These species have a stiff comb-like fringe on the leading edge of their wings. In many there is also a soft, hairlike fringe on the trailing edge of the wing as well. Apparently, the fringes smooth the air flow and lessen flutter, both of which reduce aerodynamic noise. A fine, velvety down is also commonly present on the upper surface of the primary and secondary flight feathers in these owls. This lessens the noise when wing feathers slide over one another during normal flight. These three feather features are best developed in the great gray, boreal, and northern saw-whet owls, all of which rely

The snowy owl has the second largest wing area among North American owls. Each wing is roughly the same size as two standard sheets of typing paper. The largest wings are those of the great gray owl.

heavily on their acute sense of hearing to help them in hunting. On the other hand, the feather fringes are reduced or missing in both species of pygmy-owls, the northern hawk owl, elf owl, and burrowing owl. All these latter species either hunt frequently in the daytime or specialize in hunting insects for which silent flight is unnecessary.

Colors That Disguise

I remember the first time I held a great gray owl to attach a band around its leg. She was a large female, about 2 feet (0.6 m) tall, with a 4-foot (1.2-m) wingspan. I was surprised at how little she weighed, and the experience gave new meaning to the expression "light as a feather." A thick loft of soft billowy plumes covered her chest and belly. All owls have soft body plumage—a characteristic they share with their distant relatives the nightjars. Like the nightjars as well, many species of owls have cryptic feather patterns to hide them from mobbing birds, predators, and potential prey. Such protective coloration is achieved in three ways. Camouflage colors in grays, browns, tans, and blacks mimic the background and help the owl to blend in. Disruptive designs in the form of dark bars and streaks and light-colored spots break up the bird's silhouette and conceal its outline. Last, there is countershading in which lighter-colored feathers on the bird's underside, compared to its back, offset the effect of a shadow cast by its body when it is crouched on the ground. Countershading is present in many owls but probably does not contribute greatly to their concealment since most species don't roost on the ground as do the nightjars.

Feathered ear tufts are another way many owls conceal themselves. Roughly 40 percent of owls worldwide have them. In the United States and Canada, ear tufts occur in the following nine species: the great horned owl, the short-eared and long-eared owls, the flammulated owl, the two pygmy-owls, and the three kinds of screech-owls. Ear tufts have nothing to do with hearing. For decades, biologists speculated that their principal purpose was to camouflage the birds by breaking up their outline and mimicking the ragged top of a broken branch, yet no one had tested this hypothesis until 1990. That year, Denver Holt and his colleagues in Montana published their findings after they watched two captive northern pygmy-owls react to the presence of a house cat and a tethered peregrine falcon. In every instance, when faced with one of these dangerous predators, the owls erected small tufts at the top of their head, compressed their body feathers to minimize their size, and swivelled one wing around in front of their underside to camouflage themselves. This concealment posture was never seen in confrontations between owls in the wild nor in defense of their breeding territories. On four occasions it was also seen when wild pygmy-owls were discovered and mobbed by foraging songbirds.

All the screech-owls use a similar concealment repertoire when danger threatens. The spots and streaks on the wings of these small owls accentuate their resemblance to patterned bark and improve their camouflage. Even species without ear tufts, such as the northern saw-whet,

The fringed feathers on the trailing edge of a short-eared owl's wing feathers muffle sound and make the bird's flight less noisy.

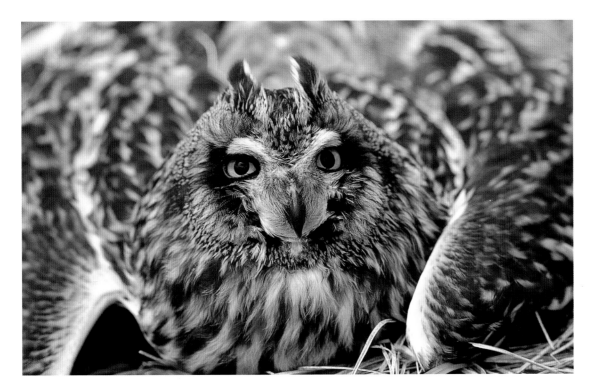

boreal, and elf owls flatten their body plumage and erect their outer facial feathers to mask the outline of their heads.

The large, pugnacious great horned owl has little to fear from most predators, so in this species its conspicuous ear tufts may function more for communication than concealment. James Duncan kept a great horned owl that would flatten its ear tufts when it was agitated or frightened and raise them high when it was watching a distant animal with interest.

Color variations in owls have interesting explanations, some dating back to the nineteenth century. Constantin Gloger was a Polish researcher who lived in the mid-1800s and studied the relationship between climate and color variation in birds. Gloger noticed that birds living in moist environments were often darker colored than those living in arid regions. His observations eventually became known as Gloger's rule. We know that melanin, the pigment that darkens feathers, also helps wet plumage dry more quickly by absorbing and concentrating the sun's warmth. Color variation in owls frequently follows the predictions of Gloger's rule. For example, northern pygmy-owls in the rain-soaked Pacific Northwest are darkish brown, whereas those living in the relatively dry foothills of the Rocky Mountains are grayish and lighter colored. In another instance, spotted owls in the arid mountains of New Mexico are noticeably paler than those living in the coastal rain forests of British Columbia and Washington.

The great horned owl has the widest distribution of any owl in the United States and Canada, and it has the greatest color variation of any of the species found on the continent. Predictably, the darkest individuals tend to be found in the moist Pacific Northwest. In the east, they are lighter and more brownish. In the arid prairies of the interior, great horned owls are often pale and grayish, and those in subarctic Canada

The short-eared owl is one of nine species of owls in the United States and Canada that has ear tufts. The presence of ear tufts are a distinguishing feature to look for when trying to identify an owl in the field.

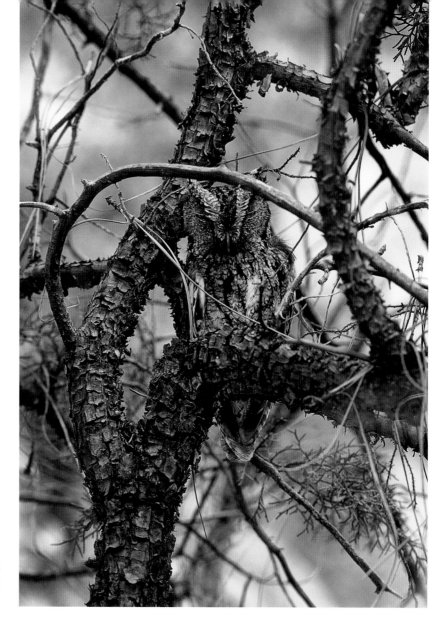

In the Chiricahua Mountains of southern Arizona, the cryptic plumage of this roosting whiskered screech-owl closely matches the patterned bark on the alligator juniper tree, which is why it chose to hide there.

are the palest, and may, at a distance, be mistaken for a juvenile snowy owl. The color variations in these owls blend seamlessly from one area to the next and bear no relationship to the sex or maturity of the bird. Furthermore, multiple color variations can occur in the same geographical area, so the trends tend to be loose and not rigidly predictable.

Among birds in general, some species have two distinct color variations that differ from the multiple color gradations of the owls I just described. Examples include snow geese, which can occur in an all-white color phase or a blue gray one; gyrfalcons, which can be white or gray; Swainson's hawks, which can be light bellied or dark; and ruffed grouse, which can be cinnamon colored or grayish. Among owls, this kind of well-defined dichromatism is characteristic of both the flammulated owl and the eastern screech-owl. Both owl species can occur either as a gray color phase or a rufus one. The use of the word phase can be confusing because it sounds like a temporary condition, when in fact it is a permanent one. A rufus eastern screech-owl is rufus for its entire life. To avoid this confusion, some biologists prefer to call these color morphs instead of color phases.

The distribution of the two color morphs in eastern screech-owls has

been studied the most. Rangewide, roughly 36 percent of these owls are rufus colored. The percentage is highest east of the Appalachian Mountains, between Alabama and New York State, where between 56 and 72 percent of the owls are rufus. This color morph is least common along the western edge of the owls' range, where it occurs in less than 15 percent of the birds. More interesting than the numerical values, are the proposed explanations for why this occurs. Frederick Gehlbach carefully analyzed the data and concluded that the rufus morph is most cryptic in subdued light such as occurs in cloudy weather. Consequently, this color variation tends to be more frequent in humid areas, and in particular, in cloudy temperate latitudes. Rufus feathers are also less resistant to abrasion than gray ones. This may explain why rufus owls are uncommon along the arid, dusty western edge of the birds' range. The difference in feather durability is due to the difference in the amount of the black pigment, melanin, which is more plentiful in gray feathers than in rufus ones.

In the mid-1970s, researchers suggested that the color morphs in screech-owls might be linked with thermoregulation. It seems that rufus owls burn more energy when they are subjected to temperatures below 23°F (−5°C) than do gray-colored birds. This metabolic difference may lead to higher mortality in rufus owls. In one severely cold winter in Ohio, for example, 44 percent more rufus owls died than gray ones. The researchers were uncertain why such a metabolic difference exists between the two color morphs, but it may be due to differences in the insulating ability of the two plumages. There could also be a fundamental physiological difference that is genetically linked with color. Clearly, more study is needed to resolve this puzzling phenomenon.

Plumage color cannot normally be used to identify the sex of most kinds of owls. Two species are an exception to this rule: the snowy owl

In central Florida, where this eastern screech-owl was photographed, the majority of the birds are rufus in color. The bird's alert expression is a reaction to my accidentally discovering its daytime roost.

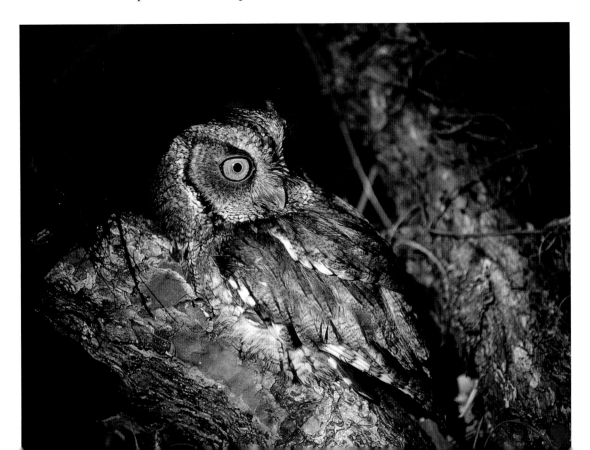

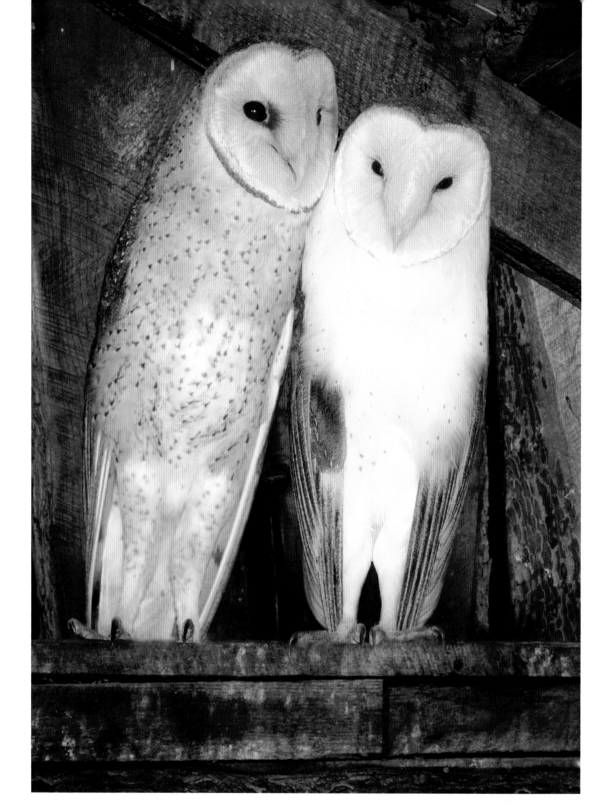

The distinctive spotty plumage on the throat, breast, and belly of the female common barn owl is readily evident when she perches next to her male partner. The female's facial disk is tawny in color, whereas the male's is more whitish. These color differences are 97 percent accurate in determining a barn owl's sex.

and the barn owl. The feathering on an adult male snowy owl tends to be pure white or white with a few small, scattered gray or brownish bars on its breast, back, and tail. An adult female, on the other hand, is typically white with conspicuous dark barring on her wings, breast, back, and tail. This handy key to sexual identification can sometimes fail since the plumage of the darkest males and that of the lightest females can be virtually indistinguishable.

In the barn owl, the male has a whiter facial disk and breast than the female, who tends to be more richly tinged with buff brown. The

female's breast and belly are also heavily flecked with relatively large dark spots, while the male has fewer of these markings and his are noticeably smaller.

When males and females differ in appearance, it is called *sexual dimorphism,* and it is a common trait in many species of birds. Take, for example, the elaborate nuptial plumes of male birds-of-paradise in New Guinea, or the courtship adornment of male Himalayan pheasants or rainbow-feathered tropical manakins. The mechanism driving this flamboyant finery is the necessity for males to compete with each other to win female approval and thus earn the privilege of mating. In the case of barn owls, the situation is reversed. The males do the choosing, and what interests them most are the spots on a female's breast and belly. Black spots signal parasite resistance and the more there are on a female's underside the better. In a European study, Alexandre Roulin found that a bloodsucking parasitic fly occurred less frequently on chicks raised by more heavily spotted females. Furthermore, the flies on these same chicks were less fertile and produced fewer eggs. His findings showed that the offspring of spotted females had a greater resistance to pathogens. In the end, the resistant females produced more fledglings than their less heavily marked counterparts and were more desirable to males searching for prospective mates. How the spot density on a female's breast is linked to parasite resistance is still a mystery.

Fretting with Feathers

Disagreement still exists whether birds evolved from the "ground up" or from the "trees down." In the first scenario, a terrestrial reptile, believed by many to be a small dinosaur, initially developed feathers to keep its body warm. Later, the feathers gradually elongated and became adventitious for nascent flight. In the "trees down" scenario, an arboreal reptile that was not a dinosaur, developed feathers that enabled it to parachute and glide more efficiently from tree to tree. The feathers had the added benefit of insulating the reptile, allowing it to maintain a higher, more constant, body temperature. Ultimately, no matter which sequence of events proves to be correct, each one illustrates the two important functions that feathers serve in modern birds: temperature regulation and flight.

Owls, like all birds, spend considerable time each day fussing with their feathers in an attempt to keep them in the best possible condition. One summer, when I was photographing a family of nesting great gray owls, I was able to watch the adult female preen herself for nearly 30 minutes in the soft muted light of the aspen canopy. At first, she stropped her bill on a branch to clean off some dried blood and bits of flesh from meals she had recently fed her chicks. Then she focused on the large flight feathers of her wings and tail. Each of the feathers was delicately nibbled as she drew its length carefully through her beak. She ended by scratching her head with the sharp talons on her foot and shaking herself vigorously to reshuffle and settle her plumage. Throughout the whole time she seemed calm and relaxed.

Feathers are not living tissue. They consist of keratin, the same protein that comprises talons, beaks, and mammalian hair. Like most birds, owls regularly anoint their feathers with secretions from a specialized gland called the preen gland, or uropygial gland, located at the base of the back. The gland secretes a mixtures of waxes and fats that the owl spreads over its feathers with its beak. The waxy secretions prevent the feathers from becoming brittle and frayed. This not only waterproofs the plumage but also inhibits the growth of fungus and bacteria that can digest and destroy the feathers. Certain fats may also discourage feather lice. Secretions from the preen gland also prevent the bird's beak from drying out and flaking.

The barn owl has a special serrated claw on the middle toe of each foot that it can use to comb and groom its facial feathers. Herons and nightjars have a similar well-developed "comb" on their middle toes, and biologists speculate that birds use the claw to remove parasites during head scratching. Herons may also use their serrated claw to remove fish slime from their face, and in nightjars the claws may help scrape off sticky secretions produced by insect prey. None of the strigid owls have these specialized claws, so it seems that their presence is not vital for healthy plumage.

Bathing may be as pleasurable to an owl as it is to a human. Researchers have watched burrowing owls in the rain, with their wings outstretched, flapping and running around excitedly outside the family burrow. Afterward, the owls shook their feathers and eagerly preened. Species such as great horned owls and barred owls will sometimes wade into shallow pools and splash water over their head and back. Spotted owls use puddles in forest streams to do the same. In Texas, Frederick Gehlbach saw several eastern screech-owls bathing together at the edge of a creek and watched other screech-owls douse themselves in an urban birdbath with less than an inch of water in it.

When water is scarce, owls, like many other birds, may dust themselves with dirt. Burrowing owls that live in arid prairies and deserts dust bathe frequently. So do short-eared owls, which push their heads into the dry soil, then flip dirt over their backs. Afterward, they fluff their feathers vigorously to work the soil particles throughout their plumage. It's not clear why birds dust themselves with dirt, but the reason usually given is to rid themselves of external parasites.

A dozen different types of chewing louse may inhabit the feathers of a single bird. Each louse species occupies a particular part of the body or focuses on a specific kind of feather. Many types of flies and ticks feed on the blood of birds, and a multitude of mites chew on bits of dead skin. The thick, downy plumage of an owl, or of any bird, is a warm, sheltered refuge where invertebrates thrive. Anything a bird can do to discourage such unwanted tenants is likely to be beneficial.

Even when liquid water is scarce and the soil is frozen solid, owls find ways to keep themselves clean. Snowy owls will rub their face in fresh powder snow to clean grime and gore from their beak and feathers. The veteran raptor researcher Tom Cade reported seeing a northern hawk owl in Alaska land atop a telephone pole capped with 2 inches (5 cm)

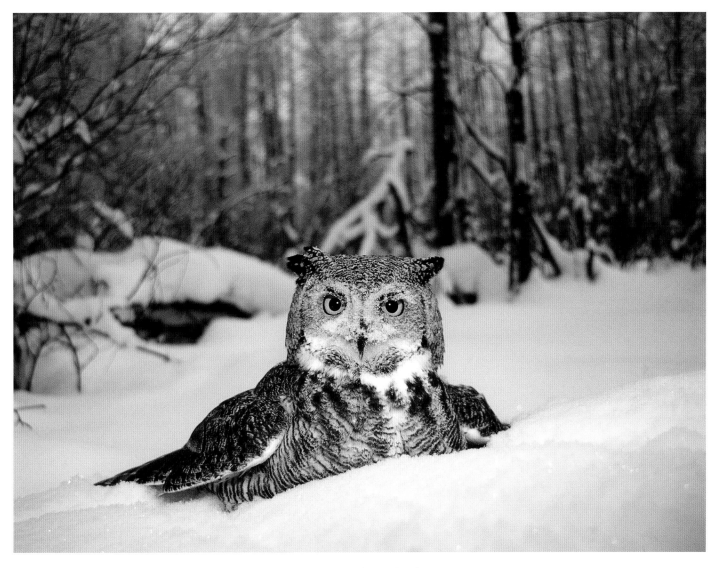

of fresh snow. The owl partly buried its face in the snow, then shook its head and body, scattering the snow. It then used its beak to toss additional snow over its back and wings. In the arctic, I've often seen wintering ravens behave in a similar way, so it doesn't surprise me that northern owls do it as well.

Preening can serve a social function when birds groom each other. This behavior, called *allopreening,* is common in owls as it is in a wide variety of species from parrots to puffins. Scientists believe that allopreening serves primarily to reinforce the strength of the pair bond, but it also benefits the feathers of the participants since they typically focus their nibbling around a mate's face, head, and neck, areas that are not easily groomed by the owner. Mother owls also commonly preen the growing plumage of their chicks. The tendency to allopreen seems to begin at a very early age in owls. I have seen great horned owl chicks less than a month old preen not only their nest mates but also the top of their mother's head and the rear of her neck. The adult owl seemed to enjoy the chick fussing with her feathers and she let the youngster nibble her plumage for almost a minute.

No matter how well a bird cares for its feathers, the ends eventually

While this great horned owl was diving for prey, the feathers on its face became covered with powder snow. A number of northern owl species use snow to clean themselves.

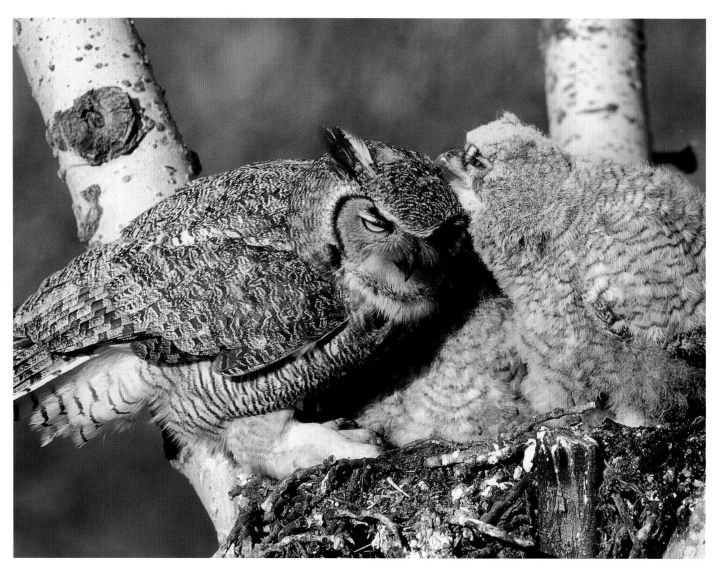

This mother great horned owl had just fed a northern pocket gopher to her three chicks when one of the youngsters began to preen her head feathers. The preening session lasted nearly a minute.

become frayed and broken, and the plumage needs to be replaced to function optimally. The thermal consequences of tattered plumage were significant in a study of burrowing owls in central California. Burrowing owls, by their underground habits, subject their plumage to great physical wear, and in summer the birds have many frayed feathers. The damaged feathers absorbed 36 percent less solar heat than did freshly molted winter plumage. Although this may have been helpful in the stifling heat of summer, it would have been an unneeded loss of energy in the cool days of winter when the birds are under their greatest thermal stress.

Molting is the process by which birds replace old, damaged feathers. It is one of the three most energy-demanding activities in a bird's life. The other two are breeding and migration. Molting requires so much energy because a bird must normally replace every feather on its body. In most species of owls, their plumage constitutes between 10 and 15 percent of their body weight. A long-eared owl, for example, may have as many as 10,993 feathers. A molting bird has energy needs beyond those required to build new feathers. It must also offset the extra costs of maintaining its temperature at a time when its body is poorly insulated,

in addition to the extra energy costs of flying with missing wing and tail feathers. Many owls shed all their old tail feathers over a span of 7 to 10 days, while also shedding some of their large wing feathers.

Molting, in owls, occurs after the breeding season when chicks are becoming independent. In most species, the parents begin to molt in June and finish by September or early October. The typical molting pattern in owls is to shed and replace all their feathers once every year. But for a number of species, such as great grays, boreals, long-eareds, spotteds, barns, and great horned owls, the molt is partial. These owls annually replace all the small feathers on their head, body, and wings but lose only some of their large tail and flight feathers. The feathers that are missed are replaced the following summer. In rare instances, flight feathers may be kept for more than two years. For example, most great gray owls may retain their juvenile flight feathers for three to four years. It's all just a matter of energy. If prey is plentiful, then the molt can be completed in a single season. If, on the other hand, prey is scarce a bird may stretch the process over two seasons, or more.

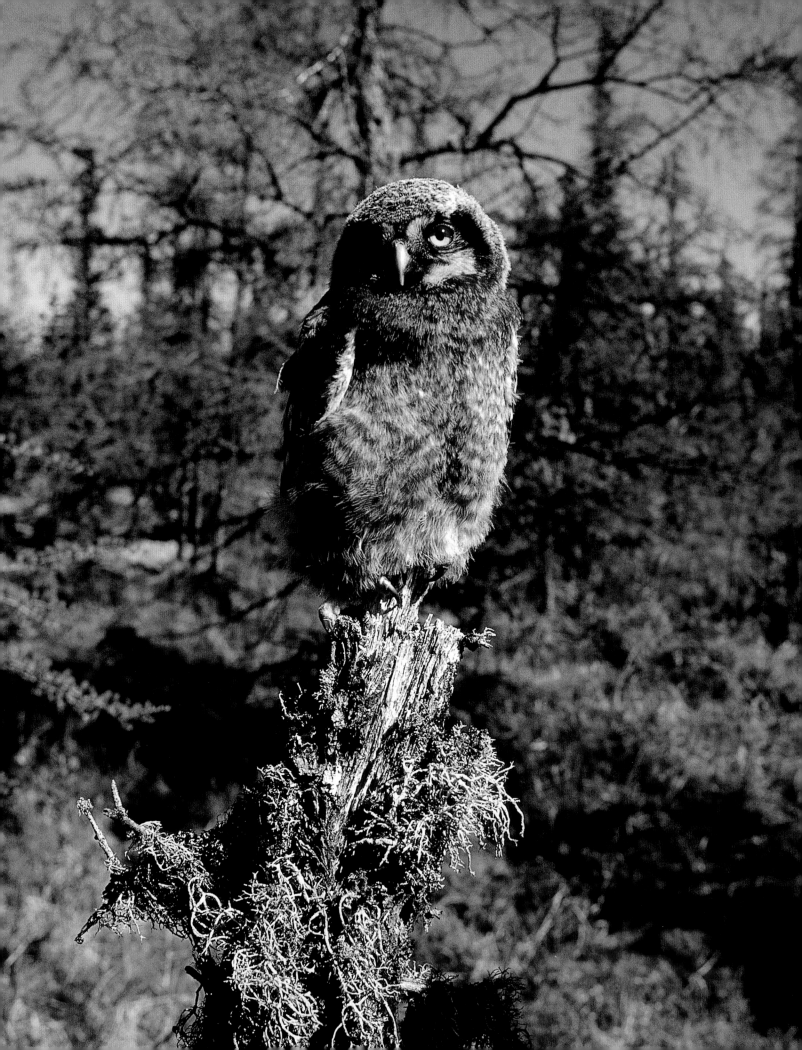

Identification Guide

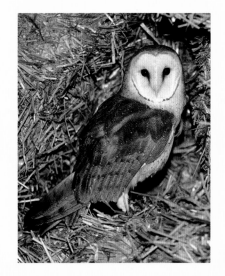

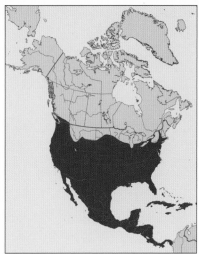

Barn Owl (*Tyto alba*)

Field Identification: A medium-size owl with dark eyes and no ear tufts. The barn owl has long legs that are lightly feathered and a conspicuous heart-shaped facial disk. It is strongly nocturnal.

Habitat: Prefers open country in wilderness areas or those close to human habitations. Frequently found in agricultural areas, around farms and abandoned buildings.

Diet: Mainly rodents, especially voles and shrews. Also consumes small numbers of birds, and rarely amphibians and reptiles.

Life Span: Maximum 8 years. Most adults live 1 or 2 years.

Status: Slow, long-term decline throughout the United States, perhaps due to changes in agricultural practices. In Canada, the population is vulnerable and fluctuates depending upon winter severity.

(*opposite*) This young northern hawk owl, barely a month old, was living in a muskeg bog in northern Manitoba.

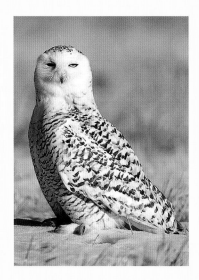
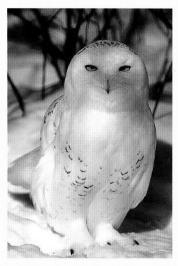
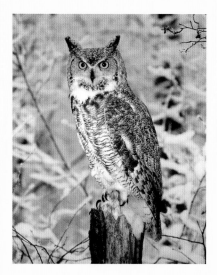

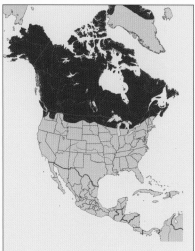
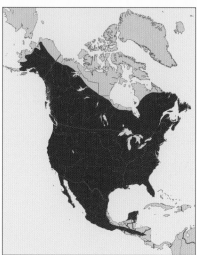

Snowy Owl (*Bubo scandiacus*, formerly *Nyctea scandiaca*)

Field Identification: A large, white owl with bright yellow eyes and no ear tufts. Adult females have conspicuous dark barring on wings, breast, back, and tail. Feet and toes thickly feathered. Commonly active in the daytime.

Habitat: Summers in open arctic tundra and winters in treeless prairies, marshlands, fields, and meadows.

Diet: Lemmings in summer; in winter preys on seabirds, waterfowl, rodents, hares, rabbits, and game birds.

Life Span: Maximum 10 years in the wild; 28 years in captivity.

Status: Population stable. The Canadian breeding population is estimated at 10,000 to 30,000 pairs. Alaskan breeding population undetermined.

Great Horned Owl (*Bubo virginianus*)

Field Identification: A large owl with lemon-colored eyes and conspicuous ear tufts. White throat distinguishes it from the medium-size long-eared owl. Overall color varies widely from pale gray to dark brown. Primarily nocturnal, but occasionally crepuscular.

Habitat: Widespread and ecologically adaptable. Equally at home in prairie riparian areas, northern boreal forests, eastern deciduous forests, and deserts.

Diet: Extremely catholic diet over its wide geographic range. Targets mainly medium-size mammals but also preys on birds, amphibians, reptiles, and fish.

Life Span: Possibly the longest-lived of North American owls. Record life span in the wild is 28 years, 7 months.

Status: Population stable. In Christmas Bird Counts it is the most widely reported owl in North America.

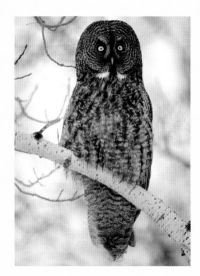

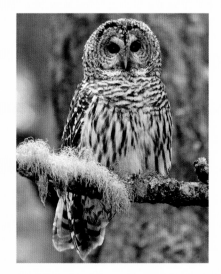

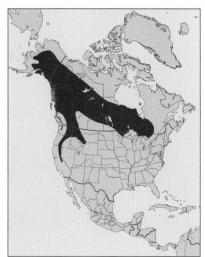

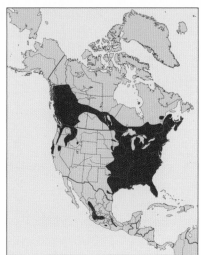

Great Gray Owl (*Strix nebulosa*)

Field Identification: By height, it is the tallest owl in North America. It has a long tail, large round facial disk, small yellow eyes, and no ear tufts. Unusually tame. Mainly crepuscular, but sometimes diurnal in northern winters.

Habitat: Northern boreal forests and the coniferous woodlands of the western mountains.

Diet: A small-mammal specialist, especially voles, mice, shrews, and pocket gophers.

Life Span: Maximum 12 years in the wild. Longer in captivity.

Status: Difficult to evaluate because of remote nesting habitat. Canadian breeding population estimated to be stable at 10,000 to 50,000 pairs. U.S. breeding population undetermined.

Barred Owl (*Strix varia*)

Field Identification: Large owl with dark eyes, pale yellow beak, and no ear tufts. Light-colored belly and chest vertically streaked with dark brown. Mainly nocturnal.

Habitat: Mature deciduous woodlands and northern boreal forests. In recent decades has expanded into the old-growth temperate rain forests of the Pacific Northwest.

Diet: Small mammals, birds, amphibians, fish, and invertebrates.

Life Span: Maximum 18 years in the wild.

Status: Increasing, especially in the Great Lakes and northeast regions. Canadian population estimated to be up to 50,000 breeding pairs. U.S. breeding population undetermined.

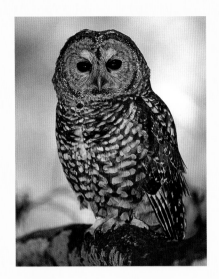

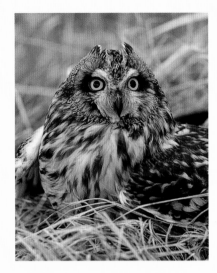

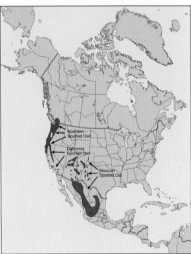

Spotted Owl (*Strix occidentalis*)

Field Identification: Medium-size brown owl with dark eyes, yellowish green bill, and no ear tufts. Chest and belly horizontally barred with dark brown. Secretive and nocturnal.

Habitat: Cool, mature forests with large tree cavities for nesting.

Diet: Small and medium-size mammals, especially flying squirrels, wood rats, and pocket gophers.

Life Span: Generally long-lived. Maximum 17 years in the wild.

Status: Elusive nature makes population estimates difficult. Currently, the northern subspecies is threatened in the United States and endangered in Canada. Extirpation in Canada seems imminent in the next decade. California subspecies declining and Mexican subspecies threatened.

Short-eared Owl (*Asio flammeus*)

Field Identification: Medium-size pale, streaked owl with yellow eyes and inconspicuous ear tufts. Flight is mothlike and buoyant as it glides and flaps close to the ground. Mainly diurnal and crepuscular.

Habitat: Nomadic and widespread species that inhabits open grasslands, marshes, sloughs, and agricultural fields.

Diet: A small-rodent specialist, especially voles.

Life Span: In North America, maximum age recorded in the wild 4 years 2 months, but in Europe up to 12 years 9 months.

Status: Slow, long-term decline most marked in the Northeast where seven states have listed the species as endangered, threatened, or of special concern.

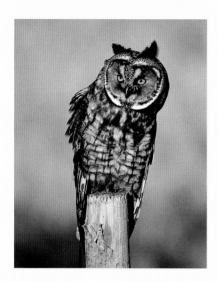

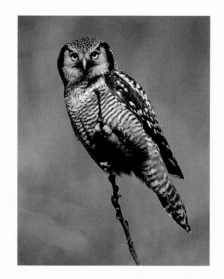

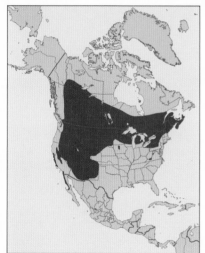

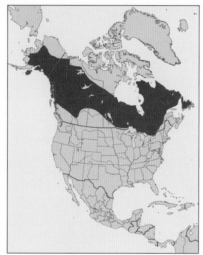

Long-eared Owl (*Asio otus*)

Field Identification: A medium-size secretive owl with a rust-colored facial disk, bright yellow eyes, and long feathered ear tufts. Its ear tufts are closer together and more upright than those of the great horned owl, whose ear tufts point outward and are widely spaced. Strictly nocturnal.

Habitat: Roosts and nests in thick forests and shrublands, but hunts almost exclusively in open habitats such as meadows, prairies, and farmlands.

Diet: A wide range of small mammals, especially voles, mice, and pocket gophers. Occasionally preys on songbirds and bats.

Life Span: North American record is 9 years.

Status: General decline secondary to forest cutting and the loss of riparian habitats, especially in the West. The Canadian population is estimated at just 10,000 to 20,000 breeding pairs. U.S. breeding population undetermined.

Northern Hawk Owl (*Surnia ulula*)

Field Identification: A tame medium-size owl with yellow eyes and no ear tufts. Has a long, rounded tail and often perches conspicuously. Hunts mainly during the day.

Habitat: Muskeg bogs and other open areas in the northern boreal forest.

Diet: Small mammals and songbirds.

Life Span: Up to 10 years in the wild.

Status: Difficult to accurately evaluate the population status as it is for all the boreal and arctic owls. The population in North America is believed to have remained stable over the past century.

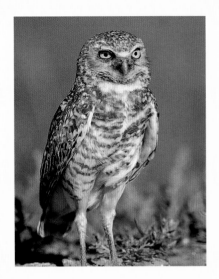

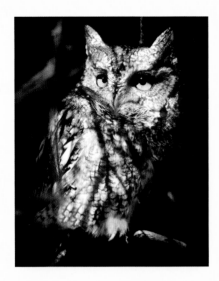

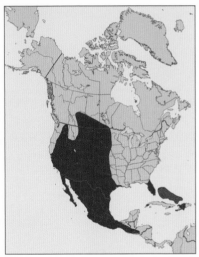

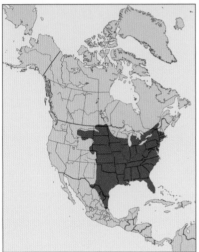

Burrowing Owl (*Athene cunicularia*)

Field Identification: A small owl, only 9 inches (23 cm) tall, with long legs, yellow eyes, and no ear tufts. Active day and night.

Habitat: Uncommon resident of western prairies and farmlands. Migrates from the northern portion of its breeding range in winter. In Florida, occurs year-round in open habitats such as pastures, golf courses, and airports.

Diet: Small mammals and invertebrates, including beetles, grasshoppers, and scorpions. Also hunts songbirds, lizards, toads, and small snakes.

Life Span: One banded owl survived 8 years and 8 months in the wild.

Status: Endangered in Canada with only 400 to 500 pairs remaining. Declining throughout the United States, especially along the eastern edge of its prairie range.

Eastern Screech-Owl (*Megascops asio, formerly Otus asio*)

Field Identification: A small grayish or reddish owl with yellow eyes and large conspicuous ear tufts. When detected may freeze on its perch, slimming its body to resemble a broken branch. Mainly nocturnal.

Habitat: Deciduous and coniferous woodlands with available tree cavities. Readily habituates to humans and may occupy suburban woodlands and use bird boxes for nesting.

Diet: Wide range of vertebrate and invertebrate prey, including small mammals, songbirds, snakes, lizards, salamanders, crayfish, and insects.

Life Span: Maximum of 14 years 2 months, but most live less than 5 years.

Status: No clear trend evident. Loss of woodland habitats may have been balanced by the species' use of suburbs. The Canadian breeding population is estimated to be stable at 10,000 to 15,000 pairs. U.S. breeding population undetermined.

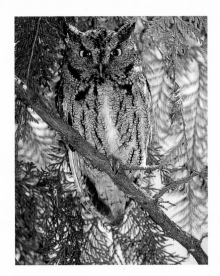

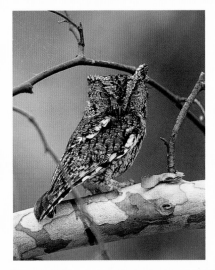

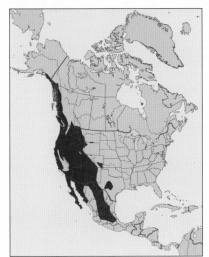

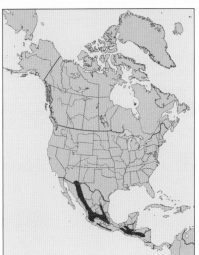

Western Screech-Owl (*Megascops kennicottii*)

Field Identification: A secretive small grayish owl, only 8.5 inches (22 cm) tall, with yellow eyes and large ear tufts. Nocturnal and secretive.

Habitat: Occupies a variety of woodland habitats with the highest densities occurring in deciduous riparian forests at low elevations. Tolerant of humans and will nest in residential areas.

Diet: Small mammals, occasional songbirds, and invertebrates such as Jerusalem crickets, carpenter ants, and crayfish.

Life Span: Maximum recorded in the wild is 13 years. Owls in captivity have lived up to 19 years. Average adult life span only 2 years.

Status: U.S. population stable. Canadian population also estimated to be stable with only 1,000 to 2,000 breeding pairs.

Whiskered Screech-Owl (*Megascops trichopsis*)

Field Identification: Smallest of the three screech-owls at just 7.5 inches (19 cm) tall. A small grayish owl with yellow eyes and obvious ear tufts. The facial bristles that are the source of its common name are difficult to see in the field.

Habitat: Oak and sycamore montane woodlands of southern Arizona and New Mexico.

Diet: Almost exclusively arthropods, including moths, grasshoppers, spiders, caterpillars, centipedes, and beetles.

Life Span: Maximum age unknown. Longest one on record is 4 years but probably live much longer as do other screech-owls.

Status: Population trend unknown.

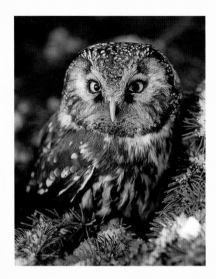

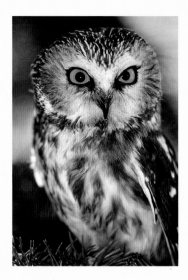

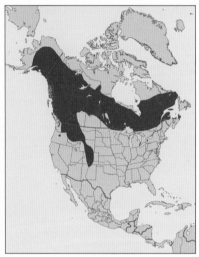

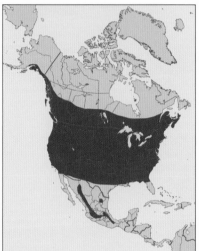

Boreal Owl (*Aegolius funereus*)

Field Identification: A small unwary owl with yellow eyes, no ear tufts, and a grayish white facial disk with a black outside border. Secretive and nocturnal.

Habitat: Boreal forest in the north and subalpine coniferous forest in the western mountains.

Diet: Small-mammal specialist, especially voles, mice, and tree squirrels. Also preys on small songbirds such as thrushes, juncos, redpolls, kinglets, and woodpeckers.

Life Span: Average adult longevity is 3 to 4 years. Maximum 15 years.

Status: Population size and trends are unknown, once again because of the remote boreal location of most breeding pairs. The Canadian population fluctuates but is possibly stable ranging from 20,000 to 100,000 pairs. U.S. breeding population undetermined.

Northern Saw-whet Owl (*Aegolius acadicus*)

Field Identification: A small nocturnal owl with golden eyes and no ear tufts. The facial disk is white above and between the eyes. Mainly active at night.

Habitat: Found in most woodlands, with highest numbers in coniferous forests at moderate latitudes. One of the commonest owls in the forests of southern Canada and the northern United States. Migrates from the northern portion of its range in winter.

Diet: Small mammals, especially deer mice and voles. Preys on small numbers of songbirds, beetles, and grasshoppers.

Life Span: Maximum in the wild is 10 years.

Status: No clear information on population trends despite the owl's widespread and abundant distribution. Total population in the United States and Canada estimated between 100,000 to 300,000 birds.

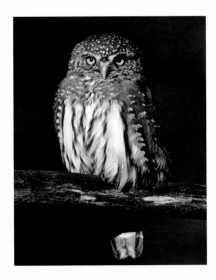

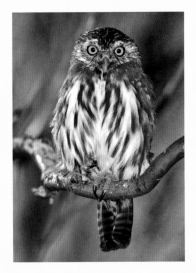

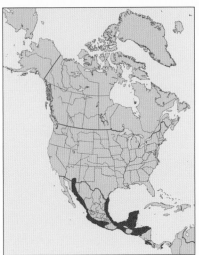

Northern Pygmy-Owl (*Glaucidium gnoma*)

Field Identification: A small brownish or grayish owl with yellow eyes and inconspicuous ear tufts. Pale belly with heavy dark streaks. Dark eyespots rimmed with white on the rear of the head. Mainly active in the daytime, and at dusk and dawn.

Habitat: Low-elevation riparian woodlands to high-elevation coniferous forests.

Diet: A bold hunter that feeds on small mammals, songbirds, lizards, and a wide range of insects, including butterflies, moths, dragonflies, crickets, and cicadas.

Life Span: Not known.

Status: Total population size difficult to evaluate. Analysis of Breeding Bird Surveys done from 1966 to 2000 suggest an annual population increase of 3.1 percent, the largest rate reported for any owl in North America.

Ferruginous Pygmy-Owl (*Glaucidium brasilianum*)

Field Identification: Small diurnal owl with yellow eyes, a greenish yellow bill, and no obvious ear tufts. Whitish eyebrows are often prominent. Two dark eyespots are located on the nape of the neck.

Habitat: Inhabits semiarid desert scrub and mesquite woodlands in the U.S. portion of its range.

Diet: Feeds largely on insects and lizards, although it also preys on songbirds and small mammals.

Life Span: Birds banded in Texas lived for 4 years. No data on maximum longevity.

Status: The U.S. range of the owl is extremely small and appears to be shrinking because of continued habitat loss.

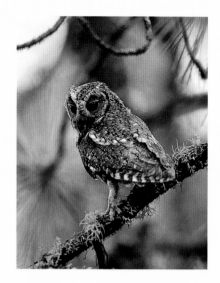

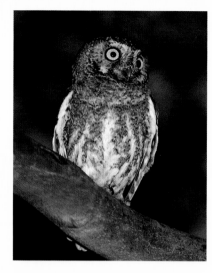

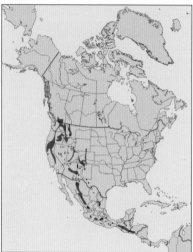

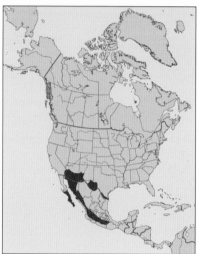

Flammulated Owl (*Otus flammeolus*)

Field Identification: A tiny, secretive, nocturnal owl with ear tufts and dark eyes. All other small owls in the United States and Canada have yellow eyes. It is barely 7 inches (18 cm) tall, making it the second smallest owl in Canada and the United States. Body plumage varies from reddish to grayish in color.

Habitat: Open forests of conifers or aspens, especially ponderosa pine. Migrates to Mexico and Central America in winter.

Diet: Feeds exclusively on insects, in particular moths, beetles, crickets, and grasshoppers.

Life Span: Maximum recorded in the wild is 8 years 1 month.

Status: The secretive habits of this small forest owl make it virtually impossible to accurately evaluate its total population size. Listed as a sensitive species in the United States and a vulnerable species in Canada where there are possibly as few as 1,500 pairs.

Elf Owl (*Microthene whitneyi*)

Field Identification: The smallest owl in the world, standing only 6 inches (15 cm) tall. It has bright yellow eyes and no ear tufts. Mainly nocturnal.

Habitat: Deserts and riparian woodlands during the spring and summer breeding season, but migrates to Mexico in the winter.

Diet: Primarily hunts invertebrates such as insects, scorpions, and centipedes, although it occasionally preys on lizards, small snakes, and young kangaroo rats.

Life Span: Maximum in the wild 4 years and 11 months; 14 years in captivity.

Status: The population appears stable, although it may be expanding its range into northern Arizona.

Son et Lumière

I<small>T WAS</small> F<small>EBRUARY</small>, and I was snowshoeing across a tamarack bog in the purifying wildness of northern Saskatchewan. I wrote about the experience in my journal:

The afternoon was gray and shadowless. Gossamer flakes of snow swirled around me, drifting on a light winter breeze. My eyes were drawn upward to the sky by the throaty croak of a raven. The curious bird circled once, then disappeared, black into white. From the trees in front of me I heard the familiar calls of a mixed flock of black-capped and boreal chickadees, each searching for calories to fuel itself against the frigidity. As I crouched to tighten the straps on my snowshoes, a soft gray shadow floated from the forest. On billowy wings it hovered above the snow about 50 yards (46 m) away. The owl, a great gray, studied the whiteness beneath it. Suddenly, it plummeted, seemingly face first, into the powder. With labored flaps it lifted itself aloft and banked toward the trees. In an instant, it had dissolved into memory. I wanted to relive the moment so I walked over to read the bird's imprint in the snow. A drop of blood testified to the owl's success at finding food—perhaps a southern red-backed vole snatched from the false security of the subnivean world. How did the owl know the rodent was there? Did it see a whisker twitch in the open or hear a muffled squeak? I'm left wondering what hidden sights and sounds an owl might know.

Others before me have had opinions of their own on the auditory and visual capability of owls. Allan W. Eckert, in *The Owls of North America,* wrote that the hearing of the short-eared owl "is so acute that it can hear the footfalls of a beetle at upward of 100 yards, the running of a mouse at 250 yards, and the squeaking of a mouse at an eighth of a mile." The visual achievements of owls were believed by some to be just as outstanding as their auditory abilities. Several studies done in the 1940s concluded that the eyes of owls were up to 100 times more sensi-

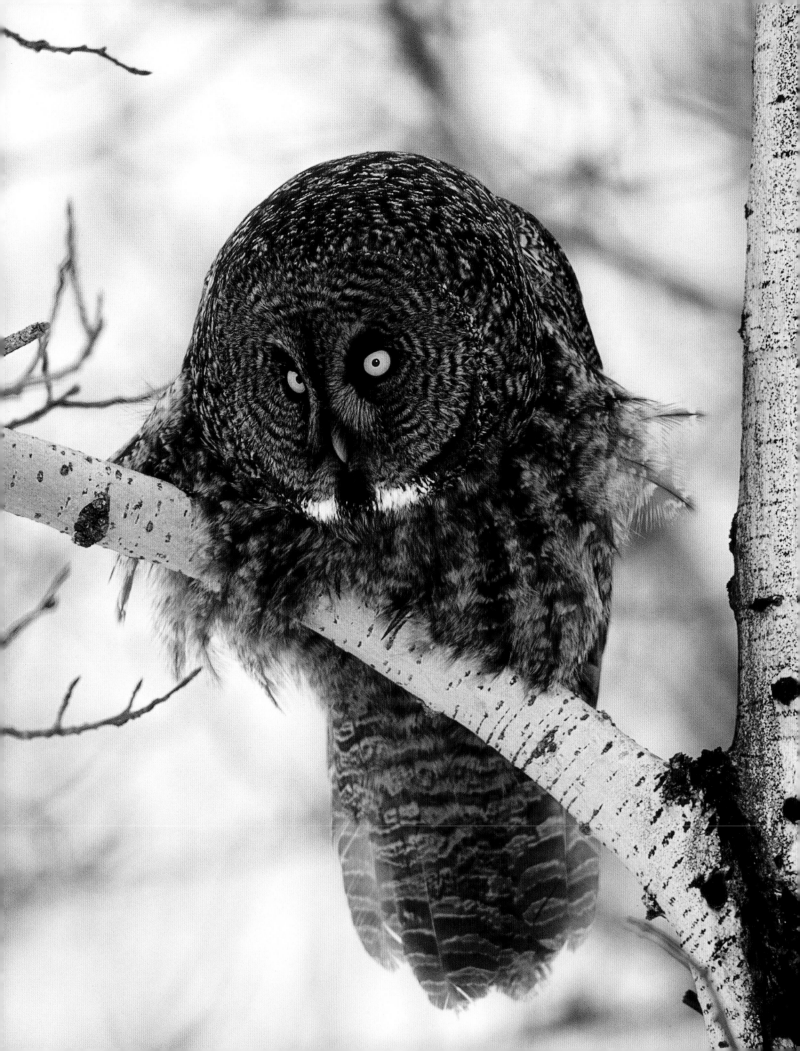

tive than human eyes. Both of these claims are so appealing because they support the popular belief that owls are superhuman in their ability to negotiate the visual and auditory challenges of darkness. Consequently, they have often been accepted without critical analysis and are repeated as scientifically proven facts even to the present day. In the 1991 National Audubon Society's video *Owls Up Close,* Kenn Kaufman, the scriptwriter and one of the world's best-known bird-watchers, claims: "We humans could consider it inaudible, the heartbeat of a mouse. After sunset we see but little. We would grope through the forest even by moonlight, and can hardly imagine making a full speed strike in total darkness and in total silence. They [owls] can, and routinely do, swoop down on prey with deadly precision in the total absence of light. As casually as we would stroll the sidewalk at noon, do they haunt the forest in the shroud of midnight."

I love science because it searches for the truth, and truth frees the mind from the purposeless grip of empty opinion. When I first began to study the biology of owls, I believed, as Kenn Kaufman and many others do, the extravagant claims made about the sensory superiority and capability of owls. It never crossed my mind to question whether these enigmatic birds had extraordinary vision and hearing. The truth is even more exciting and satisfying.

Sound Advice

When considering the physiology of hearing in a bird or mammal there are three aspects to consider: the frequency range of detectable sounds (measured in cycles per second, or hertz), the minimum threshold or loudness of a sound that can be perceived (measured in decibels), and the ability to determine the direction from which a sound originates and pinpoint its location.

When it comes to frequency range, no creatures can match the ability of mammals. Human hearing spans a range from roughly 40 to 20,000 hertz. This is the maximum range experienced by a young child. As humans age, we slowly lose the ability to detect high frequencies and our hearing range gradually shrinks. These numbers are important to remember only because it allows us to compare human hearing with that of other vertebrates.

Bats, toothed cetaceans, and some rodents can perhaps detect the highest frequency range of any creature and are capable of producing and hearing ultrasounds (those above the frequency range of humans) in the 80,000 to 100,000 hertz range. Some bats can hear frequencies as high as 210,000 hertz. Bats generate these high-frequency sounds, then listen for the echos to determine the location and size of small flying insects.

From physics we know that as the frequency of a sound increases, its wavelength gets shorter. The shorter the wavelength, the smaller the object that can generate an echo and be detected. Furthermore, a tiny object, such as a mosquito, is detected best when the wavelength of the sound approaches the size of the object under scrutiny. Some species of

(*opposite*) The feathers of this great gray owl are fluffed up to warm itself against the intense cold of a northern Alberta winter. The bird, intently watching a deer mouse, is about to launch an attack.

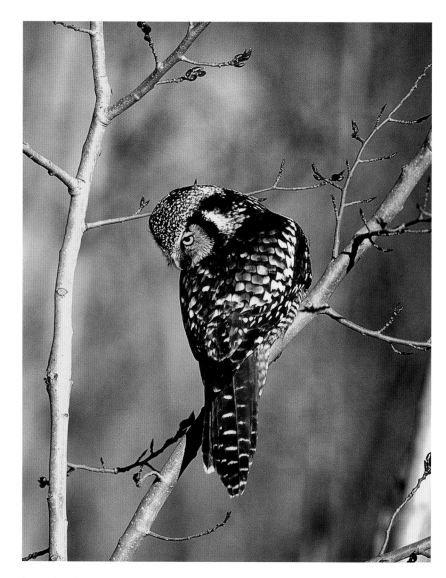

The northern hawk owl hunts primarily in the daytime. Although scientists have never tested the sensitivity of its hearing, they believe this owl relies mostly on vision to detect and capture prey.

bats that hear ultrasonic frequencies can use echolocation to detect wires as thin as 0.002 inches (0.05 mm) in diameter—thinner than the thickness of this page.

The hearing of birds that have been tested ranges from 30 to 10,000 hertz—a range narrower than most adult humans. No bird is known to hear frequencies higher than 12,000 hertz, and most have their greatest sensitivity in the 1,000 to 5,000 hertz range. The principal reason that birds have a narrower hearing range than humans and other mammals rests in the anatomy of their inner ear—the fluid-filled portion of the ear where sound vibrations are converted into nerve impulses. In mammals, the sound-sensing organ of the inner ear is called the cochlea, because of its resemblance to the spiral shell of a snail. The spiral shape allows a greater length of receptive tissue to be packed into a small space. In birds, the sound-sensing organ is also called the cochlea although it is a straight tube and not a spiral. Along the inside wall of the cochlea in both birds and mammals there is a sensitive membrane stretched throughout the organ's length that is receptive to different frequencies. Mammals hear a greater range of frequencies than birds mainly because their cochlear membrane is roughly 10 times longer.

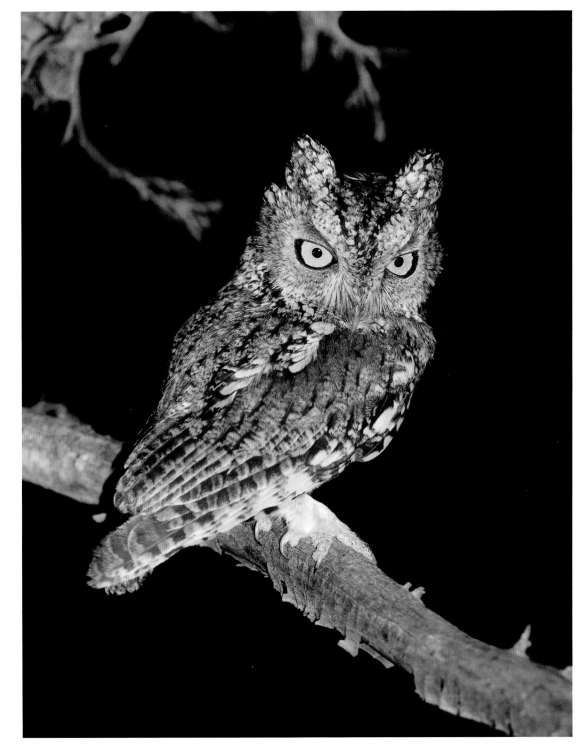

Low-frequency sounds below the hearing range of humans are called *infrasounds*. Naturally occurring infrasounds are generated by thunderstorms, jet streams, earthquakes, crashing waves, and the winds traversing mountain ranges. Keep in mind that these natural phenomena also generate additional sounds that are within the normal hearing range of humans. Low-frequency infrasounds have long wavelengths. For example, a low-frequency sound of 34 hertz has a wavelength of about 33 feet (10 m), whereas a frequency of 50,000 hertz has a wavelength of about 0.23 inches (5.8 mm). Low-frequency, long wavelength sounds are not

This nocturnal whiskered screech-owl has heard some leaves rustle and is intently searching the ground for a potential meal. The owl preys on beetles, grasshoppers, mole crickets, and other insects.

Infrasounds in Birds

To date, only one bird, the 9-pound (4.1-kg) male Eurasian capercaillie, the largest grouse in the world, is known to produce infrasounds. The capercaillie's song consists of three audible parts: a series of clicks increasing in rapidity and loudness, a pop like a cork being pulled from a bottle, and a sound that has been described as two cats fighting, a pig squealing, or a small bird singing. The varied descriptions of the final portion may result from different human observers hearing different elements of the song. Though portions of the male capercaillie's song are audible to humans, much of it is at frequencies below 40 hertz, which humans cannot usually hear. The authors of the study speculated that capercaillie use infrasounds to improve penetration of their song through the thickly forested environment in which they live and thus broadcast their message farther, perhaps more than 219 yards (200 m).

readily dampened by obstacles such as trees and vegetation, and they carry much greater distances than high frequency sounds, sometimes hundreds, even thousands of miles from their source. Homing pigeons can detect frequencies as low as 0.05 hertz, well below the frequency level detectable by humans. For pigeons, and many other birds, the detection of infrasounds may be very important in helping them navigate during migration.

Although some birds can detect infrasounds, they rarely produce these long wavelength frequencies themselves. Infrasounds are high-energy sound waves that take considerable power and a large body size to generate, so it is not surprising that they are mainly produced by the largest of creatures. For example, the haunting moans and songs of humpback whales contain infrasonic elements, and African elephants produce infrasounds to communicate over long distances. Once, when I was close to an elephant in the Serengeti Plains of East Africa, I felt my chest vibrating although I could hear no sounds. The animal was transmitting an infrasonic message.

The frequency range perceived by owls falls within that of most birds. For example, long-eared owls hear sounds between 500 and 8,000 hertz, and this is thought to apply to many species of owls. Owls, however, are not completely deaf to frequencies above and below the upper and lower limits of this range. All that happens is that the detection of these extralimital frequencies falls off dramatically and such sounds can only be heard if the loudness is greatly increased, which normally does not happen in nature.

Lewis Wayne Walker, in *The Book of Owls,* claims that the hearing of great horned owls does not extend below about 70 hertz. Walker suggests that this has important consequences for the owl and one of its avian prey, the ruffed grouse. In spring, the noisy drumming displays

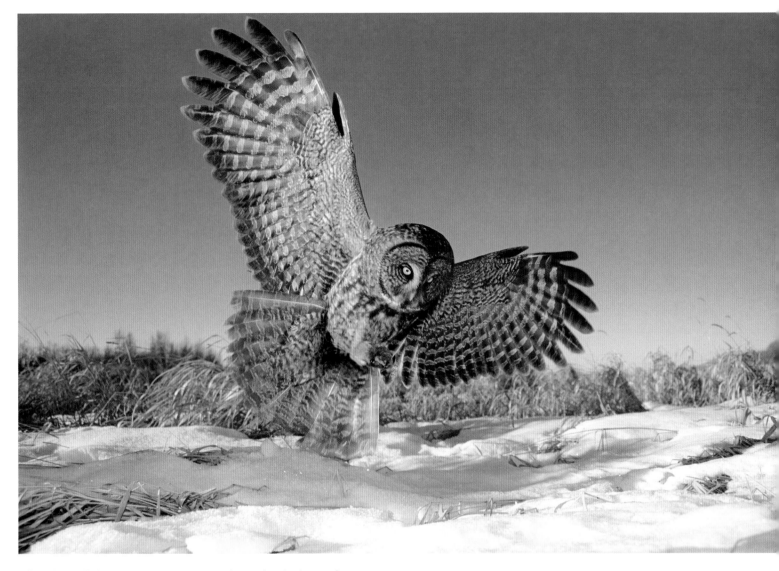

of male ruffed grouse generate sounds in the 40 hertz frequency range. Since this is below the hearing threshold of the owls, the grouse can drum with little risk of detection. Unfortunately, as appealing as this scenario sounds, Walker offers no proof that it is true.

The next aspect of hearing to consider in owls is their minimum auditory sensitivity, or the loudness of the faintest sound they can perceive. Because the hearing threshold in humans can be easily and thoroughly evaluated, it has become the standard used to measure the loudness of sounds. Thus, the point at which an average young adult can just detect a sound from silence is zero decibels. Rustling leaves have a decibel rating of 15; normal conversation, 45; crowd noise, 60; a vacuum cleaner, 75; and a pneumatic drill, 90. The threshold of pain is reached at between 115 and 120 decibels. Graham Martin, a professor at the University of Birmingham, England, has been studying the sensory world of owls and other birds for more than three decades and a synthesis of the hearing and visual sensitivity of owls is well described in his authoritative book *Birds by Night*. Martin concludes that the lower hearing threshold in owls, in general, is about 25 decibels lower than in other bird species tested so far (half a dozen species of songbirds, the pigeon, and the wild

The great gray owl uses both hearing and vision to hunt. In the final moments before striking prey, the owl swings its legs forward and spreads its talons.

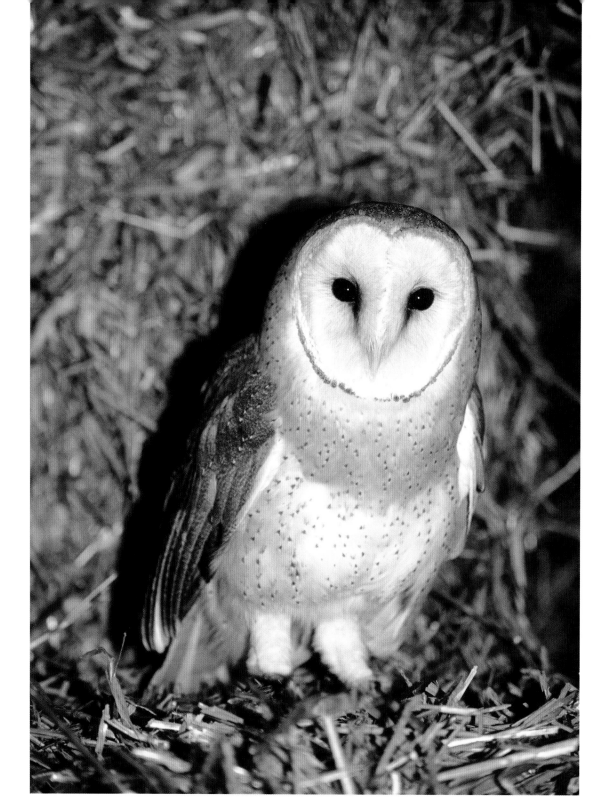

The buff-colored ruff surrounding the facial disk of the common barn owl is distinctly heart shaped and has earned the owl the nickname sweetheart owl.

turkey). Twenty-five decibels translates into approximately a 300-fold difference in sensitivity.

One reason owls hear better than other birds is because of the arrangement of feathers on their face. Many owls have their facial feathers arranged in a disk. The large, conspicuous facial disk of the great gray owl is 6.5 inches (16.5 cm) in diameter. The barn owl is sometimes called the sweetheart owl because of its romantic heart-shaped facial disk. If you examine the head of a barn owl you can see that it has a disk of loose facial feathers overlying a second disk of stiffer more compacted

feathers that are attached to a special flap of skin. The stiffer feathers are called the facial ruff. The facial ruff forms a concave wall behind the opening of the ear and scientists believe it collects sound waves, in the manner of a parabolic antenna, and focuses them at the ear opening. In short, the ruff functions like an amplifier. Masakuzu Konishi calculated that the facial ruff amplifies sounds by about 10 decibels, which yields roughly a 10-fold increase in sensitivity. The enhancement was most marked for sounds of about 7,000 hertz, which falls in the frequency range where the barn owl is most sensitive. Humans experience a similar benefit when they cup their hands behind their ears to isolate and pinpoint a sound. Biologists do not know how much control an owl has over the shape of its facial ruff and how this might affect the sensitivity of its hearing.

The lower hearing threshold in owls is superior to all other birds, but there appears to be relatively little difference between humans and owls. Martin suggests that auditory sensitivity in owls and humans may have gone as low as it can go. In fact, it may have reached the physiological limits of the vertebrate ear.

In all environments there is residual ambient noise, such as the faint rustle of vegetation, the sound of the wind, or animal vocalizations. These background sounds exist even on a totally windless day when the forest seems absolutely silent. Martin argues convincingly that this ever-present background noise has probably existed throughout evolution and might have dictated the ultimate lower limit on hearing sensitivity. In other words, even if owls or humans could hear fainter sounds, the detection of these sounds would be masked by the naturally occurring background noise.

The final aspect of hearing to consider is the ability of owls to pinpoint the location of a sound. Once when I was sitting quietly in an aspen forest, I heard rustling noises in some dry leaves about 30 feet (9 m) away. Eventually, a deer mouse stuck its head above the litter and satisfied my curiosity. At the time, I wondered how much better an owl would be at locating the mouse than I was.

The ability to localize a sound relies on two sources of auditory information: the difference in the loudness perceived by each ear and the time lag between when a sound reaches one ear as opposed to the other. Generally, when the loudness of a sound is the same in both ears and there is no time difference between your right and left side, the sound is directly in front of you or directly behind you. This pinpoints the sound in the horizontal plane, and humans can do this with an accuracy of within one degree. But what about the vertical plane? If a sound is directly in front of you is it located high or low? In this instance, human ears perform almost as well, and we can pinpoint the vertical position of a sound within roughly two degrees.

How do owls compare with humans when it comes to pinpointing a sound? Let me first describe the external anatomy of an owl's ear. The external ears of most birds are simple, round holes, identical in size and location, on either side of the head. Many owls are different from this. In 1870, the American researcher T. H. Street was the first to publish a

paper on the dramatic ear asymmetry he noted in the skulls of two saw-whet owls. Since then, ear asymmetry has been reported worldwide in up to a third of all owl species. When the Swedish owl expert Åke Norberg examined the owls that lived in the northern hemisphere, north of 35° north latitude, he found that half of North American owls and two-thirds of European owls had asymmetrical ears. He attributed this to the presence in northern latitudes of winter snow cover that often hides the prey from sight and forces the owls to hunt by hearing alone.

The nature of ear asymmetry in owls varies between species. In the barn owl, for example, the ear openings are relatively small and of equal size, but the one on the left side is higher than the one on the right. Square flaps of skin in front of the openings exaggerate the asymmetry. In the short-eared and long-eared owls, the ear openings are large, with complicated skin flaps overlying them, but they are the same size and design on both sides, though the one on the left is positioned higher on the skull than the one on the right. In these three species of owls, the asymmetry is limited to the soft tissues of the external ear.

Ear asymmetry among North American species is most dramatic in the boreal, saw-whet, and great gray owl. In all three species, the skull as well as the soft tissues is involved. In these owls, the external ears are half-moon shaped, deep vertical clefts extending over nearly the entire height of the head. The vertical ear openings involve the bone of the skull as well as the soft tissues, although the bony openings are only half as high as the soft tissue openings. The position and orientation of the bony ear openings are asymmetrical. The right ear opening is higher than the one on the left and is directed upward. The left ear opening points downward.

In 1968, Norberg conducted an ingenious experiment to see if the soft tissue and skull asymmetry in the ears of the boreal owl might have evolved to enhance the localization of sounds. Norberg used the skull of a boreal owl and attached soft plastic replicas of the soft anatomy parts to it. He then placed two tiny microphones where the eardrums would normally be located and covered the whole model with a natural skin of feathers. He subjected his model owl to sounds of varying loudness and frequency from an array of locations around the head, and simultaneously measured the loudness of the sounds detected in each of the microphones. He confirmed that indeed sounds varied in loudness from one ear to the other depending on where the sound originated in relation to the front of the skull. He also discovered that sometimes there was a time difference between when one ear detected a sound compared to the other. Researchers now know that the greater the distance between the ears, the greater the potential time difference detectable by the ears. This time lag improves the bird's ability to localize a sound. This may explain in part why owls have such large, wide heads—the increased distance between their ears improves the sensitivity of their sound localization.

Most compelling among Norberg's discoveries was that sounds directly in front of the skull were detected differently by the upward facing right ear versus the downward facing left ear. Each ear had a different

The skull of the boreal owl illustrates the extreme bony asymmetry that exists in the ears of some northern owls. Notice that the right ear points upward while the left one points downward.

area of maximum sensitivity. Norberg speculated that this could provide the owl with excellent cues for vertical localization.

A decade later, E. Knudson and Masakuzu Konishi tested a trained barn owl to determine the accuracy with which the bird could localize the position of sounds in complete darkness. They found that the owl could pinpoint the source of a sound within two degrees in the horizontal plane and four degrees in the vertical plane. Sounds with frequencies between 7,000 to 8,000 hertz were located most accurately. As remarkable as this pinpointing capability may seem, recall that healthy humans can localize sounds even better than this and pinpoint a noise within one degree in the horizontal plane and two degrees in the vertical plane. Even though humans have symmetrical ears, the greater size of our skulls when compared with those of owls means that we have a much greater distance between the openings of our ears, and this may give us an advantage over owls.

Considering what has been said about an owl's ability to localize sounds both vertically and horizontally, Norberg wondered why many species of owls, and young boreal owls in particular, sometimes tilted their heads 90 degrees to the side when they were hunting and listening for prey. He concluded that it probably takes considerable practice for an owl to accurately interpret the different auditory information it receives. By tilting its head, an owl alters the vertical position of its left and right ears. It presumably uses this to better pinpoint the vertical position of a sound source.

After exploring the science of hearing in owls I was surprised, as many of you may also be, at the conclusions. Owls hear a narrow range of frequencies very similar to many other birds and have no special abilities to detect either low-frequency infrasounds or high-frequency ultrasounds. And their frequency range is much narrower than in humans. The owl's ability to detect faint sounds is better than all other birds studied so far, but no better than humans. Finally, although owls are excellent at pinpointing the position of sounds in complete darkness they may not be as good at it as humans are.

The Handicap of Darkness

Because darkness is such an alien environment for most humans, we are fascinated with creatures that can operate under such challenging light conditions. When people see owls flying about at night, they often assume these birds have extraordinary nocturnal vision far beyond that of diurnal birds and humans. Once again, the truth is filled with surprises.

When considering the vision of nocturnal creatures it is necessary to first consider the nature of the nighttime environment. If we define night as the period between sunset and sunrise, light levels vary greatly, spanning a 1 billionfold range of available illumination. To begin with, there are three levels of twilight: *civil twilight,* when the sun first sets and is between the horizon and 6 degrees below it; *nautical twilight,*

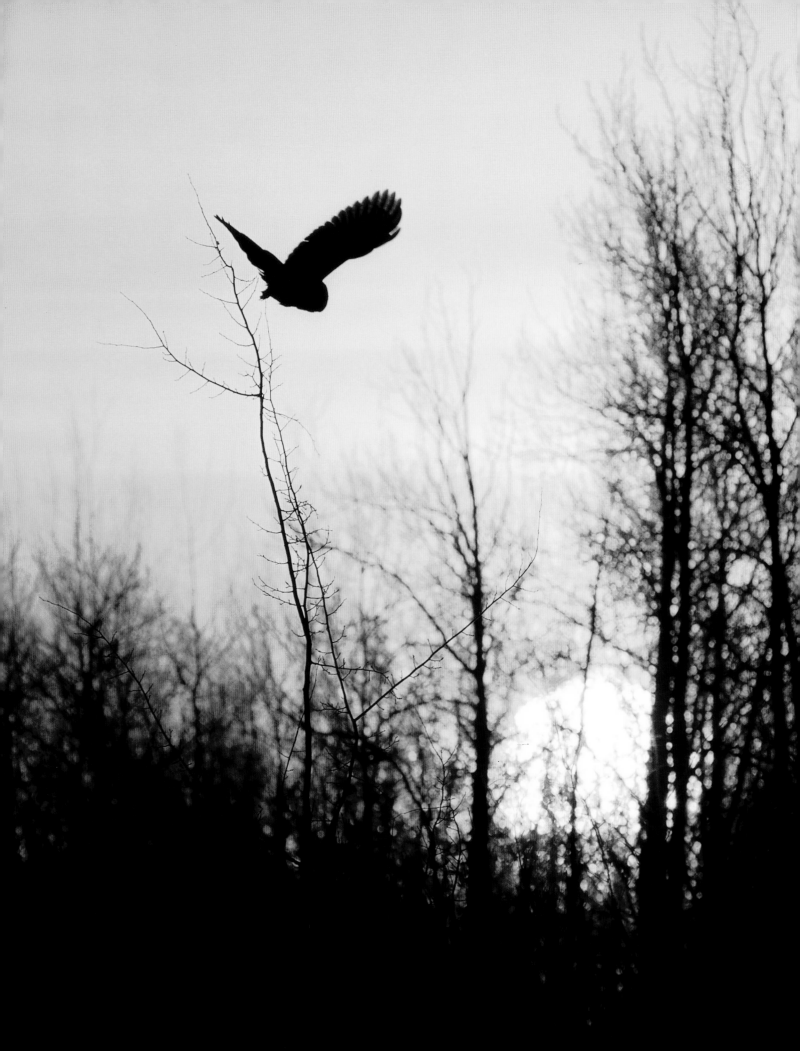

when the sun is between 6 and 12 degrees below the horizon; and *astronomical twilight* when the sun is between 12 and 18 degrees below the horizon. Naturally, the different levels of twilight also occur during the hours preceding sunrise. The average person can read a newspaper at light levels between the end of civil twilight and the start of nautical twilight.

The length of the twilight periods varies tremendously depending on the latitude. For example, at 0° latitude on the equator, the duration of civil twilight averages 21 minutes, all year round. However, at 60° north latitude, near Juneau, Alaska, civil twilight ranges from 50 minutes at the spring and autumn equinox to 105 minutes during the summer solstice in June. Clearly, an owl living in northern Alberta will experience many more hours of twilight than one living in equatorial Brazil, and thus experience less challenging nocturnal conditions.

Besides the variable light conditions of natural twilight, nighttime light levels are also affected by the phase of the moon, starlight, the presence or absence of the aurora borealis, clear skies versus clouds, and open habitats versus deep canopied forests, all of which affect the environment in which owls hunt. Even the reflective properties of the ground surface can influence available light levels. A ground surface with a fresh covering of snow, for example, is 100 times brighter than one comprised of bare, black soil. So, if you exclude the hours of twilight and only consider the nighttime light levels in an open meadow in Virginia under clear skies and a full moon, you would find that it was roughly a million times brighter than inside a nearby leafy hardwood forest on a cloudy, moonless night.

Urban humans are generally unaware of these vast differences in nighttime light levels because we never experience them in our day-to-day lives, relying instead on artificial lights to illuminate all our movements. The retina on the back wall of the human eye has two kinds of light-sensitive cells: rods and cones. Rods specialize in night vision and are sensitive to the lowest levels of light; these yield only gray images of low resolution. Cones, on the other hand, require high levels of light to be stimulated, but they produce color images that are sharp. When a person spends time in a brightly lit environment, such as the inside of a house at night, the high levels of light produced by lamps and ceiling fixtures blanch out the rods in the retina. If the person suddenly steps outside into the backyard where there are no lights, it takes time for the rods of the retina to recover and regain sensitivity before the person can see well again. It takes 30 to 45 minutes of darkness for the human eye to become completely dark adapted. If the person in the backyard stares at a bright light, for even a moment, he or she has to start over and let the retina adjust once more. Once the human eye is fully dark adapted, the sensitivity of a person's nocturnal vision can increase by a remarkable 10,000 times—a 100-fold increase in the first 10 minutes and another 100-fold increase in the next 30 minutes. Thus, the main reason humans find the darkness of nighttime such a challenging environment is not because we are physiologically incapable of seeing in low-level light, but because we never give ourselves enough time in darkness to allow our

(*opposite*) On an extremely cold winter day, this great gray owl had been hunting for several hours before the sun finally set. It was hunting rodents along the roadside.

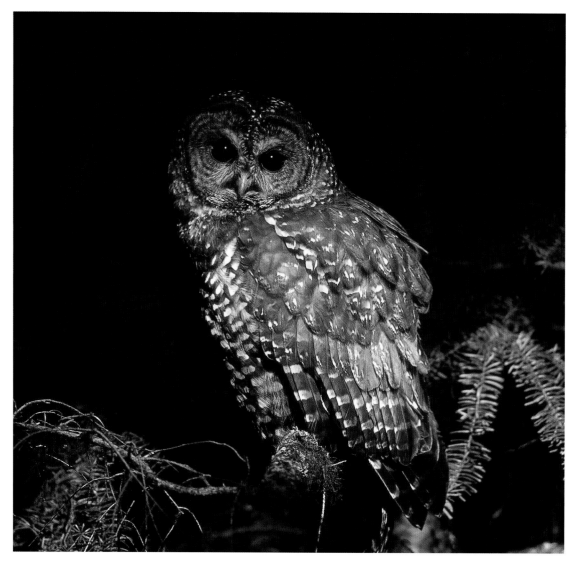

For a northern spotted owl living in the temperate rain forests of the Pacific Northwest, a cloudy moonless night can be the most challenging of light conditions under which an owl must hunt.

eyes to adapt to their full nocturnal potential. Having said that, how does the nocturnal vision of humans compare with that of owls and other birds?

Among the roughly 10,000 species of birds worldwide, a surprising few are strictly, or strongly, nocturnal in their habits. Actually, fewer than 3 percent. Included in this group are cave-nesting oilbirds from South America; 3 species of kiwis from New Zealand; a trio of nocturnal, near-flightless parrots from Australia and New Zealand; a dozen or so shorebirds including coursers, stone-curlews, and thick-knees; 100 kinds of nightjars, nighthawks, potoos, and frogmouths; and roughly 115 species of owls. Of the 204 species of owls alive today, the activity habits of only 180 of them are known, and of these, approximately two-thirds are mainly nocturnal. The others are either active mainly in the daytime or hunt both during the day and in twilight.

A common assumption made about all nocturnal birds is that they rely primarily on vision to guide them in the darkness, but this is not always the case. A short discussion of this will hopefully shed light on the full sensory world of owls and other nocturnally active birds.

One November, I watched a brown kiwi probe the wet beaches of

Stewart Island, New Zealand, as it foraged for worms and other buried invertebrates. Gordon Walls, in his 1942 classic *The Vertebrate Eye and Its Adaptive Radiation,* described the eyes of kiwis as "degenerate as a vertebrate eye can be." Indeed, vision in kiwis is quite rudimentary and the birds rely instead on a highly developed sense of smell to locate prey in the darkness. To facilitate this, kiwis are the only birds whose nostrils open at the tip of their 4- to 6-inch (10–15-cm) bill. The olfactory lobes of their brain are among the largest of all birds and their nasal cavities are richly supplied with sensory tissue.

Another time, in Trinidad, I helped local biologists conduct a census of oilbirds nesting in a rainforest cave. What I remember most about the experience was the dank humidity of the interior, the loud clicking vocalizations of the birds flying about in the shadows, the treacherous knee-deep water tumbling over the slippery rocks on the cave floor, and the cold slimy ooze of bird droppings on the walls that swallowed my hands when I tried to steady myself and keep my balance. Oilbirds, like bats and dolphins, use echolocation. The birds rely on it to fly safely inside the dark interior of their nesting caves. At night, when they forage outside for fruit, they depend on their vision and possibly on a heightened sense of smell.

Some typically diurnal birds will sometimes operate in darkness with the help of senses other than vision, hearing, or smell. For example, shorebirds such as godwits, curlews, and sandpipers use sensitive touch receptors, called Herbst corpuscles, that cover the end of their bills to successfully locate buried prey on a tidal mudflat at night. Ducks and geese do the same, using similar receptors on the tip of their beaks where minute taste buds are also located.

The common denominator that links waterfowl and shorebirds feeding in marshes and along shorelines at night, oilbirds weaving through the blackened chambers of a cave, nightjars hawking for insects above a moonlit meadow, and coursers and thick-knees hunting by starlight on an African grassland is that all are operating in a structurally simple environment with few obstacles with which they might collide and injure themselves. In many of these instances, the birds are swimming or walking about rather than flying, and their nocturnal movements do not require fine visual discrimination. With a mix of sensory equipment they adequately perform the tasks that are needed. So which senses do owls, those seemingly consummate denizens of the darkness, rely on at night?

Owls, unlike a brown kiwi in New Zealand or a Hudsonian godwit probing in the mud, have only a rudimentary sense of smell or taste and use neither of these senses to locate prey. In fact, these senses are so poorly developed in some owls that they can tackle distasteful and odoriferous prey. James Duncan watched an adult great horned owl capture giant diving beetles on the wing above a Manitoba wetland. These large beetles produce bitter, strong-smelling defense chemicals to discourage predators, but the owl was undeterred and ate more than five of these distasteful insects. In a marsh in Ohio, the carcasses of 57 striped skunks were found beneath a great horned owl's nest, once again revealing the olfactory insensitivity of this species.

As well as lacking a developed sense of taste or smell, no owl uses a sense of touch, either in its beak or in its feet, to blindly grope in the darkness hoping to hook a hapless victim. Perhaps then, the ability of owls to navigate and nourish themselves in the nighttime depends on exceptional nocturnal vision in conjunction with their heightened hearing ability.

The Eyes of Owls

Owls have exceptionally large eyes for their body size. Those of an eastern screech owl weigh 0.26 ounces (7.4 gm), which amounts to roughly 4 percent of its total body weight. Compare that to a human eyeball, which weighs about an ounce (28 gm) and amounts to roughly 0.08 percent of our total body weight. (For those readers addicted to nature trivia as much as I am, the largest eye of any terrestrial vertebrate is the 2-inch-diameter [5-cm] eye of the ostrich. The 100-ton (90,719-kg) blue whale has the largest eye of any living vertebrate, 6 inches [15 cm] in diameter; the elusive giant squid, the world's largest invertebrate has a 10-inch-diameter [25-cm] eye; and a recently described ichthyosaur, a marine reptile that lived 90 to 250 million years ago had an eyeball almost a foot [30 cm] in diameter. The ichthyosaur presumably needed such a large eye to hunt in the lightless depths of the ocean.) Among the owls that live in Canada and the United States, the largest eyes belong to the great horned owl. Its eyes are equal in size to those of an adult human, who would weigh at least 50 times more than the owl. The eye of a great horned owl is so large, the entire skull of a house sparrow can fit inside it.

The chief advantage of a large eye is that it can focus a large image onto the retina. Many vertebrate eyes are roughly globular in shape. The disadvantage of having a large, fluid-filled globular eyeball is that it is heavy and takes up considerable space in the skull. During the evolution of birds, their heads got lighter so that the center of gravity shifted backward on their bodies. This is one of the main reasons why birds have such lightweight skulls and no teeth. For this same reason, owls evolved a tubular-shaped eye rather than a globular one. A tubular eye weighs less and takes up less space in the skull. At the same time, the distance from the front curvature of the eye to the retina on the rear wall of the eye stayed roughly the same. This meant there was no reduction in the overall size of the visual image. The tradeoff for owls, in adopting a tubular eye, was that the total area of the retina was reduced. Because they lost some peripheral areas of retina, their total visual field shrank in comparison to many other birds. For example, the tawny owl of Eurasia has a total visual field of 200 degrees compared to the 328 degrees of the European starling and the 360 degrees of the mallard duck. The duck's total panoramic vision even includes complete coverage of the sky above its head. Now you might wonder why I chose to describe the eyes of a tawny owl rather than those of a North American species. The reason is simple. Worldwide, the detailed anatomy and physiology of eyes have been studied well in only one species of owl, the tawny owl, and Gra-

 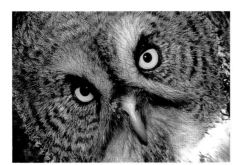

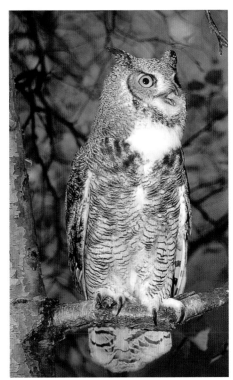 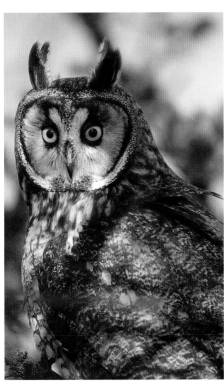 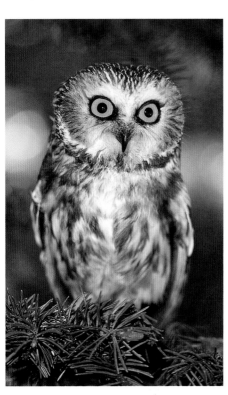

ham Martin has done much of the work. Many of the details I describe are drawn from his scientific studies.

The tubular eyes of owls are fixed in their sockets. They cannot swivel or rotate in the way that the globular eyes of humans can. An owl's eyes must face forward so that the visual fields overlap enough to enable the bird to estimate depth—a necessity for a predator that must often target moving prey with considerable accuracy. In the tawny owl, the overlap, called binocular vision, is about 48 degrees.

To compensate for their limited visual fields, owls can rotate their heads through 280 degrees and see in all directions around themselves without shifting their body position. Some observers claim that owls can rotate their head in one direction through a complete circle. In fact, once the head reaches the limit of its rotation in one direction it snaps back in the other direction so rapidly that it appears to have continued to rotate. As a child, I was told that if a person walked circles around an owl in one direction, the bird's head would come unscrewed and fall off.

Owls have large tubular eyes, binocular vision, and exceptionally flexible necks. But what about the sensitivity of their eyes to the low levels of light commonly experienced at night? Graham Martin spent many

The iris color of an owl has no effect on the acuity of the bird's vision. The iris in the barn owl and barred owl is dark brown, whereas it is different tones of yellow in the great gray, great horned, long-eared, and northern saw-whet owls. The conspicuous black ring around the yellow eyes of many owl species makes the eyes more prominent, but its function is unclear.

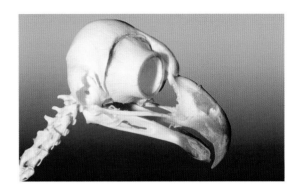

The large size of an owl's eyes in relation to the size of its brain is clearly illustrated in this skull of a great horned owl.

months training tawny owls to respond to visual stimuli of different strengths in return for a food reward. He determined that the visual sensitivity of the owl was approximately 100 times greater than that of the pigeon. The surprise was that the owl's sensitivity was only two to three times greater than that of an average human. Furthermore, since visual sensitivity in the human population varies greatly among individuals and spans a fivefold range, Martin concluded that some individual humans may have more sensitive eyes than some individual tawny owls.

Three factors determine the sensitivity of the vertebrate eye and thus the light levels it can perceive: the size of the image projected on the retina, the brightness of that image, and the sensitivity of the retina. The large size of an owl's eye and its long tubular shape produce a large image on the retina. Two other factors influence the sensitivity of the vertebrate eye.

The brightness of the retinal image is mainly dependent on the diameter of the pupil. This controls the width of the beam of light entering the front of the eye. The pupil in an owl's eye can dilate more than it can in humans and can admit 2.7 times more light. The sensitivity of the average tawny owl's eye is just two to three times greater than that of the average human, and Martin feels that this difference can be explained solely by the larger pupil size in owls, which projects a brighter image on the bird's retina. This means that the retinas in both owls and humans have a similar sensitivity and no other attribute is needed to explain the slightly greater sensitivity of the eyes of owls versus those of humans.

Rods are the retinal sensors responsible for vision in dim light. Martin and his colleagues determined that the rod photoreceptors in humans and those in the tawny owl are very similar in three vital respects—size, spectral sensitivity, and absorption range—and thus absorb an equal

The Camera Lens and the Eye of an Owl

The diaphragm of a photographic lens works in the same way that the pupil does in the human eye, and a comparison will hopefully be helpful in understanding the eyes of owls. The size of the diaphragm on a lens, called the aperture, is measured in a standard set of values, called f-stops: f/32, f/22, f/16, f/11, f/8, f/5.6, f/4, f/2.8, f/2, f/1.4, f/1. The smallest aperture among those listed is f/32. It has the smallest diameter and consequently admits the narrowest beam of light onto the film. Moving one f-stop, say from f/32 to f/22, doubles the amount of light admitted. Moving three f-stops, say from f/11 to f/4, increases the total amount of light admitted by a factor of eight

$(2 \times 2 \times 2)$. As a photographer, when I am faced with a twilight scene in which there is very little light, I may adjust the aperture of the lens to the widest opening available (often f/2.8 or f/2) to let in as much light as possible—hopefully enough to produce an image on the film. Compared to a camera lens, when the pupil of a human eye is fully dilated, the maximum f-stop possible is f/2.13. When Graham Martin made the same calculations on the eyes of a tawny owl, he found they had a maximum f-stop value of 1.3, which allows in 2.7 times more light than the maximum pupil size in humans.

Eyes That Glow in the Night

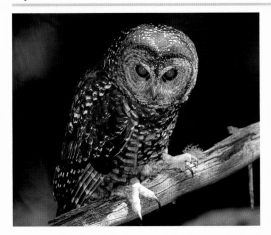

A northern spotted owl.

When the headlights of your car shine into the eyes of a white-tailed deer at night, the animal's eyes gleam brightly. What you are seeing is the shine of your headlights bouncing off a highly reflective layer called the *tapetum lucidum* in the animal's retina. The layer is basically an optical light-multiplication system that is present in the eyes of many nocturnal animals. As light pours toward the retina, some of it leaks past the rods and fails to stimulate them. The reflective tapetum bounces the light back out toward the rods so that there is a second chance for the receptors to be stimulated, thereby enhancing visual sensitivity at low light levels.

A tapetum lucidum, Latin for "bright curtain," is present in a remarkable range of creatures: carnivores, rodents, whales, bony fish, sharks, crocodilians, fruit bats, and marsupials, in addition to domestic animals such as cats, cows, goats, sheep, and horses. Birds are the only large group of animals in which few of their members have a tapetum lucidum; it is absent in all owls, and is found only in some of the nightjars.

Tapeta can be blue, green, yellow, or pink. The bright glowing reflection of the tapetum lucidum should not be confused with the red or orange eye-shine that is captured in photographs of primates, including humans, and in the photographs of many owls. In this case, the color comes from the reflection of light off blood vessels in the rear wall of the eyeball and contributes nothing to the visual sensitivity of the eye.

amount of light. He concluded: "Therefore unless maximum retinal brightness can be greatly increased over that of the human eye, visual sensitivity much in excess of that of humans is unlikely to be found in any owl species."

H. B. Barlow argues that the human retina has reached the absolute limit of visual sensitivity dictated by the physical nature of light waves and contamination by random "noise" within the system. In vision, the most important source of "noise" is spontaneous activity within the nerve cells of the retina itself. Thus, when light levels approach the limit of visual sensitivity, self-generated electrical activity within the optical nervous system itself prevents the reliable detection of lower light levels.

I conclude this section by debunking the myth that owls are blind, or nearly so, in daylight. According to Martin, the tawny owl's daytime vision is as good as a pigeon's, however it is decidedly inferior to that of either humans or diurnal birds of prey, such as the American kestrel. In the daytime, humans see approximately five times better than tawny owls. The reason lies in the anatomy of the human retina and the abundance of cones—the photoreceptors responsible for daytime color vision and acuity. Humans have a much higher proportion of cones in

their retinas than owls do. Katherine Fite microscopically examined the retina of the great horned owl and found that rods were three to four times more abundant than cones. Nonetheless, the owl had many cones, including some in the fovea, which is the portion of the retina where visual acuity is normally the greatest.

The Nocturnal Syndrome

Since hearing and vision in owls and humans are topics filled with so many myths and misconceptions, I begin this section with a quick summary of the facts. With regard to hearing, the minimum sound threshold and the ability to localize and pinpoint sounds is surprisingly similar in owls and humans, and both groups have probably reached the physiological limits of the vertebrate ear. In terms of vision, the sensitivity of the human eye is superior to owls in the daytime but, on average, is two to three times inferior at night. Most people are surprised to learn that there is relatively little difference in nocturnal vision between owls and humans.

Many owls are active at night, yet their vision and hearing are not extraordinary compared to humans, so could it be that their behavior helps them optimize their sensory abilities? Indeed, Graham Martin thinks this is exactly what is happening. Many species of owls that typically hunt at night, for example, the barn owl, long-eared owl, and short-eared owl, hunt in open environments that are structurally simple and where ambient light levels are the brightest. In habitats such as these, owls can almost fly "blindly," with minimum risk of colliding with an unseen obstacle. Furthermore, there is a wide range of light levels available to them during the different phases of twilight, moonlight, and starlight. An owl can thus match its nocturnal sensory abilities with available light conditions.

Some owls live and hunt in woodlands where light levels are at least 100 times dimmer than under an open sky and where there is a confusing array of branches and trunks with which to collide. Blind humans may offer a partial explanation as to how this may be possible. I contacted the Canadian National Institute for the Blind and learned that blind humans readily memorize the spatial layout of rooms in their homes and learn where everything is. They can move confidently through their homes and never bump into a piece of furniture or trip on a step. Perhaps owls do the same thing and memorize a spatial map of the forests in which they live—learning the location of dangerous limbs and trunks, favorite perches and approach routes, predictable prey sites, and safe flight corridors.

Many species of birds have well-developed spatial memories. For example, in the Rocky Mountains, a Clark's nutcracker may cache more than 50,000 pine seeds in late summer and fall, and recover up to three-quarters of them during the winter, even when snowfall hides the storage sites. In Norway, a willow tit may stash 50,000 to 80,000 spruce seeds each autumn, recovering many in the following winter.

The hippocampus is the portion of the brain devoted, in part, to

(*opposite*) The great gray owl often hunts in open muskeg bogs and boreal clearings, but it always nests in forests where a good spatial memory would help it to fly around without injury.

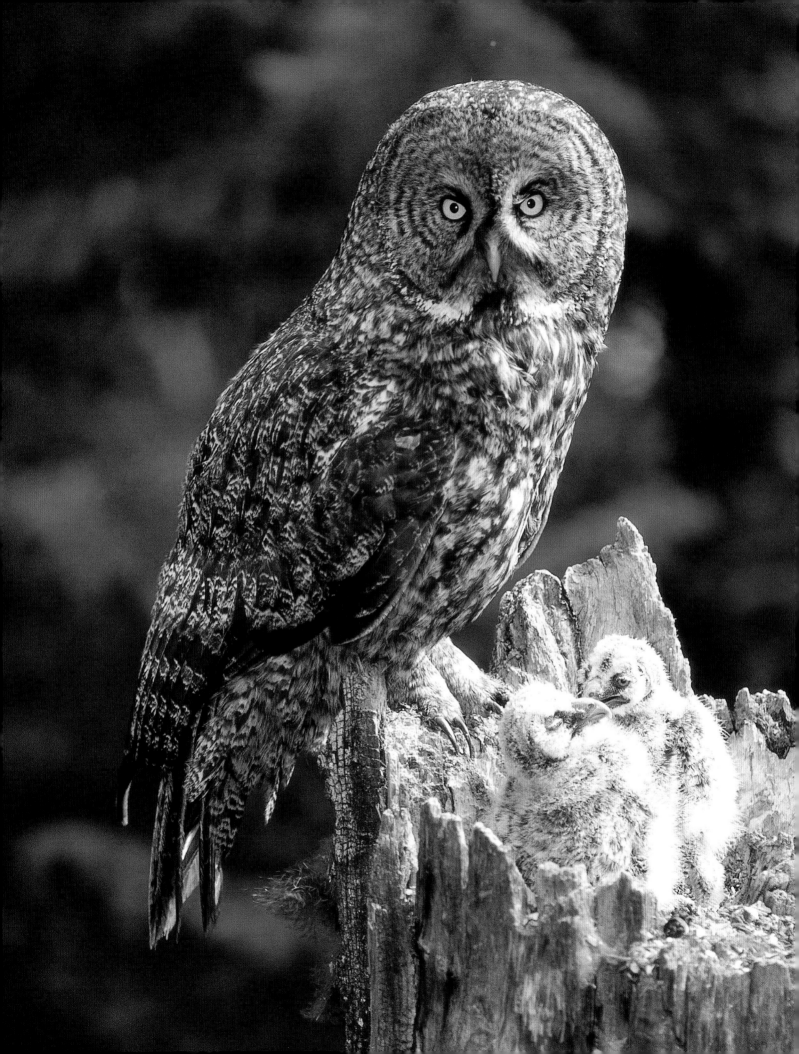

spatial memory. It's no surprise that this section of the brain is larger in birds that cache than in those that don't. What is surprising, however, is that the size of the hippocampus actually increases and decreases seasonally. In a 1996 study, researchers found that the hippocampus of the black-capped chickadee increased in size in October, the precise time when the bird is caching and needs an improved spatial memory. At present no study has looked at the hippocampus in nocturnal owls, but it is an area of research that might prove instructive.

Graham Martin observed that it is probably not mere coincidence that owl species that live in complex forested habitats and hunt under the lowest light intensities are also the species that tend to be strongly territorial and who remain on those territories for years at a time. The great horned, barred, and spotted owls are good examples of this. Long tenancy leads to greater familiarity with the territory and a more detailed spatial knowledge of it. Martin also noted that highly territorial species are often very flexible in the prey they hunt. For example, the tawny owls he studied hunted principally rodents, young rabbits, and small birds, but when these were scarce the owls went after frogs, fish, beetles, and earthworms. Martin reasoned that it was better for these owls to adopt a flexible diet in a familiar habitat than to expand their hunting range into new areas were they lacked the spatial knowledge. Martin aptly described this combination of features—preference for hunting at night in a woodland environment, strong territoriality with long tenancy, and flexible diet—as the *nocturnal syndrome*.

Even when owls are familiar with their habitat and can see under low-light conditions, they may still injure themselves at night. Many species of owls, when disturbed, may fly into branches and even collide with tree trunks in their haste to flee. This suggests that their vision and spatial knowledge is not always adequate to guide them around these obstacles. Researchers in South America found that the incidence of fractures was more frequent in nocturnal owls than in birds that were active during the day. They concluded that owls often collide with dangerous obstacles.

Owls are not endowed with a supernatural set of senses far superior to those of humans. Rather, seemingly owls can be active at night because they have adapted behaviorally and developed their spatial memory.

Haunts and Hideaways

S INCE MY FIRST visit to Florida in February 1979, I had wanted to go slogging through the black water and disorienting maze of a cypress swamp. What kept me away was my imagination—the fear of mosquito clouds thick enough to chew, venomous cottonmouths menacingly coiled on floating logs, and temperamental alligators that object to being stepped on while you're wading in water up to your waist. In January 2004, I finally overcame my fears and spent six hours sloshing through the Fakahatchee Strand State Preserve, a cypress swamp in southwestern Florida. Fakahatchee is renowned for its endangered Florida panthers and black bears, as well as its bobcats, river otters, opossums, and hundreds of birds, snakes, lizards, and frogs that live there.

In the deep shade of the swamp it was hard to tell what time it was, and morning easily merged into afternoon. Everything was infused with a deep green cast, and the vegetation was a wonderful confusion of lines, textures, highlights, and shadows. At one point I found an area of open water in which the trees all around me bristled with bromeliads—a veritable tropical garden. As I fussed with my tripod and camera I accidentally flushed a barred owl that flew to an exposed branch. It was immediately mobbed by a red-shouldered hawk and forced to fly off and hide. Moments later, from the shadows, the owl hooted its displeasure and was answered by a neighboring bird in the distance: "Who cooks for you? Who cooks for you all?" the common translation of its call. As I stood thigh-deep in the tannin-stained water of the swamp, the owls made me pause for a moment and reflect on the wild and beautiful world I was so lucky to be seeing. Earlier in the day, I had seen the tracks of a panther and found the fresh droppings of a black bear. Somehow, the wild music of those owls encapsulated all that is wondrous about wilderness.

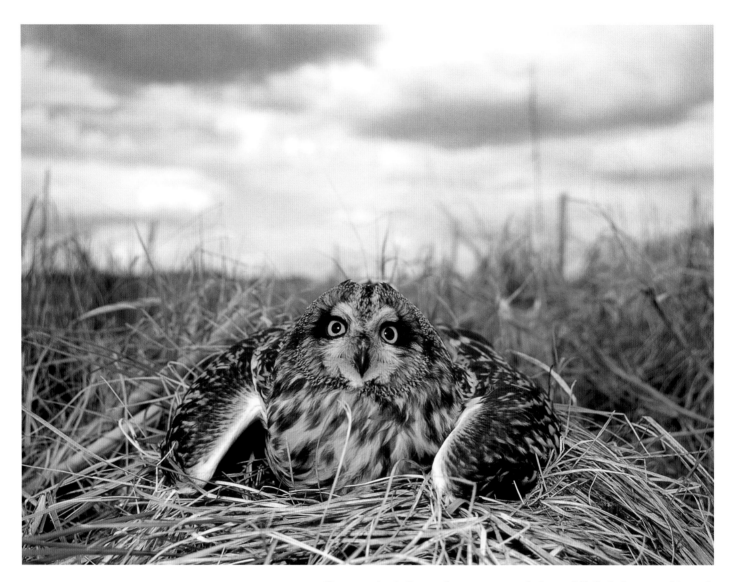

The short-eared owl is one of the two most widespread owls on Earth. This pioneering owl has colonized many distant island groups including the Galápagos, Hawaiian, Falkland, and Philippine Islands, as well as the remote Pacific islands of Micronesia.

I've searched for owls in many of the wildlife habitats of North America, from 82° north latitude, in arctic Canada, where I watched an adult male snowy owl feed a lemming to a hungry fledgling chick, to the deserts of Baja, Mexico, where I disturbed a great horned owl that was eating a peregrine falcon it had killed just moments before. The owls in the United States and Canada occupy virtually every habitat in the two countries, except the alpine tundra of the western mountains, and many have ranges well beyond the borders of the continent.

Nineteen species of owls live in the United States and Canada, but none are endemic to either country. In fact, two species of owls, the barn owl and short-eared owl, are among the most cosmopolitan of birds found on the planet. The barn owl ranges from southern Canada to the beech forests of Tierra del Fuego on the southern tip of South America. It is equally at home throughout Europe, Africa, southern Asia, and Australia. Running a close second is the short-eared owl whose global range is almost as expansive as that of the barn owl. The short-ear is found in both North and South America and across Europe and Asia. It is missing in Australia and is replaced in sub-Saharan Africa by the marsh owl.

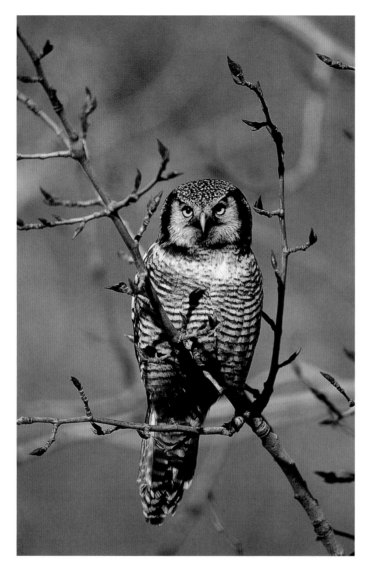

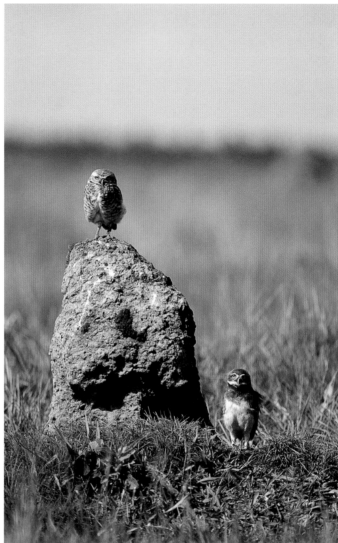

Five species of owls found in Canada and the United States are circumpolar in distribution, the boreal owl (called Tengmalm's owl in Europe), northern hawk owl, great gray owl, snowy owl, and long-eared owl, and occupy the forests and tundra of Eurasia as well as those of North America. Of these five owls, the long-eared owl has the largest range, estimated to cover 18,560,116 square miles (48,070,479 sq km), roughly twice the area of the United States.

Among the 12 remaining species that are found only in the Americas, two of them have extensive ranges. The burrowing owl roams from the windswept prairies of southern Canada to the arid grasslands of southern Chile. I found one of these charming little owls in the shifting sands of the Atacama Desert in northern Chile and several more in the steppes of Argentina, where they shared burrows with Patagonian hares. The distribution of the great horned owl is even greater, stretching more than 9,000 miles (14,484 km) from the arctic tree line of Alaska at 68° north latitude to central Argentina. In South America, this tiger of the night sky hunts above 14,100 feet (4,298 m) in the Ecuadorian Andes.

Every American state but Hawaii and every Canadian province and territory but Nunavut has at least 3 species of owls living within its bor-

(*left*) The northern hawk owl is a circumpolar species. The bird's pointed wings, long tail, and swift direct flight is very hawklike and is the origin of its common name. (*right*) I found this burrowing owl family in the cerrado grasslands of Das Emas National Park in southern Brazil. The owls lived inside the termite mound in a burrow previously excavated by an armadillo.

ders. Nunavut, the northernmost region of Canada hosts just 2 species of owls, the snowy and short-eared owls. Hawaii, the most geographically isolated of the states, also has only 2 resident species of owls, the short-eared owl and the barn owl. The first short-eared owl to colonize the Hawaiian Islands must have flown at least 2,800 miles (4,506 km) to reach these remote tropical islands, whereas the barn owl was introduced by humans in the late 1950s to exterminate rodent pests. The Hawaiian Islands have the dubious distinction of having had more species of birds introduced into them than anywhere else on Earth—at least 142 species from six continents have been released on the islands in the last 150 years, and 52 of them, including the barn owl, have established breeding populations.

If you are addicted to owls, the place to live is either Washington State or British Columbia, where it is possible to see 14 species of owls over the course of a year. With so much overlap between the species you might wonder if they compete with each other. In some instances they do, but for the most part they are able to coexist because of differences in prey selection, habitat preferences, nesting requirements, hunting styles, and activity peaks. The complexities and individual variations among the owls of the United States and Canada make them an interesting study in competition avoidance. Range maps and habitat descriptions of all 19 species are given in the Identification Guide found between chapters 1 and 2.

From Tundra and Taiga to Mountains and Marshlands

Surprisingly, only 6 of the world's 204 species of owls live in nonforest habitats, and 3 of these, the snowy, burrowing, and short-eared owl, live in Canada and the United States.

The legendary snowy owl nests on the arctic tundra and often migrates to the prairies in winter. The short-eared owl inhabits tundra, marshlands, fields, and meadows continent-wide, and the burrowing owl thrives in the big sky country of the Great Plains, in the deserts of the Southwest, and in the prairies of peninsular Florida. The burrowing owl seems misplaced living in subtropical Florida. Like many of the arid-adapted animal species living in that state today, the owls probably colonized from the west during the early to mid-Pleistocene glacial period when there was a corridor of arid habitat encircling the Gulf of Mexico. The Florida population of burrowing owls has probably been isolated from the owls in the West for the last 12,000 to 15,000 years.

The three nonforest owls that live outside of North America are Hume's owl of the deserts and grasslands of the Arabian Peninsula; the marsh owl, a sub-Saharan version of the short-eared owl; and the little owl, a burrowing owl look-alike that lives in southern Asia and Europe.

The 16 species of forest owls that live in the United States and Canada occupy a wide variety of woodlands. For example, northern saw-whet owls in New York State live in forests of white cedar and red pine; hawk owls in Saskatchewan inhabit black spruce bogs and tamarack swamps;

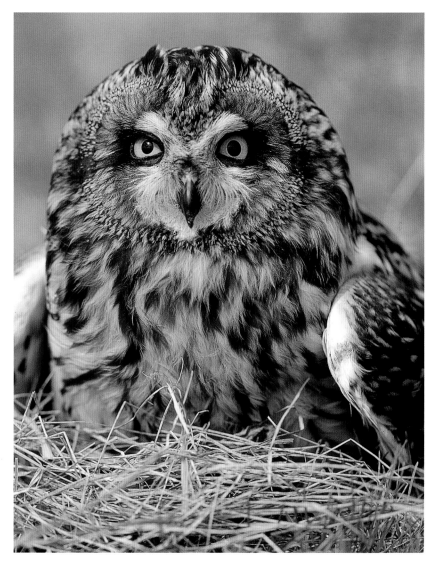

and flammulated owls in Montana hunt in open forests of Douglas fir and ponderosa pine. In Texas, elf owls live in cottonwoods, oaks, and junipers, and in Kentucky, eastern screech-owls thrive in hardwood forests of beech and maple.

Many of the forest owls have large ranges that span many different types of woodlands, and the birds seem equally at home in all of them. For example, the flexible barred owl lives in hardwood forests in the Appalachian Mountains, in cypress swamps along the Gulf Coast, and in the temperate rain forests of Washington, Oregon, and California. In the boreal forests of Canada, barred owls make their home in forests of balsam fir and aspen.

Of all the forest owls, the great horned owl is surely the most adaptable. It lives in virtually every habitat on the continent except the arctic and alpine tundra. It even finds refuge in the riparian habitats and coulees of the prairies, and in the Sonoran Desert where it nests on the arms of giant saguaro cacti.

An owl has certain basic requirements that must be satisfied for it to survive. It needs suitable terrain in which to hunt, adequate prey

(*overleaf*) The thick forested slopes of the Rocky Mountains are home to at least six species of owls. The treeless alpine regions in the distance are one of the few habitats where owls are not usually found.

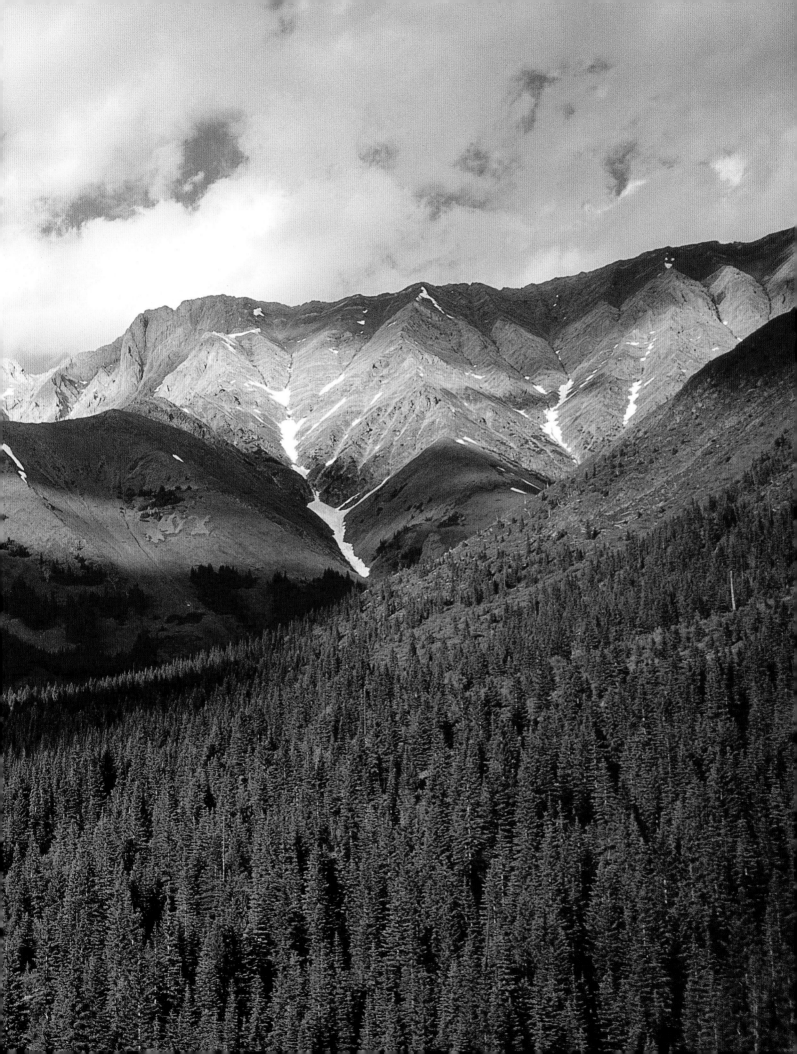

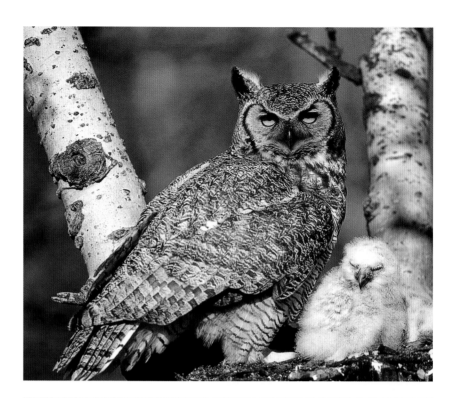

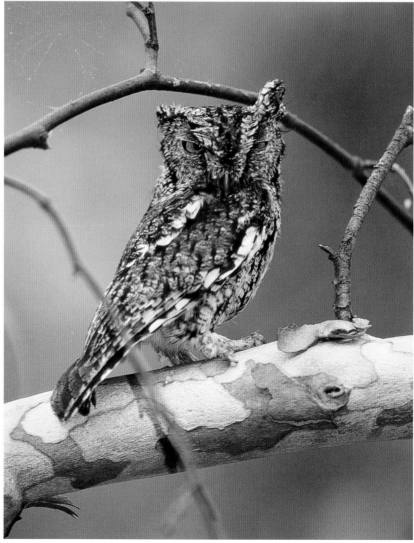

(*top*) At three weeks of age, these great horned owl chicks were already big enough that the mother spent most of her time perched on a limb nearby. She only returned to the nest to feed her chicks and brood them during inclement weather. (*bottom*) A male whiskered screech-owl may defend as many as five small territories, each centered around a tree cavity. The cavities are used as nests, roosts, and food cache sites.

to meet its daily nutritional needs, and sites where it can shelter from the extremes of climate, whether those be blizzards, thunderstorms, or heat waves. Additionally, an owl requires secure roosting sites where it can hide from predators and the mobbing attention of songbirds. Since owls don't build their own nests, they also need an old stick nest made by crows, ravens, or hawks, or an abandoned woodpecker hole or tree cavity where they can safely raise their young. Each species has its own particular way to satisfy these basic requirements.

In 1943, the American biologist William Burt was the first to define a *home range* as "that area traversed by the individual in its normal activities of food gathering, mating, and caring for young." If a home range is defended to prevent intrusion by others of its own species, then biologists call it a *territory*.

Many owls that are year-round residents defend their home ranges and maintain them as exclusive hunting and nesting territories. In one study in Michigan, barred owls defended territories of roughly 1 square mile (2.6 sq km). Great horned owls in the Yukon had territories that were on average twice that size, and sometimes four times larger. A good home range may be worth defending for many years, and its tenancy may pass from one generation to the next. Some great horned owls used the same territory for 8 years in a row, and barred owls occupied one woodlot in the eastern United States for 34 years in succession!

Some species of owls defend only the area around their nest but share common hunting grounds with their neighbors. Short-eared, great gray, and long-eared owls often behave in this way. In New Brunswick, 33 pairs of short-eared owls nested in little more than 1 square mile (2.6 sq km), whereas in Montana 30 pairs squeezed into an area half that size, with some nests being just 60 yards (55 m) apart. In Florida, up to 18 pairs of burrowing owls nested together in a third of a square mile (0.8 sq km), with each pair defending only the immediate area around their nest burrow. In Utah, two dozen barn owls nested together in an abandoned steel mill, hunting separately in fields and meadows up to 2 miles (3.2 km) away.

Because nesting owls sometimes form loose aggregations, some researchers have been tempted to call the birds colonial, or at least semi-colonial. In fact, owls are not colonial at all in the true sense as applied to seabirds, herons, and arctic geese. In those species the benefits of colonial nesting include enhanced predator detection and deterrence; information sharing as to the location of scattered, unpredictable food sources; and synchronization of breeding behavior so that hatchlings overwhelm the predator population and a greater number are able to escape. None of these benefits apply to owls, and aggregations among breeding pairs occur because of convenience and proximity to a plentiful food supply.

Elf owls, eastern screech-owls, and whiskered screech-owls often defend multiple small territories. Each territory is centered around a nest cavity, and the bird defends a small radius around it. The cavities, which the owls jealously guard, are used not only for nesting but also as roosts, food cache sites, and replacement nests in case the primary nest should

fail. Whiskered screech-owls in Arizona averaged three such polyterritories, but some pairs defended as many as five. In polyterritories, the space between the cavities is not defended.

The aggressiveness with which owls defend their territory is usually greatest during the nesting season when survival of their offspring may be at stake. During this time, territorial owners may chase and ferociously attack, with talons and beak, any trespasser. In Oregon, two northern pygmy-owls were observed in a skirmish in which they grappled and locked feet, and then tumbled to the ground. Death rarely occurs in these fights.

The ownership and defense of a territory in all birds is a simple evaluation of cost and benefit. It takes energy to patrol a territory and chase away intruders, and there is always the risk of injury in a confrontation. The larger the territory, the greater the costs of surveillance and defense. The benefits gained in defending a territory are familiarity with and exclusive access to a nest, roost sites, and prey.

When food is superabundant many species of owls maintain smaller territories and defend their borders less aggressively. In the Canadian arctic, collared lemmings alternate between periods of boom and bust on a three- to five-year cycle. One year, lemmings are running everywhere over the tundra, in densities as high as 160 per acre (400/ha). The following summer, they may be gone, their numbers crashing to less than a single lemming in 2 to 3 acres (0.8–1.2 ha). In 1996, for example, during a lemming high, there were 45 nesting pairs of snowy owls within a 5-mile (8-km) radius of my camp on Victoria Island, Nunavut. Four years later, when the lemmings crashed, not a single pair of owls could be found in that entire area. A similar scenario occurs in short-eared owls when vole numbers skyrocket on the prairies. The owls may then nest relatively close together and hunt the same rich patch of cropland. In the end, owls seem to adopt the real estate arrangement that best suits their most pressing needs at the time.

Floaters

I always assumed that all owls held a territory of one size or another. I thought the more dominant the individual the better the patch of habitat it could claim, and that even the lowest ranking bird could at least occupy exclusive use of some marginal piece of land. After all, property is vital for a male owl. Without it, he cannot attract a mate, raise young, and pass his genes to the next generation. But, it turns out that I was wrong. Some owls are indeed nonterritorial, at least temporarily, and skulk around in the occupied range of territorial pairs, risking detection, aggressive expulsion, and even death. These owls are called *floaters*. Floaters have been reported anecdotally in boreal owls in Sweden and in barred owls in Nova Scotia and Minnesota. Until the 1990s, however, no one had quantified their presence or mapped their movements and behavior. The Kluane Boreal Forest Ecosystem Project in Canada's Yukon Territory was an ambitious 10-year study to unravel the impact of the snowshoe hare cycle on plants and predators such as Canada lynx

(*opposite*) Nonbreeding great horned owls, called floaters, are extremely secretive and occupy habitat on the edges of the territories of breeding pairs.

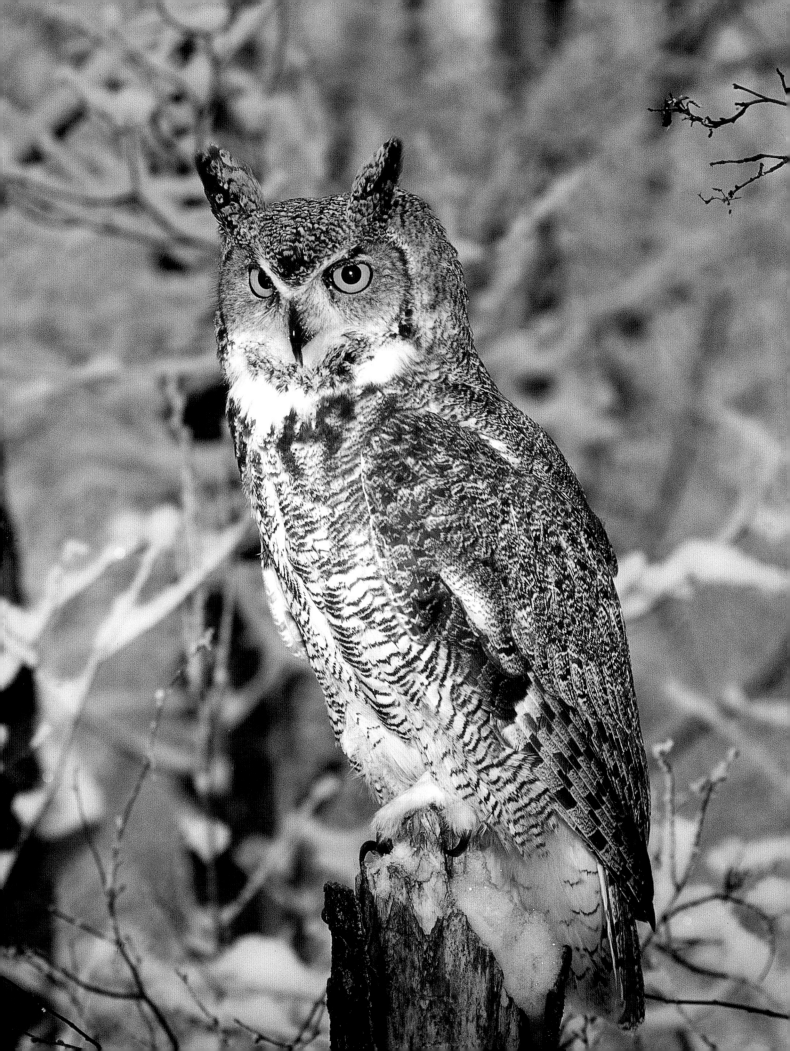

and great horned owls. The chief owl researcher, Christoph Rohner, followed the fate of 55 fledgling great horned owls with radiotelemetry and discovered that many of them live a secretive life and form a "shadow population" squeezed among the breeding territorial pairs.

Floaters are extremely furtive and sneaky, and they never vocalize. Rohner tried to trick them into hooting by challenging them to respond to the playback of territorial calls, but he never succeeded. Floaters also move over large areas. Typically, they use a home range five to six times larger than the average territory owner, and the home ranges of neighboring floaters often overlap. Occasionally a floater shifts to another area over time, sometimes switching between known areas of similar size. Their movements and home ranges never change in response to the courtship and egg-laying behavior of territorial owners, and it is unclear what motivates them to move around. Perhaps they cover such large areas to prospect for vacant territories?

During his study, Rohner found four dead great horned owls that he believed might have been killed by other owls, so floaters play a dangerous game. Not surprisingly, floaters concentrate their activities along the boundaries of established territories, perhaps to lessen their chances of being detected and expelled. Rohner was excited to learn that the size of the floater population was directly dependent on the abundance of prey. In peak hare years, the hidden floater population was as large as the conspicuous territorial population. Since standard owl population estimates are often based on hooting surveys done in the spring, the discovery that the number of mute floaters can sometimes equal the number of territorial owners is an exciting discovery and greatly changes our understanding of owl population dynamics.

Rohner wondered why so many owls were floaters. One explanation was that the birds temporarily adopt this role to defer breeding while they improve their hunting skills and increase their fitness. It could be argued that, in the long run, owls that delay acquiring a territory might increase their overall lifetime reproductive success, especially in a long-lived species such as the great horned owl, which can live for 27 years or more. Rohner also questioned whether male floaters were gaining clandestine copulations without the cost of defending a territory and providing for a brood. Females floaters, on the other hand, might benefit by settling as a secretive secondary mate of a territorial male of high quality. The other hypothesis that Rohner considered to explain why owls remained as long-term floaters was whether the aggressive social behavior of territory owners prevented floaters from breeding, and this eventually turned out to be the case. Rohner never found any evidence that great horned owl floaters mated with any territory owners, and the successful raising of chicks only occurred when a pair owned and defended a territory. Despite all that was learned, Rohner never discovered how floaters hunt in defended territories or how frequently they interact with the owners. The great horned owl is the most frequently seen owl in North America, yet scientists are just now beginning to understand some of the exciting details in the life of this ubiquitous species.

Hot and Cold Weather Woes

The owls in Canada and the United States have adapted to an extreme range of climates. Consider the elf owl. This is a sparrow-size strigid that endures the coagulating heat of the Sonoran Desert, in Arizona, where summer temperatures can soar to more than 110°F (43°C) for weeks at a time. Counter that with the winter world of a northern hawk owl in the spruce forests near Fairbanks, Alaska, that holds the record for the coldest temperature ever reported in North America, –94°F (–70°C). Only the penguins can possibly claim a greater range of temperature endurance, with Galápagos penguins panting under an equatorial sun and emperor penguins facing Antarctic winds that howl up to 125 miles per hour (201 kph) and temperatures that commonly plummet to –40°F (–40°C).

Birds, in general, have a higher body temperature than mammals, and in most species it varies between 100 and 104°F (37.8–40°C). Throughout the day, an owl's temperature fluctuates in response to activity and food supply. The body temperatures of a captive great horned owl, snowy owl, and barred owl were monitored in an outdoor cage in Minnesota from February to April. The owls' temperatures varied from 99.5°F to 104.7°F (37.5–40.4°C). When the owls were deprived of food, their body temperature dropped, and when the air temperatures rose they allowed their body temperature to rise slightly as well. This physiological ability to tolerate mild hyperthermia in summer and mild hypothermia in winter in response to food deprivation means that owls expend less energy maintaining their body temperature than if they tried to regulate it within strict limits. All owls that have been tested are able to do this. Even with their normally high body temperatures, some desert owls at the height of summer may still need to rid themselves of surplus body heat to prevent lethal hyperthermia. At the other extreme, many boreal and arctic owls must constantly guard against losing too much body heat when winter air temperatures may be as much as 140°F (78°C) colder than the temperature of their blood. So, how do owls take the heat and beat the chill?

Birds, unlike mammals, have no sweat glands in their skin to cool themselves. Sweat would simply plaster the feathers against the skin without producing the desired cooling effect. David Ligon studied the behavioral effects of rising air temperatures on four small species of owls: eastern screech-owl, whiskered screech-owl, northern saw-whet, and elf owl. Their initial response to rising air temperature was to stop all activity and compress their body feathers to reduce the insulation value of their plumage. If this was not enough to cool them, the owls began to pant, increasing their breathing rates up to 160 times per minute. All vertebrates have a thermostat in the hypothalamus of their brain that senses blood temperature and activates physiological responses when body temperature becomes dangerously high. In the small owls, when panting failed to halt their rising body temperatures they started to gular flutter. *Gular fluttering* is the rapid vibration of the upper throat muscles

(*overleaf*) Daytime summer temperatures in the Sonoran Desert of southern Arizona and northern Mexico can reach 110°F (43.3°C) for many weeks. Escaping the stifling heat can be a challenge for desert owls.

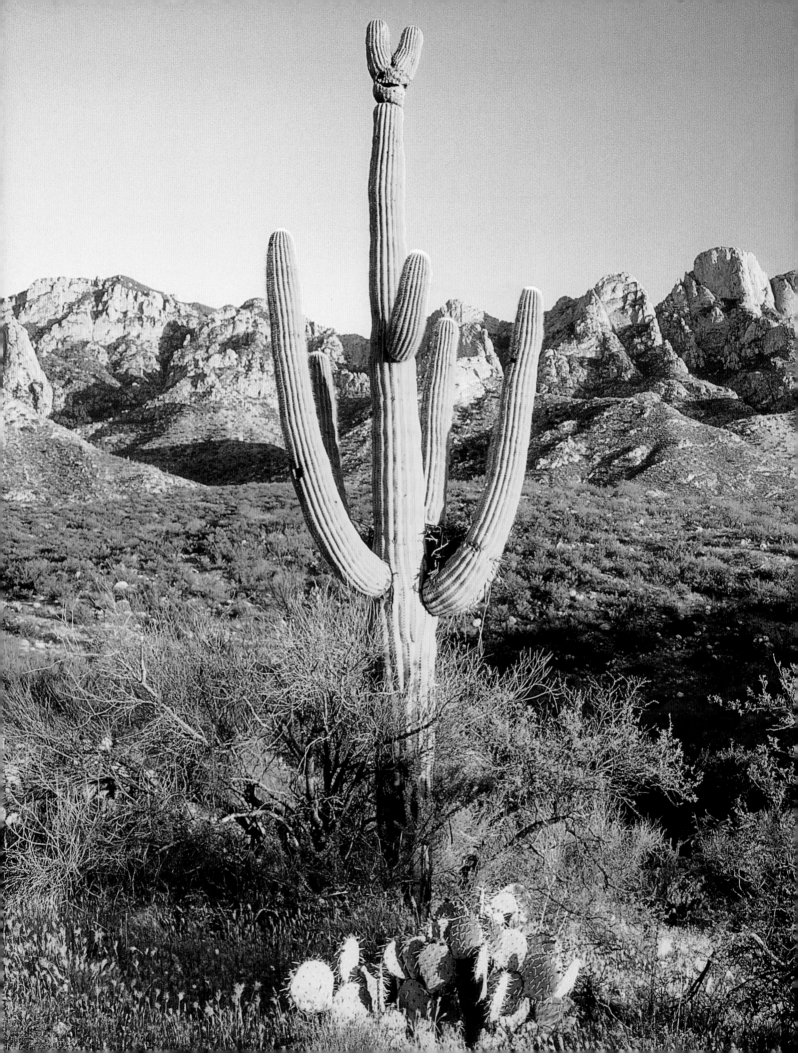

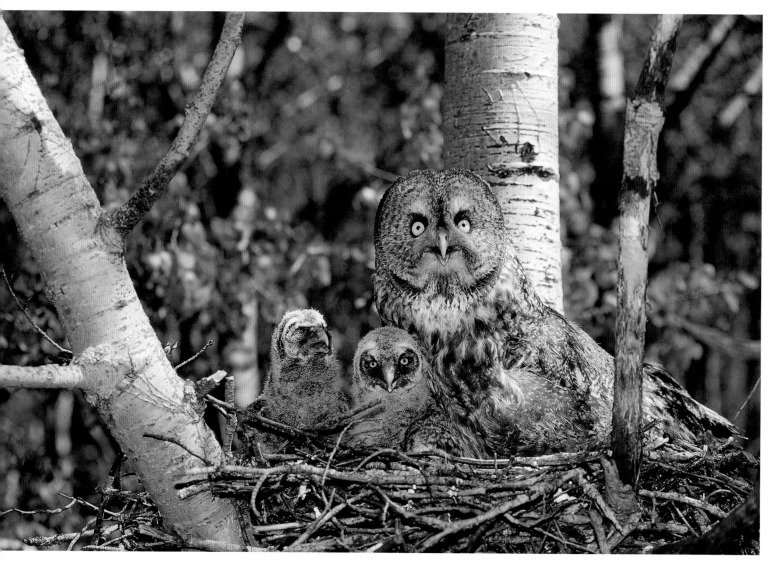

(*above*) Northern owls, such as this family of great grays, are well adapted to cold temperatures, but on a hot summer day they must pant to stay cool. (*opposite*) By drooping her wings and exposing the more lightly feathered undersides, this adult female great gray owl was attempting to cool herself on a sultry summer day in northern Alberta.

that increases the rate of evaporation from the moist lining of the throat and mouth. All the owls that were tested could gular flutter at rates over 400 per minute, and eastern screech-owls reached 540 flutters per minute. This behavior requires an obligatory water loss, so desert species that live in extremely arid habitats engage in this behavior only as a last resort. In Ligon's study, two of the elf owls eventually died when their body temperatures reached 108°F (42.2°C). One saw-whet died when its temperature reached 109°F (42.8°C). The lethal body temperature in many species of birds is much higher than this, and ranges between 115°F and 117°F (46.1–47.2°C). Ligon could not explain why the owls he tested seemed so intolerant to hyperthermia compared to many other birds.

Another way that owls can cool themselves is to shunt blood to lightly feathered areas of their body, such as their beak, toes, and legs. A domestic chicken, for example, can lose up to 12 percent of its body heat through the surface of its beak, and it's likely that in owls the beak is also a good radiator of heat. The lightly feathered legs of barn owls and burrowing owls are another good place to lose body heat and they flush a noticeable pink when the birds are overheated. Even the lightly

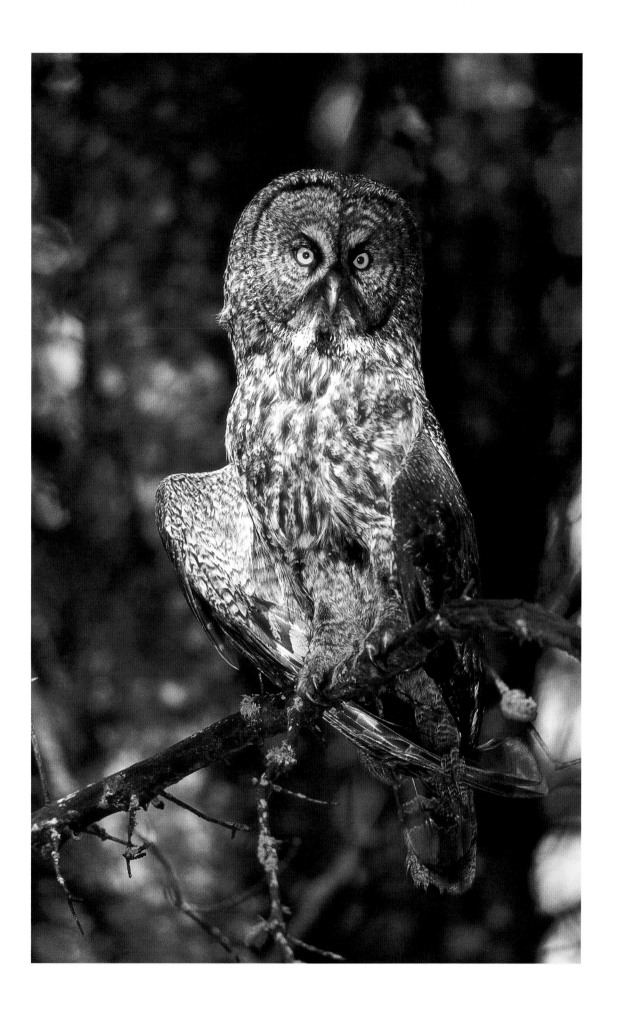

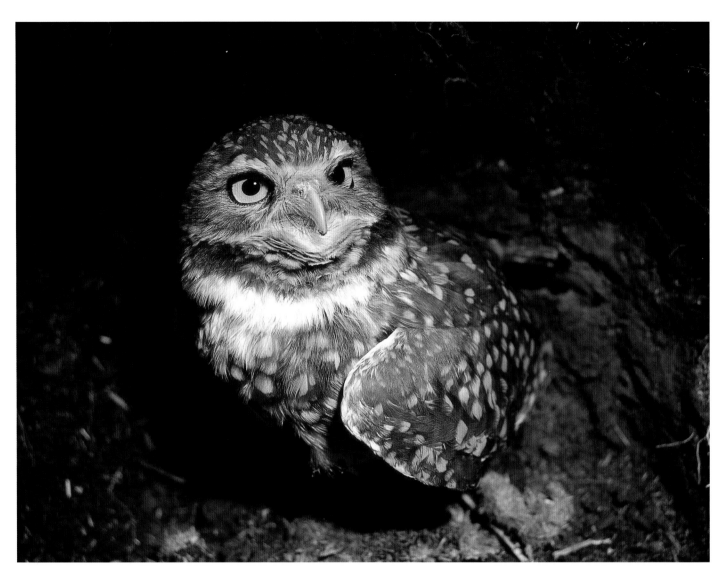

(*above*) The underground burrow of a burrowing owl may be 10 feet (3 m) long. Direct sunlight never reaches the nesting chamber at the end. The burrow is a refuge from the extremes of weather. (*opposite*) Old woodpecker holes in saguaro cactuses are a common place for elf owls to roost and nest. The saguaro is the largest cactus in the United States, growing to heights of 60 feet (18.3 m) or more.

feathered underside of an owl's wings can dissipate heat. One hot summer day, I watched an adult great gray owl droop its wings and expose the undersides to the air to help cool itself.

The best way for an owl to keep from overheating in the summer is by avoiding high temperatures altogether and finding shelter in a cool refuge during the hottest part of the day. Many owls select the thick bushy branches of a conifer as a daytime roost to shield themselves from the direct rays of the sun. When the temperature rises, burrowing owls avoid standing on the hot surface of the ground and escape to the darkened depths of a burrow where the humidity is higher. In deserts, the ground temperature can sometimes climb to 150°F (65.5°C).

Natural cavities and old woodpecker holes are another refuge used by the smaller owls to escape from warm weather. In the searing heat of Arizona's Sonoran Desert, the insulation provided by a woodpecker hole in the trunk of a tree-size saguaro cactus is probably vital to an elf owl. The temperature and humidity inside a saguaro cavity are moderated by the fleshy pulp of the cactus and never reach the extremes of the outside air.

The spotted owl appears easily stressed by heat. Some biologists have

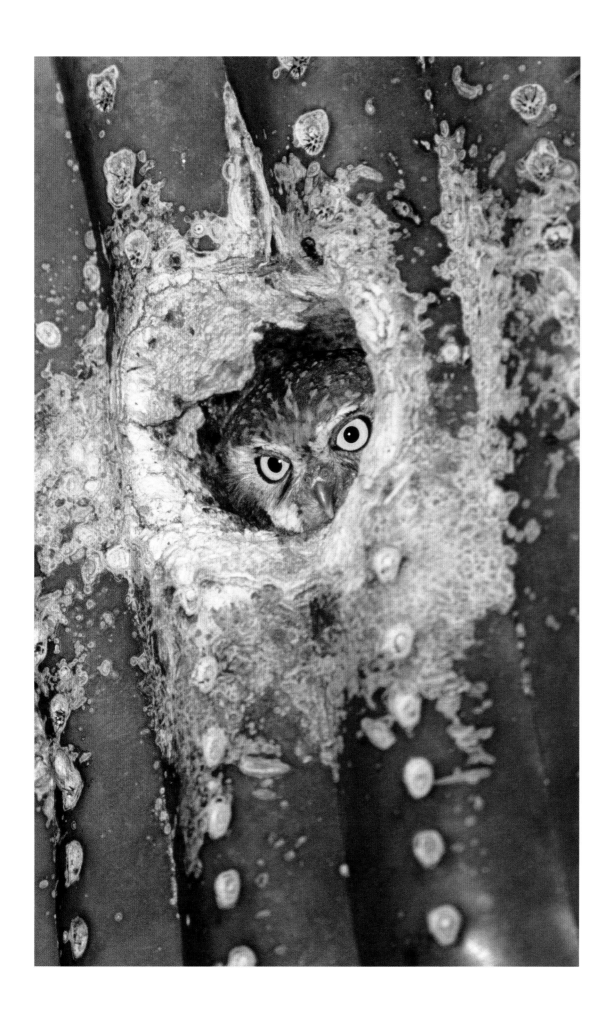

proposed that this may be the reason why they live in heavily shaded old-growth forests in the Pacific Northwest. The spotted owls that live in Arizona and New Mexico limit their range to cool coniferous forests in steep narrow canyons where high temperatures rarely occur. Usually there is a stream or river nearby that further cools the environment.

For much of the year, staying warm is probably a bigger problem than cooling off for the owls in Canada and the United States. All the northern owls have feathers on their legs and toes to keep themselves warm, and the feathers are thickest in the arctic-dwelling snowy owl. As expected, barred owls in Canada also have heavily feathered toes, but those in Georgia and Florida do not—reflecting their different needs for cold protection.

Among the owls in North America, barn owls probably illustrate the importance of feathered extremities more than any other species. The barn owl is most at home in the south and did not expand its range north into southern British Columbia until around 1909 when the felling of forests and subsequent spread of agricultural land provided suitable habitat. The barn owl, with its long, lightly feathered legs, relatively thin body plumage, and scanty fat reserves, is poorly adapted to the cold winters in southern Canada. When temperatures drop to the freezing point, these owls try to stay warm by crouching and sitting on their legs, or by standing on one foot while the other is tucked into the warm fluffy feathers of their belly. Lorraine Andrusiak believes that barn owls could not survive in British Columbia without the thermal protection afforded by man-made structures such as barns and abandoned houses. She found that 96 percent of the barn owls in the province roost and nest in such sheltered sites. Canadian barn owls are at the northern edge of the species' range where their tolerance to cold is pushed to its limits. Without a change in their plumage, the birds will likely continue to teeter on the edge of survival.

A basic principle in biology predicts that small owls lose more heat from their body surface than large owls do. This is one reason why the heaviest owl, the arctic snowy owl, lives in one of the coldest climates, and the smallest owl, the desert elf owl, lives in one of the hottest ones. What this principle means to an owl is that the small species must rev up their metabolism to stay warm when the air temperature is still relatively high. This burns calories, which must be balanced by fat reserves or an increased intake of food. Large owls, on the other hand, can withstand much lower temperatures before they need to increase their metabolism.

The temperature at which a bird's metabolism begins to increase to offset losses in body heat is called its *lower critical temperature*. In the barn owl, for example, that temperature is 72.5°F (22.5°C), which explains why they fare so poorly in cold weather. The lower critical temperature in the long-eared owl is 72°F (22.2°C) during the summer when the bird is molting, and 52°F (11°C) in winter when its plumage is at its thickest. The lower critical temperature for the snowy owl is just above freezing at 36.5°F (2.5°C). It has the lowest critical temperature of any

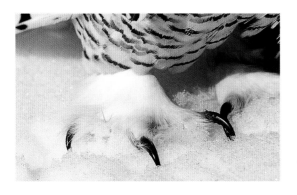

The thickly feathered feet of the snowy owl protect the bird from the extreme frigidity of arctic winters when temperatures commonly dip below −22°F (−30°C) for weeks at a time.

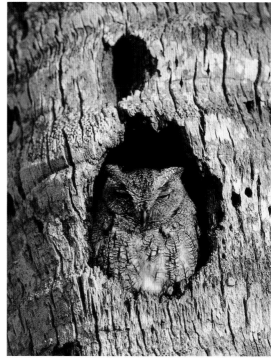

On a cool winter morning, this eastern screech-owl was warming itself at the mouth of its nest cavity in a palm tree in southern Florida's Everglades National Park.

owl species tested, but two other arctic birds are even better adapted. The common raven's lower critical temperature is 32°F (0°C) and that of the willow ptarmigan is an amazing 20.6°F (–6.3°C).

The cold tolerance of the snowy owl results from its large body mass and thick winter plumage. All northern owls have a dense collar of down at the base of each body feather. This traps a layer of insulating air next to their skin and greatly increases the insulation of their plumage. The zoologist James Gessaman measured the heat conductance through the thick feathers of the snowy owl. He discovered it was lower than any other bird except the Adélie penguin, and equivalent to the exceptionally warm pelt of the arctic fox. Gessaman believed that the snowy owl could survive ambient temperatures lower than any recorded in the Northern Hemisphere. To prove his point, he subjected a captive snowy owl to increasingly colder temperatures. He first dropped the temperature to –67°F (–55°C) and held it there for three hours. He followed this with two hours at –106.6°F (–77°C) and five hours at –135°F (–93°C). To put these temperatures in perspective, the coldest temperature ever recorded on the planet is –128.9°F (–89.4°C), at Vostok, the Russian research

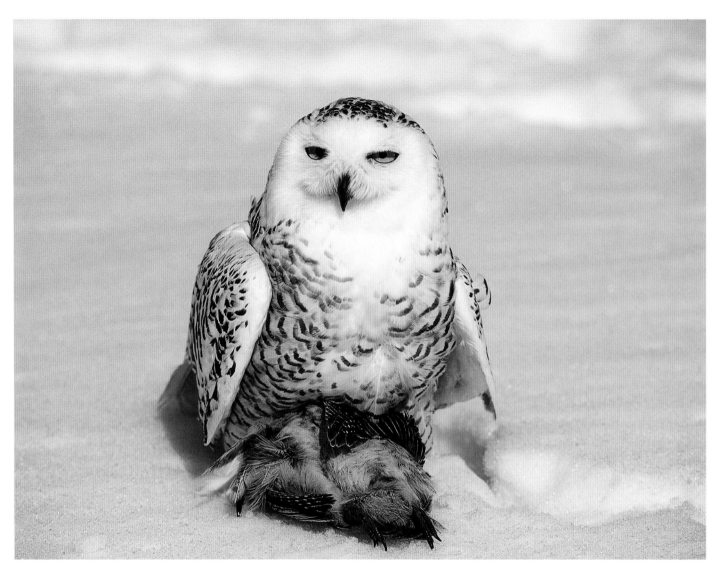

Even on the Canadian prairies where this snowy owl was hunting gray partridge, winter temperatures can be extremely cold; the owl's thick plumage and heavily feathered legs and feet are necessary adaptations.

station in the center of the Antarctic ice cap. Amazingly, the snowy owl survived these lethal temperatures with no signs of frostbite, although its nictitating membranes were pinkish in color indicating that it did rupture some small blood vessels. Enduring such paralyzing temperatures demands a high input of energy in the form of food and without it most owls would perish within a day or two in such extremely low temperatures. At –135°F (–93°C), the snowy owl burned calories at five times its basal rate.

Roost Rewards

Most owls have regular clusters of trees, natural cavities, or vacant burrows where they spend time in seclusion. Barn owls often hide in old buildings but they also roost in tree cavities, on cliffs, and in riverbank burrows. In the West, long-eared owls and western screech-owls sometimes squeeze inside the globular stick nests of American magpies, and eastern screech-owls in Texas hide among clusters of vines. All these sites, called *roosts,* offer the owls a number of important benefits. They protect the occupant from hot sunshine and cold winds. For example,

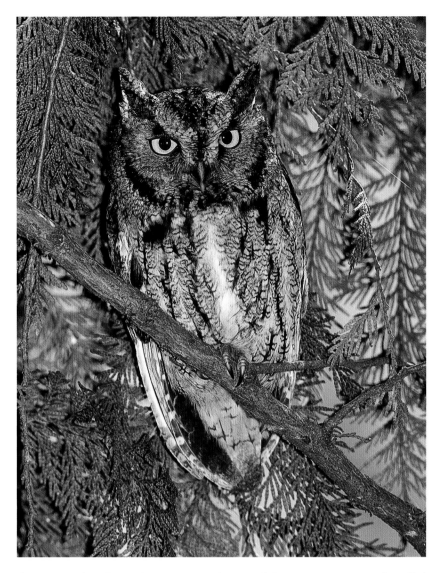

This western screech-owl in British Columbia was roosting in a western red cedar. The owl used the same cluster of cedars for most of the winter.

dense stands of conifers can cut the wind by 75 percent, and ruffed grouse roosting within them can lessen their heat losses by one-fifth. It's likely that owls benefit in a similar way.

Roosts also offer concealment from predators and a place to hide from mobbing songbirds. Great gray owls, boreals, northern saw-whets, screech-owls, and flammulated owls that roost in trees often perch next to the trunk so that their cryptic plumage blends with the mottled bark and hides their presence. Some owls use the same location night after night for weeks, months, and sometimes years. An eastern screech-owl, on the other hand, might change its roost four times a day to avoid sun, wind, or the annoying attention of agitated songbirds.

Researchers in Colorado looked at the roosting behavior of boreal owls. Typically, an owl chose a roost within 55 yards (50 m) of its last hunting perch from the previous night. On average, the roosts were less than a mile apart (1.6 km). Sometimes the bird used the same tree on consecutive nights, and at other times it traveled as far as 4 miles (6.4 km). The roost trees of choice were Engelmann spruce, and these were selected two-thirds of the time. These tall bushy conifers have the densest branches of all the trees in the area and seemed to offer the owls the

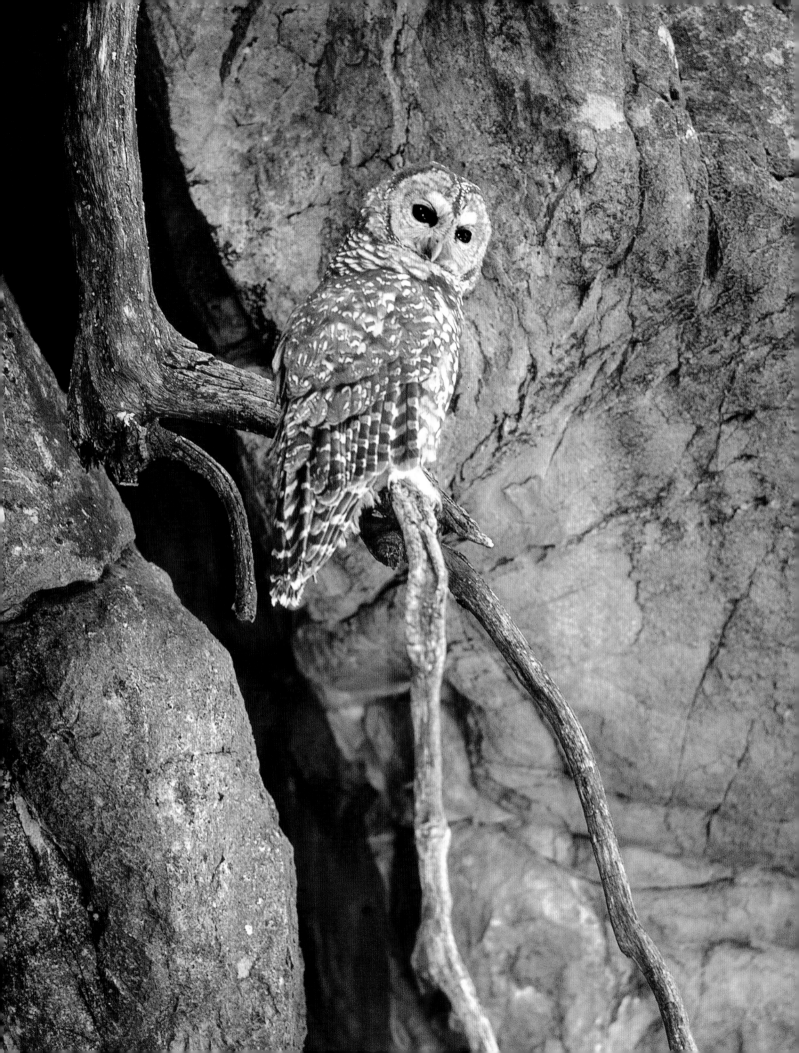

greatest physical protection and concealment. In the end, the choice of which roost tree a boreal owl selected was a combination of the right species, in the right place, at the right time.

In the Yukon, Christoph Rohner and his colleagues noticed an interesting shift in the roosting behavior of great horned owls from winter to summer. During the winter, the owls chose well-concealed perches at midcanopy levels, roughly 15 feet (4.6 m) off the ground, as is typical of many large forest owls. From mid-June to August, however, they shifted to lower branches, often less than 6 feet (1.8 m) off the ground, and to old tree stumps and fallen logs out in the open. The change in roost selection coincided with the emergence of bloodsucking blackflies that transmit avian malaria. When the researchers measured the blackfly density at the different roost sites, they found that they were highest at midcanopy levels and lowest out on open ground. The owls seemed willing to risk possible predation by Canada lynx and coyotes to avoid the blackflies.

In Kluane National Park, where the study was conducted, 57 percent of the owls were infected with avian malaria. Such infections appear to be common in owls. In California and New Mexico, 91 percent of spotted owls tested had malaria, and infection rates in Finnish boreal owls were sometimes as high as 95 percent. In boreal owls, avian malaria causes anemia, and the infected females produce smaller clutches of eggs. The deleterious impact of the infection on other species of owls has not yet been studied.

In addition to malarial parasites, blackfly bites can cause other serious problems. In fledgling great horned owls, exposure to multiple blackfly bites can sometimes produce extensive skin lesions with enough blood loss to cause anemia and dehydration. In 13 cases, the fledgling owls actually died from the insect bites.

During the breeding season, owls normally roost alone, but when winter arrives a few species may cluster together in communal roosts. This behavior is seen in some long-eared, short-eared, and barn owls and sometimes in northern saw-whets. In his 1938 classic *Life Histories of North American Birds of Prey*, the pioneering ornithologist Arthur Cleveland Bent reported 14 barn owls roosting in separate holes in a single large tree in Pennsylvania and more than 50 of them flushing from a clump of oak trees in southern California. Bent also mentions 15 long-eared owls roosting together in a single mesquite tree in a dense thicket near Tucson, Arizona. Long-eared owls typically form communal roosts beginning in August or September and disband in February or March. Up to a hundred owls may share the same roost, but more commonly, fewer than 20. The owls often perch less than 3 feet (1 m) apart, and range from 2 to 16 feet (0.6–4.9 m) off the ground.

Wintering short-eared owls commonly roost on the ground. When there is lots of snow or the ground is soggy, they often move to dense clusters of trees. Up to 200 short-eared owls may roost together on a small patch of prairie or marshland, sometimes within 3 feet (1m) of each other. When short-eared owls roost in trees they may do so with long-eared owls. The owls hunt independently and don't seem to inter-

(*opposite*) This Mexican spotted owl was roosting in a shaded canyon high in the Huachuca Mountains of southern Arizona. Spotted owls seem especially sensitive to high temperatures, and they are able to survive in desert environments only when they can escape to relatively cool refuges.

act socially. A safe refuge close to abundant food seems to be the main prerequisite for communal roosting.

The informal name for a group of owls is a *parliament*. I couldn't find the origin of the word, or when it was used for the first time, but it certainly made me laugh. I'm betting that the word was coined by a committee of politicians hoping that some of the mythical wisdom ascribed to the birds might improve their public image.

Fleeing from Winter

Eleven of the 19 species of owls in the United States and Canada are typically year-round residents that weather the winters and normally do not leave the security and familiarity of their home range. Among the other 8 species, 2 are obligatory migrants and 6 are partial migrants.

Elf owls and flammulated owls are the 2 species that always flee from winter. Two reasons compel them to leave. First of all, their small body size means they have a large surface area in proportion to their body mass and are thus poorly adapted to conserve body heat. And second, both eat mainly insects and other invertebrates that either die or become dormant once the weather turns cold. The combined challenges of increasing energy demands and a scarcity of suitable prey leaves them with no alternative but to migrate to warmer areas in Mexico or Central America where invertebrates are active all year round.

The partial migrants are those species that are migratory in just the northern part of their range. Usually this includes individuals that live in Canada and the northern United States during the breeding season and then migrate south in the fall. Included in this group are the northern saw-whet, barn owl, short-eared owl, long-eared owl, burrowing owl, and snowy owl. Some individuals of these species do remain on their breeding grounds throughout the winter, but many, if not most, migrate to wintering areas where temperatures are less frigid and accessible prey is more plentiful. One long-eared owl banded in Montana was recovered in Guanajuato, Mexico, 2,000 miles (3,219 km) south, and another from Saskatchewan was found 2,500 miles (4,023 km) away in Oaxaca, Mexico.

If food is plentiful, however, owls that normally migrate may not. In early December 2005, at least 80 short-eared owls were hunting voles in the marsh grasses near Beaverhill Lake, in central Alberta. Lisa and Chuck Priestley reported that many owls overwintered that year, an unusual occurrence for this northern area. Ninety-five short-ears were counted in mid-February, and 98 in late March.

The prairie burrowing owl is a good example of a partial migrant. Most of the owls that normally breed in Canada and the northern United States migrate to the southern Great Plains and Mexico. And Canadian owls may migrate farther south than those in the northern United States, an example of "leapfrog" migration. Since 1989, Geoff Holroyd has been studying burrowing owls on their wintering grounds in southern Texas and northern Mexico to determine if, in fact, this is what is happening.

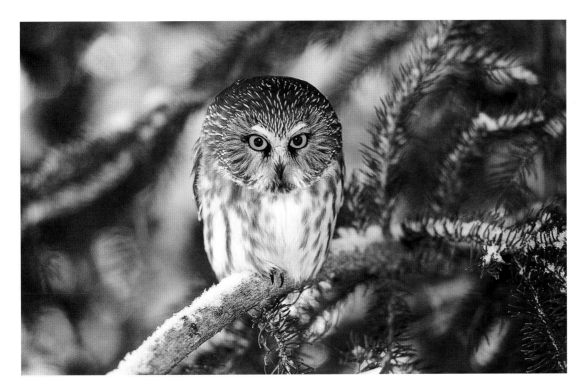

Snowy owls are another partial migrant that regularly winter in the northern prairies of Canada and the United States. In any given winter, I can see up to a dozen of these arctic owls within a day's drive of my home in Calgary. Paul Kerlinger and Ross Lein looked at the age and sex distribution of wintering snowy owls. They discovered that immature males wintered the farthest south and adult females the farthest north. Immature females and adult males ranged somewhere in between. This makes sense when you consider the body size of the different age and sex classes: juvenile male snowy owls weigh the least and adult females weigh the most. Heavy-bodied adult females can withstand colder temperatures than lightweight males and are consequently able to winter farther north. Once again, this highlights the importance of body mass and surface area in the lives of northern owls, for which the conservation of body heat is a continual challenge.

All species of owls typically defend a territory during the crucial breeding season when young are being protected and fed. Year-round residents continue to defend their home ranges in winter, but they are usually less aggressive and more tolerant of intruders at that time. Biologists wondered whether migrant species might defend temporary territories on their wintering grounds. It turns out that snowy owls do just that. In a marsh in Wisconsin, the wintering snowy owls defended small territories less than 1 square mile (2.6 sq km) in size, attacking and driving away trespassers. Combatants might swoop at each other and collide in midair, grabbing each other's talons.

In Alberta, winter territories were held exclusively by female snowy owls who defended areas roughly 0.5 to 2 square miles (1.3–5.2 sq km) in size for up to 80 days. Immature females held larger territories than adult females, which may have been a reflection of their inexperience in defending and selecting the best winter habitat. Males appeared to be

Many saw-whet owls that live in the northern parts of their range migrate south in the winter. This owl had established itself at a residential bird feeder and was preying on the local redpolls and chickadees.

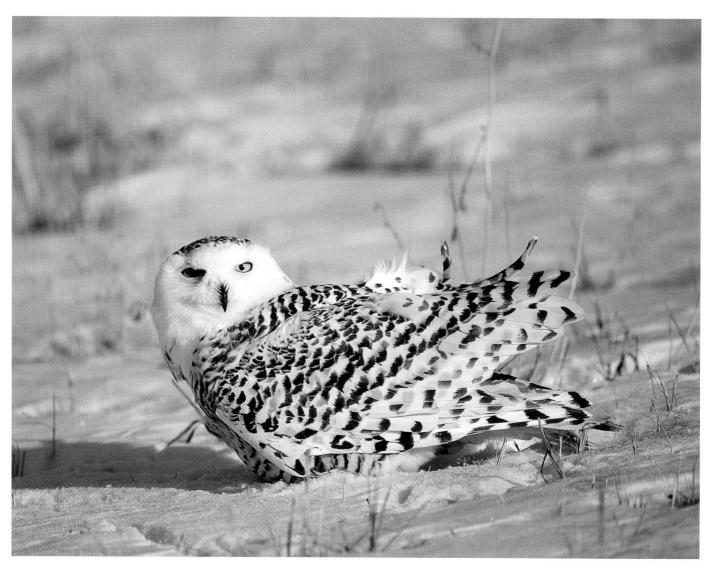

Snowy owls commonly migrate to the windswept northern Great Plains. The treeless grasslands closely resemble the wide open spaces of the arctic tundra where the owls breed in the summer.

nomadic, although some of them remained fixed to a small area for up to 17 days.

Three of the normally nonmigrant owl species, the spotted owl, great gray owl, and northern pygmy-owl, are sometimes forced to make short movements in response to severe winter conditions in their home range. For example, spotted owls in the mountains of California may move 40 miles (64 km), descending 4,000 to 5,000 feet (1,219–1,524 m) in elevation, searching for improved winter conditions. Great gray owls in California's Yosemite National Park may also move to lower elevations in winter. In Oregon, great gray owls sometimes travel as little as a mile (1.6 km) or as far as 27 miles (43.4 km) in search of thinner snow cover. Northern pygmy-owls in the American Rocky Mountains live at altitudes as high as 11,800 feet (3,597 m), but in winters when snowfall is heavy they often descend to lower elevations to find suitable hunting areas.

Bird-watchers universally rejoice at the periodic mass winter movements of large numbers of great gray, northern hawk, boreal, and snowy owls. These cyclical invasions are called irruptions. They are not migra-

tions in the common sense of the definition and are discussed in the following section.

In general, the details of owl migration are poorly understood. Most species, it seems, migrate at night and alone. However, in Europe, long-eared owls reportedly arrive in flocks on islands such as the Shetlands after crossing a minimum of 120 miles (193 km) of open ocean. The routes that the birds follow, and the cues they use to navigate, are mostly a mystery. Biologists, however, know a little about the migration routes of flammulated owls, which they believe travel to Mexico in October via upland habitats and return north in April via lowlands. The distribution and availability of invertebrate food is thought to be the reason for the different routes.

Owls, like other migrant birds, probably use a variety of cues to find their way south and back again. They may use the position of the sun and stars to navigate, or they may rely on polarized or ultraviolet light. Magnetite, an iron compound believed to be sensitive to Earth's magnetic field, has been found in the brain of a number of migrant bird species and may function like a magnetic compass. Any or all of these may operate in owls, but nothing is known about this at the present.

Owl Invasions

In February 1978, Amherst Island in southern Ontario was invaded by great gray owls, and I drove there to witness the spectacle. Within a couple of hours of my arrival, I had seen more than a dozen great grays and added a new bird to my life list. One fellow I met that day had driven 16 hours straight, from Ohio, to see a great gray. He spent 10 minutes examining the bird through binoculars from the window of his car. He then turned around and headed home. His wife, who was a passenger in the car, seemed less than enthusiastic about her husband's obsession.

Sightings of northern owls, including great grays, boreals, northern hawk owls, and snowy owls, are on the wish list of many bird-watchers and nature enthusiasts. Luckily, these enigmatic northern birds periodically move from the remote hinterlands of their arctic and boreal breeding grounds and invade the populated areas of southern Canada and the northern United States. Bird-watchers call these infrequent winter invasions a bonanza; ornithologists call them *irruptions*.

Irruptions of snowy owls have been recorded the longest. According to the historian Alfred Gross, the first one was reported in the winter of 1833–34. Between that year and 1945, he estimates there were roughly 24 snowy owl irruptions, occurring at intervals of 3 to 5 years. Nothing suggests that these periodic invasions are any less frequent today than they were 60 years ago, and they continue to thrill owl lovers on a regular basis.

Possibly the largest irruption of snowy owls ever recorded occurred in the winter of 1926–27. Across the eastern United States, there were 2,363 sightings of snowy owls. One bird made it as far south as Mag-

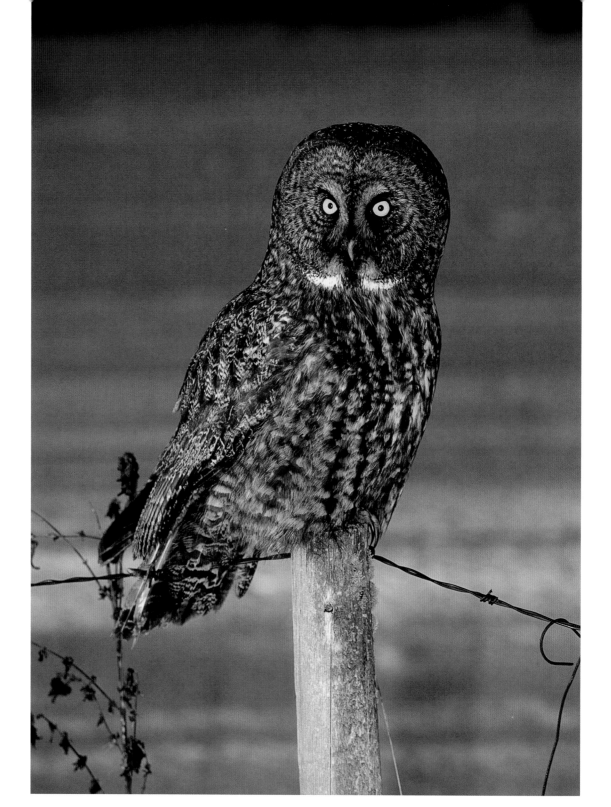

The scientific name for the great gray owl is *Strix nebulosa,* which means roughly "the screeching owl with feathers like a cloudy sky."

nolia, North Carolina. Even though owls were sighted in a dozen states, roughly 90 percent of them settled in Michigan, Maine, New York, Massachusetts, and Minnesota. Alfred Gross wrote in the *Auk:* "Some of the owls became lost and bewildered in the storms and fogs which prevailed at that time and flew far out to sea. After long periods of fruitless wandering many undoubtedly succumbed and were drowned, but others took refuge on passing ships." Two owls flew aboard the SS *Winifredian* on November 19, 1926, when the ship was 400 miles from land. The birds were brought to Boston harbor and released. A few days earlier, a

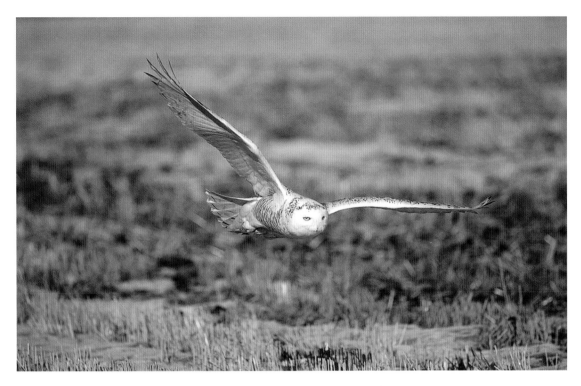

solitary owl had landed on the SS *Leviathan* when it was more than 600 miles from shore.

The reception the owls received was not always warm. That historic winter, approximately 1,500 snowy owls were taken to taxidermists in Ontario and Quebec. We don't know how many more were shot for target practice and left to rot. The sum of all these numbers paints an impressive picture as to the magnitude of the 1926–27 irruption.

Four years later, in the winter of 1930–31, there was another irruption of snowy owls. Although fewer owls were involved, they wandered farther afield. One bird was spotted in South Carolina, and another two in Georgia, one of which was shot at Cockspur Island. One snowy owl flew to Bermuda, roughly 700 miles (1,127 km) off the South Carolina coast. It was the third recorded owl sighting in Bermuda. Two other owls had visited the island in January 1907, but they were promptly shot. In earlier times, an appreciation of nature was often expressed through the barrel of a gun.

Unfortunately, owl irruptions are unpredictable. In some winters only one species, perhaps snowy owls, will invade southward in great numbers, whereas in other years it may be great grays, boreal owls, and hawk owls, in addition to snowy owls. An irruption may occur in a limited area of Saskatchewan or Manitoba one winter or spread across Canada and into the United States, as it did in the winter of 2004–5. In the winter of 1978–79, great gray owls invaded Quebec and New England. Five years later, in the winter of 1983–84, another irruption occurred, but this time it was centered in Ontario and Quebec, and only a few owls spilled over into the United States. Great gray owls irrupted south again in the winter of 1991–92, this time mainly into Minnesota and Michigan.

To understand why irruptions occur, you need to understand how

Irrupting snowy owls often hunt in agricultural lands where there are open spaces and an abundance of rodents that feed on the crops.

The Great Owl Irruption of 2004–2005

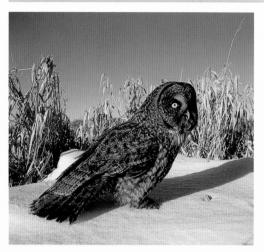

A great gray owl.

One of the largest irruptions of great gray owls ever recorded occurred in the winter of 2004–5 in Ontario, Quebec, and the northeastern United States. By the end of December 2004, roughly 59 great grays were wintering near Orillia, Ontario, and another 46 were tallied on the outskirts of Ottawa. Along the north shore of the Saint Lawrence River, more than 500 great grays were counted between Quebec City and Montreal. Veteran owl researcher Robert Nero affectionately refers to the great gray owl as "the phantom of the northern forest" in recognition of the bird's generally elusive nature. To count hundreds of these owls along the highways of a heavily traveled thoroughfare in southern Quebec is truly a remarkable occurrence.

The hinterlands of northern Minnesota proved to be an even better place than Quebec

if you were an incurable "owlaholic." During January and February 2005, many Minnesota owlers saw more than a hundred great grays in a single day. One sharp-eyed birder reported seeing a staggering 226! By the end of winter, the respected Minnesota Ornithologists' Union estimated that at least 5,225 great grays, 475 northern hawk owls, and 600 boreal owls had invaded the state from the remote northern forests of Canada—the largest numbers ever recorded for these species. Compare this with the previous year in Minnesota when wintering owl numbers were more typical: 35 great grays, 6 northern hawk owls, and a single boreal owl.

Farther west in Alberta, owls were also on the move that winter. Although many great grays were seen, the irruption in Alberta involved mostly northern hawk owls. Ray Cromie banded 171 hawk owls between October 2004 and March 2005, a record winter for him since he began banding in 1985. Previously in Alberta, there had been sizable hawk owl irruptions in the winters of 1999–2000 and 1991–92.

(*opposite*) Irrupting northern hawk owls can be surprisingly unwary around humans. This bird allowed me to approach within 10 feet (3 m) of its perch.

northern owls make a living and what happens when conditions change. On their breeding grounds, the arctic-nesting snowy owl and all three of the northern forest owls, the great gray, boreal, and northern hawk owl, prey almost exclusively on small rodents that are active throughout the winter. In the case of the snowy owl, the rodents they hunt are mainly brown and collared lemmings, whereas the forest owls principally target meadow voles, northern red-backed voles, and deer mice. A hungry great gray owl may gobble up more than 1,400 voles in one year. Surprisingly, none of these small rodents hibernate to avoid the frigidity of winter.

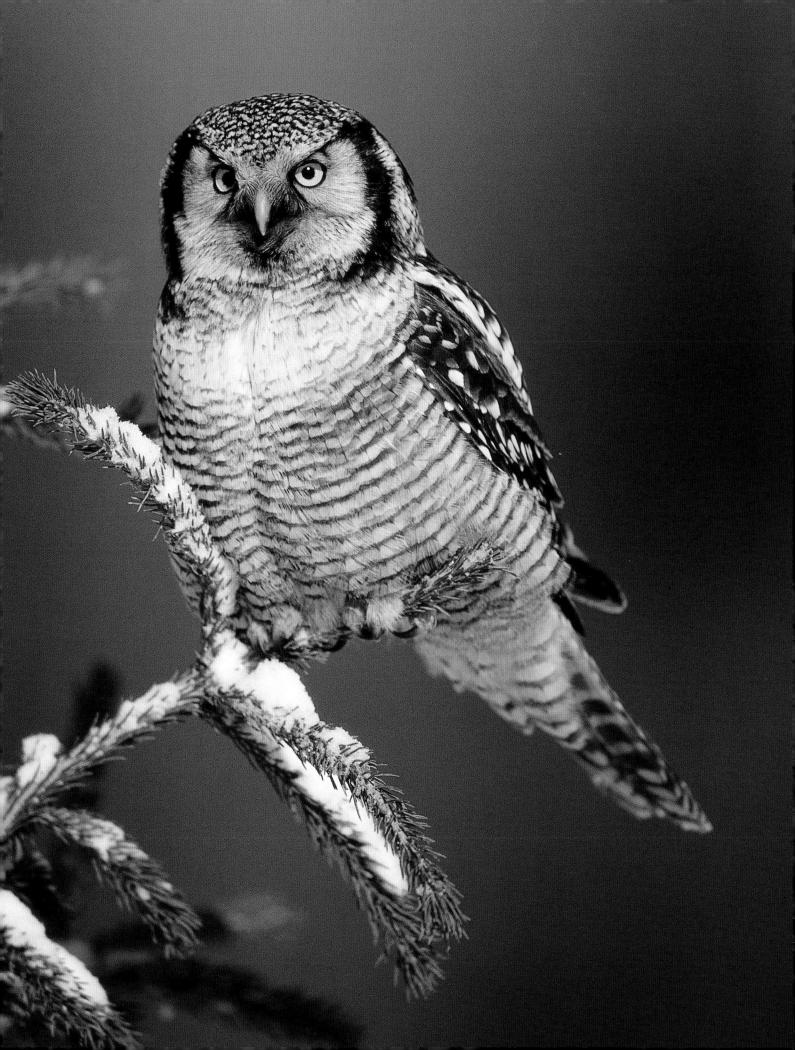

Wintering snowy owls begin to move into the prairies in November and December and they may stay until late March. Few, however, remain in the same area for more than a couple of weeks at a time.

Instead, they dig a network of tunnels at the base of the snow pack, called the *subnivean habitat*. Here, under the snow, they continue to scurry around, gnaw on roots, bark, shoots, and fungi, and occasionally nibble on a side order of insects such as springtails, aphids, leafhoppers, and scavenging ground beetles. Insulated by a thick blanket of snow, the temperature in the subnivean habitat hovers around the freezing point all winter long. Some of these rodents even breed in winter, an indication of how well adapted they are to life beneath the snow. A blanket of snow may protect the voles and lemmings from the lethal cold, but it's no protection against many of the northern owls.

The one thing that most people know about lemmings is that their numbers fluctuate wildly between boom and bust. Vole populations also follow cycles lasting three to five years, and in both cases, the reasons for this are still debated. No matter why rodent populations cycle, the fact is they frequently do, and this greatly impacts the owls that depend on them for their winter survival.

When rodents are abundant, all the northern owls respond by producing larger families of young. In peak lemming years, for example, a snowy owl may lay 11 eggs. If, as winter approaches, the local rodent population suddenly crashes, adult owls and young alike must seek better hunting grounds or risk starvation. Scientists believe two things combine to create the most spectacular irruptions: a high population density of owls, usually the result of a bumper crop of offspring, followed by a sudden scarcity of prey. Even when rodent numbers are not especially low, the owls may still have trouble hunting them effectively if the snow is too deep or if an icy crust that the owls cannot penetrate has formed on the surface. Either way, the owls are crowded and hungry.

During an irruption year when the owls first begin to wander south, prospecting for better hunting areas, they are usually still quite healthy.

Gordon Court, endangered species biologist and raptor specialist for the province of Alberta, believes that as the desperate birds search farther and farther afield, they slowly lose weight. For many of these invading owls, an irruption is a race against time. Some hungry northern owls may travel more than 600 miles (966 km) during an irruption. One northern hawk owl banded in Camrose, Alberta, in the winter of 2000 traveled to Anchorage, Alaska, at the end of winter, a distance of 1,400 miles (2,253 km). Court remembers an irruption into Alberta in the early 1990s when hundreds of young snowy owls, unable to find enough prey, died of starvation. Snowy owls are the heaviest owls, and healthy adults commonly weigh between 4.5 and 5.5 pounds (2–2.5 kg). That winter, Court found starving owls that weighed less than 2 pounds (907 grams). He told me, "The owls were so thin they were nothing more than flying feather dusters."

In most irruption years, however, the invading owls do not perish in great numbers. Most locate good hunting grounds, survive the winter, and then return to northern breeding grounds the following spring. Court can't explain how the owls locate scattered pockets of prey in the winter, often in areas they have never been before. He chuckles. "One day there may be a single great gray hunting along the edge of a field and the next day there are six of them. How did the word get around? It's a mystery to me."

Most irrupting owls head north again in late February or early March. Why don't they stay where the hunting is good? The main reason to leave seems to be that their hunting habitat is distinctly different from their nesting habitat. For example, an irrupting northern hawk owl may hunt very successfully in open farmland fringed with trees, but most need secluded coniferous forests and muskeg bogs to successfully raise a family. The same applies to snowy owls that may spend the winter hunting a stubble field in southern Alberta but are then compelled to return to the treeless tundra of the arctic to rear their young.

The irruption I remember best was the one in January 2000 in northern Alberta. I was more than happy to drive 1,400 miles (2,253 km) in bitterly frigid weather to savor an invasion of great grays and northern hawk owls. At one point in the trip I watched five great grays hunting at the same time along the snowy ditch beside the highway. On whispering wings, they floated from perch to perch, listening for muffled rustles. When they detected life, they plunged feet first into the snowy drifts to capture their hidden prize. I watched them scratch their face delicately with sharp taloned feet, snooze in the winter sunshine with their feathers fluffed erect, and magically melt into the forest like a wisp of smoke. Is it any wonder that an owl irruption excites the hearts of so many of us?

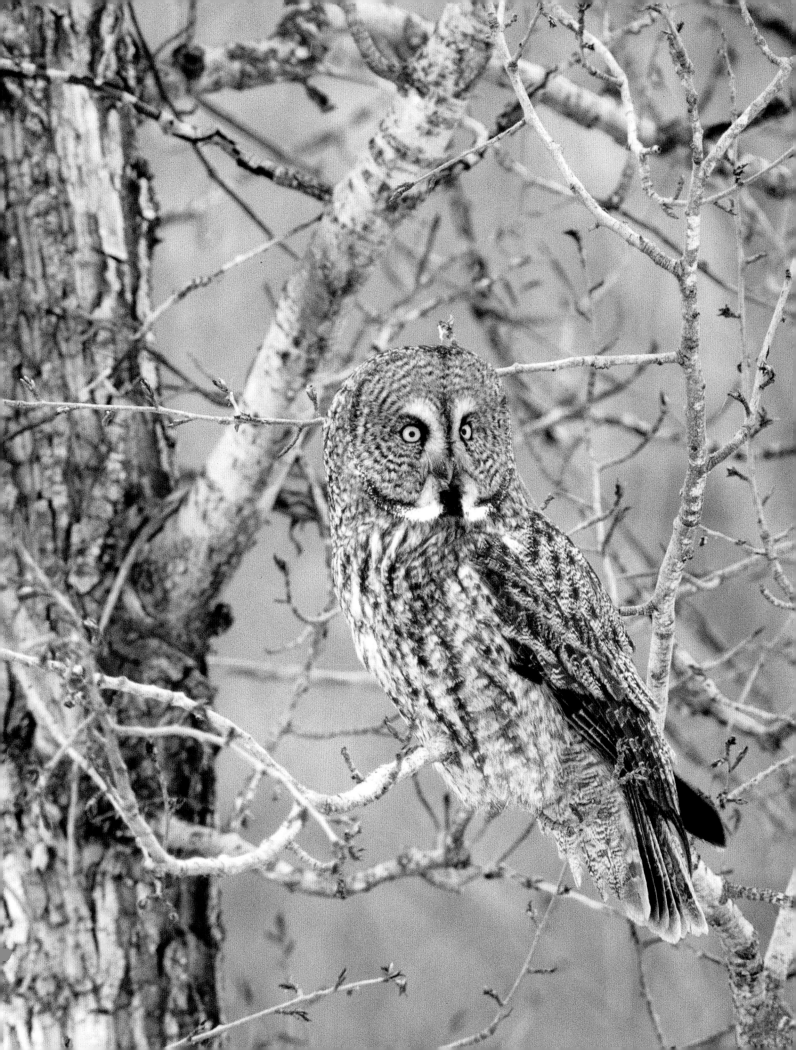

The Owlish Appetite

I N LATE MAY 2000, I learned about a northern hawk owl that was nesting in a charred snag in an old burned forest in northern Alberta. As I drove along the gravel logging road near the site, I spotted a lone owl perched at the top of a dead spruce tree beside the road. When I stopped to watch the owl, the squeaking brakes on my Jeep flushed two American wigeons that were resting in a puddle in the ditch. As the ducks flew across an open burned area, the owl attacked the male duck and drove him to the ground. I couldn't believe my eyes. An adult wigeon weighs roughly 1.5 pounds (0.7 kg), more than twice the weight of a full-grown northern hawk owl. There are no records of a hawk owl attacking any species of waterfowl, so this wigeon became the largest prey item ever reportedly killed by the owl. In timely fashion, it suddenly started to rain, so I decided to make myself a peanut butter and jelly sandwich while I waited to see what had happened to the duck and the owl who were now hidden from sight. After 30 minutes my curiosity was killing me so I walked over to see what had happened. By this time, the owl's mate had flown in, and as I approached, both owls flew back toward their nest, seemingly abandoning the dead duck. For an instant, I thought I had carelessly disturbed the birds and forced them to abandon their kill. Suddenly when I was almost at the carcass, a northern goshawk flew up, carrying the dead wigeon in its talons. The pirate flew for about 20 feet (6 m) then dropped its prize. As the goshawk flapped away, one of the hawk owls swooped down at it. The owl then flew to a nearby snag and glared at me as I examined the duck. Part of the duck's shoulder and neck had been eaten. As soon as I left, the hawk owl landed and reclaimed its kill. The owl was still guarding the carcass and feeding on it when I returned the next morning to check on them.

Owls do not feed on seeds or fruit, nor do they nibble on leaves or

(*opposite*) The great gray owl is the tallest owl in North America, yet it is remarkably hard to spot when it perches quietly in the leafless branches of a winter aspen tree.

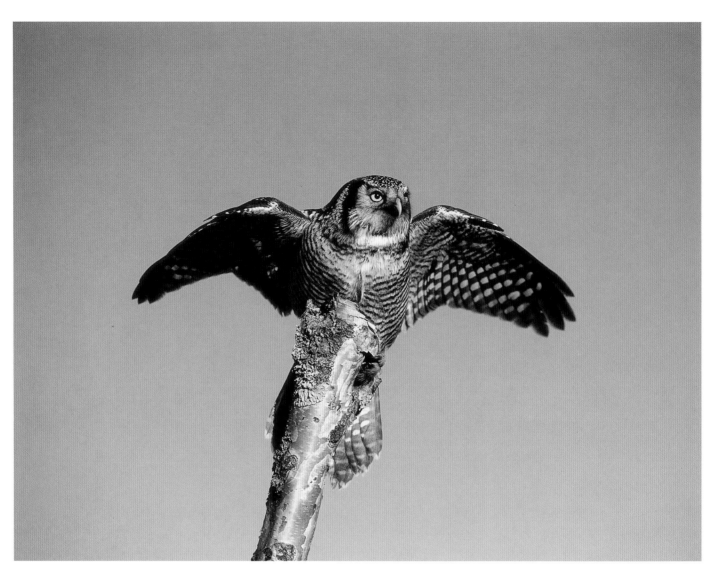

Typically a hunting northern hawk owl will change perches every 3 to 10 minutes, and move up to 100 yards (91 m) to its next perch. They fly farthest when leaving a high perch.

flowers. All owls eat other animals to survive, so, by definition, they are birds of prey—raptors, from the Latin verb *rapere,* meaning "to carry off by force." Owls share their carnivorous dietary preferences with the diurnal birds of prey, which include 237 hawks, eagles, kites, harriers, and Old World vultures; 61 falcons and caracaras; 7 New World vultures; 1 osprey; and a single secretarybird, for a total of 307 species.

Worldwide, owls and diurnal birds of prey share the same habitats. Pick any location on the planet where a diurnal bird of prey is found and there is likely one or more species of owl living in the same area. The one possible exception is the alpine tundra, which caps the summits of the world's great mountain ranges. No owl is a regular resident of this treeless habitat.

The majority of owls are predators of small mammals, birds, reptiles, amphibians, and an assortment of invertebrates, including insects, crayfish, centipedes, spiders, and scorpions. Most species eat a variety of these foods, although they may, at times, concentrate on certain ones to the exclusion of others. For example, the northern saw-whet owl, over much of its range, eats mainly woodland mice, especially deer mice. On the Queen Charlotte Islands off the coast of British Columbia the owls

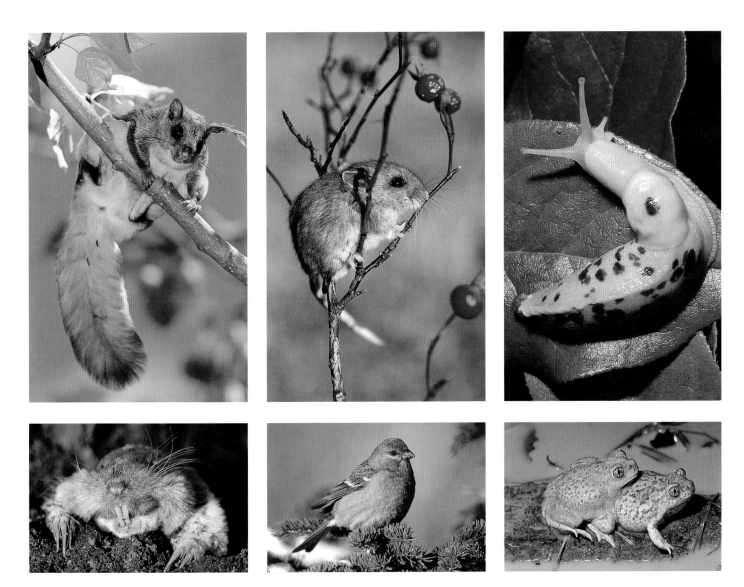

also eat amphipods and isopods gleaned from the intertidal zone, and slimy banana slugs that forage on the wet forest floor.

Frederick Gehlbach claims that the eastern screech-owl eats at least 138 different vertebrates and likely as many invertebrate species, earning it the title of the most varied diet of any owl in North America. Even so, 76 percent of the owl's diet, by weight, consists of rodents and songbirds. The great horned owl ranks a close second when it comes to catholic tastes. This wide-ranging species eats everything from beetles to bitterns, tadpoles to turtles, and rodents to red foxes. In Florida, they tackle baby alligators, and in coastal British Columbia they sometimes concentrate on seabirds, feeding heavily on rhinoceros auklets and pigeon guillemots. They probably catch most of the auks as they return under darkness to their nesting burrows, but some of them may be deftly plucked from the surface of the water at night as they rest. My friend Ray Cromie calls the great horned owl the "night shark" and with good reason.

No species of owl is a full-time dietary specialist. In this way they differ markedly from the worldwide diurnal birds of prey, among whom there are bone-eating bearded vultures, snail-eating kites, crab-eating

Most owls eat a range of foods, including small mammals such as the northern flying squirrel, deer mouse, and northern pocket gopher; songbirds such as the pine grosbeak; amphibians including these mating plains spadefoot toads; and invertebrates such as the banana slug.

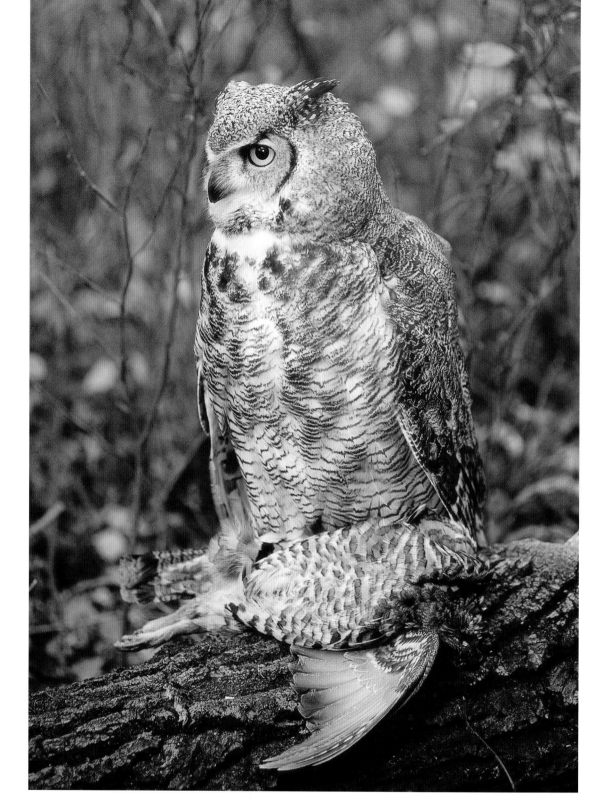

Although great horned owls do most of their hunting at night, they will not pass up a vulnerable target in the daytime. This owl has captured a ruffed grouse.

hawks, bee and wasp–eating honey-buzzards, snake-eating eagles, and bat-eating falcons.

Carrion is a food source that is largely ignored by owls, although scavenging has been reported in a few species. A northern hawk owl in Ontario was seen scavenging scraps from a dead moose; a great horned owl in Illinois fed from the frozen flank of a red fox; a snowy owl in Svalbard, Norway, was spotted with the remains of a ringed seal killed by a polar bear; and a northern pygmy-owl in Montana stripped a road-killed pine siskin off the highway and cached it in a nearby tree.

Robert Nero speculated in his book *The Great Gray Owl: Phantom of the Northern Forest* that many owls are probably killed when scavenging bait from traps set for furbearing animals. To see if this might be true, Chris Siddle examined the raptors that were accidentally killed in the 350 traps set by a single trapper near Fort Saint John, British Columbia. He did this for four consecutive winters. At least eight owls were killed: two boreal owls, four great horned owls, one great gray owl, and a single barred owl. The trapper admitted that other raptors were killed but he didn't submit them for examination. Considering the hundreds of traplines that lace the Canadian north, the incidence of owls scavenging baited traps and dying as a consequence may be an overlooked, but significant, mortality factor.

Overall, the scavenging lifestyle has been largely ignored by owls. Perhaps, in the nocturnal world, owls have never been able to outcompete the keen-nosed mammalian carnivores who presently have a monopoly on locating and consuming dead stuff in the darkness.

In North America, as everywhere else, the largest owls hunt the largest prey. A 4-pound (1.8-kg) snowy owl on its wintering grounds will hunt mallards, black ducks, and common eiders, the heaviest duck in North America. Snowy owls also prey on ring-necked pheasants and burly 7.5-pound (3.4-kg) white-tailed jackrabbits. Every winter, the audacious owls also tackle house cats, risking the ire of 40 million feline fanciers in the United States. Considering that house cats kill an estimated 26 million birds per year in Virginia alone and another 38 million in Wisconsin, I heartily root for the owls and wish them greater luck.

Predictably, medium-size owls hunt prey proportionate to their size. Thus, spotted owls commonly prey on bushy-tailed woodrats, Douglas squirrels, and northern flying squirrels. Barn owls, in the same size category, regularly hunt Norway rats.

Overall, owls in Canada and the United States most frequently prey on mice, voles, squirrels, shrews, moles, and rats. These small mammals are the principal prey of eastern and western screech-owls, comprise 84 percent of the diet of great gray owls, 75 to 92 percent of that of long-eared owls, 85 to 95 percent of short-eared diets, and up to 98 percent of the barn owl's daily fare.

I was surprised to learn just how many small mammals these owls can consume. In one study in Finland, 40 pairs of short-eared owls and their young, nesting in an 8-square-mile (21-sq-km) plot of land, ate approximately 38,000 voles during the summer breeding season. The eminent U.S. ornithologist Paul Johnsgard calculated that an average adult barn owl, with a maximum life span of 8 years, might catch and consume roughly 8,800 mice in its lifetime. Assuming each one of those mice ate about 10 percent of its body weight in food per day, a single barn owl would save farmers about 58 pounds (26.3 kg) of grain crops that would otherwise be lost to the gnawing jaws of the rodents.

Many owls will hunt birds if the opportunity arises, but none are such committed avian predators as the Cooper's and sharp-shinned hawks and the peregrine falcon, which, in its worldwide distribution,

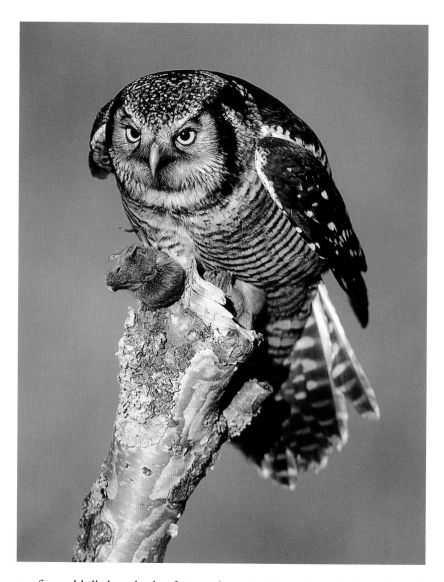

A northern hawk owl can consume one or two mice of this size in a single feeding. Surplus prey is stashed and eaten later.

strafes and kills hundreds of winged species. Even though the owls can't match the speed and agility of falcons and hawks, many still hunt their feathered kin. The eastern screech-owl, for example, eats 83 different species of birds, including swallows, thrushes, wrens, jays, starlings, finches, woodpeckers, and warblers. A funny story about a bird-eating eastern screech-owl was described in 1931 by Arthur Cleveland Bent, who told of an owl that came down the chimney of a house in New Jersey and ate the family canary, pulling the unfortunate songbird through the bars of its cage. A few yellow feathers were all that remained of the songster.

Even the medium-size barred owl has been known to occasionally capture birds such as blackbirds, warblers, woodpeckers, thrushes, blue jays, and northern bobwhite quail. An inquisitive scientist in Wisconsin released 55 live house sparrows in a cage with a solitary barred owl. One hundred fifty-four hours later, the hungry owl had eaten every single sparrow.

The fast-flying northern pygmy-owl and northern hawk owl probably target birds more often than other owl species, in part, because they hunt in the daytime when songbirds are most active. The wolfish

hawk owl will boldly tackle surprisingly large birds. Besides the rare attack on ducks, it has also been known to kill pileated woodpeckers, gray partridge, and spruce grouse, all of which are the same weight or heavier than the owl.

When it comes to audacity and rapaciousness, the northern pygmy-owl displays the heart of a lion in a body smaller than a blue jay. Few songbirds are safe in the hunting territory of a pygmy-owl. There is even a record of an ambitious northern pygmy-owl attacking a 6-pound (2.7-kg) barnyard chicken—a 38-fold difference in weight between predator and prey. The biologist Gordon Court jokes that if "pygmy-owls were as big as beavers, cows wouldn't be safe."

A number of owls also hunt cold-blooded amphibians and reptiles. In Alberta, northern pygmy-owls hunt western toads and spotted frogs, especially in spring when the croaking males are conspicuously calling from their breeding ponds. Farther south, in Idaho, some burrowing owls reportedly stockpiled Great Basin spadefoot toads at the mouth of their nesting burrows. Spadefoot toads are explosive breeders that react to heavy spring rains by amassing rapidly, in great numbers, in temporary pools where they are vulnerable to predators.

The ferruginous pygmy-owl preys on reptiles to a greater degree than any other species in Canada or the United States. This small owl has a very limited range in Texas and Arizona along the Mexican border. In the warm climate where they live, snakes and lizards are active for much of the year and are a logical choice of prey. In Arizona, reptiles comprise nearly half of the owl's diet, and in Texas, one study revealed that the owl preyed on nine different species of lizards.

When it comes to owls and reptiles, the most interesting story has to be that of the eastern screech-owl and the slender blind snake, sometimes called the worm snake because of its pinkish brown color and resemblance to an earthworm. In Texas, the screech-owls prey on nine different species of small snakes, so what makes the slender blind snake story so special? The veteran Texas biologist Frederick Gehlbach discovered that the owls often brought live blind snakes back to the nest whereas all other vertebrate prey, including eight other species of snakes, were killed beforehand. He wrote in his entertaining book *The Eastern Screech Owl:* "Four times I watched adult screech owls bring live blind snakes, coiled in their bills instead of dangling like the carcasses of other snakes. Certainly the blind snake's writhing defensive behavior and smooth cylindrical body, smeared with repellent secretions, make it difficult to kill. But the owls do try to kill the snakes. . . . Dropping them live into nest cavities can be nothing more than thwarted feeding behavior."

Apparently the uninjured live snakes burrow into nest debris and can stay there for up to 15 days. Gehlbach found as many as 15 live snakes in a single nest box in suburban Texas. Apparently, the snakes survive by eating fly and ant larvae that scavenge the dead carcasses stockpiled in the nest boxes to feed the chicks. Even if the introduction of the live snakes is accidental and not purposeful, it benefits the owls. Over a 16-year period, Gehlbach found that 10 percent of fledglings died in nests

Owls and Fish

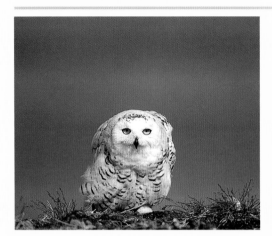

An arctic-nesting snowy owl surrounded by rivers and lakes filled with fish.

Half a dozen owls in the Old World specialize in hunting fish. In southern Asia, there are three species of fish owls in the genus *Ketupa*, and in Africa the ecological equivalents are the three fishing owls of the genus *Scotopelia*. All have bare legs and toes, and the soles of their feet are covered with spiny scales to assist in holding slippery fish. The same suite of adaptations are present in the piscivorus osprey.

In North America, fish as food is largely ignored by most owls, but occasionally they prey on them. In 1840, John James Audubon described how snowy owls caught fish in Labrador. Supposedly, the owls would lie on a rock next to a pool and wait for a careless fish to rise to the surface. With lightning reflexes, a bird would thrust out a taloned foot and hook the unfortunate victim. In the Canadian arctic, Michael Wotton found a headless lake trout in a snowy owl nest, but he didn't actually see the bird catch the fish. The water level in the nearby creek had dropped sharply in the previous weeks and he thought the owl might have snatched the fish from shallow water after it was trapped in a pool.

Snowy owls are not alone in their occasional taste for fish. One researcher examined the cavity nest of a western screech-owl and found a 10-inch (25-cm) mountain whitefish. In coastal areas, this little owl also eats tidepool sculpins. How it catches these fish is a puzzle. Perhaps it uses the same technique as its close relative the eastern screech-owl, which typically flies from a perch or hops from shore and grabs the aquatic prey with its feet. The eastern screech-owl uses this tactic to successfully catch fish and tadpoles in water that is usually less than 4 inches (10 cm) deep.

The barred owl often lives in forests where there are wetlands nearby. Not surprisingly, the owl sometimes wades into water to catch prey such as perch and American eels. The adaptable great horned owl also feeds occasionally on fish. A freshly killed Dolly Varden trout and an arctic grayling were found in a nest of these owls along the Tuluksak River in western Alaska. Both fish weighed around 28 ounces (794 gm). We don't know how the fish were caught, but anecdotal stories suggest that great horned owls wade into water up to 6 inches (15 cm) deep and grab fish with their feet. Both Dolly Varden and grayling frequently spawn in shallow water, which may make them vulnerable to hungry owls.

where there were no blind snakes versus 3.6 percent mortality in those nests that had live snakes in them. Although he didn't have enough data to definitely explain why the snakes are beneficial, he suspected they ate the insect larvae that competed with the nestlings for stored food, and when the snakes were present a greater proportion of the food was eaten by the growing chicks. Although live blind snakes are most commonly found in association with eastern screech-owls, biologists have also discovered them in the nests of western screech-owls, whiskered screech-owls, and elf owls.

Naturally, the two smallest species of owls, the flammulated and the elf owl, focus their feeding on the smallest prey. They principally hunt invertebrates, those spineless wonders of the natural world: moths, June beetles, dung beetles, praying mantids, centipedes, cockroaches, crickets, grasshoppers, spiders, and caterpillars. The average prey size taken by flammulated owls in one study was only 0.6 inches (1.5 cm) long, and it's likely that elf owls also hunt prey of that size.

Invertebrates need warm temperatures to remain active, so in winter, both of the small owls must migrate to Mexico or Central America, where such prey are active all year round. In summer, the elf owl is found along the warm border areas with Mexico, but the tiny flammulated owl ranges all the way north to southern British Columbia. In May, when flammulated owls return to their northern breeding areas, the nights are often cool. Thus, it would seem unlikely that this nocturnal owl could find many invertebrates moving about. But it turns out that even on nights when the temperatures are below freezing, owlet moths are flying around the forest canopy. Without these cold-hardy moths, the owls could never survive the cool spring temperatures at the northern edge of their breeding range.

Flammulated owls prefer mature stands of Douglas fir and ponderosa pine that are 100 to 200 years old. The population of owlet moths in these open forests is four times greater than in the coniferous forest farther west. The high prey density of moths and the open structure of the forest provide the small owl with ideal hunting conditions and enable it to breed so far north.

No matter what an owl eats, it needs lots of calories to sustain itself. Owls are hot-blooded, high-performance, energy-burning hunting machines that require a continual infusion of fuel in the form of food. Birds maintain a higher average body temperature than mammals, roughly 5 to 7°F (3–4°C) higher. Thus, a bird's metabolic rate is greater than that of a mammal of the same body weight, necessitating a greater amount of food. On average, a wild owl consumes between 5 and 48 percent of its body weight in food per day, depending on its body weight, activity levels, prevailing temperatures, and plumage adaptations.

All food consumption studies in owls have been done on captive birds. Naturally, a wild owl, actively searching for prey and defending a territory, burns at least two to three times more calories than a sedentary captive. As part of his doctoral research, Carl Marti kept four species of adult owls in outdoor pens in Colorado for a year with as much food as they wanted. Over the year, the great horned owl consumed an average of 4.7 percent of its body weight in food per day; the long-eared owl, 12.7 percent; the burrowing owl, 15.9 percent; and the barn owl, 10.1 percent.

Air temperature influenced how much food the captive owls ate. Marti compared the differences in food consumption at 30°F (–1°C) versus 70°F (21°C). In all cases, the owls ate more food when the temperature was colder. The burrowing owl ate 10 percent more; the long-eared owl, 16 percent; the great horned owl, 20 percent; and the barn owl, 29 percent. A basic principle in biology predicts that a small owl

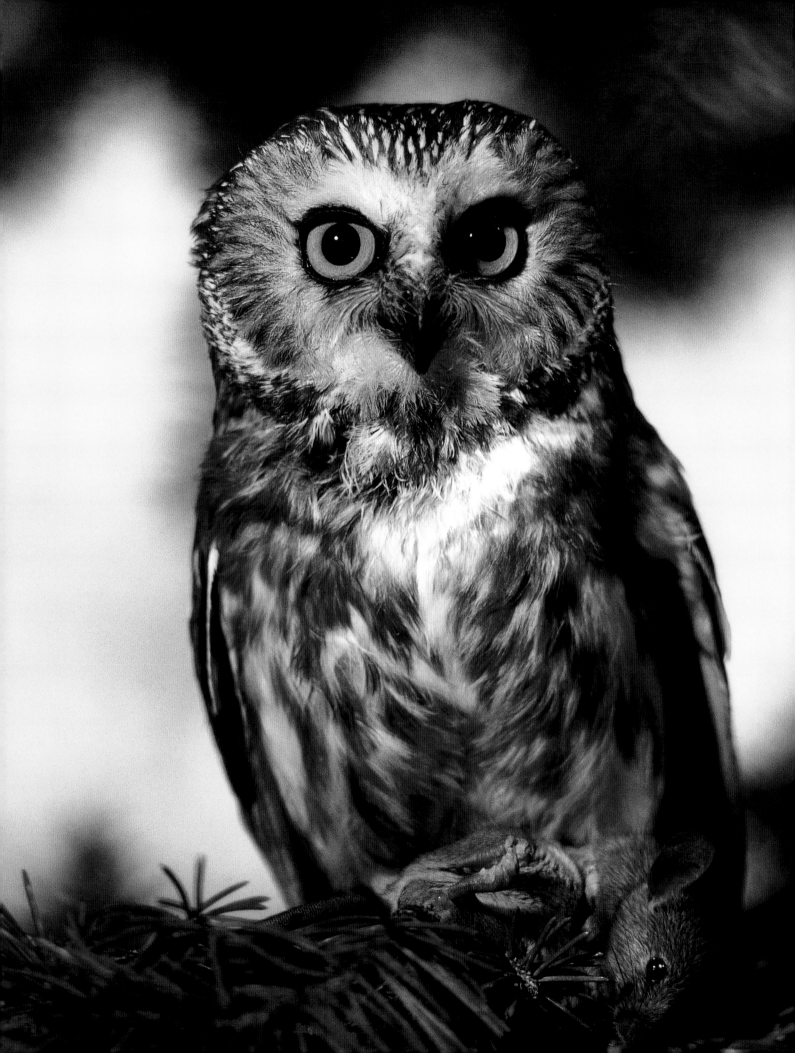

loses more heat from its body surface than a large owl and consequently requires proportionately more energy to stay warm in cold weather. So it was a surprise to discover that the 5-ounce (142-gm) burrowing owl, the smallest of the four, increased its food consumption the least in sub-freezing temperatures. This strongly suggests that the burrowing owl's plumage and physiology are well adapted to cold, and compensate for its diminutive size. On the other hand, the great increase in the barn owl's energy needs testifies to how poorly it copes with chilly winter temperatures, which sets a limit on the northern extent of the owl's range.

Foods That Fight Back

Not all prey that owls eat submit without a struggle. Some fight back. In Sweden, a dead Eurasian eagle owl, the largest owl in the world, had a 12-inch (30-cm) adder in its stomach. Researchers thought the owl had probably been bitten by the venomous snake after it was swallowed alive. The great horned owl, a close relative of the eagle owl, also preys on venomous snakes. In the San Joaquin Valley of California, the legendary rattlesnake researcher Laurence Klauber found the remains of 37 snakes, including 4 rattlesnakes, when he dissected 1,014 great horned owl pellets.

The large owls are not the only ones that tackle venomous vipers. In South America, the bold little burrowing owl sometimes preys on young neotropical rattlesnakes. How these different owls overpower the dangerous snakes without getting bitten is a mystery. In Africa, I have watched secretarybirds kill and consume deadly cobras and puff adders, and I wonder if owls might kill snakes in the same way. The secretarybird repeatedly stomps on the head of the snake with its tough feet until the snake stops writhing. The bird then picks it up in its beak and swallows it whole. Another possibility is that owls attack venomous snakes when the snakes are busy swallowing prey and unable to defend themselves.

Hungry owls also prey on scorpions, which are potentially deadly. These dangerous invertebrates have been recorded in the diets of whiskered screech-, eastern screech-, burrowing, and flammulated owls. The greatest scorpion killer of all is the tiny elf owl, perhaps because many of these owls live in the desert where scorpions are most plentiful and diverse. David Ligon reported that adult elf owls readily ate scorpions and also fed them to their young. He found four scorpions in the stomach of a single owl, and all the scorpions had the stinger removed The venomous stinger of a scorpion is located on its last abdominal segment, so by removing this, the owl essentially disarms the animal. Ligon also found scorpions stockpiled in nest cavities. They also had their stingers removed, suggesting that this disarmament strategy was common.

Diurnal birds of prey with their sharp-edged beaks, penetrating talons, and aggressive demeanor would seem to be a highly dangerous target, and an unlikely one for an owl to consider. Not so for the rapacious great horned owl. In 1981, I found a great horned owl in Baja, Mexico, that had killed a peregrine falcon and was eating it. Such attacks on

(opposite) This northern saw-whet owl was hunting house mice around an abandoned farm in rural Saskatchewan.

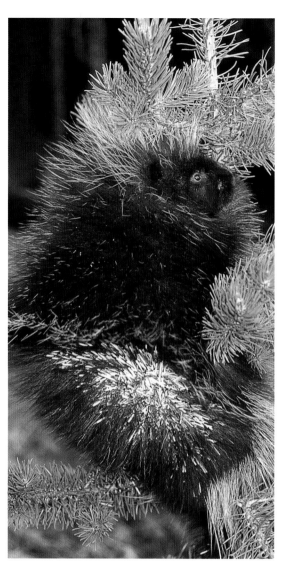

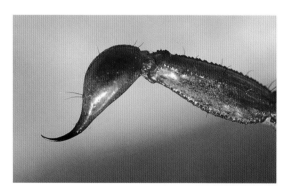

Some prey animals are armed with dangerous defenses. Potential deadly prey include rattlesnakes, and scorpions that have venomous stingers on the tips of their tail. Porcupines, even young ones, have quills that can injure an attacking owl.

peregrines are surprisingly common. Along the cliffs of the Hudson and Mississippi Rivers, biologists attempted to reintroduce peregrines to their former haunts but their efforts were often foiled by owls that killed both the young and adult falcons. In Alberta and Saskatchewan in the 1990s, peregrine reintroductions were often done in large urban centers such as Calgary, Edmonton, and Regina, partly to lessen the threat from predatory great horned owls.

Peregrines are not the only raptor that great horned owls attack and eat. In a study in central Alberta, great horned owls killed up to 44 percent of nestling red-tailed hawks. In Arizona, the owls preyed on 25 young Harris's hawks from 64 nests, and in some summers in New Jersey they killed up to 21 percent of nestling ospreys. Most, if not all, of the attacks probably occurred under the cover of darkness when the owl had an advantage over the protective parents.

The northern goshawk is arguably the most ferocious of raptors in North America when it's defending its nest and young. Attila the Hun, the famous warrior king who terrorized the eastern Roman Empire, apparently adorned his battle helmet with the image of a goshawk whose bold fierceness he admired. There are reports of irate female goshawks

attacking and driving off hungry black bears and wolverines, so it is an audacious owl that would tackle such a bird. In Canada's Yukon Territory, a great horned owl that was feeding chicks killed and ate a brooding adult female goshawk and her three-week-old young. Christoph Rohner suspected the owls were also responsible for the disappearance of a second brood of goshawk young, but he could not confirm this. Rohner admitted that this type of predation was a rare event, and the risky attack may have occurred because snowshoe hares were scarce and the parent owl was having difficulty feeding her chicks.

Sometimes the prey fights back and wins. In California, a northern pygmy-owl attacked a long-tailed weasel, which grabbed the owl and killed it in self defense. From Washington State, there is a 1953 record of a single Steller's jay and 8 to 10 gray jays mobbing and killing a northern pygmy-owl.

It's not surprising that the great horned owl, which has a well-established reputation for attacking dangerous prey, sometimes loses the fight. Museum taxidermists find porcupine quills deeply embedded in the legs and facial area of many of these owls that die from other causes. In October 2004, a starving adult female great horned owl was found near Saint John, New Brunswick, and the unfortunate bird would have eventually died from her injuries if she had not been killed humanely by the wildlife officer who found her. An autopsy revealed the extent of the injuries. The owl's entire underside, literally from head to toe, bristled with multiple quills embedded in her skin. As is typical of porcupine quills, a great many had migrated into the bird's soft tissues. Several had penetrated the abdominal cavity and were lying among loops of intestine. Others had punctured the liver, and a few were wedged near the heart. Examiners felt that the many quills that had penetrated the large flight muscles on the owl's breast were the deadly ones. The damage caused by the quills probably prevented the owl from flying normally and she was slowing starving to death as a result.

Pellet Diaries

More is known about the dietary diversity of owls than about any other aspect of their biology. The reason for this is pellets, which the birds conveniently regurgitate from their stomach. Pellets consist of the indigestible parts of an owl's diet and include such items as fur, feathers, beetle wing cases, bones, claws, teeth, mollusk shells, and fish scales. Owls are not the only avian pellet producers. Grebes, cormorants, herons, eagles, hawks, gulls, shrikes, and crows are some of the others. But the pellets produced by owls have been better studied than in any other group of birds.

When regurgitating a pellet, an owl looks like it is choking, but this causes the bird no harm. It's no different from a cat or dog throwing up a fur ball. The pellets originate in the second chamber of the owl's stomach. The first chamber, called the *proventriculus,* is the glandular stomach, where acid and digestive enzymes are secreted. The second chamber, called the *gizzard,* is the thick muscular stomach, where food

gets churned and pulverized. From the gizzard, liquid nutrients flow to the small intestine and the indigestibles left behind get compacted into a neat wad, which is eventually regurgitated as a pellet.

Generally, the largest owls produce the largest pellets. Those of barn owls and burrowing owls are roughly an inch (2.5 cm) in length and three-quarters of an inch (1.9 cm) in diameter. Great gray owls and great horned owls regurgitate pellets that are 3 to 4 inches (7.6–10.2 cm) long and 1 to 2 inches (2.5–5 cm) in diameter. The snowy owl produces even larger ones. Many are more than 4 inches long. I measured one on Victoria Island in the Canadian High Arctic that was close to 5 inches in length. As far as I know the biggest snowy owl pellet ever measured was 6 inches (15.2 cm) long, 1 inch (2.5 cm) in diameter, and weighed more than 2.5 ounces (70.8 gm). Those dimensions are greater than the height of an elf owl and almost twice as heavy.

Young owls start to regurgitate pellets when they are only 8 to 10 days old and theirs, of course, are the smallest pellets. The pellets from the three insect-eating owls, the flammulated, elf, and whiskered screech-owl, are also very small and largely composed of chitinous material from the exoskeletons of invertebrates. These pellets disintegrate quickly and blow apart in the wind.

A question I am often asked is how soon after a meal are pellets regurgitated? The time is highly variable, ranging from 7 to 22 hours. The digestibility of the prey and season of the year influence the speed of pellet formation. In winter, pellets are generally produced more quickly, perhaps because the bird consumes more prey to keep warm and thus fills its gizzard faster and needs to empty it sooner. Also, if the prey is heavily feathered or furred this shortens the time between pellets. It may simply be a function of gizzard capacity. Once the gizzard is full, the bird regurgitates the contents.

I dissected this snowy owl pellet from the Canadian High Arctic. It contained the bones and fur of collared lemmings and a single bird beak that looked as if it might have belonged to a snow bunting or a lapland longspur.

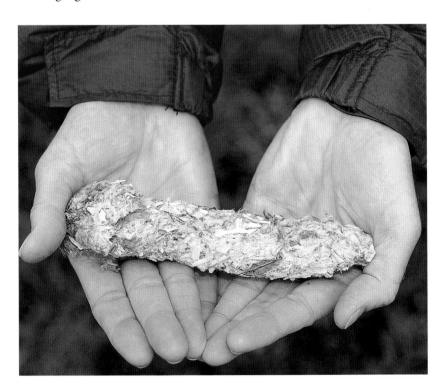

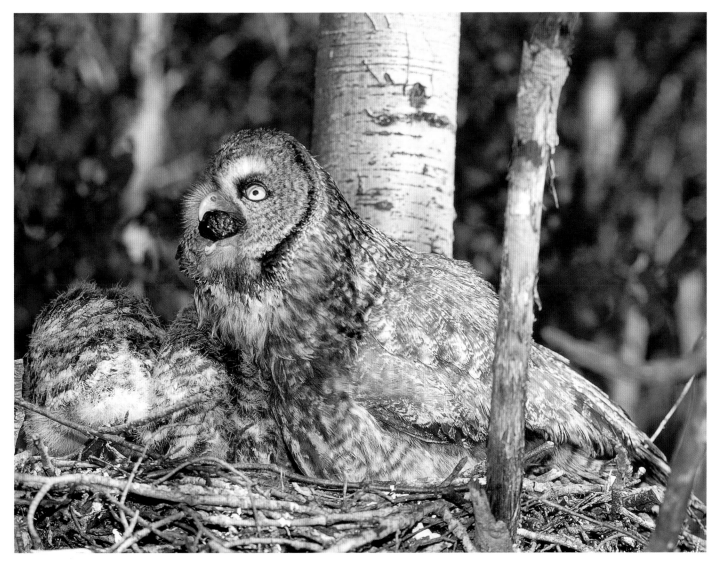

On average, an owl casts one to two pellets each day, depending on its food consumption. The sight of food, or the urge to begin hunting, often compels an owl to regurgitate a pellet. A pellet usually includes the undigested remains of more than a single prey animal. For example, the pellet of a barn owl typically contains the remains of 3 to 6 small mammals. James Duncan examined one snowy owl pellet that contained the bones and teeth of 27 voles.

Owl pellets, more than those of other birds, are a valuable source of dietary information because many remain intact for months, sometimes longer than a year. Furthermore, since owls don't generally dismember their prey before swallowing it, the pellets often contain bones, teeth, beaks, and claws that provide valuable clues about an owl's diet. In Europe, one study compared the proportion of bone in owl pellets versus hawk pellets. The researchers found that owl pellets contained 45.8 percent bone as opposed to 6.5 percent bone in hawk pellets. There are two reasons for the difference. Owls often swallow their prey whole, and the acidity in an owl's stomach is less corrosive than it is in a hawk's stomach so fewer bones get digested.

Owl pellets can reveal many details about an owl's dietary habits,

This great gray owl is eating a pellet that was regurgitated by one of her three chicks. This is a common behavior and may be meant to keep the nest clean.

The pH Scale

Acidity is measured using the pH scale, which ranges from 0 to 14. Seven is neutral; values below that are acidic while those above are alkaline. The pH value in an owl's stomach ranges from 2.2 to 2.5 compared to 0.2 to 1.2 in diurnal birds of prey. These numbers don't seem that different until you realize that the pH scale is logarithmic, meaning that a drop of 1, say from 4 to 3, corresponds to a 10-fold increase in acidity. If you drop from 4 to 1 the acidity increases a thousandfold. Thus, the digestive juices in the stomach of diurnal birds of prey can be anywhere from 10 to 5,000 times more acidic than those in an owl's stomach. This is why the bone-eating bearded vulture in Africa, for example, can completely digest the dense vertebrae of a cow in just 48 hours. For comparison, apple juice has a pH value of 3.0; vinegar and lemon juice are 2.2; and the human stomach is usually 2.0 or more.

but there are some things they can't tell us. For example, there is nothing unique about any owl pellet that can disclose which species of owl definitely produced it, so the owner must always be deduced from circumstantial evidence, such as the nearby presence of the owl itself, or from habitat and geographic clues. Moreover, pellets cannot tell us the total number of prey animals an owl has eaten. At best, the dissection of a pellet can reveal the minimum number of animals the bird consumed. It is not a record of the owl's entire diet for that time period since some bones and other fragments may be lost or digested. Furthermore, some meals such as caterpillars and earthworms yield few regurgitated remnants. Even with these limitations, the analysis of owl pellets is a valuable, inexpensive way to determine an owl's general diet.

Researchers typically collect pellets at roosts and nest sites, where many can be gathered at one time. My wife, Aubrey, collected 50 pellets under a spruce tree that had been the winter roost of a great horned owl. She did this for a government mammalogist who was doing a small mammal survey in Alberta. He told us that the analysis of owl pellets was one of the best ways to learn the distribution of small secretive mammals. Other species of owls may also drop large numbers of pellets in a single location. One northern saw-whet owl dropped 66 pellets beneath the perch where it roosted. Barn owls may use the same roost for years, and enough pellets may accumulate to fill two to three bushel baskets. Roosts that are used by more than one owl may yield even greater numbers of pellets.

Denver Holt has been studying the communal roosting habits of wintering long-eared owls for many years. He estimates that the average winter roost in his area of Montana has 5 to 10 long-eared owls in it. If you assume that each owl ejects a single pellet every day and that the owls use the roost for about 100 days in an average winter, then using

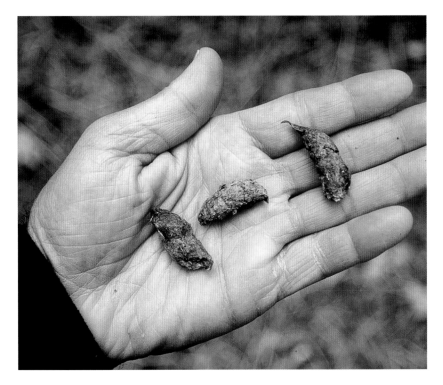

The size of an owl pellet is not a reliable way to identify the owner. I collected these within the territory of a nesting northern pygmy-owl who I suspect was the owner, but they could also have been regurgitated by a boreal or northern saw-whet owl.

simple arithmetic you can predict that 500 to 1,000 pellets can be collected at such a roost in a single winter season. Holt is currently analyzing more than 30,000 pellets that he has collected.

Owl pellet dissection is an entertaining way for schoolchildren to learn about predators and prey, and an increasingly popular activity. Until quite recently, I thought this was a wonderful idea with no associated health risks. In fact, I've often collected pellets in the wild and teased them apart with my bare fingers to examine their contents. But in March 2005, a newsletter published by the Minnesota Department of Health reported an outbreak of *Salmonella* bacterial poisoning in two elementary schools where the children dissected owl pellets from a captive barred owl as part of a science project. More than 50 children developed diarrhea, fever, and abdominal cramps. Because of this, I now recommend that people handle only pellets that have been purchased from a recognized biological supply house that sterilizes the pellets with heat.

Hunting Techniques

Owls employ many different hunting styles to feed themselves. Their most common tactic is to sit and wait. With this method, the bird monitors a stretch of terrain from an elevated vantage point, then launches an attack once a vulnerable victim is spotted. Logically, the higher an owl perches, the greater an area it can scan. But as it moves higher, the faint rustle of prey becomes harder to hear and the owl must increasingly rely on vision as its primary tool of detection. Northern hawk owls, snowy owls, and both species of pygmy-owls are principally visual hunters. They typically perch 20 to 40 feet (6–12 m) off the ground, at the tops of trees, telephone poles, and cliff edges.

In Norway, Geir Sonerud found that high-perching northern hawk owls were most successful at capturing prey when the victim was close to them and there was no snow on the ground to hamper the capture. For hawk owls in Alaska's Denali National Park, the mean striking distance was 26 feet (8 m), although the birds sometimes launched an attack from as far away as 69 feet (21 m). Northern hawk owls hunting in Norway would generally wait 3 to 10 minutes at a perch before they moved to another spot, sometimes more than 100 yards (91 m) away. The distance they flew depended on the height of the perch they were leaving. They flew farther from high perches than from lower ones. Snowy owls wintering on the Canadian prairies fly 100 to 200 yards (91–183 m) between hunting perches, usually after an unsuccessful wait of 10 to 15 minutes. The distance is frequently dictated by the spacing of telephone poles.

A number of factors determine the height of a hunting perch. Owl species that rely on hearing to supplement their vision naturally perch closer to the ground. A lower perch may also be beneficial in catching insects that are small and less active than small scurrying mammals. Ambient light levels also influence perch height. Owls can detect moving prey from a greater height during the day than they can in darkness, no matter how good their nocturnal vision might be. Even moonlight has an impact. Eastern screech-owls in Kentucky perched higher when moonlight was available, averaging 6 feet (1.8 m), versus 4.6 feet (1.4 m) on moonless nights. A final factor that influences the height at which an owl hunts is the availability of perches, and this is dictated mainly by the type of vegetation in which an owl is hunting. For example, a flammulated owl foraging in an open ponderosa pine forest with little shrubbery on the ground naturally perches higher than a northern saw-whet searching in a dense willow thicket.

The ear asymmetry in great gray owls suggests that they rely heavily on their acute hearing to help them target prey. As a result, they perch lower than owls that use mostly vision to hunt. Great grays typically select trees on the edge of clearings and perch on mid- to lower level branches at an average height of about 18 feet (5.5 m). They usually attack prey that is less than 165 feet (50 m) away. In one report, the average perch-to-prey distance was only 34 feet (10.4 m). Ray Cromie, a master owl bander, claims he has often lured a perching great gray from 200 yards away (183 m) by letting a live house mouse run over the snow beside the road. He recalls several times when he was successful even when the owls were 400 yards (366 m) away. In these long-distance attacks, the owls certainly rely on their vision, not their hearing, to detect the prey.

Boreal and saw-whet owls have the most dramatic ear asymmetry of any of the species, and this suggests that they rely heavily on hearing to detect their prey. The extremely low height of their hunting perches supports this conclusion. Hunting saw-whets typically perch between 5 and 10 feet (1.5–3 m) high on branches, shrubbery, and fence posts. Boreal owls in Sweden perched even lower, an average of 5.5 feet (1.7 m)

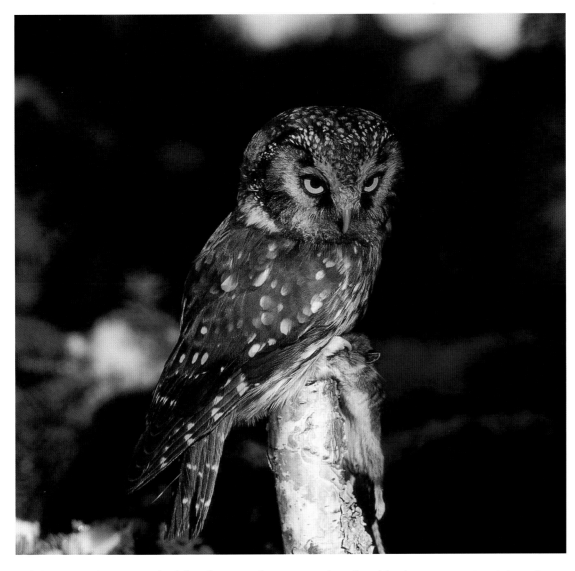

off the ground; in central Idaho their perches averaged 13 feet (4 m) in height.

Boreal owls are impatient hunters, changing perches frequently, often every 2 to 4 minutes. Flight distances between perches average around 19 yards (17 m) but can stretch to seven times that distance. During one night's hunt a boreal owl may cover a distance of a mile or two, but these owls tend to concentrate their movements within a small area, doubling back frequently rather than traveling in a straight line. Once the owl detects prey it may loiter for up to 30 minutes, waiting for its victim to move into a vulnerable position.

A variation on the sit-and-wait tactic is what I call the run-and-grab technique. I have often watched burrowing owls run across the prairie to stomp on a grasshopper, bite its head, then swallow the insect whole. Elsewhere, barred owls sometimes catch crayfish and frogs on foot, elf owls snatch centipedes and sun spiders from the ground, and whiskered screech-owls hop on Jerusalem crickets.

One style of hunting is unique to the northern pygmy-owl. You might call it the peek-and-plunder method. This enterprising owl

Boreal owls hunt from a relatively low perch height where they can use their sensitive hearing to detect prey such as this deer mouse.

Snow-plunging

A snow-plunge imprint left by a great gray owl.

Snow-plunging is one of the most dramatic hunting methods used by owls. Robert Nero says the behavior is so common in great gray owls that plunge-marks can be used to prove the presence of this species. Nero wrote in the nature magazine *Blue Jay*: "Typically, a perching or hovering owl locates prey by sound, then drops head downward and forcibly into the snow, breaking its fall with its wings and reaching deeply with its long legs for its prey." From an analysis of high-speed photography, it seems that in the instant before hitting the snow, the owl pulls its head back and penetrates the surface with its legs fully extended and talons spread.

I've examined dozens of imprints left in the snow by hunting great gray owls, and they vary a great deal. Some beautifully register the slotted tips of the bird's outstretched wings with a depression left by its body. Others are just a circular hole punched in the snow by the owl's legs, with no markings left by the wings. In these latter cases, the owl doesn't land, and only its dangling feet penetrate the top of the snow. Photographs from Scandinavia show a great gray owl almost disappearing into the snow during a deep plunge.

I've often read that a snow-plunging great gray owl can capture prey hidden under 18 inches (46 cm) of snow. Locating prey in snow searches nest holes for vulnerable young and adult songbirds. When it finds them, it squeezes inside and grabs them. Observers have seen the owls catch a downy woodpecker, a brown creeper, and three winter wrens in just this way.

Coursing, where a bird quarters back and forth in open terrain on a zigzag path, is the second most common hunting method used by owls. When coursing, an owl flaps and glides, 6 to 10 feet (2–3 m) off the ground, in the style of a northern harrier. This technique is most successful when the owl flies very slowly, giving it time to thoroughly

that deep is such a remarkable sensory feat that I suspect it may be one of those biological myths that are sometimes blindly accepted without scientific substantiation because it is so wonderful to imagine and satisfies our common belief that owls have exceptional hearing. To date, the only study I know that actually measured the snow depth of successful plunges was a master's thesis written by Michael Collins in 1980. Collins measured the length, width, and depth of 54 plunge-holes made by hunting great gray owls wintering in Manitoba. Although snow depths in the study area ranged from 9.4 to 28 inches (23.8–71.1 cm), the deepest plunge-hole that Collins measured was only 13 inches (33 cm) deep, and the average was 8.3 inches (21.1 cm). Blood was found in 6 of the 54 plunge-holes, which Collins assumed indicated a successful capture. Of those, the average snow depth was 8 inches (20.3 cm). Great gray owls can certainly locate and capture prey hidden under the snow, but the maximum depths at which they can hear prey is unknown.

In Sweden, Åke Norberg, reported a great gray that penetrated a snow crust strong enough to support the weight of a 176-pound (79.8-kg) man. To effectively penetrate the surface of crusty snow, a diving owl needs height and body weight. Ten to 15 feet (3–4.6 m) seems to be adequate for snow-plunging in great gray owls and is a common launching height for them. They also have the requisite body weight to give their plunges the force necessary to puncture the crust and penetrate deeply into the snow. An average adult great gray owl weighs roughly 2.4 pounds (1.1 kg), making it the third heaviest owl discussed in this book. No one has witnessed snow-plunging in the heavier snowy owl or great horned owl. Perhaps the hearing in these owls is not acute enough for them to locate prey hidden under the snow, which prevents them from using this as a hunting method.

Three other species of owls, the boreal owl, northern hawk owl, and barred owl, share the snowy world of the great gray and could possibly snow-plunge for food. There is a single report from Manitoba of an unsuccessful snow-plunging attack by a boreal owl, but this behavior seems to be extremely rare in these birds. The boreal and hawk owls weigh less than half as much as a great gray, and Norberg believes that their size prevents them from effectively plunging for prey in this way. The barred owl, on the other hand, weighs around 1.6 pounds (726 gm), which is heavy enough to snow-plunge for prey, and there are reports confirming this behavior in Nova Scotia, Manitoba, and Minnesota.

scan the ground beneath it with its eyes and ears. The barn, short-eared, and long-eared owls routinely forage in this way. These owls have low wing-loading and well-developed fringing on their flight feathers, which enables them to fly quietly and slowly without stalling. If one of these owls needs to study a patch of ground for some time, it may hover. But hovering burns considerable energy and no owl will do this for very long—half a minute being the usual maximum on a windless day. Strong winds can lessen the energy it takes for an owl to hover and help them remain stationary for a longer time. Even owls with heavy

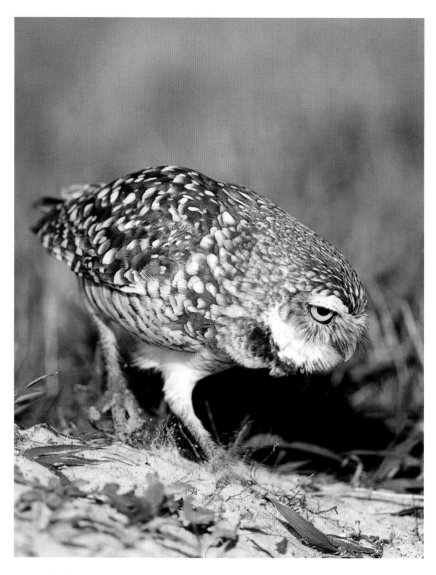

This male burrowing owl in Florida was resting outside its burrow when it saw a grasshopper. It ran over and pinned the insect to the ground with its foot, then ate it.

wing-loading, such as the snowy owl and great horned owl, can hover in strong winds. Many of the smaller owls also hover when they are hunting. Burrowing owls do it in the windy prairies, and elf and flammulated owls hover to pluck insects off the leaves of trees.

Owls also hunt in the manner of the fast-flying forest hawks that navigate rapidly through a woodland hoping to surprise and frighten prey into exposing itself. This is an effective strategy adopted by great horned owls, barred owls, and northern hawk owls to catch birds and small mammals such as squirrels.

The last hunting tactic I describe is hawking, in which an owl captures prey on the wing like a flycatcher or swallow does. As you might expect, this technique requires speed and maneuverability and is employed mostly by the small owls. The elf owl and flammulated owl are the two best examples, but they are not the only ones. One eastern screech-owl caught 37 moths that were fluttering around a barnyard light.

Bats are another aerial prey that occasionally appear in the diet of owls, although less commonly than you might expect considering that many owls are active at night when bats are flying around. It may be that

the flying agility of bats makes them a difficult target. Even so, there are records of short-eared owls, eastern screech-owls, barn owls, and burrowing owls catching bats on the wing. Even heavy-bodied spotted owls sometimes capture bats in flight.

Owls, like most predators, use a repertoire of hunting methods, each of which carries an obligatory energetic cost and produces a certain level of success. When prey is plentiful, an owl can afford to use high-energy hunting methods such as hovering, hawking, and coursing because it can capture enough food to offset the costs. When prey is scarce owls shift to low-energy searching modes such as the sit-and-wait tactic. When conserving energy, they tend to perch longer in one spot and fly shorter distances between perches. It's all an unconscious analysis of cost and benefit.

Worldwide, virtually all owls capture prey with their feet. The few exceptions are the smallest owls that often hunt on the wing and sometimes catch insects with their beak. During the last few yards of an aerial attack, an owl typically switches from flapping flight to gliding. This reduces flight noise and also makes the attacker less conspicuous to vigilant prey. In the final moments before the strike, the owl swings its legs forward so that they follow the identical path that its face was following. The angle of the legs has to be exact. If the legs are too high, the owl's momentum will carry the bird backward and it will crash on its tail. If the legs strike too low, the bird will flip forward on its face. Even if the owl is inaccurate in judging the exact position of its prey, perhaps because it's hidden under grass or snow, the spread of its talons allows for a margin of error. For example, the talon spread in an adult great horned owl covers an area of 31 square inches (200 sq cm) so the bird can afford to miscalculate slightly and still hook the prey with at least one of its talons.

Owls capture prey with their feet, but they generally kill it with a bite on the head or neck, as falcons do. Owls, however, do not have the "tomial teeth" that falcons have to make their bite more effective. A single tomial tooth is present along the cutting edge on each side of a falcon's upper beak. Raptor biologists believe that falcons use these teeth to cut or injure the spinal cord of their prey when they bite into the neck. The tomial teeth may also help falcons kill prey that is larger than themselves. Most other birds of prey kill their victims by penetrating the vital organs with their sharp, powerful talons.

Most owls don't consume their victims on the spot unless the prey is small and can be eaten quickly. Perhaps they feel too exposed and vulnerable to ingest their meal on the ground. Many of them habitually fly to a "plucking post" that can be a familiar limb, a fallen tree, or broken snag to eat their meal. Barred owls often use an old nest as their plucking post and the remains of multiple meals may accumulate there. In one such nest, a researcher found the leg of an eastern cottontail rabbit, the tail of a fish, scraps of fur, and a handful of feathers and fish bones.

Eagles, hawks, and falcons usually dismember their prey and eat it in bite-size pieces torn from the carcass. Owls, on the other hand, of-

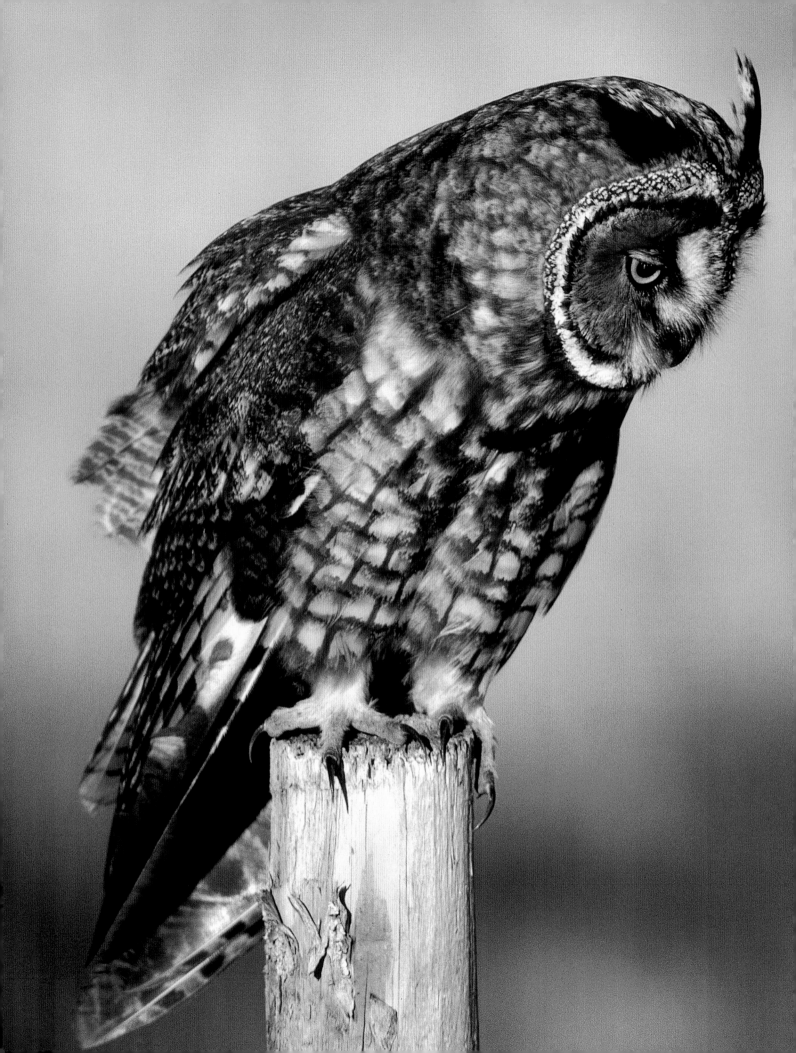

ten swallow their prey whole. In fact, a great gray owl or a barred owl can swallow 10 whole mice in a row. In Alaska, one great gray owl had 13 redpolls in its stomach. A barn owl can easily swallow a full-grown Norway rat, the tip of the rat's tail lolling from the corner of the bird's mouth as the final evidence. One great horned owl swallowed an entire adult muskrat estimated to weigh almost a pound (0.5 kg), with a few spasmodic jerks of its head. The most amazing feat of swallowing I've ever seen was a young barn owl chick about 7 days old swallowing a vole almost as large as itself. It took 30 minutes of convulsive gulping to finish the job, and afterward the chick appeared to be exhausted. Sometimes such prodigious feats of ingestion may kill an owl; one northern saw-whet choked to death on a mouse that was too big to swallow.

Owls don't always swallow every scrap of a carcass. For example, ferruginous pygmy-owls frequently clip off the long chitinous legs of insects and decapitate and partially pluck the birds they plan to eat. Long-eared and short-eared owls sometimes eviscerate rodents and leave the entrails uneaten. And great horned owls often discard the large head and feet of snowshoe hares.

The hunting success of an owl depends on a number of factors: the nature of the prey, the age of the owl, and the weather conditions. Invertebrates are generally the easiest prey to catch, followed by amphibians, reptiles, and mammals. Birds are generally the hardest to capture. Variations in the visual acuity, alertness, and reaction time among the various prey animals determine how easy or how difficult they are to catch.

Flammulated owls prey largely on invertebrates and are successful 81 percent of the time. In Texas, eastern screech-owls have a similarly high success rate with invertebrates, around 83 percent, but when they switch to mammals, birds, and lizards, their success rate drops to 56 percent. Wintering snowy owls in Alberta successfully catch small mammals in 58 percent of their attempts but succeed only 9 percent of the time when they hunt gray partridge. In one Michigan study, overwintering snowy owls failed on every attempt they made to catch birds, but succeeded in roughly half their attacks on mammals.

The age of an owl also determines how successful it is at hunting. Not surprisingly, juvenile owls need many months after their first summer to acquire enough experience to catch a diversity of prey. Many start by hunting invertebrates while their parents continue to feed them supplementary meals. As they gain skill and confidence they gradually move to more difficult prey. Peter Boxall and Ross Lein found that among wintering snowy owls in southern Alberta, adult females were successful in hunting two-thirds of the time whereas juvenile females succeeded in just one out of three attempts. The juveniles also appeared inept at handling prey, sometimes dropping it in flight, and they were also much slower at manipulating and swallowing their meals. An adult took just 12 seconds from the time of capture to ingestion versus the 43 seconds a juvenile needed to complete the same task.

Weather conditions also greatly impact the hunting success of owls. Deep or crusty snow protects small mammals and makes them more

(*opposite*) Long-eared owls frequently use coursing as a hunting method but will readily switch to a perch-and-pounce tactic if the circumstances are right. This particular bird is breaking with tradition by hunting during the day, something this species rarely does.

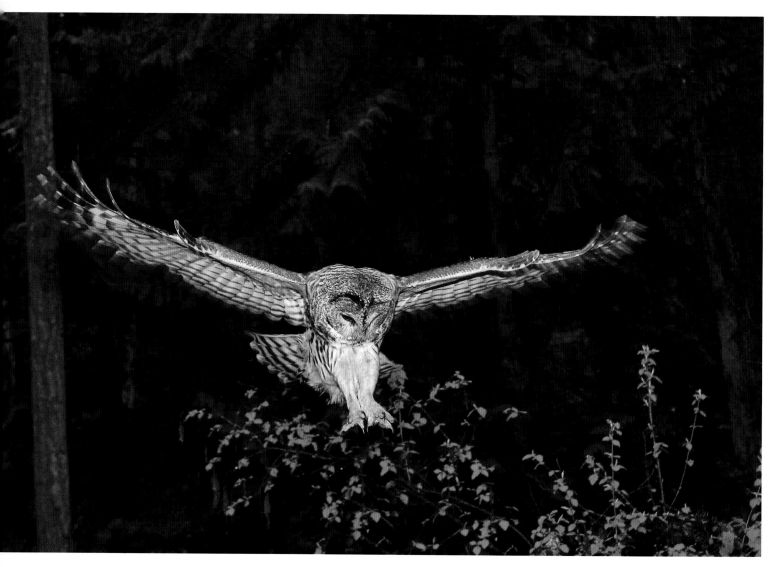

The talon spread on the barred owl is roughly 5 to 6 inches (13–15 cm). This allows the owl a margin of error when striking prey. It can be off slightly and still yield a successful capture.

difficult to capture. Heavy rain and wind can also reduce hunting success. Stormy weather can mask the faint noises made by small mammals hidden in the grass so that owls are unable to accurately pinpoint their location. Naturally, without accurate auditory cues, an owl's success rate drops dramatically. Under difficult weather conditions, European long-eared owls captured prey only once in every six to eight attempts.

The European owl expert Heimo Mikkola estimates that at least two-thirds of all hunted prey get away. Many escape for the reasons outlined above, but in some cases it's just bad luck on the part of the owl—a branch gets in the way and blocks the bird's grasp, or the prey suddenly catches sight of the owl and gets away.

Since winter storms can sometimes impair an owl's ability to hunt successfully, at least two northern species have evolved an unusual capacity to withstand starvation. Snowy owls can drop to half their normal body weight and still survive. Great gray owls are even hardier and can withstand a 70 percent weight loss and still survive. A bird in such an emaciated state would probably only recover if captured and fed in captivity.

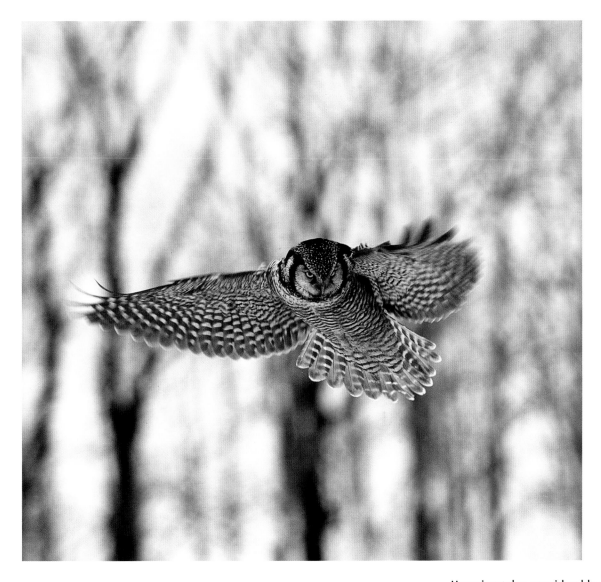

Hoarding for Hard Times

When hunting is good and prey is abundant, owls may kill in excess of what they can cram into their stomach. The problem becomes what to do with the extra food. Diurnal birds of prey can store surplus food in their crop—a saclike out-pocketing of their esophagus. For example, African white-backed vultures, which often feed in ravenous throngs, can stuff 15 to 20 percent of their body weight into their crop. I've seen these vultures gorge themselves to the point where they couldn't fly and had to stay grounded while they digested some of their meal. If a predator were to threaten them in this situation, the vultures would quickly disgorge some of their stored food so that they could escape. Unfortunately, owls don't have a crop, so the only option they have to deal with surplus food is to cache it in a safe hiding place. This caching behavior is most common in the northern owls.

Erkki Korpimäki, who studied boreal owls in Finland, concluded that the following four factors contributed to the evolution of food caching in northern owls: small body size, cold climate, variable weather causing temporary food shortages, and availability of safe storage sites. In North

Hovering takes considerable effort and burns substantial amounts of energy. This northern hawk owl took advantage of a strong wind to lessen the energetic costs.

In winter, a redpoll that froze after it was cached must be thawed before a boreal owl can consume it. The owl thaws the prey with its own body heat, in much the same way that it would incubate an egg.

America, scientists know of at least six species of owls that hoard extra food in winter. Eastern screech-owls may store surplus prey equal to half their body weight in selected trees cavities. For an adult bird, this would be enough food to last for up to five days. Northern hawk owls have been known to cache up to 20 prey items in less than three hours. They hide the extra food in snow drifts, old woodpecker holes, spruce boughs, and the tops of decaying stumps.

Boreal owls, because of their small size, are especially vulnerable when inclement weather forces them to stop hunting. Snowstorms and blizzards can mean days of fasting, and the colder temperatures that often accompany these storms can further drain their energy reserves. When this happens, a boreal owl closely guards any surplus prey it has. Commonly, it will cache extra prey within 50 feet (15 m) of its daytime roost to guard it from thieving ravens, gray jays, and pine martens. If a thief locates a cache, the owl will move the food to a new location, sit on it, or immediately consume it.

In North America, some of the larger owls also hoard surplus prey to buffer themselves against the vagaries of the northern climate. For example, spotted owls and barred owls cache extra food in the broken tops of snags, in hollows at the base of trees, on moss-covered limbs, and under fallen logs.

An owl's cached food can sometimes freeze solid in winter. That's a problem for these birds because their beak isn't strong enough to cut frozen meat into pieces. If the owl swallows the frozen prey whole, it risks damaging the delicate tissues of its esophagus and stomach. So how do they cope with this problem? Søren Bondrup-Nielsen serendipitously discovered that when captive boreal and northern saw-whet owls were given frozen prey, they thawed the food with their own body heat by sitting on it as if they were warming an egg. To study this fur-

ther, he challenged the owls with frozen mice that had been chilled to different temperatures. The first thing the owls did was to bite the head of the dead mouse. He wondered if this was a reflex killing behavior or whether the bird was evaluating the temperature and solidity of the prey. When the mouse was frozen, the owls grabbed it with both feet and sat on it, sometimes covering it completely with their ruffled belly feathers, in the same way they would incubate an egg. Periodically, the owls stood up and bit the mouse on the head again. Bondrup-Nielsen interpreted this behavior as the owls testing the hardness of the prey. When the initial temperature of the frozen mouse was 3°F (–16°C), the owls might test it like this four times before they began to eat it. When the mouse temperature was 20.5°F (–6.4°C) the birds usually tested it twice, and when the mice were barely frozen at 30°F (–1.1°C) the owls generally began to eat after testing them once. The temperature of the thawed prey was always above freezing and averaged 35°F (1.6°C) when the owls consumed them. It took 22 minutes for the owls to thaw the coldest mice to this temperature. Partially thawed prey was a challenge for the birds and it took a lot of tugging and biting before they could eat it. At times, the owls resumed thawing the mice after they had eaten the unfrozen portions.

Since half a dozen northern owls cache prey in winter, it's reasonable to assume that all of them thaw frozen prey with their body heat even though it has only been witnessed in the great horned owl in the wild. In southern Illinois, observers watched a great horned owl thaw and eat the flank of a frozen red fox. In Manitoba, James Duncan observed a great horned owl thawing frozen prey at least twice in the wild. Other raptors such as northern goshawks, merlins, and gyrfalcons also cache surplus prey in winter, but no one has observed them thawing prey, although it is a probable necessity. For me, such interesting gaps in the natural history of owls and other wild creatures make observing their lives a continual voyage of discovery.

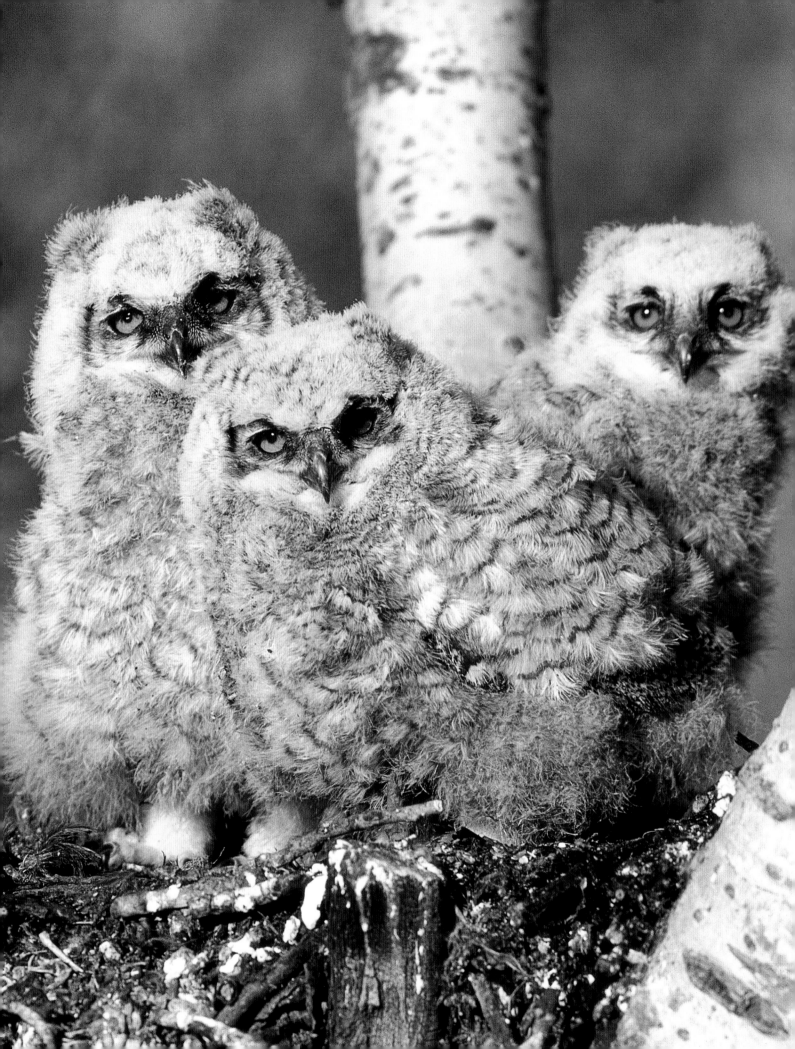

Family Life

The Huachuca Mountains are an island sanctuary of oak and pine forest that rises up from the sweltering lowlands of the Chihuahuan Desert in southeastern Arizona. In June 2006, I explored this legendary "sky island" and had a remarkable day. The morning began with a clear cerulean sky as it does so often in early summer. The soft green shade of the oak forest was a welcome refuge from the heat of the surrounding desert. The flight of a pair of Montezuma quail rustled the desiccated leaves by the roadside and hinted at other natural wonders to come. After a short hike up a dry riverbed, I was flanked on two sides by a towering vertical cliff of golden rock. The cascading song of a canyon wren echoed around me. As my eyes adjusted to the shadows in the rocky cliffs, I saw a darkened crevice, midway up, where two downy Mexican spotted owl chicks huddled. For three hours I sat quietly and watched the chicks and their parents. While the young owls tugged on the dried remnants of a carcass in their shadowed crevice, the parents preened and snoozed from shaded perches nearby. How could the day get any better? But it did. Later that afternoon, in another forested valley in the Huachucas, I spotted a whiskered screech-owl, an elf owl, and a great horned owl. For me, any four-owl day is a great one.

The mainland United States and Canada are situated within the temperate and polar latitudes of the Western Hemisphere, with the exception of peninsular Florida, which is subtropical. Seasons are a feature of northern environments, and both temperate and polar regions experience four distinct seasons. The climatic variations between the seasons is more dramatic the farther north you travel. I live in Calgary, Alberta, at a latitude of 51°01' north, where winters are too long and too cold, summers too short and too dry, and spring and autumn too fast and too fickle.

Ten species of owls breed in Alberta. All of them begin nesting in

(*opposite*) By a month of age, the size differences present when these young great horned owls first hatched have largely disappeared.

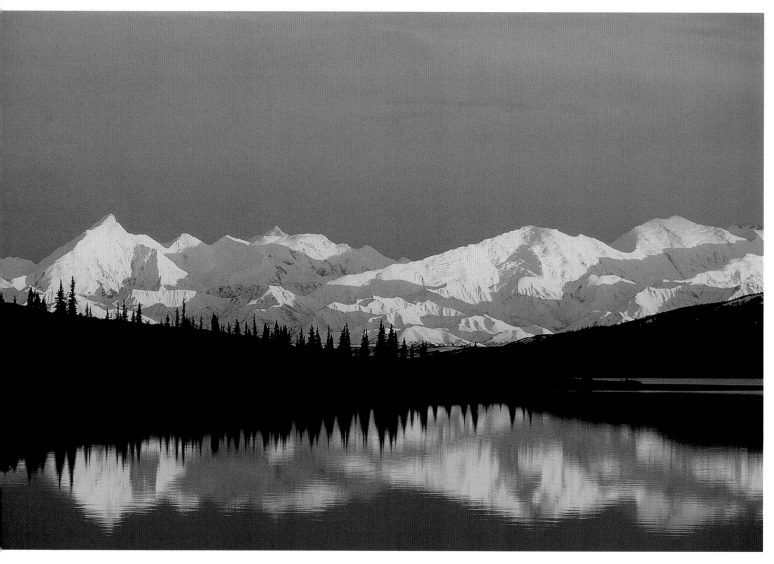

In spring, the day length, or photoperiod, in Alaska's Denali National Park increases more than five minutes each day. The cumulative change over time is a strong initiator and synchronizer of owl behavior.

late winter or early spring, lay eggs in late spring, and raise their young throughout the summer. This same seasonal pattern applies to virtually all the owls in Canada and the United States regardless of the latitude in which they live. The only thing that varies in different locations is the actual date within the seasons when an activity typically begins and ends. For example, great horned owls in Alberta usually begin to lay eggs in early March whereas those in Pennsylvania and Ohio lay in January and February and the ones in subtropical Florida start in December. The timing of breeding in these different populations evolved to coincide with an abundance of available prey for hungry growing chicks. Also, the breeding season usually occurs when local weather conditions are not too harsh to threaten vulnerable young.

The first step in successful reproduction is pair formation. In this regard, the owls in Canada and the United States can be loosely divided into two groups: year-round residents and those that are mobile. The latter either migrate to escape the climatic extremes of winter or nomadically move around in response to fluctuations in cyclical prey populations. The year-round residents include the barn, great horned, barred, and spotted owls, the two pygmy-owls, and the three species

of screech-owls. In some parts of its range, the northern saw-whet owl also falls into this category. In these 10 species of owls, both members of the pair usually share a common territory throughout the winter. The pair are together very little at this time, but occasionally cross paths. In spring, their behavior slowly changes, the amount of daylight triggering the change.

In temperate and polar latitudes, day length, or *photoperiod,* is the most common environmental trigger used by wildlife to synchronize seasonal behaviors. In owls, the day length coordinates molting and migration and also initiates the hormonal changes needed to stimulate pair formation.

To fully appreciate how much day length can vary from place to place, it helps to review some tidbits of meteorological trivia. The shortest day of the year is the winter solstice on December 21. It is also the first official day of winter. From that day on, the days get longer until the summer solstice on June 21, the longest day of the year and the first official day of summer. In Calgary, we gain an extra 2 minutes 40 seconds of daylight each day after the winter solstice. If you live in Tucson, Arizona, at 32°13' north latitude, you gain 1 minute 15 seconds of daylight every day. North of Anchorage, Alaska, at 67°34' north latitude, the gain is 8 minutes and 30 seconds. Consider for a moment the cumulative increase in day length after a month. Tucson residents gain 68 minutes of additional daylight; Calgary folks receive 80 extra minutes; and the hardy Alaskans gain a whopping 4 hours and 15 minutes. These monthly changes in daylight, from the modest to the dramatic, synchronize many aspects of the seasonal behavior in owls.

In birds, receptors in the hypothalamus, deep within the brain, sense the changes in day length. Even eyeless birds respond to changes in day length because the light cues do not travel through a bird's eyes as you might expect. Instead, minuscule amounts of light penetrate the skull and reach the sensitive areas of the brain where they trigger a reaction. Triggered by light, chemical messengers from the hypothalamus stimulate the pituitary gland, in another part of the brain, to release hormones that travel to the ovaries and testes and awaken them. This last step leads to the release of crucial sex hormones that are the final regulators of reproductive behavior. Under the chemical influence of sex hormones, owl pairs change their behavior. The birds cross paths more often, perhaps seeking each other out. They start to roost together, vocalize, preen and nibble the sensitive feathers on each other's face and neck, and bill-fence with one another. These changes are the behavioral cement that reinforces their bond and are vital if the pair is to successfully raise young.

Owl pairs that occupy year-round territories may not breed every year even though their hormones urge them to do so. It's not clear why some pairs fail to breed, but it probably has something to do with food availability and the nutritional health of the individuals, especially the females. It may be that some owls take a year off from raising young to bolster their energy reserves and regain optimal health. Though the reasons for nonbreeding are unclear, biologists have recorded it in a num-

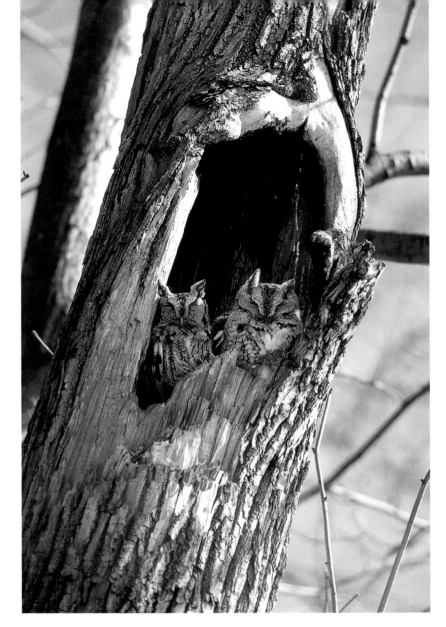

Early in the breeding season, pairs, such as these eastern screech-owls, begin to roost together. Throughout the winter they would have roosted alone. In this instance, a gray color morph and rufus morph have paired together.

ber of species. In Scotland, in any one year, 17 percent of barn owl pairs are nonbreeders. In northern spotted owls, 40 to 54 percent of pairs may not breed in a given season, with some pairs failing to breed for five years in a row. In June 2005, I visited the verdant rain forests of Olympic National Park in Washington, where 23 pairs of spotted owls were being monitored. That year, only one pair of owls raised young, whereas the previous year 92 percent of them did. In the Yukon, Christoph Rohner estimates that individual females in his study group of great horned owls skipped breeding about once every three years, which meant that only two-thirds of the pairs raised chicks in any one season.

The behavior of year-round residents is different from migrant owls and nomads, which typically establish new territories every spring though they may return to the same general area where they bred the previous season. Their transiency is not conducive to protracted pair bonds. For these drifters, it is likely too difficult for mates to synchronize their arrival at their breeding territories. Consequently, each spring they begin to court a new partner. Occasionally snowy owls and boreal owls keep the same mate for successive seasons, but these are the exceptions. Some

of the nomads, for example male boreal owls and northern hawk owls, may doggedly remain in their territories throughout the winter while the females wander. There is a compelling reason for this. Suitable nest cavities in good hunting habitat are often limited, and the males stay behind to retain ownership of these valuable sites for the next breeding season. Even in species where the males stay put and the females wander, the males usually end up with a different partner each season.

The age at which owls begin to pair and raise young varies with the species. In owls, as in most birds, this is related to their life span. The small owls don't live as long as the large owls, so they start to breed at an earlier age, usually when they are one year old. The larger species, such as snowy, barred, and great horned owls, don't begin breeding until they are at least two years old, and sometimes three. An owl's nutritional condition, which is a direct reflection of its hunting ability, ultimately determines when it will begin to breed.

Who Gives a Hoot?

Owls are the most vocal birds of prey, so it comes as no surprise that their calls are an integral part of their breeding behavior. Many species of owls produce a dozen different calls. They peep, trill, toot, bark, growl, squeal, shriek, chitter, rattle, whistle, whoop, chuckle, boom, and buzz. As for hooting, very few do.

The most distinctive vocalization in every species is the male advertising call used to proclaim ownership and occupancy of a territory. This call is also meant to intimidate and frighten rivals. These male signature calls are unique to each species. In 1983, it was the difference in the calls of the look-alike eastern and western screech-owls that convinced the American Ornithologists' Union that the two were separate species.

Modern sonogram equipment converts auditory signals into a visible graph. With the help of this technology, biologists have discovered that each male bird has a unique call pattern, like a vocal fingerprint, in the same way that each human has a uniquely recognizable voice. Researchers in northern Alberta are currently using vocal fingerprinting to learn how many seasons a given barred owl remains in the same territory. To obtain this kind of information in the past, researchers had to capture and mark the bird in some way, and this always entailed stress for the owl, possible abandonment of its territory, and a potential risk of injury to the struggling bird.

The early naturalists wrote colorful descriptions of owls and their calls, and I find their observations and fanciful interpretations entertaining to read, albeit scientifically questionable. The legendary Henry David Thoreau wrote this about the eastern screech-owls calling around Walden Pond: "It is no honest and blunt *tu-whit, tu-who* of the poets, but, without jesting, a most solemn, graveyard ditty, the mutual consolations of suicide lovers remembering the pangs and the delights of supernatural love in the infernal groves.... *Oh-o-o-o-o that I had never been bor-r-r-r--r-n* sighs one on this side of the pond, and circles with

(*overleaf*) This male snowy owl was defending a territory in Canada's High Arctic by the beginning of April. Early occupancy of a territory improves a male's chances of attracting a female partner.

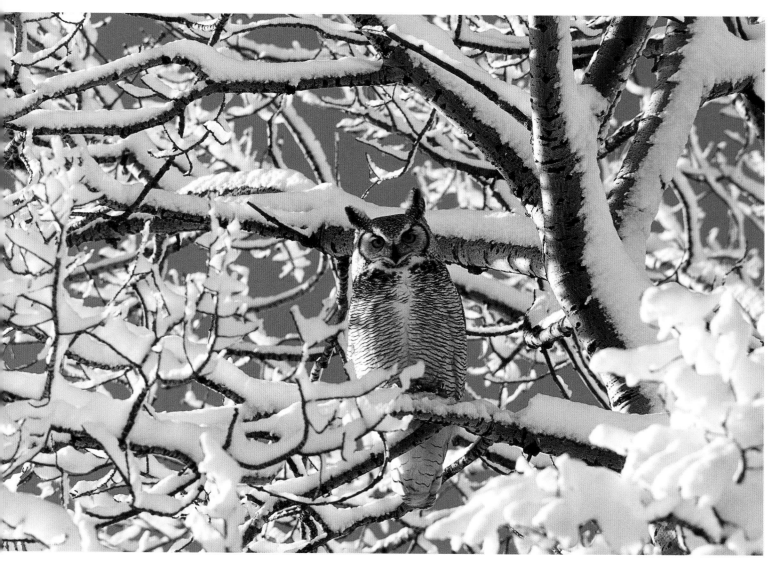

A male great horned owl may not begin to breed until he is two years old, and sometimes three. He must first claim and defend a territory where there is enough prey to attract a female.

the restlessness of despair to some new perch on the gray oaks. Then—*that I never had been bor-r-r-n* echoes another on the further side with tremulous sincerity."

My favorite description of an owl's song was written in the late 1800s by Napoleon Comeau to describe the call of a male boreal owl. He described it as "a slow liquid note that resembles the sound produced by water slowly dropping from a height; hence the Montague Indians call it *pillip-pile-tshish* which means 'water dropping bird.'"

Most owls have a range of vocalizations that they use besides the territorial advertising call given by males. They have calls that signal fright and others that are screamed while threatening an enemy. Specialized calls are also used to summon a partner or beg for food; others are given while preening a mate, during copulation, or during the transfer of prey. One call that is very similar in all the species is the insistent hissing made by hungry chicks. One author compared the sound to a noisy child slurping soup.

Most owls are nighttime songsters. In general, male owls begin calling around dusk, stop during the middle part of the night, then resume again before sunrise. Biologists assume they stop calling when they

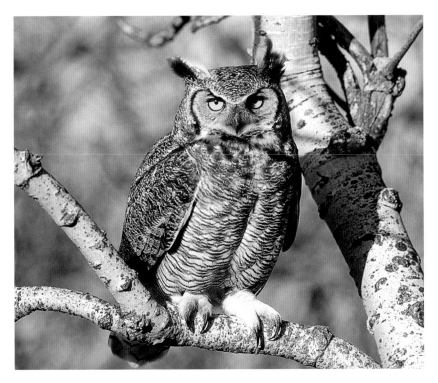

When a great horned owl is aggressively hooting at an intruder, its body posture changes very little and its beak is barely open.

begin to hunt. In one Swedish study, great gray owls called for nearly four hours every night, repeating their sequence of low-pitched hoots no fewer than 310 times. A western screech-owl in Washington called continuously for two hours at the rate of eight times per minute, for a total of 960 calls. Boreal owls in a study in the western United States called for two to three hours with infrequent pauses of several minutes.

A number of environmental factors influence nightly calling activity. David Palmer evaluated the effect of temperature, snowfall, cloud cover, wind, and the phase of the moon on the singing behavior of boreal and northern saw-whet owls in Colorado. The factors that reduced calling frequency the most were wind and snowfall, and when the two were combined, the birds sometimes stopped vocalizing altogether. Cloud cover and cold temperatures had no effect on owl vocalizations in Colorado, but the temperatures never dropped below 0°F (–18°C). In Scandinavia, when temperatures reached –13°F (–25°C), boreal owls called less often. Moonlight appeared to stimulate calling in both species of Colorado owls. In other studies, involving elf owls and the three species of screech-owls, moonlight also stimulated vocalization.

In Alberta, Lisa Takats and Geoff Holroyd monitored 300 nocturnal calls from six species: barred, boreal, saw-whet, great gray, and great horned owls, and northern pygmy-owls. The owls were more vocal in the early evening and in the hours around sunrise, and were significantly quieter between midnight and 4:00 a.m. As in Colorado, cloud cover had no effect on calling rates, but precipitation and strong winds inhibited the birds. The inhibitory effect of precipitation varied. Light rain or snow caused a small reduction in vocalization rates, whereas calls stopped completely in heavy rain or snow. As elsewhere, call rates increased during a full moon and decreased during a new moon.

Overall, the best conditions for calling seem to be cold, calm, clear

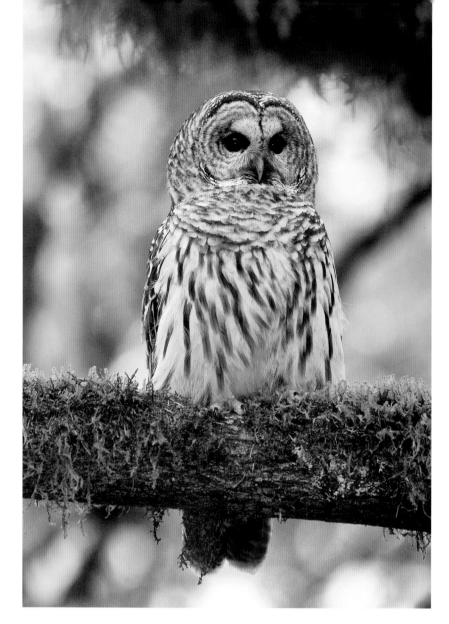

Besides the familiar territorial call of the male, a barred owl pair may sing a duet, in which the birds cackle, hoot, caw, and gurgle in a jumbled mix of calls.

nights—conditions that are ideal for the transmission of sound. On an average night, the whistle of a boreal owl can be audible a mile (1.6 km) away. Under the best conditions, a whistle can be heard at twice that distance. The ferruginous pygmy-owl also produces a remarkably loud call for its small size. At a distance of 10 feet, the male's tooting song may reach an intensity of 78 decibels (the same noise level as an air conditioner) and be audible half a mile (0.8 km) away.

Even though the small owls can generate surprisingly loud calls, the loudest calls are given by the largest owls. Large owls also produce calls with the lowest frequencies. Loudness and low frequency determine how far a sound will travel. On a cold, still night the low-frequency hooting of a great horned owl can sometimes be heard 3 miles (4.8 km) away. George Sutton, who did a survey of nesting birds on Southhampton Island in the Canadian High Arctic in the 1930s, stated that the deep *hooooo* call of a male snowy owl was audible for up to 7 miles (11.3 km) across the flat open tundra.

Male owls begin to give their territorial calls in early spring, and many continue after the female has started to incubate. Some even vocalize after the chicks have hatched. In a Colorado study, northern saw-

Hooting and Ventriloquism

A male flammulated owl.

There is a simple explanation why large owls produce lower frequency calls than small owls. In general, the size of an owl's voice box, or syrinx, increases with body size. A larger syrinx produces lower-pitched sounds. In virtually all the owls, the male's syrinx is larger than the female's, so his calls are consistently deeper in tone, and an experienced listener can recognize the difference. Since female owls are usually larger than their partners, their vocal attributes should be exactly the opposite of what I have just described. Without getting too technical, the tone of a call is also dependent upon the diameter of the air passages between the lungs and the syrinx, and in the male owl they are larger. As a result, male calls are lower in frequency than those of females.

All this detail may seem like an unnecessary esoteric digression, but it is crucial information if you want to understand the unique vocalizations of the male flammulated owl. Despite being the second smallest owl in Canada and the United States, the calls of the flammulated are surprisingly low pitched in tone, much lower, for example, than either the eastern or western screech-owls, both of which are more than twice its size. The flammulated owl's hoots are well known for their low frequency and their ventriloquistic character, which makes the bird difficult to pinpoint. Being a ventriloquist may help the tiny owl hide its location from larger owls that sometimes prey on it.

So how does such a small owl sing so low? First, its syrinx is larger than its body size would predict, and its vocal cords are thickened the way they get in a human who has laryngitis and a hoarse voice. Furthermore, the skin on the owl's throat stretches and acts like an amplifying chamber.

whet owls typically called from 70 to 93 days. Male boreal owls in the same area called for as few as 19 days and generally no more than 49. The record was set by a male boreal who called expectantly for 102 days but never attracted a mate. Unpaired males, in all species of owls, seem to call the longest. Unpaired flammulated males may sing all summer long.

Vocalizing in male owls can be a highly infectious activity, and neighbors will often call back and forth in response to each other. In the Canadian arctic, George Sutton heard as many as a dozen snowy owls

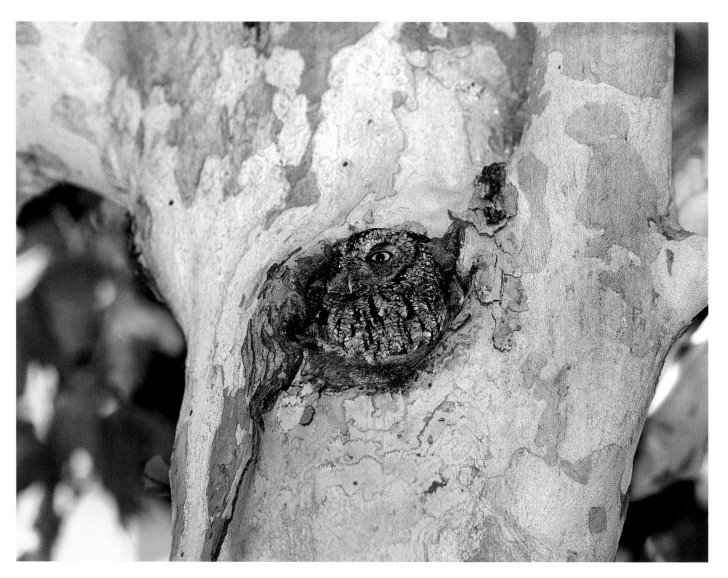

A male whiskered screech-owl may sing from the entrance of several nesting cavities hoping to seduce the female into investigating each. The female makes the final decision on which cavity the pair will use.

hooting at the same time. Once, when I was in Catalina State Park in Arizona, one elf owl began to call, which stimulated a response from five other owls that were in the vicinity. Researchers in Minnesota often heard two to four barred owls call in sequence. One time, two barred owls were heard hooting when they were about 0.8 miles (1.3 km) apart. The owls gradually moved closer to each other, hooting all the while, until they sounded as if they were within 15 yards (13.7 m) of one another. They continued to hoot loudly and repeatedly for about 10 minutes, then both of them retreated toward the center of their respective territories where they resumed calling.

In the majority of owl species, the females also have a full range of calls similar to those of their male partner, but they call much less frequently to advertise the pair's territory. In at least five species (whiskered screech-owl, eastern screech-owl, northern pygmy-owl, barred owl, great horned owl) the male and female sing duets. Either the male or the female starts to sing and the partner responds with its own song, either during or within a second or two of the other finishing. In great horned owls, for example, the female typically starts with a seven-note song lasting about three seconds and the male answers with a five-note

response of the same duration. The pairs may sing like this for up to an hour.

The size of an owl determines the site from which it calls. The larger species are less vulnerable to predators so they often call in the open. Snowy, great horned, barred, and spotted owls sing from perches where they are conspicuous to other owls and humans alike. The smaller owls, such as the flammulated and northern saw-whet owls, usually call from within dense foliage or tuck themselves close to the trunk of a tree where their cryptic plumage camouflages them.

All the cavity-nesting species, such as the screech-owls and boreal owl, commonly sing from the mouth of a nest site to which they hope to lure a prospective partner. In southern Arizona, I watched an elf owl call from the opening to an old woodpecker hole in a saguaro cactus. It chattered like a puppy dog for nearly an hour before it finally flew off to hunt.

Courtship Conduct

It's not enough for a male owl to have a seductive voice, he also needs the "right stuff" to attract and keep a mate. Among year-round resident species, 92 percent of Florida burrowing owls remain together for multiple breeding seasons. Great horned owls may stay together for at least five years, and possibly for life. Many whiskered screech-owls mate with the same partner for more than one season, and eastern screech-owls may stay together until one of the partners dies. Although year-round residents generally remain faithful to their previous partner, it's quite possible that females reevaluate their partners at the beginning of each breeding season. After all, it's in their best interest to pair with a mate that will ensure that their genes get passed to a new generation.

Fifty years ago, the majority of researchers studying animal behavior, the science of *ethology,* were men. At the time, many of them had an unconscious male bias and consequently an unshakeable belief that female mammals and birds were mere shrinking violets and the passive recipients of male attention and selection. Early ethologists believed that choice was not a female prerogative or possibility. Times change and science has shown us the error in that assumption. Ethologists now recognize that among many bird species, including most owls, the females do the choosing, and it is they who select the partner with whom they will mate.

In owls, as in many other birds, choosing a mate with the right stuff means finding one that has a suite of attributes: freedom from serious disease, experience, hunting ability and capacity to provision a family, an aggressive nature to guard and patrol a territory, and the strength and endurance to evict intruders.

How then might a female owl evaluate a potential partner and decide whether he wins or loses? Most of what I propose is highly speculative and unproven, but the selection process has been studied in many other animal species and it may also apply to owls.

To begin with, a female owl could use voice quality to evaluate a po-

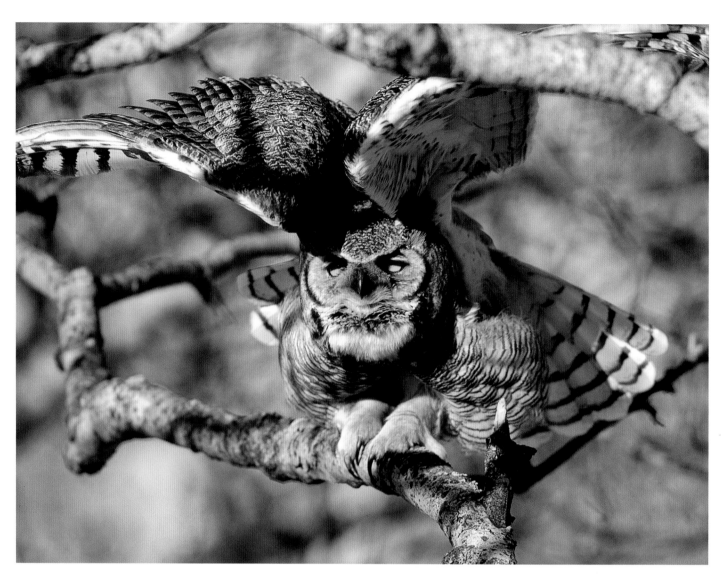

This great horned owl had just finished hooting when a neighboring owl responded with a territorial call of its own. The owl immediately flew in the direction of the neighbor and a bout of calling ensued that lasted for more than 15 minutes.

tential male partner. For instance, let's look at Britain's tawny owl—the Old World relative of the barred owl. Researchers in England found that the frequency of the territorial song of a male tawny owl was related to the bird's body mass, which in turn was a reflection of his age and health. Heavier birds produced songs that were lower in tone, whereas males infected with parasites sang abbreviated higher-frequency versions of their calls. I suspect that female tawny owls can perceive these subtle differences and use the information when selecting a mate.

An unhealthy male, say one with a heavy load of blood parasites, may not have the energy reserves to call as often or as loudly as a healthy male. Females prospecting for a mate may assess the quality of the vocalizations of competing male neighbors to evaluate their health and energy level. In elk, for example, bulls that bugle the most attract the largest harems. Some dominant males may bugle 48 times in 30 minutes. In the thumbnail-size spring peeper frog, the most vigorous males may peep 4,500 times in a night. These fast-talking males are the ones that lure the most mates. Could it be that vociferous male owls enjoy similar reproductive benefits? Some male owls expend a lot of energy calling. For example, some boreal owls in a Swedish study called for

nearly 11 hours straight, and one individual hooted 1,559 hoots in just 22 minutes. One particularly vigorous male called approximately 4,000 times in one night.

Courtship displays may be another way that females assess the vitality of a potential partner. In many owl species, males perform elaborate courtship flights that require skill and stamina—a testimony to the performer's health and experience. For example, barn owls make screeching song flights as they patrol their territories, and they may hover like a moth in front of the female. Male northern hawk owls display by circling and gliding on stiff wings. Snowy owls do the same but then float to the ground with their wings held rigidly aloft. Burrowing owls climb steeply to a height of about 100 feet (30 m) or so, where they hover laboriously for 5 to 10 seconds, then swoop rapidly toward the ground. Halfway down, they start the sequence again. Male long-eared owls fly on a zigzag course through the trees of their territory, using strenuous deep wing beats interspersed with glides and wing claps.

The most spectacular and energetic courtship flights are those of the male short-eared owl. During a sky dance, the displaying male circles and ascends to a height of 260 to 300 feet (80–91 m), then dives steeply, wing-clapping rapidly 8 to 12 times as he plummets. The wings are clapped by striking them together beneath the body. Witnesses say it sounds like a person slapping his thighs as fast as possible. The male may repeat his exhausting performance 13 times before landing on the ground near the female, where he fluffs himself up and sways enticingly from side to side.

Many male owls also have elaborate ground displays in which they crouch in front of the female, fluff up, sway, and strut. Male long-eared owls, snowy owls, and great horned owls parade for their mates in this way. Such displays afford a discriminating female another chance to evaluate the condition and color of a male's plumage, all of which indicate his healthiness and perhaps his desirability as a prospective mate.

Once a female owl has chosen a partner, most pairs engage in frequent mutual preening and courtship feeding—behaviors that strengthen the pair bond. Robert Nero has been studying great gray owls for more than three decades. In his book *The Great Gray Owl: Phantom of the Northern Forest,* he eloquently describes courtship feeding in these beguiling owls:

> The male, instead of immediately swallowing a captured mouse, carries it to a nearby perch and sits motionless, staring quietly, prey hanging from its beak. It is a tantalizing sight for the female.... The sight of the dangling mouse releases in the female an ancient pattern—a curious mimicry of a hungry, young owl—shifting her weight deliberately from one foot to the other, bobbing her head and hooting softly, she begins chirping like an owlet. The male is mesmerized by the performance, hearing a sound he has not heard since attending a nest eight months earlier. He sits, watching closely as she flies toward him and lands on a nearby perch.... After some hesitation, for she is larger than he is, stimulated by the female's continued display, the male flies to perch beside her, closing his eyes as he leans toward

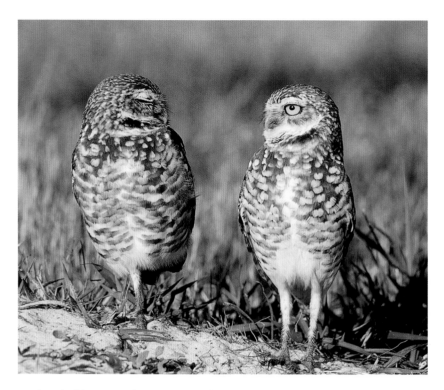

In burrowing owls, one researcher identified 13 different adult vocalizations and 3 calls used by the young of the species. As in most species of owls, the majority of the calls were associated with the breeding season.

her, holding out the mouse. With closed eyes and a slight mewing sound the female seizes the mouse.

A female owl may stop hunting several weeks before she begins to lay her eggs, and from then on, the male hunts for both of them. The reason for this is poorly understood but it may be that the female owl, burdened with developing eggs, is less agile and is not able to hunt for herself, so she relies on her mate to provision her. The courtship feeding behavior of flammulated owls makes a strong case for this explanation. In Colorado, one study showed that as soon as the females stopped feeding themselves, they rapidly gained weight. The females spent the entire night, for many days in a row, perched near their nest cavities, waiting for their male partners to feed them. By the time they began to lay, some of the females had increased their weight by 68 percent. Male terns also feed their mates during the egg-developing phase. Biologists believe that these egg-heavy females have too much difficulty hovering and hunting, so they rely on their mates to hunt for them.

Two additional reasons for females to let their mates do all the hunting is to evaluate the foraging proficiency of their male partner and at the same time assess the abundance of available prey. In many species of owls, a well-fed female develops more eggs and lays a larger clutch.

House Hunting

Burrowing owls in Florida nest in underground tunnels that can be 10 feet (3 m) long, yet they appear poorly equipped to dig such excavations. Typically, these owls appropriate the abandoned burrows of gopher tortoises, common gray foxes, striped skunks, and nine-banded armadillos. If such burrows are unavailable, however, an enterprising

Polygamy

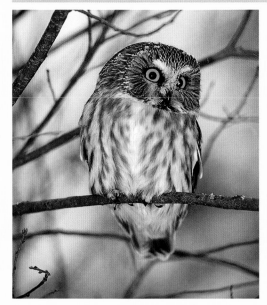

Northern saw-whet owls are one of the few species of owls in which polygamy has been recorded.

Polyandry and polygyny are the two forms of polygamy—the mating system in which an individual has more than one partner. In *polyandry*, a single female raises young with two or more males. In *polygyny*, a male mates with two or more female partners and raises chicks with each of them.

Among owls, polyandry is extremely rare; it has only been observed in Scandinavian boreal owls, although biologists suspect that it also occurs in North American saw-whets. In polyandry, the female abandons her first clutch once the chicks are partially grown and leaves the male to provision them alone while she locates an unmated male and starts a second family. The female thus maximizes the number of genes she passes to the next generation. If she were to raise two consecutive clutches with one partner, the season would be exhausted before the young were independent, and her effort would be wasted. The females that are most likely to be polyandrous are those that pair with a mate who maintains a high feeding rate during incubation and brooding, indicating his superior hunting proficiency and a bountiful supply of prey.

Among owls, polygyny is by far the more common form of polygamy, although it is still a rare event. In North American owls, biologists have reported polygyny in northern saw-whet, eastern screech-, northern hawk, burrowing, long-eared, snowy, and barn owls. A common feature among these owls is their strong reliance on small rodents, such as lemmings and voles, whose populations cycle through years of boom and bust. In a good year, when prey is plentiful, a polygynous male can attempt to provision the young of two different females. If, however, the food demands of the two families are greater than the male can satisfy, some of the offspring may starve, usually those in clutch number two since they typically receive less attention from him. In 1953, Adam Watson pioneered a study of nesting snowy owls on Baffin Island in arctic Canada. There, he monitored a bigamous male who attended two females at nests less than a mile (1.6 km) apart. The second female didn't begin nesting until three weeks after the first one. Despite the asynchrony, the male fed and defended the chicks in both nests and all 15 young fledged.

Irina Menyushina studied nesting snowy owls on Wrangel Island in the Russian arctic from 1990 to 1995. During her study, she observed five cases of polygyny. In all instances, the nests were close together; one pair was only 350 yards (320 m) apart. The bigamous males always abandoned one of the families early. The surprise is that none of the bigamous males, unlike the one in Watson's study, raised more young than his monogamous neighbors. So why did the males try at all? When prey is superabundant, a male owl has little to lose, and everything to gain genetically, by trying to raise two families of chicks.

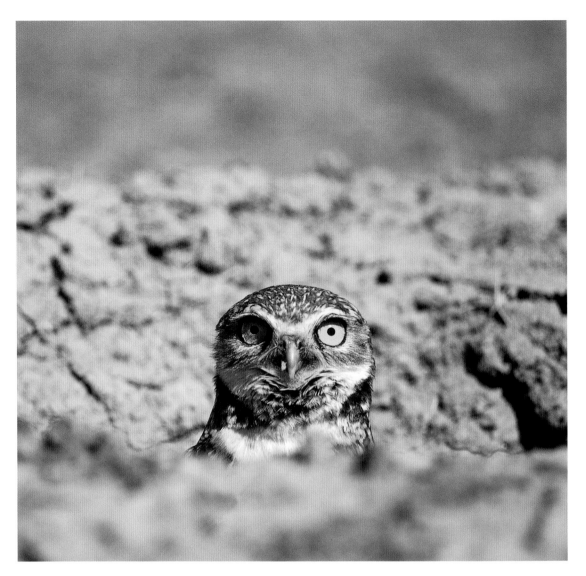

This burrowing owl was nesting in an abandoned burrow in a black-tailed prairie dog colony on the Montana-Saskatchewan border. Two other pairs of owls were nesting nearby.

pair can excavate their own burrow in loose sand in just two days, using their beak and feet as digging tools. The tunnels are sloped slightly downward and are usually long enough to incorporate at least one turn to the right or left, which prevents direct sunlight from reaching the nesting chamber at the end.

Burrowing owls in the prairies and deserts of the West are not as lucky as their Florida kin. Because western soils are too hard for the owls to excavate, they rarely dig their own burrows. Instead, they take up residence in the deserted burrows of prairie dogs, badgers, coyotes, swift foxes, and striped skunks. So reliant are they on borrowed burrows, that before the days of the pioneers, the burrowing owls' range in Canada closely matched the range of the badger.

Even though prairie burrowing owls rarely dig their own homes, they can take full credit for imaginative landscaping. In most western areas, the material of choice is shredded horse or cow manure, whereas in former times, they probably used sun-baked bison chips. I've often found owl burrows with an inch or two (2.5–5 cm) of dried shredded dung spread around the mouth and spilling into the entrance of the tunnel. Once, in a mischievous moment, I removed the dung to see what would

The litter at the mouth of this burrowing owl burrow was mostly shredded cattle dung. The bits of red are the amputated legs of grasshoppers that the birds were eating.

happen. Within 48 hours, the birds had replaced it. In suburban El Paso, Texas, burrowing owls use dog droppings to adorn their nests.

Gregory Green and Robert Anthony, working in the Columbia Basin of Oregon, speculated that the manure might mask the owls' scent from keen-nosed predators such as badgers and reduce predation. In their study, 15 burrowing owl nests were lost to badger predation but only 2 of those were nests that had been lined with cattle dung, suggesting that the presence of the manure offered a measure of protection. Other researchers have suggested that perhaps dried droppings attract dung beetles, which can then be easily caught and eaten by young chicks once they start to loiter outside the burrow. Although the manure seems to serve some biological purpose, it's hard to explain the presence of other visible bits of trash these owls collect and sometimes scatter on their doorstep—things like shredded paper, shells, cigarette butts, corn cobs, fragments of bone, bits of charcoal, scraps of fur, feathers, and even divots from a golf course.

The Florida burrowing owl is not the only tunneling owl. In Colorado, researchers found 13 nest tunnels belonging to barn owls that were dug into the dirt walls of canyons in the state's north central region. This

(*right*) This long-eared owl was nesting in a small wooded area adjacent to a prairie meadow. The jumble of sticks she chose as a nest were the remains of a collapsed American magpie nest. In Idaho, roughly 70 percent of the owls rely on vacated magpie nests. (*opposite*) This great gray owl settled into the broken top of an ancient balsam poplar tree, 30 feet (9 m) off the ground. The owl added no material to the nest before laying its two eggs.

142
OWLS OF THE
UNITED STATES
AND CANADA

was a surprise since barn owls usually nest in hollow trees and buildings, both of which were available nearby. The barn owls in the canyons dug their burrows in only four to nine nights, including an enlarged chamber at the end where they could lay their eggs. Apparently the other nest sites were rejected because the tunnels offered greater protection from the extremes of the local weather. Sample temperatures measured within the burrows were cooler during the day and warmer at night than the outside air. This was important since barn owls don't tolerate the cold very well because of their thin feather insulation and low fat reserves.

Aside from the burrowing owls and barn owls, no other species or population of owls in the United States and Canada build their own nests. The large woodland owls, such as the great gray and great horned owl, as well as many of the medium-size owls including long-eared, barred, and spotted owls, frequently take over the abandoned stick nests of ravens, crows, and hawks, especially those of red-tailed, red-shouldered, and broad-winged hawks. In the West, the collapsed stick nests of American magpies are popular with long-eared owls, and in southwestern Idaho, 91 out of 130 nests were located there.

Besides using old stick nests, spotted owls often lay their eggs inside the exposed tops of broken snags or on the roofs of Douglas squirrel nests. In the Tularosa Mountains of New Mexico, 59 percent of spotted owls nested atop mistletoe brooms. Owls don't usually renovate their new homes by adding any greenery or lining material though they may scrape the bowl of the nest a little deeper.

Two owls, the snowy and the short-eared owl, nest on the ground, but unlike the burrowing owl, they nest on the surface rather than underground. In the early 1880s, the U.S. arctic explorer Adolphus Greely found a snowy owl nest on Ellesmere Island in High Arctic Canada at 82°40' north latitude, the northernmost owl nest ever reported. In 1996,

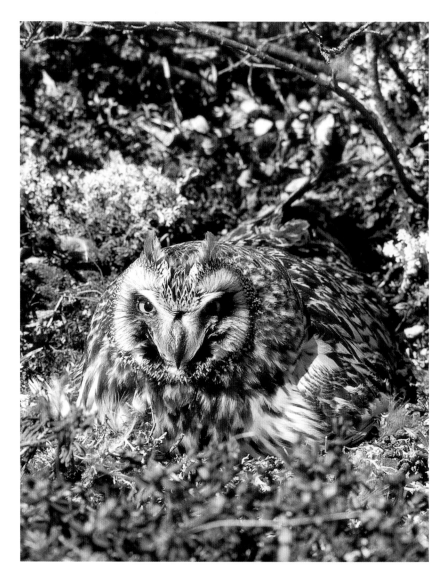

The cryptic plumage of this female short-eared owl blends especially well with the ground cover of lichens and willows in this nest in arctic Manitoba.

120 years later, I visited the site where Greely had overwintered and also found a nesting snowy owl.

Both the snowy and the short-eared owl make their nest by scraping a shallow depression in the turf. The nest hollow of a short-eared owl is typically 1 to 2 inches (2.5–5 cm) deep, whereas that of the snowy may be 6 inches (15 cm) below ground level, perhaps to better shelter the eggs and chicks from frigid arctic winds. Both owls often nest on hummocks, mounds, or ridges, sometimes next to a sheltering rock or bush.

Snowy owls always select a nest site where the adjacent tundra vegetation is short so that they have an unimpaired view of the surrounding terrain. Short-eared owls, on the other hand, nest in grasslands, hayfields, and stubble fields surrounded by vegetation that varies in height. In one Montana study, 90 percent of the short-eared owl nests were in vegetation that was less than 1.5 feet (0.5 m) high, which was tall enough to hide the bird yet not so tall that it would impede its view of approaching predators. Short-eared owls are unique in that they sometimes add small bits of grass and other vegetation to their nests, but nothing elaborate.

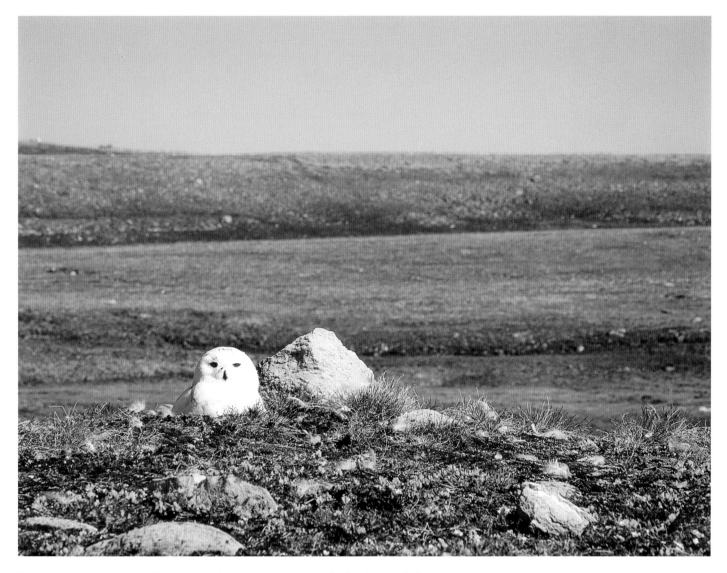

In both short-eared and snowy owls, a few downy belly feathers, likely shed from the mother's incubation patch, also line the nest.

In the High Arctic, especially where vegetation is sparse, you can easily find old snowy owl nests by searching for mounds where the plant growth is richer than the surrounding area. These mounds have been fertilized with chick droppings, old regurgitated pellets, and uneaten carcasses that combine to dramatically enrich the soil. In 1962, on Victoria Island in the Canadian arctic, one botanist carefully collected the plants around a number of owl nesting mounds and identified 32 different species of plants. The most common species were white-flowered prickly saxifrage and curled snow lichen. David Parmelee observed that because these plants trap water and seeds, they attract lemmings that burrow in the peat, and these in turn lure hungry arctic foxes. For this very reason, Inuit hunters in former times would set their fox traps on deserted owl mounds.

Large owls can afford to nest on the ground because they can usually defend themselves and their offspring from predators. They also have the body mass to endure the thermal challenges of late winter

Compared to the surrounding tundra, the nest mound of this snowy owl in the Canadian arctic contains a thick covering of wildflowers. The flowers are mainly yellow oxytropes, known locally as locoweed because of the plant's intoxicating effect on many grazing animals.

storms in such unsheltered nesting sites. On the other hand, all the small owls—screech, pygmy, northern saw-whet, flammulated, elf, and boreal—as well as the medium-size northern hawk owl and barn owl nest in sheltered locations. Even the larger spotted owl and barred owl prefer hidden, secluded nests when they are available. For example, in Saskatchewan, two-thirds of the barred owls chose secluded cavities in the trunks of live or dead trees instead of exposed stick nests. Some of the nest cavities were 8 feet (2.4 m) deep. Spotted owls in the Pacific Northwest show a similar preference for cavity nests. These two large-bodied owls require a large tree cavity, and only trees of great age reach such dimensions. Rain forest trees in the Pacific Northwest are often 150 to 200 years old before they are big enough to house a nesting spotted owl.

The smaller nesting forest owls often use abandoned woodpecker holes, especially those excavated by the largest head-bangers, the pileated woodpecker and the northern and gilded flickers. They also nest in natural tree cavities that result from forest fires, fungal decay and wind-broken limbs and trunks.

The barn owl, more than any other owl, nests in human structures such as water towers, silos, attics, old mine shafts, drinking wells, church steeples, and the hayloft of barns. Their proclivity to nest around humans and their eerie nocturnal screeches have no doubt incited many ghostly tales. In 1917, Joseph Lippincott wrote this about the barn owl: "After listening night after night to the harsh screams, and even louder growling, rattling noise he can make, sounds which in the dark hours fairly make the shivers jump up and down one's spine, I can imagine that woods could seem haunted and that, in the silent flopping flight of the big whitish bird, any superstitious person could see a ghost or almost any uncanny being in the visionary world."

Sheltered nest sites such as small tree cavities and woodpecker holes offer a number of obvious benefits to tenants. Many diurnal birds of prey, as well as the larger owls, hunt small owls, and a cavity nest provides protection. Small owls purposely select a small entrance hole to exclude potential predators. Often the entrance hole is so small that it barely allows the owner to squeeze inside. Cavity nests also offer thermal advantages. During summer, in the mountains of Arizona, temperatures can vary from 23°F (−5°C) at night to 97°F (36°C) during the day. Temperatures inside nesting cavities in the same area vary between 54 and 88°F (12–31°C), a considerable amelioration.

Small cavities can sometimes be scarce and greatly in demand, not only by the local owls, but by many other shelter-seeking creatures. In Arizona, the tree cavities used by whiskered screech-owls are also sought by bats, squirrels, chipmunks, ringtails, elegant trogons, spiny lizards, and snakes. In Alberta, many house hunters compete for old pileated woodpecker holes: northern pygmy-owls, northern saw-whet owls, and boreal owls, as well as northern flying squirrels, red squirrels, American kestrels, and three species of ducks, including the bufflehead, common goldeneye, and Barrow's goldeneye. Thus, once a suitable nest cavity is found, an owl will guard it from thieves. Female elf and boreal owls may

(*opposite*) A hollow knot in an aspen poplar makes a perfect nest hole for a northern saw-whet owl. Often the holes are just large enough for the owl to squeeze through. A larger hole might allow a predator such as a pine marten or fisher to get in.

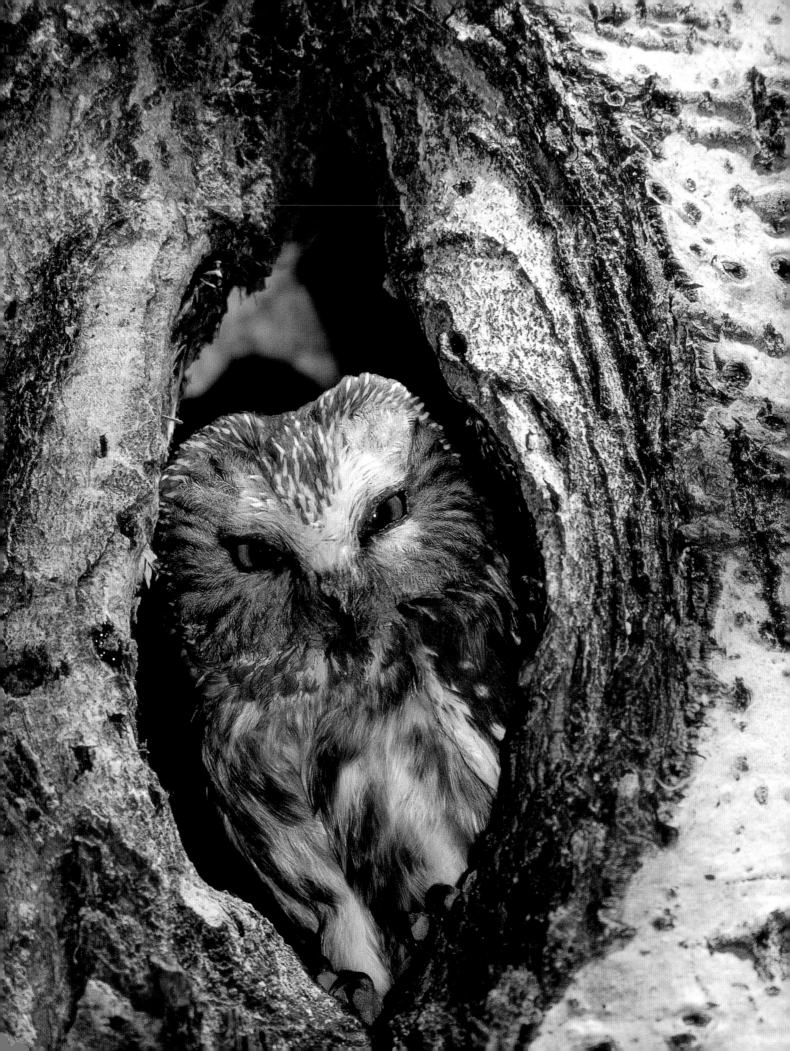

Biologists refer to the crow-size pileated wood-pecker as a keystone species because of its importance in creating cavities that other forest inhabitants take over once they are abandoned.

roost in a cavity for several weeks, protecting it from robbers until they are ready to lay. And a spotted owl pair may perch near a prospective nest site for up to 68 days before egg-laying begins.

When no vacant nest cavities are available, an owl may usurp one that is already occupied and evict the lodger. In an Arizona study, elf owls, despite their diminutive size, forced ash-throated flycatchers, acorn woodpeckers, and gila woodpeckers out of their nests. In Colo-rado, Arch McCallum examined a flammulated owl nest that contained a northern flicker egg in addition to its own two eggs. In another in-stance, in New Mexico, he found a female flammulated owl incubating two white owl eggs as well as five pale blue eggs belonging to a bluebird that had presumably been evicted. We don't know whether nest-robbing owls kill the birds whose homes they steal.

House-hunting owls also steal stick nests. Many decades ago, egg collecting was a socially acceptable pastime for amateur naturalists. One physician from New Haven, Connecticut, climbed to the stick nest of a barred owl and found a single owl egg as well as three eggs belonging to a red-shouldered hawk that it had ousted. The following year, when the good doctor climbed to a nearby nest of a red-shouldered hawk, he was

delighted to find two handsomely marked hawk eggs, as well as a barred owl egg. A case of tit for tat.

During the breeding season, female owls not only choose their partners but also the nest site. Many males participate by giving their mates a tour of prospective nesting locations, but the female makes the final choice, and for a good reason. The female is the one that will incubate the eggs, and her larger body size requires her to inspect a nest for a suitable fit. In flammulated owls, the male may enter a chosen cavity and give a *boop-boop* call. The female then follows him inside, where she presumably evaluates his housing choice. A male northern hawk owl may begin showing nests to his mate two months before egg-laying begins. Often he'll trill from a cavity opening, and peer out, waiting expectantly for the female to show up. Sometimes he'll carry food inside with him as a further inducement for her to follow. In Washington, researchers watched a tooting northern pygmy-owl fly in and out of a cavity several times until the female finally showed interest in the site. A male boreal owl may sing from five different prospective nest cavities, bidding the female to inspect each one thoroughly and make a choice. Great gray owls sometimes visit prospective nests 11 to 29 days before

In the badlands of southern Alberta, I have found great horned owls nesting in natural cavities eroded out of the clay-covered slopes. Cavities are an uncommon place for these owls to nest.

Nest Parasites

Reusing any nest carries certain risks; risks of the microscopic size. Three major groups of invertebrates inhabit most raptor nests: animal saprovores, litter fauna, and parasites. The saprovores include skin beetles and carpet beetles that feed on hair, feathers, skin flakes, excrement, and the rotting tissue of carcasses and pellets. Many nests become badly soiled with decaying feces, old pellets, and desiccated prey. One author described the filth and stench of a reused barn owl nest as almost overpowering. The litter fauna include springtails and oribatid mites that decompose dried grass, moss, and decaying wood found in the bowl of the nest. The worst are the bloodsucking parasites that feed on both nestlings and adults. These include predatory mites, fly maggots, and Mexican chicken bugs, a relative of the common bedbug. One barn owl nest hosted 1,778 chicken bugs.

James Philips and Daniel Dindal compiled a list of the invertebrate fauna found in some owl nests. Thirty-one species from 12 families of invertebrates inhabited a boreal owl nest; 40 species from 22 families lurked in a barn owl nest; and 39 species from 21 families invaded a

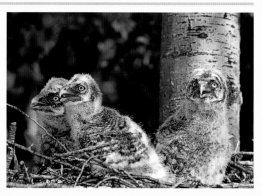

Open nests such as this one used by a family of great gray owls contain fewer invertebrate parasites than sheltered cavity nests.

burrowing owl nest. Invertebrate diversity was usually less in open nests than in sheltered cavity nests.

Many nest invertebrates can overwinter as adult females or eggs and survive for up to 30 weeks, waiting for their hosts to return. No one knows whether this menagerie of invertebrates can harm an owl or its offspring enough to impact reproductive success. The answer awaits an inquisitive mind.

laying begins, and great horned owl females may also start four weeks in advance.

Whether an owl reuses a nest from the previous season probably depends on whether suitable alternatives are available and whether the nest led to the successful fledging of young in the past. Failed nests are often abandoned. In Massachusetts, barred owls used a hollow tree for 10 years in a row until the tree eventually rotted away. Barred owls nesting in Saskatchewan, settled in the attic of a shed 12 years out of 13. And one pair of spotted owls in Oregon nested in the same site for six consecutive seasons, whereas another pair used five different nests during the same 6 years.

Barn owls, more than any other owl, use nests repeatedly. Some nest sites in Europe have been occupied for more than 100 years, and the belfry of a wooden church in Flushing, New York, had resident barn owl families for 46 years in a row. In both cases, multiple generations of owls held tenancy.

Some stick nests are not reusable after a single season. Owls never add new sticks or make repairs of any kind to their nests, so they gradually deteriorate. One spring, I watched an occupied great horned owl

nest, near Calgary, for three months. The owl had appropriated an old red-tailed hawk nest built in the crotch of an aspen poplar. The nest was about 1 foot (0.3 m) deep and 2.5 feet (0.8 m) in diameter. By the time the three owl chicks left the nest there was not a single stick remaining, and the last of the brood was left perching by itself in the empty crotch of the tree.

The Cloacal Kiss

When it comes to copulatory efforts, mammals reign supreme among warm-blooded vertebrates. For example, ermine can stay coupled for up to 2 hours, and a male African lion may copulate 157 times in 55 hours. Even bonobos, or pygmy chimpanzees, one of our closest relatives, are sexual paragons who copulate repeatedly, not only for reproduction, but also to settle disagreements, appease superiors, and demonstrate affection. Birds, by comparison, are much less athletic in their quest for insemination. To begin with, birds don't have a penis, although ratites such as the ostrich, emu, and greater rhea, as well as storks, flamingos, and geese have a thickening along one wall of their cloaca that can become erect and function like a penis.

Without a penis, how do birds stay linked together long enough for insemination to occur? Owls and other birds have perfected the maneuver called the "cloacal kiss"—the cloaca being the terminal portion of a bird's intestinal tract into which the kidneys and reproductive tracts also empty. During mating, their cloacae pout and kiss for three or four seconds—just long enough for millions of sperm to be passed to the female. Burrowing owls have been observed mating like this 8 times in 35 minutes, and a pair of flammulated owls mated 14 times in 17.5 hours. Barn owls probably have the highest copulation rates among owls, mating hundreds of times in a breeding season.

Owls commonly begin to mate two to three weeks prior to egg-laying. Spotted owls typically mate once or twice a night during this time. The act of mating is often preceded by mutual calling or duetting as is the case in northern hawk owls, great horned owls, and whiskered screech-owls. Some species, such as the short-eared owl, are quiet copulators. In these owls, when the male approaches, the female simply lowers her body to a horizontal position, in a gesture of solicitation, and the pair mates. Sometimes the male brings a present of prey, as snowy owls and great horned owls occasionally do, but it is not a necessity.

During mating, male owls of all species balance lightly on the female's back. To keep their balance, they may extend their wings slightly and gently grasp the feathers on the female's nape. Various owls accompany the act with a serenade. Burrowing owls warble; whiskered screech-owls trill; and barn owls make a staccato squeal. Once the cloacal kiss is completed, the male quickly dismounts. The pair may shake and fluff up their feathers, rub their bills together, preen each other briefly, or simply fly apart.

In 1992, Jeff and Angela Gottfred observed a pair of great horned owls mate 12 times, between February 8 and February 23. Copulation

Hybridization and Northern Spotted Owls

Hybridization is the interbreeding of two different species to produce fertile offspring. Of the nearly 10,000 species of birds on the planet, almost 1,000 of them have interbred in the wild and produced hybrid offspring. The incidence of interbreeding is even higher than 10 percent in some groups of birds, such as grouse, quail, woodpeckers, and hummingbirds, and in many of the herons and hawks. Among waterfowl (swans, geese, and ducks), nearly half of the world species have been known to interbreed.

The European owl expert Heimo Mikkola claims that owls have the lowest hybridization rate among birds, about 1 percent. In North America, rare interbreeding has been reported between eastern and western screech-owls, and between the barred and northern spotted owls, the subspecies that occurs in the Pacific Northwest. Interbreeding between the latter two species is a serious concern among conservationists, and the issue is at the heart of a heated political and biological controversy.

Beginning in the late 1880s, the barred owl slowly spread across Canada from east to west. This probably happened as a consequence of fire suppression, increasing forest age and nesting tree diameters, and the establishment of riparian forest corridors. The first barred owl moved into the range of the northern spotted owl in British Columbia in 1943. By 1965, barred owls had expanded into Washington; they were in Oregon by 1974 and in California by 1981. In a matter of a few decades, the barred owl and the spotted owl, which had been separated for

thousands of years, were now living, literally, side by side.

Barred owls are slightly larger than northern spotted owls and they often displace their smaller relatives. The invading barred owls have been implicated in the decline of spotted owls, which were already endangered because of widespread logging of old-growth forests, their native habitat. Additionally, the spotted owl gene pool is being diluted by hybridization with barred owls.

Between 1970 and 1999, more than 9,000 spotted owls were banded in Washington and Oregon, and of these, 47 were hybrids. This suggests that hybridization between resident spotted owls and the newly arrived barred owls is still relatively rare. All the hybrids, informally called "sparred owls," resulted from a male spotted owl pairing with a female barred owl. When the hybrids bred with barred owls they produced 15 young, whereas matings with spotted owls produced only 1 owlet. Elizabeth Kelly and Eric Forsman felt that further studies were needed to determine why the hybrid/spotted owl matings produced so few young. They concluded that competition for prey and nesting habitat between the two species was probably a much more serious threat to the spotted owl than hybridization.

was always brief, lasting four to seven seconds, and it was usually preceded by mutual hooting. While the male was mounted, the pair squealed with a rapid series of high-pitched notes. Afterward, the male flew to another tree; the female's behavior was most unusual. She remained horizontal and motionless on her perch for up to 10 minutes after the male left. During this time her tail showed spasmodic muscular movements. The observers could not explain this behavior and questioned whether it might assist in sperm transfer and fertilization. These interesting and detailed observations were not made by professional biologists and under-

score the important contributions that interested naturalists can make to our understanding of animal behavior.

At about the same time that owl pairs begin to mate, the male starts to hunt and bring prey to the female on a regular basis. This is when the female often stops hunting for herself altogether. In cavity-nesting species, such as the boreal and saw-whet owls, the females may stay inside the cavity continuously to safeguard it against theft and to conserve their energy for egg production. This is when males may begin to stockpile huge amounts of prey at the nest, and the hoarding continues throughout much of the egg-laying and early incubation periods. In 1892, Charles Bendire, a U.S. army officer and one of the founding fathers of the American Ornithologists' Union, described a great horned owl's nest in Oregon that contained "a mouse, a young muskrat, two eels, four bullheads, a woodcock, four ruffed grouse, one rabbit, and eleven rats." In the Yukon, a nest of the same species contained 12 snowshoe hares, and another one in Saskatchewan held 2 hares and 15 northern pocket gophers.

Elf owls, when stockpiling their nest cavities, choose the largest items in their diet. These include scorpions, sphinx moths, snakes, lizards, and mice. In Sweden, one boreal owl nest contained 13 shrews, 4 voles, and a single nestling bird—a total of 18 items weighing 191 grams, which was 45 percent more than the weight of the owl. A photograph from Barrow, Alaska, published in 1955 shows a snowy owl nest with eggs and hatching chicks surrounded by 83 brown lemmings. In 1997, during a population explosion of meadow voles, a burrowing owl in Moose Jaw, Saskatchewan, set the record for the largest stockpile ever recorded in a single nest: 210 meadow voles and 2 deer mice!

The difference between stockpiling and caching is location. *Stockpiling* is the hoarding of surplus prey in the nest itself, while *caching* is the storing of food away from the nest. Most owls stockpile prey during the breeding season, and at other times of the year they cache. Stockpiling offers several advantages over caching. During the breeding season, surplus prey stored in the nest can be guarded by the female. Furthermore, since the female does all the incubation and brooding, stockpiled prey is conveniently within reach if she gets hungry or needs to feed the young. No time is wasted retrieving food from distant hiding places whose locations could be forgotten.

Oology 101

Eventually, after all the hooting, house hunting, food sharing, and mating, the female finally begins to lay. All owls lay eggs that are whitish, rounded, and unmarked. It seems logical that cavity-nesting owls would have white eggs since they would be easier to find in the dim light of the interior, and cryptic markings would be unnecessary to camouflage the eggs from thieves since the eggs are hidden from view. Cavity-nesting woodpeckers and kingfishers also have white eggs, probably for the same reasons. That being the case, I wondered why the large owls that nest in the open also have white eggs that are boldly conspicuous when

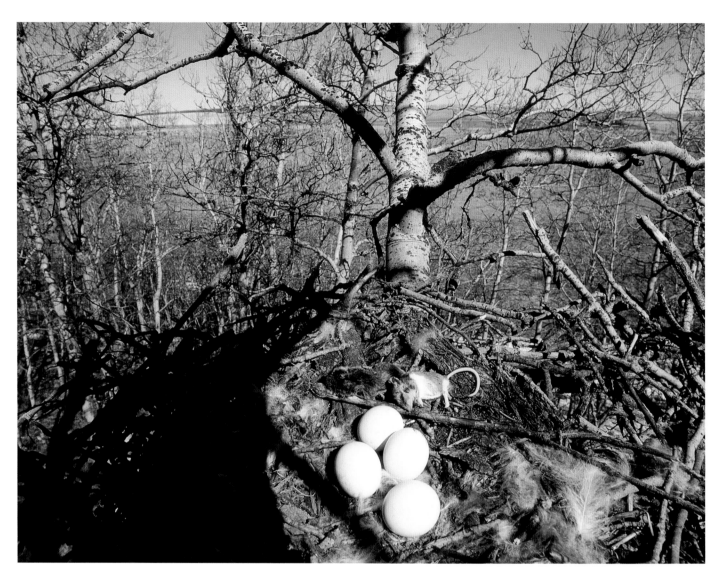

A clutch of two or three eggs is most common in the great horned owl. This larger than average clutch is a reflection of the abundant prey in the area. The male owl has stockpiled a dead deer mouse at the rear of the nest.

the female is absent. Many eagles and large hawks, which are fierce defenders of their nests, have eggs that are blotched and somewhat cryptic, presumably to mask their presence, so why don't owls do the same? Perhaps, the answer lies in the fact that owls cover their eggs almost continuously once they start to lay, and since the mother is always nearby to protect them, cryptic coloration would be superfluous.

The largest owls, of course, lay the largest eggs. The average weight of a great horned owl's egg is roughly 1.8 ounces (51.3 gm), and that of a snowy owl, 2.1 ounces (60 gm). Both weigh roughly the same as a medium to large chicken's egg. The tiny elf owl lays an egg that weighs only 0.26 ounces (7.4 gm). By way of comparison, a single egg from a snowy owl weighs more than a mother elf owl and her clutch of three eggs.

I'm addicted to nature trivia, and birds' eggs are a good source of biological minutiae. A good friend of mine, Frank Todd, who shares my passion for such trivia, wrote the ultimate source for such bird facts, *10,001 Titillating Tidbits of Avian Trivia*. The egg of an elf owl is small, roughly the size of a puny grape, but it is gargantuan when you compare it to the egg of the bee hummingbird of Cuba, the smallest bird in the world. The hummingbird's egg weighs a mere 0.013 ounces (0.37 gm),

and it would take five such eggs to match the weight of a penny. The ostrich occupies the other end of the spectrum and produces the world's largest egg, weighing 3.6 pounds (1.63 kg)—and strong enough to support the weight of an adult human. The largest bird's egg that ever was belonged to the extinct elephant bird that lived in Madagascar. The elephant bird weighed nearly 1,000 pounds (454 kg) and laid eggs as large as a football. One such egg was estimated to weigh 27 pounds (12.2 kg) and have a volume equal to that of 180 hen's eggs.

The smaller the bird, the greater the relative size of its egg in proportion to its body weight, the point being that small owls normally make a greater energy investment in their clutch than large owls. For example, the weight of a great horned owl's egg is roughly equivalent to 3.2 percent of the female's body weight, whereas the tiny egg of an elf owl is equal to about 18 percent of the mother's weight.

The number of eggs that owls lay varies from 1 to 11. The elf, flammulated, great gray, great horned, spotted, and barred owls lay clutches of 2 or 3 eggs. Clutches of 5 eggs are common for barn, long-eared, short-eared, eastern screech, northern saw-whet, and boreal owls. The largest clutches, containing 7 eggs or more, are laid by northern hawk, burrowing, and snowy owls. The largest clutch ever reported for an owl contained 13 eggs, which belonged to a northern hawk owl in Finland. There is one other record of a snowy owl laying 13 eggs, but some authorities suspect that the clutch may have been laid by two females. There are many confirmed instances of snowy owls laying 11 eggs.

A number of factors determine how many eggs a female will lay: latitude, the owl's age and body size, the dimensions of the nest cavity, and prey abundance. In European owls, Heimo Mikkola reported that clutch size varied with latitude, decreasing from north to south. In North America, Gale Murray compared the clutches of seven owl species (eastern screech, great horned, burrowing, barred, long-eared, short-eared, and northern saw-whet) from museum collections and found that the clutch size increased slightly with latitude, similar to the trend noted in Europe.

Clutch size may also vary with the female's age and body size. This relationship has been well studied in eastern screech-owls by Frederick Gehlbach. He found that older, larger females tended to lay more eggs and to lay them earlier in the season.

A third determinant of clutch size may be the size of the nest cavity itself. Erkki Korpimäki found that Finnish boreal owls nesting in large cavities laid more eggs. However, this may have been a consequence of the female being better fed since the males stockpiled more food when the cavities were large, and a well-fed female lays more eggs than an undernourished one. In any case, the relationship between cavity size and clutch size was slight.

The abundance of prey is the single largest factor determining clutch size in owls. It is best illustrated in species that depend on small mammals whose populations are cyclical. For example, in an average year, short-eared, long-eared, and boreal owls lay 3 to 5 eggs, but when vole numbers erupt, their clutches increase to 6 to 9 eggs. Snowy owl

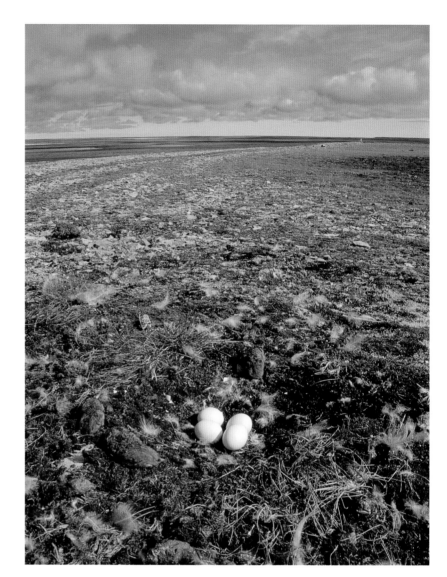

In both of these snowy owl nests, the female owl has scratched away some of the underlying tundra to deepen the nest bowl. The feathers scattered about are those normally shed from the mother's brood patch that keeps the eggs and young warm.

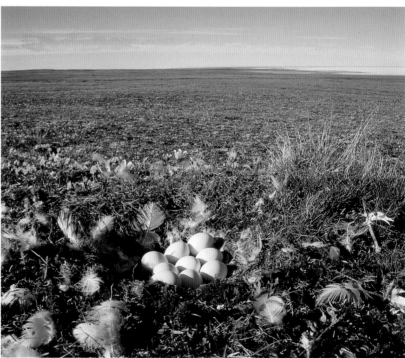

Clutch Size and Incubation Periods

Species	Scientific name	Mean clutch size	Range	Incubation period (in days)
Snowy owl	*Bubo scandiacus*	3–5	2–11	32–33
Great horned owl	*Bubo virginianus*	2–3	1–5	30–37
Great gray owl	*Strix nebulosa*	2–3	1–5	28–36
Barred owl	*Strix varia*	2–3	1–5	28–33
Spotted owl	*Strix occidentalis*	2–3	1–4	28–32
Barn owl	*Tyto alba*	5	4–8	29–34
Short-eared owl	*Asio flammeus*	5–6	1–11	26–37
Northern hawk owl	*Surnia ulula*	7	3–13	25–30
Long-eared owl	*Asio otus*	4–5	2–10	25–30
Eastern screech-owl	*Megascops asio*	3–4	2–7	27–34
Burrowing owl	*Athene cunicularia*	6–7	1–11	28–30
Western screech-owl	*Megascops kennicottii*	3–5	2–7	33–34
Boreal owl	*Aegolius funereus*	3–5	1–10	26–32
Whiskered screech-owl	*Megascops trichopsis*	3	2–4	Unknown; estimated = 26
Northern saw-whet owl	*Aegolius acadicus*	5–6	4–7	27–29
Ferruginous pygmy-owl	*Glaucidium brasilianum*	5	2–7	28
Flammulated owl	*Otus flammeolus*	3	2–4	24
Elf owl	*Micrathene whitneyi*	3	2–5	24

Note: Barn owls may sometimes raise two broods, even three, in one year. Incidence of second clutch in Utah is 5 percent, in California 56 percent.

clutches vary in a similar way in response to fluctuating lemming numbers. When the rodents are scarce, the owls may lay 2 or 3 eggs, or none at all. When lemmings are plentiful, the birds may lay three times that many.

In owls, as in all birds, there is an interval of one to three days between the laying of successive eggs. In the arctic-nesting snowy owl that interval may stretch to five days during inclement weather. In all the species, the female starts to incubate, at least partially, after the first or second egg has been laid, no matter how large the clutch will eventually be. As a consequence, if an owl lays 9 eggs, egg number one will have been incubated for about two weeks before the last egg is finally laid. This situation dramatically affects the hatching sequence (see chapter 6).

The Tedium of Incubation

Female owls do all the incubation, and they begin after laying the first or second egg. Before she starts to lay, the mother owl sheds feathers from a small area on her belly. This naked patch of skin, called the *brood patch,* softens, thickens, and becomes heavily vascularized to facilitate

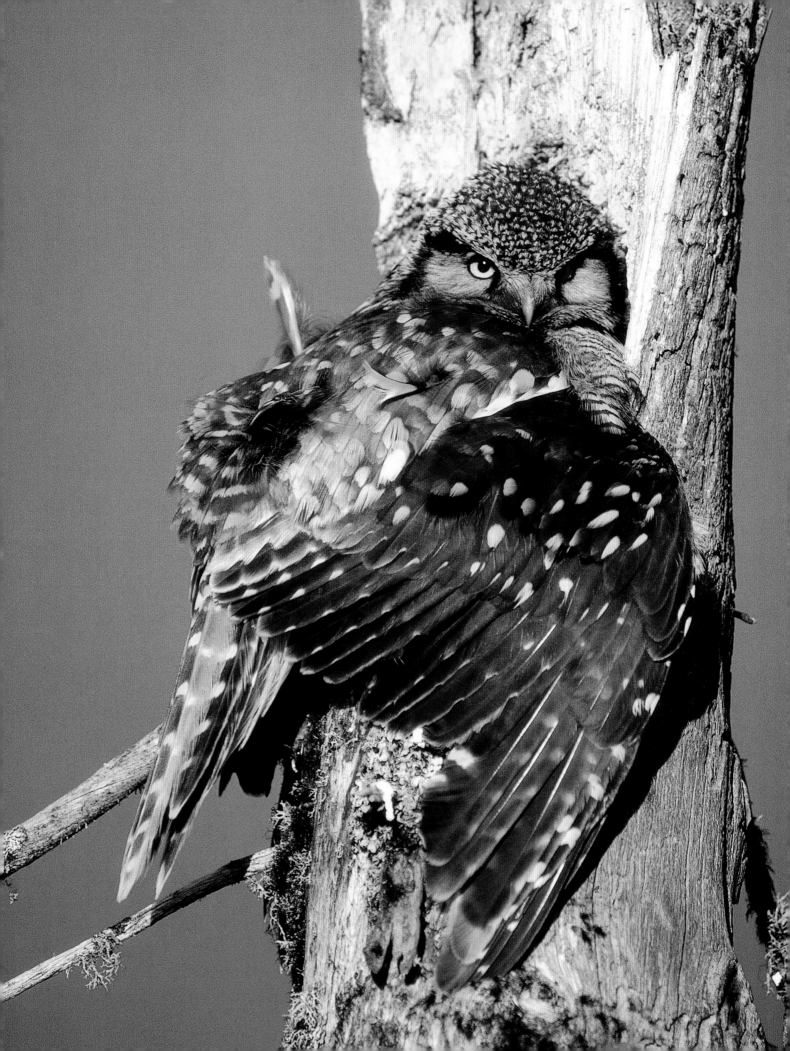

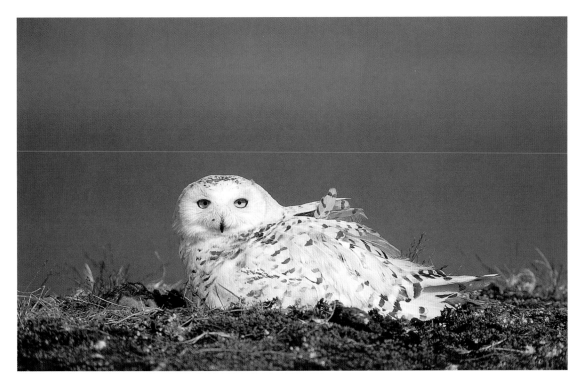

the transfer of her body heat to the eggs. Ideally, the temperature of the eggs is kept within 5 to 7°F (3–4°C) of the mother's body temperature. The hormone prolactin, secreted by the pituitary gland in the bird's brain, regulates the development of the brood patch and also plays a large role in stimulating the mother to incubate tirelessly. Under the hormone's influence, one persistent eastern screech-owl incubated an infertile egg for 78 days—a month and a half longer than the usual incubation period.

The incubation period is the time required for the embryo to develop inside the egg, assuming the egg is kept continuously warm. In owls, as in all birds, it varies with the size of the egg. For the tiny egg of an elf owl the incubation period is 24 days versus 32 days for the large egg of a snowy owl. Considering that there is an 8.5-fold difference in size between the eggs of the two species, 0.26 ounces (7.4 gm) versus 2.1 ounces (60 gm), I would have expected a greater difference in the incubation periods.

The incubation period can also vary within a single species, sometimes by as much as 5 to 10 days. (See table of clutch size and incubation periods above.) One reason for this is that a female may spend more time off the eggs during hot weather. This is often the case in eastern screech-owls where the incubation period can vary from 27 to 34 days.

During incubation, most females spend 85 to 95 percent of their time resting quietly on top of their eggs. Some female great gray owls in Finland were even more tenacious, spending 99.4 percent of their time incubating. Northern owls must cover their eggs continuously since many of them lay while snow still covers the ground and when nighttime temperatures commonly dip below freezing. Arctic nesting snowy owls lay in the middle of May when air temperatures may plummet to −4°F (−20°C). In Saskatchewan, veteran bird bander Stuart Hous-

(*opposite*) This female northern hawk owl was precariously incubating three eggs in the top of a broken spruce snag. The incubation period for this species is 24 to 30 days, as it is for most medium-size owls. (*above*) The day after I took this photograph of an arctic nesting snowy owl, a storm battered the tundra with 40-mile-per-hour (64-kph) winds and covered the ground with 2 inches (5 cm) of snow. The snow melted within three days.

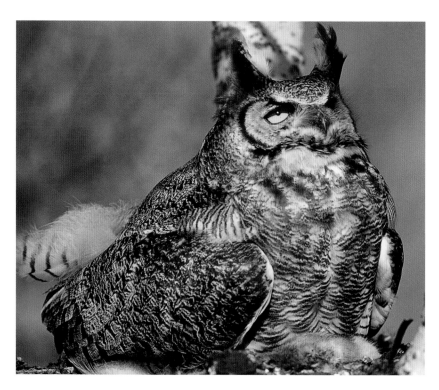

This incubating female great horned owl lazily watched a red-tailed hawk circling slowly overhead. The nest that the owl had taken over was an old hawk nest; perhaps the original owner was hoping to reoccupy its nest.

ton observed a great horned owl that successfully incubated two eggs in temperatures that dipped to –29°F (–34°C), which is roughly 128°F (71°C) below the ideal temperature of an incubated egg.

Avian embryos are remarkably tolerant to periods of chilling and appear to suffer no damage when cooled for short periods. For example, an incubating great horned owl in Saskatchewan left her eggs uncovered for 20 minutes while she joined her mate who was hooting at a neighbor. The temperature at the time was a frigid –13°F (–25°C), yet both eggs hatched and produced normal fledglings. Mild chilling of an egg usually results in nothing more serious than a longer incubation period. Of course, owl eggs are not impervious to freezing. On Wrangel Island in the Russian arctic, Irina Menyushina reported that snowy owl eggs sometimes froze and cracked in cold weather when caribou or musk oxen accidentally grazed near a nest, temporarily frightening the female away.

While the female incubates, the male continues to bring her food as he did in the weeks preceding egg-laying. Male great gray owls commonly bring three to five vole-size animals to the female every day. A male owl may bring the food directly to his mate at the nest, sometimes vocalizing to announce his approach. In some cavity-nesting species, such as northern hawk owls and pygmy-owls, the male calls from a nearby perch and summons the female to join him and retrieve her meal. The female may swallow the prey immediately or take it back to the nest to eat.

Even with regular feedings, most incubating females slowly lose weight, and they continue to do so after their eggs hatch and while they brood the chicks. A detailed weight loss analysis was done on flammulated owls in Colorado. Prior to laying, the females' average weight was 2.9 ounces (82.2 gm). Their weight dropped to 2.8 ounces (79.3

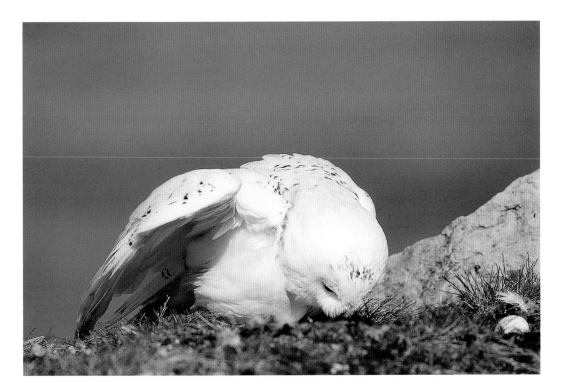

gm) during incubation, and afterward to 2.2 ounces (62.4 gm) during brooding. By the time the chicks fledged, a female's weight was at its lowest point of the year, at 2.1 ounces (59.5 gm)—a 29 percent weight loss from her prelaying maximum.

Frederick Gehlbach weighed a female eastern screech-owl during the six weeks she incubated and brooded her young. On April 2, while incubating, she weighed 6.2 ounces (176 gm). Roughly four weeks later when all four eggs had hatched she weighed 5.6 ounces (159 gm). Overall, she lost about 10 percent of her body weight. James and Patsy Duncan routinely weigh female great grays that have lost up to a third of their body weight in the one to two months they were busy at the nest incubating and caring for their young. They believe that females purposely eat less so that the chicks get more food. The extra food enhances the young owls' growth rates and subsequent chances of survival.

I've watched many female owls incubate their eggs and it appeared to be just as boring for them as it was for me watching them. They snooze, gaze about, and aimlessly nibble on sticks in the nest. One great horned owl broke the tedium by trying to catch an annoying horsefly with her beak. She snapped at it four times but never caught it. To pass the time, cavity-nesting females often peer out of the nest hole. Ferruginous pygmy-owls peer outside their nest cavities up to 35 times a day, looking around for an average of about four minutes each time.

In the monotonous life of the incubating female, egg turning is a big event. The mother owl uses her beak to gently rearrange the eggs and roll them around. A female barn owl may turn her eggs 4 or 5 times a day; a female long-eared owl, as often as 12. Egg turning serves two important biological purposes. Eggs in the periphery of the nest get moved to the center of the clutch where temperatures tend to be several degrees

A female snowy owl gently turns her eggs several times a day to ensure even incubation and normal development.

higher. Moreover, regular turning prevents the membranes surrounding the embryo from adhering to the inside of the eggshell, which can lead to faulty development.

The two ground-nesting species, the short-eared owl and snowy owl, sometimes have to deal with eggs rolling out of the nest bowl. This may happen when a female is frightened and she accidentally dislodges an egg in her haste to escape. When she returns to the nest, she uses her beak to roll the egg back into place. Female short-eared owls sometimes defecate on their eggs when they are suddenly flushed from their nest. Some authors have suggested that this is purposeful, and that the putrid-smelling feces are meant to dissuade a predator from eating the eggs. More likely, the incubating female may not have defecated in some time and the stored feces are expelled as part of her fright reflex.

The burrowing owl appears to have retained the innate tendency to retrieve dislodged eggs even though it doesn't nest on the surface of the ground. Connie Toops wrote about a burrowing owl from Midland, Texas, that lived on a golf course and rolled 27 golf balls into its burrow, where it already had a full clutch of eggs.

Even the most dedicated females leave their eggs periodically for short recesses. During their breaks, they retrieve prey from their mate, preen, stretch, cast a pellet, or defecate. Females always defecate away from the nest, which keeps it clean until the young hatch. Female ferruginous pygmy-owls take from 3 to 17 breaks a day, averaging about 24 minutes at a time. These small owls nest where the climate is warm, so they can afford to leave their eggs unattended. Boreal owls nesting in the mountains of Colorado took only 2 recesses a night, each lasting about 15 minutes. Great gray owls in the cold northern forests of Scandinavia took only 3 breaks throughout the day. None of the breaks was longer than 5 minutes, and most were less than 3. In total, the great grays were off their eggs for less than 9 minutes in 24 hours.

Sexual Dimorphism: The Great Debate

Within a species, when the male and female differ in size, biologists call it *sexual size dimorphism*. In most species of birds, males are larger than females. The common explanation given for this is that larger males are better able to compete with rivals for access to females, are more attractive to females (presumably because they are better able to hunt and defend a territory), or both. But in some groups of birds, the females are larger than the males; this is called *reversed sexual size dimorphism* (RSSD). It occurs in jaegers and skuas, phalaropes, frigatebirds, and oystercatchers. It is most pronounced in the tropical northern jacanas, or lily-trotters, where females weigh as much as 45 percent more than males. Reversed sexual size dimorphism also occurs in most birds of prey and is especially common in the hawks and eagles, falcons, and owls. Many explanations have been proposed for reversed sexual size dimorphism, and biologists have been debating the topic for more than 100 years. It's likely that the reasons vary for different groups of birds, and for each group, there may be more than one reason why RSSD evolved.

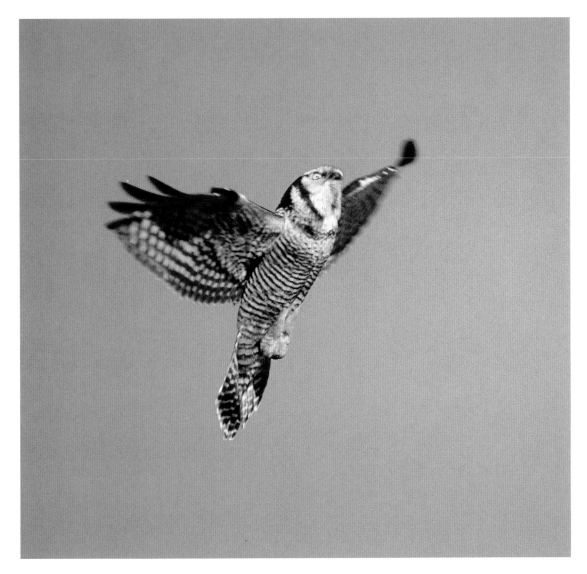

Reversed sexual size dimorphism occurs in most of the owls in North America but to a different degree in each species. It is most pronounced in the boreal owl, where females may weigh 40 percent more than males. The biological explanations for reversed sexual size dimorphism in owls fall into three broad categories: diet and hunting ability, physiological factors, and nest defense.

In 1970, Caroline Earhart and Ned Johnson reviewed the size differences and food habits in the owls of the United States and Canada. They concluded that owl species that ate vertebrates showed the greatest size differences between the sexes, while species such as the flammulated owl that fed mainly on invertebrates showed a low degree of sexual differences, or none at all, as in the burrowing owl.

Among the vertebrate-hunting owls, pairs tend to hunt prey of the same size, but they may focus on different types of vertebrates. For example, female boreal owls hunt more voles than males, and males take more birds than females do. Birds are agile, fast-flying prey, and small maneuverable male owls are better adapted to hunt them than are their larger partners. A small raptor of any species can fly faster, accelerate quicker, climb at a higher rate of speed, and turn more sharply than a

A small-bodied male, such as this northern hawk owl, can fly faster, accelerate more quickly, climb more rapidly, and swerve more sharply than his larger-bodied mate. Such qualities may be advantageous for him in defending his territory from rivals.

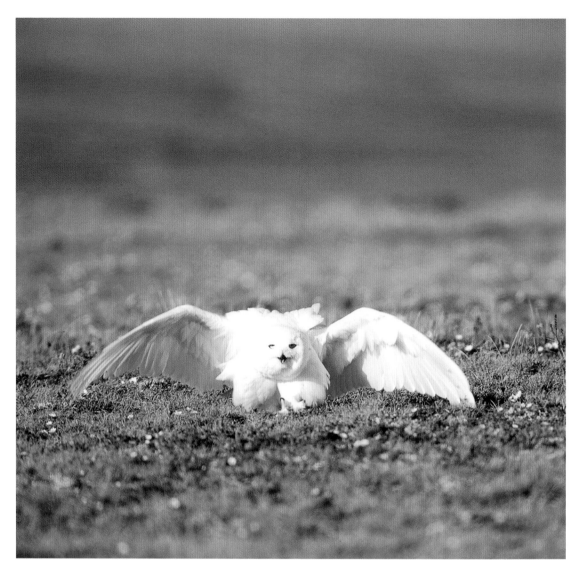

When I inadvertently approached an incubating female snowy owl, her mate swooped down on me several times, then landed and moved toward me in a threatening strut. He barked repeatedly during the display.

large raptor. So when an owl is hunting agile prey, it helps to be small. Body size thus seems to play a crucial role in the segregation of diet.

Females might also select smaller agile males because they are better able to hold and defend a territory. In most owls, defense of a territory involves chases and aerial strikes, and a small male might have an advantage in such interactions. On top of that, a small owl burns less energy when hunting, and as a result, consumes less prey. This means that a greater surplus of food is available for the female and her clutch of young.

Physiological factors may influence the degree of dimorphism in owls for three possible reasons. To begin with, large females lay larger eggs and larger clutches than small females. Furthermore, large-bodied females are better adapted to conserve body heat in cold environments and to withstand temporary food shortages. The northern owls, which are the most dimorphic, often begin nesting when weather and food conditions are highly unpredictable. In such circumstances, a large-bodied female's ability to fast and still keep the eggs warm would be advantageous. In boreal owls, females that begin nesting earliest are larger than neighboring females that nest later, when conditions are easier.

A final explanation for RSSD might be that large females are better able to defend their nest and young. The female's imposing size and greater striking power should be advantageous, and in most cases it is indeed the females that most aggressively attack intruders. In eastern screech-owls, Gehlbach observed that females defended the nest not only physically but also vocally. Once the chicks left the nest, screech-owl females roosted closer to the young, presumably to protect them more effectively. Snowy owls and northern hawk owls are the exceptions when it comes to nest defense. In these two species, the males usually defend the nest, even though they commonly weigh 10 to 20 percent less than their female partners.

Open stick nests and surface ground nests suffer more predation than cavity nests. If defense of the nest was a widespread selective force in the evolution of reversed sexual size dimorphism, then species that nest in the open should show a greater degree of dimorphism than cavity nesters. This is simply not the case. Pygmy-owls, boreal owls, and northern saw-whet owls all nest in cavities, yet they are more dimorphic than many of the species that nest in the open. The conclusion that can be made from all of this is that there are probably multiple reasons why RSSD evolved in owls, and the reasons may not be the same for every species.

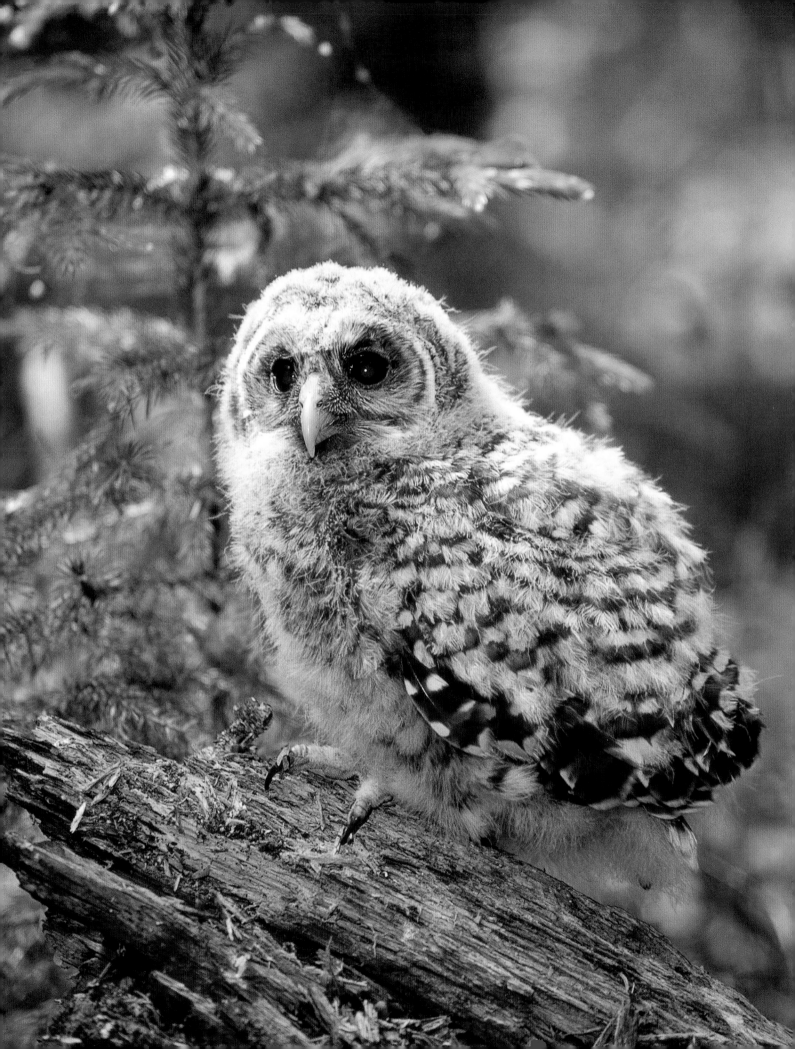

The Next Generation

O N MARCH 31, Easter Sunday, 2002, I found a great horned owl nesting in a grove of aspens about 20 miles (32 km) from my home in Calgary. I had been keeping track of the owls in that forest since 1985, and I decided that it was finally time to photograph their entire nesting cycle, from eggs to fledged young. I erected a tree stand about 30 feet (9 m) up in a nearby aspen and about the same distance from the nest. At first, I wore a hockey helmet with a face mask and a heavy leather jacket to protect myself from a possible owl attack. Despite their legendary reputation for ferocity and aggression, neither adult ever threatened me in the three and a half months I worked with the family. After the first week, I sat in my tree stand in the open and the female and chicks ignored me completely. The closest I came to an attack occurred when an accident prompted me to rescue a chick.

That year it was unseasonably cold during the last week of April when more than 3 inches (7.6 cm) of snow fell. When I climbed up to my tree stand on April 30, I could see only two of the three chicks in the nest. At first I suspected that the smallest owlet had starved during the cold weather and been cannibalized by its nest mates, something great horned owls are known to do. When I climbed down from my perch, I found the third chick huddled on the ground behind a fallen tree where it was protected from the wind. Perhaps the young bird was blown out of the nest by a strong gust of wind or was accidentally ousted by an aggressive house-hunting Canada goose, of which there were several pairs in the nearby wetland. I knew that the vulnerable youngster was not yet strong enough to climb to safety and would be an easy target for a hungry coyote. So, I decided to launch a rescue operation. Using a 25-foot (7.6-m) ladder, I climbed up the nest tree as fast as I could and "slam-dunked" the chick back into the bowl of the nest. The mother

(opposite) This young barred owl that is still unable to fly has left the family nest and relies on its strong toes and sharp talons to help it climb to safety.

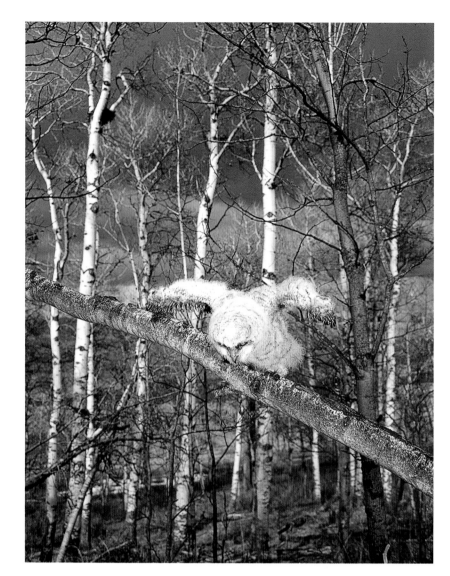

This three- or four-week-old great horned owl chick had fallen from its nest and was hiding on the ground. I put the young owl back in the nest. It did not yet have the strength or coordination to climb and was too young to survive on its own. The family nest is visible in the upper left of the tree.

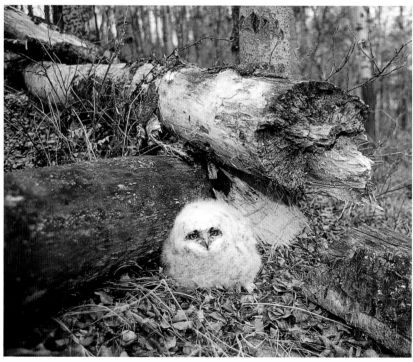

owl glared from a branch 10 feet (3 m) above me. She snapped her bill and barked repeatedly but never attacked. I wondered if she recognized my good intentions. The scientist in me thought she probably did not, but at the time, I wanted to believe she did. In the end, all three owl chicks survived and fledged. It was one of the most gratifying owl experiences I've ever had.

During the weeks of incubation, many natural tragedies can befall a clutch of eggs. A prairie lightning fire can cook the eggs of a short-eared owl. Days of driving snow in Alaska can prevent hawk owls from hunting, forcing the hungry birds to abandon their clutch. A spring downpour in Florida can flood the hopes of a pair of burrowing owls, and a windstorm in the Rocky Mountains of Montana can topple the nest tree of an unfortunate great horned owl. Then there are the eggnappers. On the ground, keen-nosed skunks, badgers, armadillos, foxes, and coyotes investigate every tantalizing odor. Clawing their way through the trees are clever squirrels, northern raccoons, pine martens, and fishers. Even ponderous black bears will climb a rotten poplar snag to pillage a nest of barred owls. Additional threats come from the skies where sharp-eyed gulls, ravens, crows, and magpies are ever watchful for a clutch of eggs momentarily ignored. The average hatching success for most owls varies between 60 and 85 percent. Of these, cavity-nesting species fare somewhat better than owls that nest in the open, where their eggs are more easily detected by predators.

Early Chick Life

Every hatchling is equipped with an egg tooth—a hard sharp projection on the tip of its upper beak that it uses to free itself from the shell. The chick must wiggle, kick, squirm, stretch, and chip its way to freedom without any help from its mother. The power for its first pecks comes from a specialized hatching muscle on the back of its neck. Later, the muscle atrophies and the egg tooth falls off in about a week.

Once the shell begins to crack, called *starring,* the owl chick usually breaks free in one to three days. Young barn owl chicks can be heard calling from inside the egg for a day or two before they hatch. Parents don't normally help the chicks, but one researcher watched a barn owl mother use her beak to break off fragments of shell, remove shreds of membranes from the hatchling, and groom the youngster clean. In Texas, Frederick Gehlbach caught a mother eastern screech-owl nibbling pieces of eggshell while she straddled her hatchling, and he suspected that she had helped the chick hatch. This rare behavior has not been reported for any other species of owls.

Empty eggshells sometimes get crushed and trampled into the nest, but more often the female carries them away and discards them. Mother eastern screech-owls carry them from 2 to 70 yards (1.8–63 m) away from the nest. Some mother owls eat the eggshells. This keeps the nest clean and is also an easy way for the female to recover some of the minerals she lost when producing her eggs. Removing eggshells from the nest, either by throwing them away or eating them, may be important

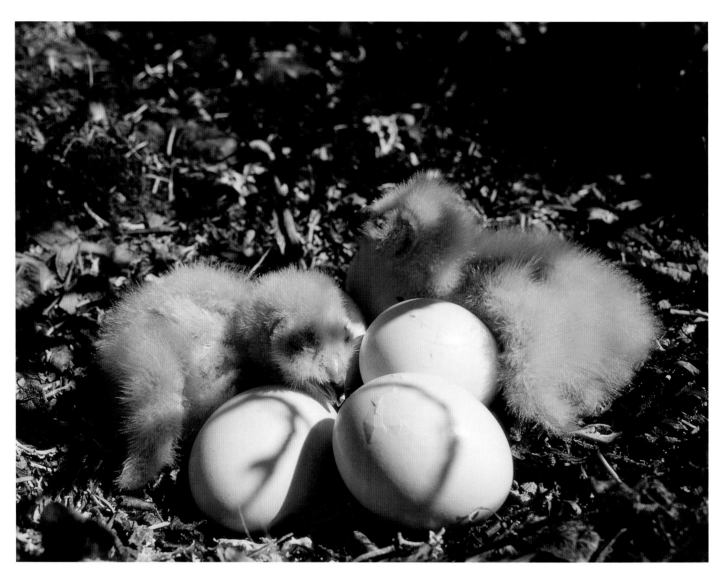

An egg tooth is still visible on the beak of this newly hatched short-eared owl chick in the foreground. One of the remaining eggs is starred and about to hatch.

for the survival of the other chicks in the nest that have not yet hatched. Gehlbach found eggshells of eastern screech-owls that had slipped over the top of other eggs in the nest and prevented them from hatching properly, killing the chicks.

At least 1 to 3 percent of eggs never hatch. They fail because the eggs are infertile, or the embryos die from cold temperatures or an infection. Most unhatched eggs eventually get broken or kicked out of the nest by the antics of the rambunctious chicks. Twice, Gehlbach saw an eastern screech-owl mother carry a whole egg in her mouth and drop it at a distance. This happened after the other chicks had hatched and the discarded egg was presumed to be sterile or addled.

Some eggs that remain unhatched don't belong to the owls. On nine occasions, Saskatchewan bird bander Stuart Houston found the intact eggs of other species in the nests of great horned owls. The eggs belonged to northern pintails, a mallard, a gray partridge, and American coots. How did they get there? Houston speculated that live prey brought to the nest might expel an egg in its final struggles, or else a fully formed egg was present in the oviduct of the victim and the owls devoured the flesh around it, leaving the egg intact.

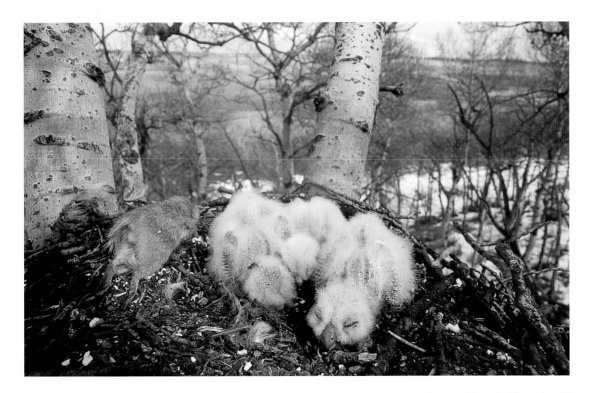

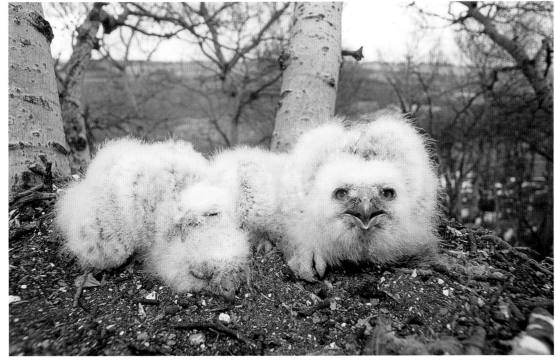

Freshly hatched chicks are wobbly, can barely crawl, and are unable to stand or lift their head. Their eyes are sealed shut until they are about 8 to 10 days old. The initial iris color in most young owls is a uniform bluish gray, as it is in many newborn mammals, including human babies. By the time an owlet leaves the nest, the natal iris color has changed to the bright yellow or dark brown color of adulthood.

All young owls start life with a uniform coat of whitish down. Within a few weeks this natal down is shed and replaced by a second thicker coat of down that is distinctive for each species. Long-eared owl chicks

(*top*) These three great horned owl chicks are less than 10 days old as evidenced by the sealed eyes of the largest one. A dead Richardson's ground squirrel is being stored on the edge of the nest. (*bottom*) The eyes of this great horned owl chick are bluish, as are those of all newly hatched owls regardless of what color the eyes will be in adulthood. The adult eye color is acquired by the time the young owlet leaves the nest.

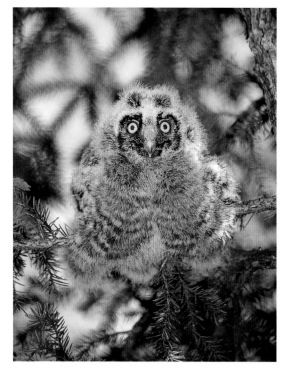

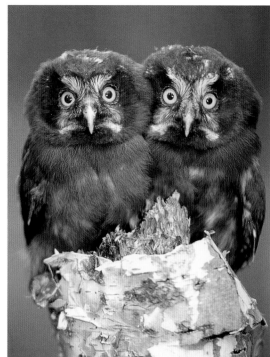

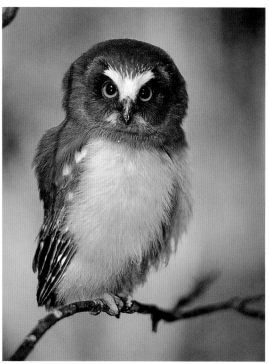

All owls hatch with a coat of whitish down. Within a few weeks the natal coat is replaced by a second downy coat that is distinctive for each species, as illustrated by this long-eared owl chick, boreal chicks, young snowy owl, and northern saw-whet chick (*clockwise from top left*).

have a light gray coat with a dark chocolate face; downy boreal chicks are sooty brown with stark white eyebrows; snowy owl young are dark gray all over; and great horned owl chicks have a buffy brown body, light gray head, rusty face, and bright white moustache. I think the most photogenic owlet of the lot is the northern saw-whet chick, which has lemon yellow eyes, a chocolate brown body, buffy belly, and a bright white triangle emblazoned on the center of its forehead. In all species of owls, juvenile feathers that resemble adult plumage gradually grow in and replace this second downy coat.

Brooding

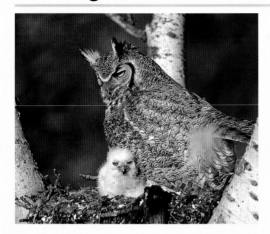

This great horned owl mother is brooding two smaller chicks while the largest chick looks around.

Newly hatched owl chicks are vulnerable to chilling, so the mothers of all species cover their young almost continuously to keep them warm until they are about 10 to 14 days old. This behavior is called *brooding*. During these weeks, a mother great gray owl will leave her chicks alone only three or four times in 24 hours, and generally for about four minutes at a time. Once the chicks are a few weeks old, the mother slowly reduces the time spent brooding them. At first, the mother leaves them only during the warmest part of the day. Later, she may brood them only at night, and later still, only during inclement weather. By the end of this period, the chicks' second coat of down has grown in and it is thick enough to keep the youngsters warm.

Young great horned owls, and presumably all other species as well, gradually gain the ability to thermoregulate their body temperature. For example, by day 15, young horned owls have reached 25 percent of adult capacity to regulate their temperature; at day 20 they are up to 69 percent; at day 25 they reach 90 percent; and at day 47 they are at 95 percent.

If a downy chick, or even an older one that has many juvenile feathers, gets soaked by a cold driving rain it can become dangerously hypothermic. In open exposed nests, mother owls will brood chicks of all ages if the weather turns threatening.

Asynchronous Hatching: A Strategy

Most owls start to incubate their clutch part-time after laying the first or second egg. As a consequence, the eggs hatch in roughly the same order in which they were laid. For example, in a short-eared owl clutch of 7 eggs the time difference between the first and last hatchling ranges from 12 to 18 days. If a snowy owl lays 10 or 11 eggs, the last chick may not hatch for a full 30 days after the first one. This asynchronous hatching naturally leads to marked differences in the size of the chicks. In one clutch of snowy owl chicks on Baffin Island in the Canadian High Arctic, the smallest chick weighed 0.9 ounces (26 gm) while the largest one weighed 13.4 ounces (380 gm), almost a 15-fold difference.

The most important factor determining the rate of chick growth is the abundance of prey. When prey is plentiful, the chicks are well fed and they grow quickly. When prey is scarce, the chicks receive fewer meals and their growth slows down, or even stops. Underfed chicks may not only stop growing, they may lose weight. One newly hatched snowy owl lost 45 percent of its body weight, although it eventually recovered. In all species of owls, the largest chicks beg more vigorously than the

The size difference among these three northern saw-whet chicks is easily seen. The largest chick is probably four to six days older than the smallest one at the rear.

smallest ones, and by bullying their siblings, they get most of the food. Not until the biggest chicks are satiated do the smaller ones manage to get a meal.

When an owl chick is 2 to 3 days old, it can survive a day or two of fasting, but it will soon die if it gets nothing to eat. Julian Potter and John Gillespie described one such weakened barn owl runt as "a pitiful, bedraggled and filthy little fellow, having evidently been trampled on by the others." Once an owl chick stops moving, the dead youngster may be treated as prey. The mother may cannibalize it or feed it to the other chicks. In one study of European barn owls, 16 percent of the young ones were eaten by their siblings. In all the cases where cannibalism occurred, either prey was scarce, the weather was unfavorable for hunting, or the adult male was unhealthy and could not provision his family adequately.

Hungry, desperate owl chicks may even resort to killing the weakest siblings. Frederick Gehlbach felt that the smallest chicks are sometimes killed during food struggles when the older siblings are appreciably larger than the starvelings. When he compared suburban and rural screech-owls in Texas, he found cannibalism occurred in 16 percent of suburban

nests and in 31 percent of rural nests. In some cases he was certain that some of the smallest chicks had been killed by their larger siblings. Such siblicide is a common behavior not only in owls but also in herons, boobies, and a number of eagles.

Asynchronous hatching, and the resultant cannibalism and siblicide that sometimes occur, is a form of brood reduction. It is a way for parent owls to raise as many offspring as a variable prey population will permit. When prey is limited, the oldest chicks are fed and the youngest starve. If owl chicks hatched at the same time, a general weakening of the entire brood might result in more of them dying.

Although asynchronous hatching is the rule for most of the owls in Canada and the United States, the eggs of burrowing owls and northern pygmy-owls sometimes hatch at the same time. In these two species, the mother owl may delay incubation until the clutch is almost complete, in which case the chicks hatch within a day or two of each other. In one Montana nest of pygmy-owls, the entire six-egg clutch hatched in one to two days. In Alberta, however, there was evidence that some northern pygmy-owls hatched asynchronously as is typical of most other species of owls. Why the difference in the two areas? It may be that pygmy-owls, as well as burrowing owls, are flexible in their incubating behavior. Under typical circumstances, they delay incubation until the clutch is nearly complete. But should cold weather intervene while the mother is laying, she may begin incubating her first egg part-time to prevent chilling and loss.

Life in the Nest

The male owl feeds his mate for several weeks before she begins to lay eggs and continues to do so while she is incubating. Once the chicks start to hatch, food demands rise abruptly, and he then provisions the entire family. Male barn owls may bring six prey items to the nest in under 35 minutes, one prey item at a time. In Arizona, one male elf owl made an average of 79 feeding trips a night to feed his mate and their two chicks. Male flammulated owls may increase their food deliveries from 2 moths per hour when the female is incubating to 16 moths per hour once the chicks hatch. In Scandinavia, male great gray owls usually deliver 3 to 4 voles per day during incubation, 5 to 6 during hatching, and 9 to 10 by the end of two weeks. Some males may deliver as many as 14 voles in a single day. Assuming that each vole weighs about 1.8 ounces (51 gm), the total adds up to 1.6 pounds (726 gm) of prey—almost two-thirds the weight of the adult female.

As long as the mother owl is at the nest, she is the only one that feeds the chicks, even when the male catches the prey and delivers it. When the chicks first hatch, the mother feeds them tiny morsels. If the prey is a vertebrate, she may give them bits of heart, liver, and intestines. Snowy owl chicks are not fed any food with bones in it until they are at least 5 days old. By the time the young chicks are 10 days old, they are given partially dissected lemmings, and by two weeks of age, they can swallow a whole lemming. Many of the other owl species, such as barn

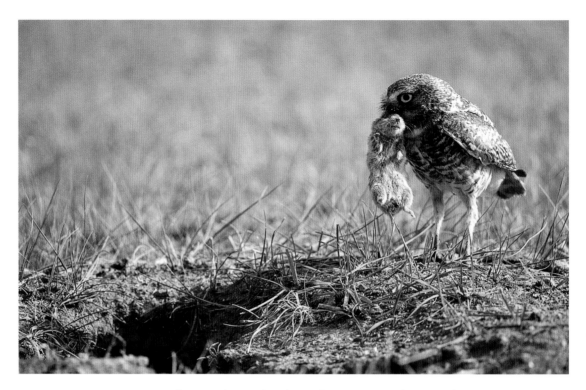

This male burrowing owl is delivering a vole to his female partner who is underground brooding their young. The mother accepted the prey at the mouth of the burrow.

owls, great horned owls, and great grays, also give their ravenous young a whole rodent to swallow when they are two weeks old. If the prey is larger than a small rodent, the mother dismembers it and feeds it to the chicks in large pieces. It takes another three weeks or so before the growing owlets have the strength and coordination to tear large carcasses apart for themselves. If a chick manages to grab a large piece of food, it guards it jealously and doesn't share it with any of its nestmates.

As the chicks grow, the nest gets crowded and the mother owl is forced to move to a nearby perch. When the mother moves out, the youngest chicks are often still too small to regulate their own temperature and require brooding to stay warm, so they huddle together or squirm underneath their older siblings for warmth. Even at this stage, the male parent continues to bring food to the female, and she in turn delivers it to the youngsters in the nest. In a few species, such as the northern hawk, barred, and eastern screech-owls, the males may occasionally feed the chicks directly. When they do, they simply drop the prey in the nest and fly off. Male owls rarely dismember prey and feed it to their young.

The mother's visits to the nest are not always to deliver food. I watched a mother great horned owl who had been perched about 10 feet (3 m) away from her nest fly in to do some housecleaning. In quick succession, she swallowed some old pellets regurgitated by her trio of chicks, nibbled on a few shed feathers, and ate some bits of whitewash splashed on the rim of the nest.

The eating of nestlings' feces by mother owls has been reported in great grays, snowies, barn owls, and short-eared owls. On two occasions in North Dakota, Robert Murphy watched a mother long-eared owl ingest fresh feces. He speculated that such behavior might make nest sites less conspicuous to predators. In songbirds, the eating of feces by

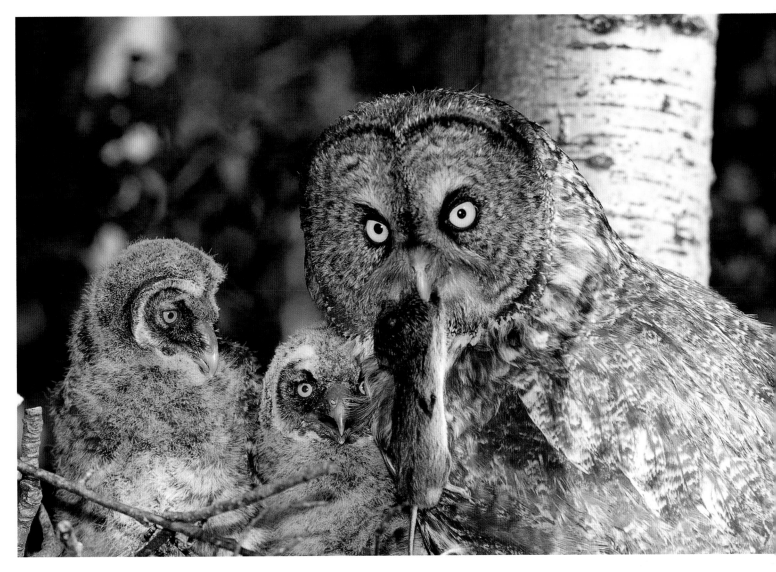

The male parent of this great gray owl family hunted throughout the day to supply meadow voles for his three hungry chicks. The mother owl pictured here took the food from him and she alone fed the young.

some parent birds is thought to be an attempt to keep the nest clean or to obtain nutrients, although many species carry the feces away from the nest and drop them at a distance. The reason why owls eat feces is unknown.

When chicks aren't begging for food or snoozing with a full stomach, they spend their days quietly watching the world around them. I have many fond memories of witnessing such moments. One time, on Ellesmere Island, in the Canadian High Arctic, I was lying on the tundra in the warm glow of the midnight sun, yards from a dozing snowy owl chick. Its eyelids were heavy, but the youngster perked up when a large black and yellow bumblebee flew beside it. The owl tilted its head this way and that to watch the fuzzy bee sip nectar from the scarlet blossoms of a hairy lousewort. Another time, in the boreal forests of northern Alberta, I chuckled at the reaction of a great gray owl chick as it peered over the edge of its nest to watch a feather float softly to the forest floor. The owlet leaned dangerously close to the edge then suddenly jumped back in fright when it almost toppled out.

My most heartwarming memory of a curious chick happened with one of the great horned owl youngsters I observed for three and a half

Adult male owls often decapitate prey before bringing it to the nest, as has happened with this red squirrel lying beside two barred owl chicks in a nest cavity. The reason for this behavior is unknown.

months. One evening, shortly after sunset, a commercial jetliner passed high overhead on its approach to the Calgary airport. The plane intercepted the last rays of the sun and its jet stream became a ribbon of gold set against the deep blue of the twilight sky. One of the owl chicks spotted the golden beam and followed its path as it moved overhead, its yellow eyes open wide with interest. The wild innocence and purity of the moment brought tears to my eyes.

When chicks are not looking around they pick at their toes, nibble on nest debris, preen themselves and each other, stretch, and flap. Owl chicks that are raised in the security of cavities often cram together at the cavity opening to peek outside. There isn't much else for them to do. The peaceful security of the nest is a short-lived event in their lives, and eventually all must leave to face life's challenges.

Roamers, Branchers, and Homebodies

When the time comes for owl chicks to leave the family nest, their behavior differs depending on whether they were raised in open nests or in the relative security of a cavity. Short-eared owls and snowy owls nest on the surface of the ground—a vulnerable place to be. Both species sometimes have large clutches of young, and when adults make repeated feeding trips to the nest, they may inadvertently betray its location. Arctic foxes catch nestling shorebirds by watching the movements of the parent birds, and it's quite possible that bobcats and canny canids, such as red foxes and wolves, do the same to locate owl nests. To counter this threat, young snowy and short-eared owl chicks abandon the nest and roam away as soon as they are mobile enough to waddle. Young short-eared owls leave the nest when they are roughly two weeks old,

and snowy owls when they are three weeks old. Adam Watson described snowy owl chicks at this stage as quick and agile afoot.

Snowy and short-eared owl chicks grow the fastest of any owlets. When a short-eared owl chick is just 10 days of age, it may weigh 10 times as much as it did at hatching. A snowy owl chick may increase its weight by 60 to 70 percent in a single day. Some snowy hatchlings may eat half their body weight in prey in a day, and on some days, a few owlets may consume their entire weight in prey.

At two to three weeks old, the young ground-nesting owls are still many weeks away from independence, and their parents continue to feed and protect them. Eventually, the entire clutch disperses, and the chicks hide apart from each other, making it more difficult for predators to locate them. Short-eared owlets usually move about 60 yards (55 m) from the nest, and occasionally up to 150 yards (137 m). Snowy owl chicks may spread out over 0.4 square miles (1 sq km), but they always stay within their parents' defended territory.

Young short-eared owls start to fly when they are roughly five to six weeks old. Once they are flying they may join up again with their

This young snowy owl chick had left the family nest and was hiding on the tundra nearby. I found the chick close to the historic cabin where the famous American arctic explorer Adolphus Greely overwintered 120 years earlier. Greely recorded the northernmost snowy owl nest ever reported at 82°40' north.

Owl chicks that are raised in stick nests and leave before they can fly are called branchers. In barred owls this happens when the chick is four to five weeks old.

siblings and roost together. Young snowy owls can't fly until they are six to seven weeks old, but even after they can, they tend to stay apart from each other.

Owl species that use stick nests, the tops of broken snags, and other open locations off the ground are less vulnerable to predation than ground-nesters, but their young are still at risk. These species include the larger owls such as the great horned, great gray, barred, spotted, and northern hawk owls, which can normally defend their young against predators. My owling buddy Gordon Court and I once watched a nesting great gray owl that was brooding two chicks atop a 20-foot-high (6-m) balsam poplar snag. At midday, we left our photo blind to grab a quick sandwich and when we returned, less than an hour later, both chicks were dead and the mother had a bloody laceration on her right foot. There was one dead chick in the nest and the other one, which had bite marks on its head, had been cached under a fallen log. From the wounds and the caching behavior, we guessed that the predator was probably a fisher or a pine marten. The parent owls had been unable to prevent the attack. So even the chicks of large, fiercely defensive mothers

are at risk, and the young need to disperse from the nest as soon as they can, which is exactly what they do.

Some northern hawk owl chicks leap from the nest when they are just three weeks old. At this age, they are already three-quarters grown. They get this large so quickly because male hawk owls are maniacal hunters during the breeding season. They feed their young three to four times more frequently than other northern owls, making up to 41 food deliveries in a day. The maximum feeding rate reported for a great gray owl was 14 trips per day, and most days it was only 9 or 10.

Biologists call these early departing owl chicks *branchers*. Young great gray owl chicks branch at three to four weeks of age when they weigh around 40 to 60 percent of an adult's weight; barred and spotted owl chicks leave when they are four to five weeks old; and young great horned owls depart at five to six weeks, when they reach about 75 percent of their parents' weight. Although branchers are more than half grown when they abandon the family nest, none have their parents' defensive or hunting skills.

Leaving the nest can be as simple as climbing onto an adjoining limb. Many flutter and flop to the ground, usually under the protective cover of darkness. Later, they may huddle under a bush for a while, sit next to a fallen log, or settle atop a small stump, but eventually they all find a safer elevated perch. However, some spotted owl chicks may spend up to 10 days stranded on the ground—a dangerous place since their noisy begging calls can attract a predator.

The chicks cannot fly at this age but they are expert climbers. A young barred owl chick can scale 20 feet (6 m) up the vertical trunk of a tree in a matter of seconds. It does this by flapping its small wings for balance and gripping the bark with its needle-sharp talons and hooked beak.

Branchers may roost together in the same tree, or even on the same limb. One time, I found three great horned owl chicks perched in the same aspen tree within 10 feet (3 m) of each other. The next day they were roosting in separate trees, more than 50 yards (46 m) apart. No matter where a brancher settles, its persistent feeding calls guarantee that it will not be forgotten by its parents. No one has studied the frequency and loudness of these begging calls among North American owls, but the details are well known for the Eurasian eagle owl, a close relative of the snowy and great horned owls. In Sweden, hungry eagle owl chicks may call every 10 seconds, and the sound is audible up to 0.6 miles (1 km) away on a calm night. As the chicks grow, they call more frequently. In June, they might call up to 550 times per hour; in July, 600 times per hour; and in August, a remarkable 900 times per hour. In one night, an insistent eagle owl chick might scream 5,000 times for food.

Branchers begin to fly at different ages, but most can do reasonably well by the time they are 7 to 10 weeks of age. They start out by gliding and slowly learn to fly by flapping. During the branching stage of chick life, most mother owls resume hunting for themselves and also begin to provision the young. Even so, the male parent continues to supply the youngsters with the majority of their meals.

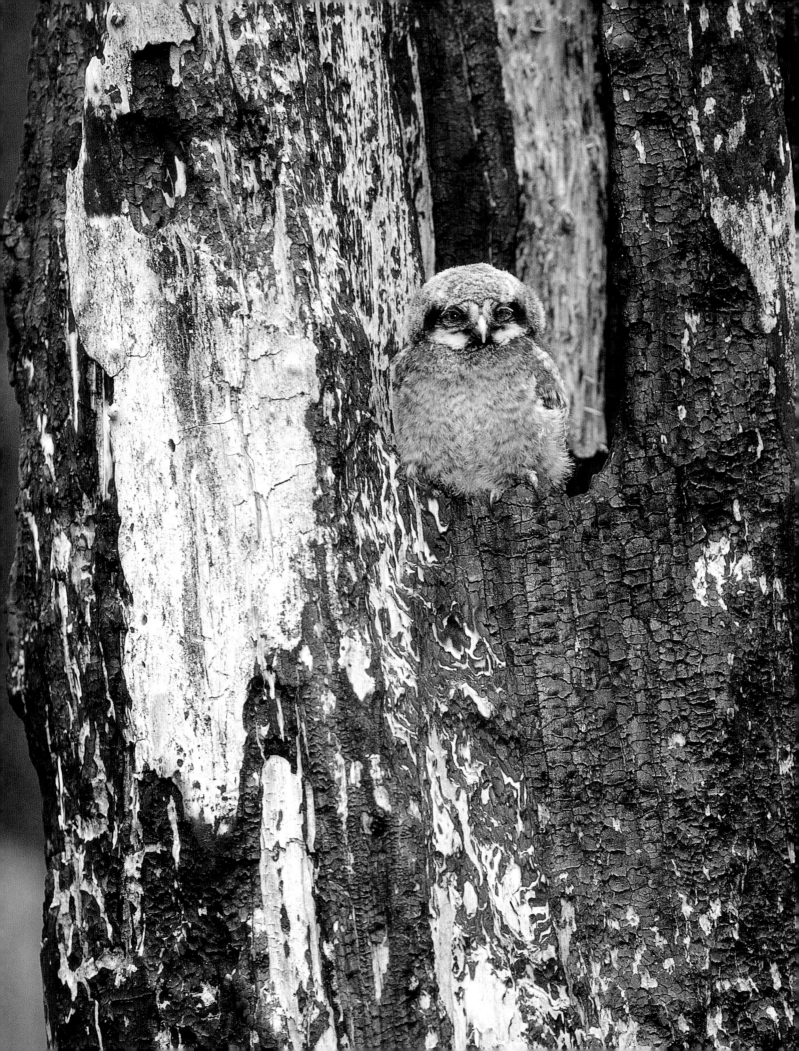

Owl chicks reared in cavities are homebodies and they stay in the security of the family nest until they are much further along in their development than the roaming and branching species. Most of them leave at night when they are 4 to 5 weeks old. Since cavity-nesters are generally the smaller species of owls, their growth is further advanced at this age than it would be in the larger owls. Some, such as the pygmy-, boreal, and northern saw-whet owls, can already fly, but not very well. None of the screech-owls can fly when they first leave the nest, but most are flying within a week or so of departure. The flying ability of chicks is directly related to their body weight when they vacate the family nest. Those that are virtually adult size, such as the elf owl, can fly immediately, although not well. Because the screech-owls are only 70 to 80 percent of adult size, they require a short period of additional growth and maturation before they are able to fly. Until then, they jump and flap through the branches. Frederick Gehlbach describes their climbing ability as parrotlike. If they get accidentally grounded, they waddle to the nearest tree and scale it to safety.

A chick that has left the family nest and can finally fly is said to have fledged. So far, no one has compared the fledgling survival of cavity-nesting owls with that of species nesting in the open, but it has been done in songbirds. The fledging success in cavity-nesting songbirds averages 66 percent, versus 46 percent for those that nest in the open. Furthermore, open-nesting songbirds fledge faster than those raised in cavities, 27 days versus 38 days. Researchers speculate that open-nesting birds are more vulnerable to predation and the young must fledge as quickly as possible. Similar selective forces probably operate in owls, and for the same reasons.

Even after the chicks are flying, the parents continue to defend them. At this stage, the adult birds may have invested two to three months in raising their young and have the most to lose, so many continue to aggressively deter predators with their talons. Of equal, or more, importance, the adults continue to feed the fledgling owls while the young birds hone their hunting skills. In the smaller owls, such as the pygmy-owls and the flammulated and boreal owls, the free meals continue for about a month after the chicks leave the nest. In burrowing owls the handouts last for about two months, and in great gray, great horned, and barred owls, the adults may continue to feed their young for up to four months after they leap from the family nest.

Insects are the first prey that many fledgling owls attempt to catch for themselves. You might predict that this would be the case for the smaller species, but even the large young of great horned owls tackle grasshoppers and beetles. Fledglings may also practice their skills by pouncing on inanimate objects. The young hunters eventually graduate to larger prey, but it takes time to sharpen their skills. In one study of hunting success in short-eared owls, adults caught prey 19 times out of 33 strikes, whereas juveniles succeeded only twice in 13 attempts—a 58 percent success rate for adults versus 15 percent for juveniles. The survival of young owls often hinges upon the supplemental meals they continue to get from their parents.

(opposite) This young northern hawk owl was raised in the cavity of an old tree snag that was charred and hollowed out in a forest fire. All young hawk owls leave the nest at roughly three weeks of age, long before they are able to fly.

The most dangerous time in a young owl's life is the several months after fledging. The main dangers come from predators and humans. The youngsters, being more mobile, often stray from their parents, who could protect them, and many of them are killed by mammalian and avian predators. (See chapter 7 for a more detailed discussion of predators.) The dangers posed by humans are mostly unintentional, but nonetheless deadly. The young owls can be impaled on barbed wire fences, and a few collide with airplanes. The greatest number are killed by vehicles on highways, often because the inexperienced owls hunt for prey in the grassy ditches beside roads. (See chapter 8 for more about human and owl interactions.)

Toward the end of summer, the parents slowly, or sometimes abruptly, stop feeding their imploring chicks. The mother is often the first one to do this, possibly because she has a shorter history of provisioning them than the male parent and the behavior is less ingrained in her. It could also be that the weight loss she incurred while incubating and brooding the chicks makes her less nutritionally fit and more focused on restoring her own health.

The severing of dependency between parents and offspring is as old as biology itself. Each party has a selfish biological agenda. The offspring want the meals and protection to continue as long as possible, and the parents want to terminate them as soon as possible but not so soon as to seriously jeopardize their youngsters' odds of survival. The parents must weigh the concern they have for their offspring against the needs of their own survival, including the energetic costs of molting and possibly migration. No parent owl will feed a youngster to the detriment of its own survival. In the end, each must ultimately fend for itself.

The Young and the Restless

Birds' urge to migrate is synchronized by photoperiod. The changing day length produces a "migratory restlessness," which ultimately stimulates the birds to depart. The actual hormone mix that produces the requisite restlessness differs among species and includes multiple chemicals originating in the gonads, adrenal glands, and thyroid. Departure of young owls from their parents' home territory, called *natal dispersal,* is different from migration. Migration is an annual event in which birds travel in a prescribed direction, often aiming for a specific destination and using navigational skills. Natal dispersal, on the other hand, is a once-in-a-lifetime movement that all juvenile owls make at the end of their first summer.

Siblings often disperse at roughly the same time, and neighboring youngsters from different families may also depart during the same period. For example, juvenile great horned owls in the Yukon disperse between the first week of September and mid-October. Most juvenile Mexican spotted owls in New Mexico disperse between September 10 and 29, and siblings depart no more than two weeks apart.

Although juvenile siblings may leave their parents at about the same time, they often head in totally different directions and travel differ-

Young short-eared owls disperse alone from the family territory when they are several months old. Until then, siblings may roost together, as these are doing here in the prairies of Montana.

ent distances. The directions the young birds travel are often random, although rivers and mountain ranges may act as barriers and determine, in part, the direction the young owls follow. Many juvenile owls, especially among species that are nonmigratory, disperse less than 125 miles (201 km) from their parents' territory. Florida burrowing owls average a distance of only 0.7 miles (1.1 km), whereas northern spotted owls in the Pacific Northwest travel about 15 miles (24.1 km).

Some hardy juveniles, however, make marathon dispersal movements. One young long-eared owl banded in Minnesota was recovered in Pueblo, Mexico, 1,926 miles (3,100 km) away. Another one from Saskatchewan ended up in Oaxaca, Mexico, a distance of 2,486 miles (4,000 km). Juvenile snowy owls hold the record for dispersal distance. David Parmelee banded three young snowy owls on Victoria Island, in the Canadian High Arctic, on July 18, 1960. All three were relocated in the two years following their dispersal. One was found in eastern Ontario, another in Attawapiskat, on the coast of James Bay, and the third one was recovered on the other side of the world on Sakhalin Island in Russia, roughly 6,000 miles (9,656 km) from its birthplace.

Some early authors suggested that parental aggression was impor-

Many tragedies can befall a young long-eared owl when it disperses from the family territory in the first autumn of its life. This one became entangled in a barbed wire fence probably when it was hunting at night.

tant in driving juveniles out of the family territory and forcing them to disperse. But this is not the case. Dispersal, like migration, appears to be mediated by hormones, and some exciting discoveries have been made in western screech-owls. Two factors affect the physiology of a juvenile screech-owl toward the end of summer: the marked reduction or cessation of prey deliveries by parents and the increasing competition for food among siblings. James Belthoff and Alfred Duffy hypothesized that both these factors cause stress, which stimulates the adrenal glands to produce the hormone corticosterone. This hormone stimulates an increase in locomotor activity, culminating in dispersal. Only juveniles that have ample fat reserves disperse, while their leaner siblings stay behind. The stragglers are able to improve their physical condition once their siblings have left and there is less competition for food, and they disperse later. Belthoff and Duffy observed that the most dominant sibling was generally the first to disperse and the most subordinate chick was the last to leave. They concluded that the order of dispersal among siblings correlated perfectly with dominance status, and they assumed the reason for this was that dominant birds were in the best physical condition.

Dispersal for juvenile owls entails leaving the familiarity of their natal territory and contending with a wide range of new challenges and dangers. They must repeatedly traverse unfamiliar terrain, find food in a succession of new hunting grounds, avoid conflicts with unfriendly resident owls who view them as potential rivals, and skirt attacks from a retinue of predators, many of which they may have never seen before. Many young owls ultimately succumb to the inherent risks of dispersal and independence. In the end, 50 to 70 percent die before they reach the age of one. Of the minority that survive, some may live for many years. The small owls usually live less than 10 years, the larger species as

long as 15 to 20. The oldest wild owl on record is a great horned owl that lived in Winnipeg, Manitoba. It survived for at least 27 years and seven months.

One October, in Churchill, Manitoba, visitors witnessed the final moments of one dispersing snowy owl that didn't make it. The bird had been perched on a snowdrift all day. Its movements were sluggish, its gaze transfixed. The hapless owl probably never heard the rush of the young polar bear coming through the willows behind it, or it may have been too weak to react. In a sweep of a paw, the young owl's ordeal was over.

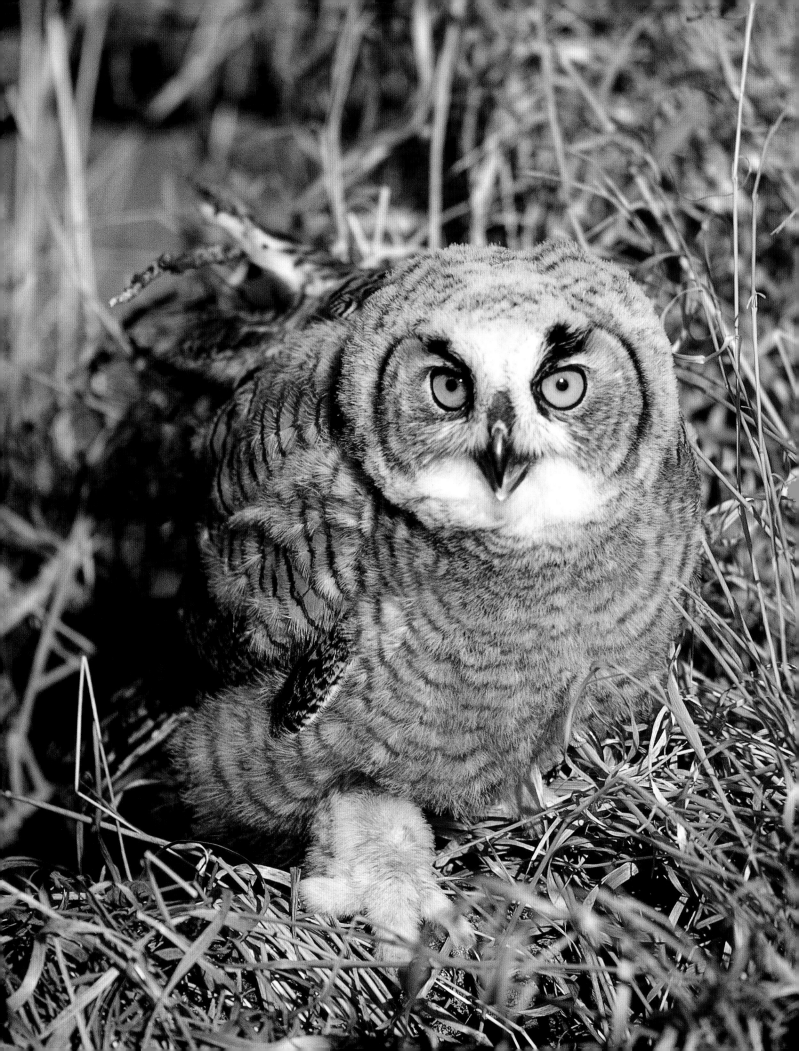

Predators, Pirates, and Pests

Photographing nesting owls often involves weeks of preparation. I may set up a canvas blind on the ground and slowly move it closer until the subject finally accepts it completely. At other times, I've hauled heavy metal tree stands aloft or used aluminum towers, some over 40 feet (12 m) tall, to get a higher vantage point. Thus it's a real treat when I find an unwary owl, of any species, that I can photograph from the ground with no concealment. This was the case with the northern hawk owl I found nesting atop a 15-foot (4.5-m) broken snag in a black spruce bog in northern Manitoba. For several days I visited the nest and took photographs of the mother feeding and brooding her large chicks, who were spilling over the edges of their small nest cavity. The owls seemed completely undisturbed by my presence. A week went by before I returned to check on the progress of the nest one more time. As I approached, I saw that the three chicks were missing from the top of the snag. The mother owl was calling in an agitated way from a spruce tree nearby. My first thought was that a predator, such as a pine marten, must have located the nest and eaten the chicks.

The excited female looked stunning against the cobalt blue sky above, so I moved closer to take her photograph. As I fiddled with my camera, I was suddenly struck in the back of the head. The blow was so forceful that I thought someone had punched me and I turned around angrily to confront my assailant. I was surprised to see no one there, just a small male hawk owl glaring at me. I rubbed the tender spot on my head to check for blood. Fortunately, the male had not used his talons in the surprise attack. Unknowingly, I had walked too close to a chick that was likely hidden in the shrubbery nearby. At the time I didn't know that young hawk owls routinely abandon the family nest when they are only three weeks old and that their parents feed them on the ground. I moved back a few feet and focused again on the female. I wanted that

(opposite) This young great horned owl tried to catch a Richardson's ground squirrel but was too inexperienced to succeed.

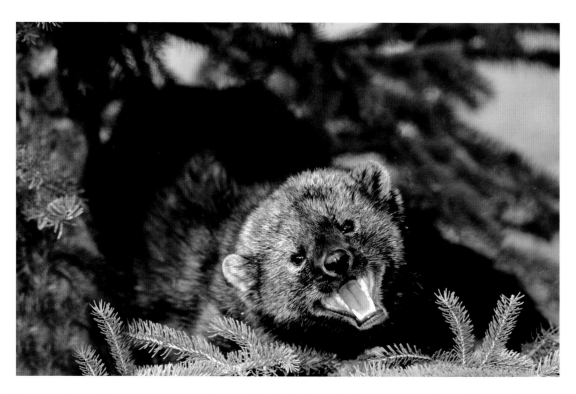

The fisher, sometimes called the American sable because of its luxuriant fur, is an arboreal predator that preys on nesting birds, including owls, hares, squirrels, and porcupines.

photograph. As I looked through the camera, the male struck again. This time his talons were spread, and he boldly hit me in the forehead. When I pulled back from my camera there was blood all over the back of it, and I couldn't see clearly out of my left eye. I instantly remembered the story of the British bird photographer Eric Hosking who lost an eye to an irate tawny owl under similar circumstances. I turned and ran out of the forest as fast as I could; the male hawk owl following behind. When I was safely away, I examined my bleeding forehead and found four puncture wounds over my left eyebrow. Luckily my eye had been spared. I left, admiring the bird that could rout an enemy 200 times its own weight.

As fierce as an adult owl can be in defending itself and its young, there will always be hungry predators that will risk preying on them. Because owls can escape by flying, not many mammals are fast enough to catch one, unless of course the bird is cornered inside a cavity. The largest cavity-nesting owl is the barred owl. In fact, it is the largest cavity-nesting bird of any species in the United States and Canada. Tree-climbing black bears, bobcats, pine martens, fishers, and wolverines could all potentially ambush an adult owl in its nest cavity. However, the clawing noise of a predator on the bark is usually enough to alert the bird and allow it time to escape. Still, there are reports of black bears killing barred owls in Manitoba and multiple records of boreal owls and northern saw-whets being caught by martens and fishers, the two most arboreal members of the weasel family. In Texas, eastern screech-owls are cornered and killed inside their cavities by opossums and ringtails, and in one study in Idaho, raccoons were suspected of preying on nesting long-eared owls on at least three different occasions.

Predatory mammals probably pose the greatest threat to ground-nesting owls. For example, incubating short-eared owls are sometimes

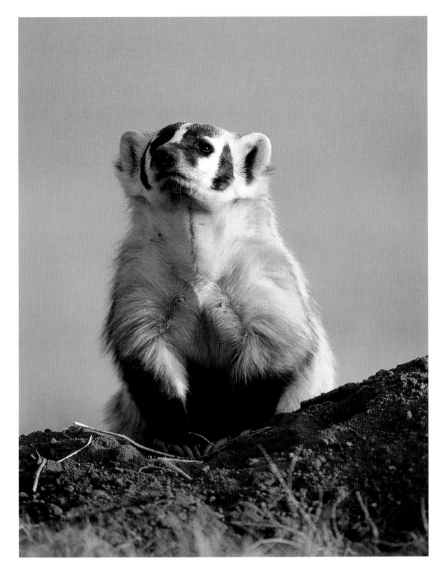

The American badger is the most common predator of nesting burrowing owls. Ironically, old badger diggings are sometimes used by the owls as nesting burrows.

killed by bobcats and red foxes. In Scotland, researchers found the remains of 76 short-eared owls—8 adults and 68 young—at a red fox den. Burrowing owls also fall victim to predatory mammals, especially badgers and coyotes that dig them out. In the Columbia Basin of Oregon, badgers were the number one predator of nesting adult burrowing owls, accounting for 90 percent of predation losses. During a two-year study in Nebraska, Martha Desmond documented the loss of 15 broods of young burrowing owls to hungry badgers, which was nearly 8 percent of the broods she was monitoring. And in southern Alberta, during the summer of 2005, Helen Trefry saw 12 broods of burrowing owls eaten by badgers in a single week! With such high losses, it's not surprising that the crafty little burrowing owl has evolved a deception to fool gullible predators.

As early as 1882, the prestigious journal *Nature* published an article titled "The Scream of the Young Burrowing Owl Sounds Like the Warning of the Rattlesnake." Roughly 50 years later, Joseph Grinnell, the eminent ornithologist who studied the avian life of California for more than 40 years, penned this colorful description of an owl burrow he excavated.

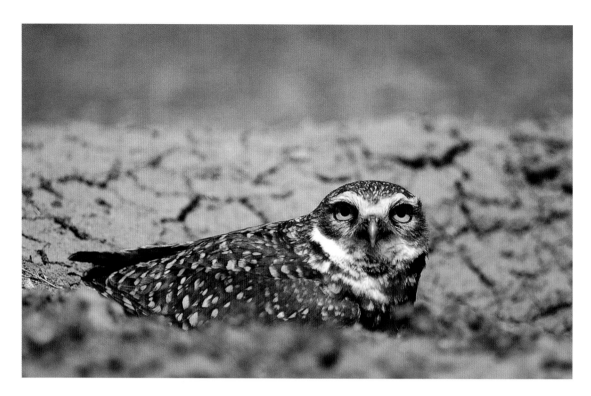

To dissuade nest predators, the burrowing owl produces a buzzing sound that imitates the agitated rattle of a rattlesnake—one of the few examples of acoustic mimicry in the animal kingdom.

When the burrow had been dug out two-thirds of the way to the end, a buzzing screech was heard that seemed so nearly like the muffled rattle of a rattlesnake that it was hard to feel sure that there was no snake in the burrow. As the digging proceeded this noise was heard more and more clearly. Finally the terminal cavity was opened up, disclosing six young owls. Their main defense was the utterance of the rasping, penetrating, rattling hiss, nearly like the angry buzz of a rattlesnake when disturbed on a warm day. This utterance was a deterrent in our case; might it not be so as regards carnivores that dig out or enter burrows such as the burrowing owls inhabit? Badgers, coyotes, weasels, and possibly such rodents as marmots and ground squirrels might thus be deterred from molesting the owls.

Mimicry in the natural world is a strategy used by many different animal groups to deceive and deter predators. It occurs in two forms, visual and acoustic. Visual mimicry is by far the more common of the two. Familiar examples include harmless hoverflies that resemble stinging wasps, edible viceroy butterflies that mimic poisonous monarchs, and nonvenomous kingsnakes that look like deadly coral snakes. By contrast, acoustic mimics, such as the burrowing owl, are relatively rare.

The dissuasive hiss of the burrowing owl is produced by young and adults alike when they are cornered inside their burrow. When the owls are outside their den they use a different vocalization, a screaming chatter, to threaten predators. Several species of rattlesnakes overlap the range of burrowing owls in North America, and since the potentially dangerous serpents commonly use burrows as refuges, the mimicry seems plausible. Though it appears obvious that the owls mimic the snakes to frighten away predators as well as burrow competitors, not until 1989 did a trio of researchers at the University of California actually test the theory and evaluate the reaction of mammals to the sound of a hissing

Guardian Owls

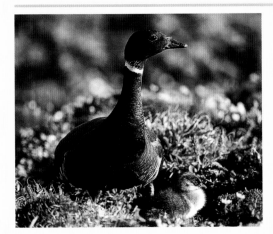

This black brant and her goslings made it safely to a nearby pond after nesting within 40 yards (37 m) of a nesting snowy owl.

Arctic ducks and geese seem to be aware of the snowy owl's ability to deter a hungry fox, and many of them nest near the owls apparently to gain protection from them. On Banks Island, in the western Canadian arctic, I found two pairs of black brants nesting within 40 yards (37 m) of an incubating snowy owl. There are similar anecdotal reports from other areas of the Canadian arctic as well as from Alaska and Wrangel Island off the northern coast of Russia. The best information on the association of owls and nesting waterfowl comes from a study conducted on Bylot Island, in Nunavut. Jean-Pierre Tremblay and his colleagues studied the nesting success of a colony of snow geese and the impact that a nearby nesting snowy owl had on arctic fox predation. In 1993, 236 goose nests were concentrated within 0.6 square miles (1.5 sq km), and the nests were clustered around a single nesting snowy owl. Some of the goose nests were less than 27.3 yards (25 m) from the owl, and nesting success that year was 90 percent. The following year, nesting snowy owls were absent from Bylot Island, presumably because of a crash in the local lemming population, and only 51 goose nests were found at the same site. Most of the nests were isolated and scattered unlike the previous year when they were clumped together around the nesting owl. Without the protective influence of the owl, only 23 percent of the goose nests hatched successfully.

owl. They discovered that the acoustic mimicry was indeed effective. California ground squirrels, a burrow competitor of the owls, responded to the defensive hiss of the owl as cautiously as they did to the sound of an actual rattlesnake.

The large powerful snowy owl, which also nests on the ground like the burrowing owl, doesn't need deception to deter a predator. It has the temperament and muscle to dissuade even the most fearsome of its enemies. I couldn't find any records of a successful attack on a healthy adult snowy owl by any predatory mammal. However, there are many reports of the audacious owls routing red and arctic foxes and even forcing large arctic wolves to take to their heels. Snowy owls can kill fox pups and seriously lacerate an adult fox with their talons. If any fox is imprudent enough to approach within 50 yards (45.7 m) of a nesting snowy owl it will likely be attacked and evicted.

Large birds of prey pose a greater threat to adult owls than do mammalian predators. There are records of red-tailed hawks killing long-eared owls and ferruginous hawks killing burrowing owls. The fast-flying accipiter hawks that routinely prey on birds are notorious owl predators. For example, sharp-shinned hawks kill northern pygmy-owls; Cooper's

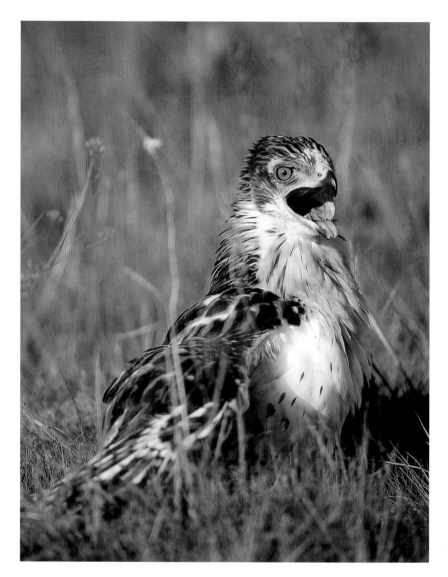

(*right*) This young ferruginous hawk is mantling over, or guarding, prey that it recently captured. These large powerful prairie hawks attack and kill burrowing and short-eared owls. (*opposite*) Although other owls are an uncommon prey of the great horned owl, it has been recorded killing nine different species, including the barred owl pictured here.

hawks prey on boreal, flammulated, and pygmy-owls; and the rapacious goshawk kills great gray, spotted, hawk, boreal, and long-eared owls.

But predatory owls pose the greatest threat to other owls. For example, barred owls and long-eared owls hunt northern saw-whets; spotted owls prey on western screech-owls and northern pygmy-owls; and northern hawk owls kill boreal and saw-whet owls.

The snowy owl, which is the heaviest and most powerful owl on the continent, should logically pose the greatest danger to other owls. But surprisingly, only the short-eared owl ends up in the snowy's diet. I watched a snowy owl near Barrow, Alaska, fly off with a dead short-eared owl in its talons, and biologists on Tatoosh Island, Washington, observed a snowy owl near a cache of three dead short-eared owls. The scarcity of other owls on the snowy owl's menu is probably a reflection of its preference for open treeless habitats where few other species of owls occur.

The great horned owl, the second heaviest owl in Canada and the United States, is the greatest owl killer of them all, preying on at least nine species of its kin, from snowy owls to screech-owls. In Oregon, up to 30 percent of juvenile spotted owls are killed by great horned owls,

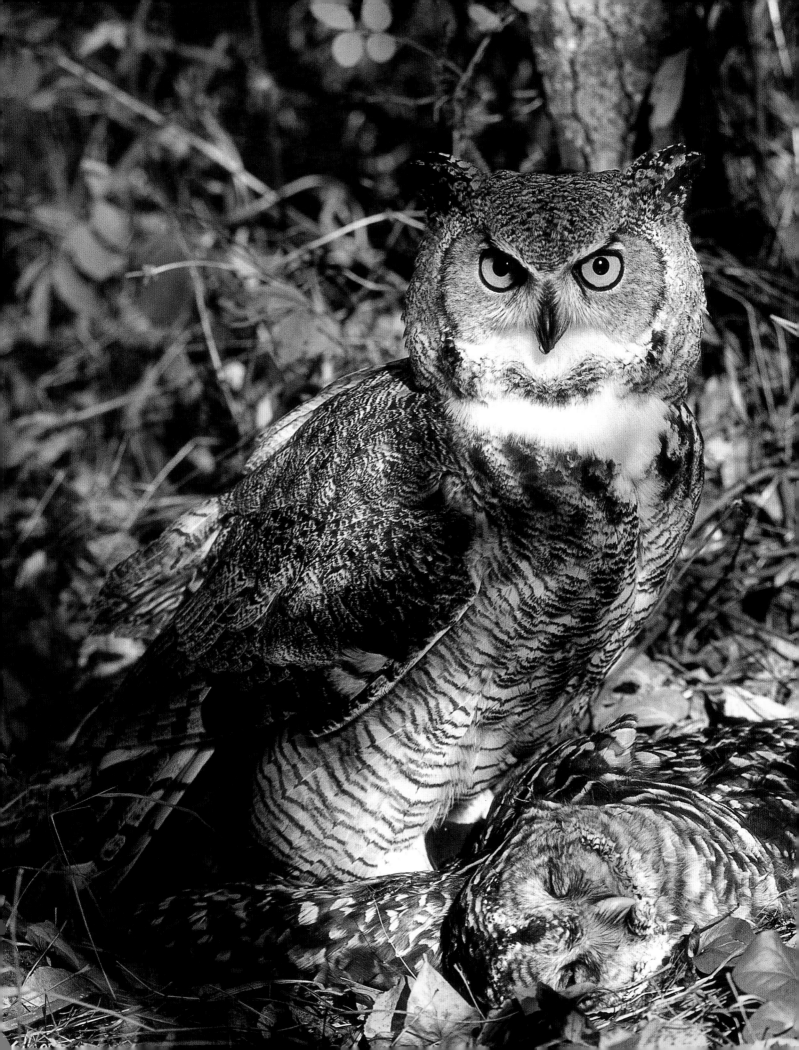

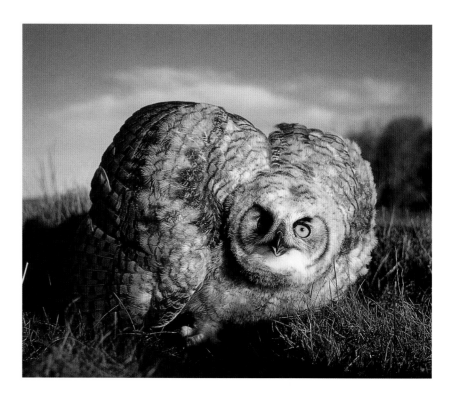

A young great horned owl will make itself look as large and intimidating as it can to discourage a predator.

and in Manitoba and northern Minnesota, up to 65 percent of juvenile great gray owls end up in the talons of a great horned owl.

Owls have a repertoire of behaviors they employ to protect themselves against predators. Their first line of defense is to avoid detection in the first place, and their secretive roosting behavior and cryptic plumage evolved for just this purpose. If an owl is discovered, it will usually fly away, but if flight is not possible, it will defend itself. First, it fluffs its body plumage and partially spreads its wings to appear two or three times larger than its normal size. At the same time it bends forward menacingly and sways back and forth. This visual defense is often preceded or accompanied by bill-snapping, hissing, or occasionally, low drawn-out screams. If the performance fails to dissuade an attacker, the owl's vocalizations may increase in intensity, getting louder and higher in pitch. When an attack seems imminent, the owl's final defense rests with its talons, and it may rake with its feet, or flop on its back and strike out fiercely.

One species of owl, the long-eared owl, sometimes employs an elaborate distraction display when its eggs or young are at risk. Arthur Cleveland Bent wrote: "I know of no bird that is bolder or more demonstrative in defense of its young, or one that can threaten the intruder with more grotesque performances or more weird and varied cries." Bent climbed to a nest where the female was brooding young and he described the ensuing reaction. "Her cries of distress soon brought her mate to the scene, and the performance began. Both parents were very demonstrative, flying about close at hand, alighting in the tree close to me, threatening to attack me, and indulging in a long line of owl profanity. One of the owls occasionally dropped to the ground, as if wounded, and fluttered along, crying piteously or mewing like a cat; by this ruse she succeeded in tolling my companion some distance away before she flew.

This wounded-bird act, which I have never seen performed by any other bird of prey, was repeated several times on this and on other occasions." Other observers have reported distraction displays in great gray owls and barred owls as well.

Kleptoparasitism

When one species of animal steals food from another, biologists call the behavior *kleptoparasitism*. Food piracy is well developed in seabirds, and relatively common among skuas, jaegers, gulls, and frigatebirds. Such thievery is exciting to witness and I've been lucky to see it happen often. Along the coast of Hudson Bay during a summer snow squall, I watched a parasitic jaeger harry an arctic tern in a lengthy high-speed chase filled with loops and dives. In the Galápagos Islands I have frequently seen frigatebirds harass boobies and tropicbirds, forcing them to disgorge their meals. The whalers of the 1800s called frigatebirds man-of-war birds because of their aerial thievery.

Among land birds, stealing food from each other is a relatively rare event, except in birds of prey. African vultures are notorious for stealing carcasses from each other, and gangs of these hissing thieves can even intimidate cheetahs, jackals, and solitary spotted hyenas, forcing them to relinquish their meals. In addition, bald eagles routinely pilfer prey from ospreys, hawks steal from harriers, and falcons steal from each other.

Kleptoparasitism in owls is uncommon, but it does happen. Ross Lein and Peter Boxall described seven different encounters between wintering snowy and short-eared owls. In one instance, a snowy owl that was perched on a power pole saw a short-eared owl flying with a mouse in its feet, about 500 yards (457 m) away. The snowy owl pursued the smaller owl and both disappeared behind a low rise. Seconds later the short-eared owl flew straight up about 50 feet (15 m) with empty feet, having seemingly surrendered its meal. The agitated victim stooped toward the snowy owl several times before flying away. In a salt marsh in Massachusetts, a wintering snowy owl pirated prey from a northern harrier. The owl flew under the harrier, turned on its back, and grappled for the small rodent the harrier was carrying in its feet. The prey fell to the ground and the owl followed it. The harrier circled overhead, calling excitedly, then flew away.

Big, powerful snowy owls are not the only strigids that purloin prey; short-eared owls also do, and their victims are usually harriers. One spring in southern Alberta, I found a northern harrier nest in the cattails of a prairie slough and spent some time photographing the birds. I remember an exciting attack by a short-eared owl on the male harrier as he returned to the nest to feed a vole to his mate. The harrier, which didn't see the owl approaching from above and behind, noticed the pirate at the last moment, just in time to swerve and avoid being hit by the aggressor's talons. The maneuverable owl was not dissuaded and followed the harrier closely, swooping on it repeatedly. The harrier veered from the direction of its nest and flew out over the treeless prairie, perhaps not wishing to disclose the nest's location. The harried raptor soon

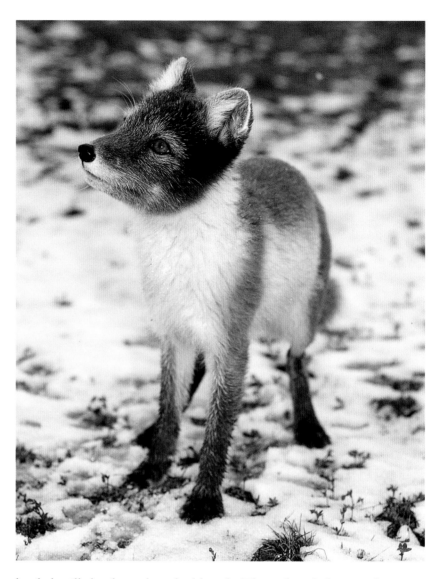

Birds of prey commonly steal food from each other but rarely steal from a mammal. However, in the Russian arctic, snowy owls are regularly seen stealing lemmings from arctic foxes.

landed, still clutching the valuable vole. The owl circled twice, then gave up and flew off.

The readiness with which a victim surrenders its prey to a pirate probably depends in large part on the owner's motivation, which would be greatest when it was feeding chicks and had the most to lose from a pilfered meal. The male harrier in my story was feeding three young chicks, with three more about to hatch, and he appeared ready to risk injury to feed them.

The rarest act of piracy is when an owl steals prey from a predatory mammal, and only the snowy owl has been seen doing this. Irina Menyushina watched the bold birds steal lemmings from arctic foxes on Russia's Wrangel Island. The owls resorted to piracy when the snow cover was deep and lemmings were difficult to catch. Under these circumstances, the owls constantly shadowed the foxes when they were hunting. While the canid was stalking or digging, the owl would perch at a distance of 500 to 650 feet (152–198 m) away. As soon as the fox caught a lemming, the owl would fly in and attack with its talons. Menyushina described what often followed: "To escape, the fox would jump and run, making sharp turns; if this was unsuccessful, the fox would drop its

prey and lunge at the owl with open jaws. That was the moment the owl was waiting for; it would dive past the fox, snatch up the lemming and fly away. Sometimes, foxes chased owls in such situations, but always without success."

A Call to Arms

In every forest, prairie, or patch of arctic tundra there are songbirds with a grudge against owls. The reason is simple: owls eat songbirds. So when passerines suddenly discover an owl in their midst, they often mob and pester it. One winter I sat by the roadside in northern Alberta to watch a northern hawk owl hunt for rodents. A flock of eight or nine hoary redpolls flew around the owl and perched in nearby trees, calling excitedly. At one point, a female hairy woodpecker joined the redpolls and chirped loudly from a dead snag close to the owl. The owl ignored the birds and eventually flew to another hunting perch about 50 yards (46 m) away.

Even playing a tape recording of an owl or imitating it with your voice can incite a mobbing reaction in songbirds. One autumn, in the Rocky Mountains west of Calgary, I whistled the territorial tooting call of the northern pygmy-owl and attracted three species of chickadees, mountain, boreal, and black-capped, as well as several red-breasted nuthatches, two gray jays, and a solitary blue jay. All were calling excitedly, searching for the owl they were certain was hiding somewhere in the trees. They finally left after three or four minutes of fruitless hunting.

In the early 1900s, John Darlington Carter described, in the colorful prose typical of his era, how some crows harassed a barred owl.

> No sooner was the bird on the wing than a party of Crows, idling in the neighborhood, gave chase with all the choice expletives which are reserved for the big owls. When perched in the midst of a cawing mob, the Owl would duck its head when one of the Crows made a dive at it, and would often counter by a thrust of the beak. When the crows were quiet enough, the snapping of the Owl's beak could be plainly heard for 100 yards. The Owl did not make any visible attempt to use its feet as weapons. On two occasions it dived inside a big hollow beech tree, leaving the watching mob outside. No doubt the Crows would have gone away in time, but in both cases the Owl came out again before they had dispersed. When perched in the open, the Owl's plan, if it had any, was to endure the pestering and profanity until the Crows one by one lost interest and drifted away; then by early stages, approach, and finally disappear in the nest cavity. It did not approach its nest so long as a single Crow appeared to be watching. There was no loud talk near the nursery door.

Mobbing may benefit songbirds in three different ways. It may drive an owl away, teach inexperienced offspring that an owl is a dangerous predator, or warn naive young that a predator is nearby and that caution is needed. Although owls will sometimes flee from a mob of agitated songbirds, they are just as likely to do nothing. The owl's response may depend on the size of the birds that are mobbing it and the potential

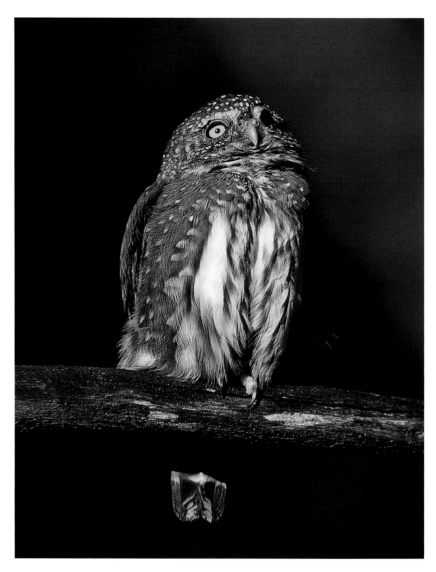

This northern pygmy-owl is responding to a pair of gray jays that started to harass it. Eventually, the owl flew off.

risk of injury. For example, a barn owl will usually try to escape from a harassing group of crows by flying to a safer, more hidden refuge. A barred owl harangued by ravens will do the same. Crows and ravens will commonly follow a retreating owl, calling loudly, possibly to rally neighbors to join in the chase. The official names for groups of these birds are a murder of crows and an unkindness of ravens, suggesting that owls are probably prudent in avoiding confrontations with these capable corvids.

When the tormenting songbirds are small and harmless, the owls often ignore them. Roosting boreal owls and northern saw-whets may even shut their eyes and appear to sleep. Frederick and Nancy Gehlbach watched a whiskered screech-owl that was roosting next to the trunk of an alligator juniper tree in Arizona. It was being mobbed by a number of house finches, Bewick's wrens, Hutton's vireos, and white-breasted nuthatches. The harassment lasted roughly five minutes, during which time the owl barely lifted an eyelid.

Songbirds gang up on owls, no matter what the owls are doing, whether hunting, nesting, roosting, or sleeping. No behavior pardons them from punishment. Many species of mobbing birds make them-

When an owl is sighted, the agitated croak of a raven can rally other ravens in the neighborhood, as well as other songbirds that all join together to mob the owl.

selves conspicuous with jerky tail and wing movements. Their agitated calls are instantly recognized by many other species, which is why mobs often contain multiple species. Gangs of pestering songbirds are mostly bluster, and they rarely strike an owl. Even so, I have seen irate red-winged blackbirds and western kingbirds strike a short-eared owl, and I've also heard of a tree swallow hitting the head of a great horned owl hard enough to dislodge a feather.

It's laughable how small a mobbing species can be compared to the owl it is pestering. For example, a tiny brown creeper joined a mob of Steller's jays, American robins, and pileated and acorn woodpeckers that were tormenting a great horned owl. In another instance involving a spotted owl, an Anna's hummingbird threw its weight into the fray. Try to imagine a full-grown Anna's hummingbird, weighing just 0.15 ounces (4.3 gm), challenging a spotted owl that weighs, on average, 1.3 pounds (590 gm)—a 142-fold difference, rather like a 10-year-old child taunting a bull elephant with a sharp stick.

The most thorough analysis of owls being mobbed by songbirds was done by Frederick Gehlbach in Texas in a study that compared urban and rural populations of eastern screech-owls. Gehlbach observed 134

Blue jays mob owls more often than other birds because owls often prey on them.

mobbings. His conclusion was that mobbing evolved principally to warn young birds and mates that a known dangerous predator was in their midst. Driving an owl away and teaching naive offspring which predators to fear were secondary benefits.

Gehlbach discovered that 60 percent of mobbing events occurred during the nesting season when screech-owls were feeding a clutch of hungry chicks. At that time of the year, the owls preyed heavily on songbirds and their newly fledged young. Wintering birds and migrants mobbed the owls less often than permanent residents. Texas screech-owls hunt mainly resident birds and mammals in the winter rather than seasonal or migratory songbirds, which consequently viewed the owls as a lesser threat. In fact, resident songbirds comprised 82 percent of mobs versus just 17 percent for wintering and migratory species. Interestingly, songbirds rarely mobbed fledgling screech-owls, and when they did, their attacks were less intense. Gehlbach surmised that this was a further indication that mobbing birds evaluate the threat an owl poses and adjust their behavior accordingly. Resident birds that mobbed the most—blue jays, northern cardinals, Carolina wrens, tufted titmice, and Carolina chickadees—were also the species that the owls hunted most. Thus, the greater a songbird's risk from predation, the greater its tendency to mob.

Gehlbach found that mobbing even took place at vacated owl roosts and empty nest cavities. For example, blue jays would mob these sites up to 240 days after they were abandoned. Gehlbach wrote in his fascinating book *The Eastern Screech Owl* that "the birds have memory of former danger and knowledge that any large cavity is hazardous."

Owls are not always the ones being mobbed, sometimes they join in themselves. Gehlbach watched a male eastern screech-owl join a flock of songbirds mobbing a black rat snake. In the arctic, four short-eared

False Eyespots

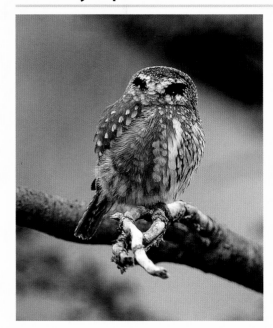

The false eye-spots on the nape of a pygmy-owl.

Pygmy-owls have two black oval spots, edged with white on the back of their head that resemble eyes. False eyespots also occur in other creatures such as tropical coral reef fishes, butterflies, moths, caterpillars, bush crickets, and the sunbittern, a bird of the neotropics. One South American leptodactylid frog has dramatic eyespots on its rump. When threatened, the frog lifts its rump toward the attacker.

The assumption has always been that pygmy-owls have false eyespots to deter an attack from the rear by a hungry predator, such as a spotted owl, great horned owl, goshawk, or Cooper's hawk. Caroline Deppe and colleagues wanted to know if the eyespots might also affect mobbing behavior in small forest birds since both species of pygmy-owls hunt songbirds, and in return, are mobbed by them. The researchers used wooden replicas of northern pygmy-owls, some with false eyespots painted on the nape of the neck and some without. To heighten the deception and elicit a mobbing reaction in the local songbirds, they played the owl's territorial call, as well as the mobbing calls of mountain chickadees and red-breasted nuthatches. They repeated the test in 32 different sites, and altogether 31 different species of birds mobbed the wooden models. Black-capped chickadees and red-breasted nuthatches responded more often than other species and were present at 50 percent of the trials. Deppe and her colleagues concluded that the eyespots appeared to drive the mobbers to the front of the owl. This suggested that the false eyespots may protect pygmy-owls from rear attacks by the tormenting songbirds. Additionally, by directing mobbers to the front, owls might more easily attack their tormenters.

owls ganged up on a snowy owl and mobbed it for more than a minute. Some short-eared owls are bold enough to mob bald eagles, rough-legged hawks, American bitterns, red foxes, and badgers. In Aravaipa Creek, a riparian woodland in Arizona, researchers tethered a live great horned owl. Within a few minutes, six elf owls began vocalizing and at least four of them swooped in on the large owl. One of the mobbing birds actually struck the large owl in the head before it could be moved to safety.

Owls and Humans

I saw my first spotted owl in June 1989 in the old-growth forests of western Oregon. A wide-eyed graduate student led me deep into the forest where giant trees towered above us and the ground was soft and cushioned with mosses. It had rained earlier in the morning and the air was humid and filled with a rich earthy fragrance. As we walked, I heard the haunting call of a varied thrush and the distant musical trills of a winter wren. After about 30 minutes my guide stopped and whistled loudly. As he did, he searched the darkened forest overhead for a movement. Suddenly an owl swooped silently onto a mossy limb and stared at us with eyes as black as midnight. The student pulled a live pet-store mouse from his backpack and set the unfortunate rodent on a fallen log beside us. Without hesitating, the owl floated down on muted wings and clutched the gift in its talons. We fed it two more mice and then waited to see what would happen. The owl had been fed like this many times before and it seemed to know there would be no more free meals that day. It turned and drifted away—a feathered shadow melting into a confusion of distant limbs and hazy greenness.

In the United States and Canada, the northern spotted owl has ignited controversy and stirred emotions more than any other species. In Oregon, the year I saw my first spotted owl, the loggers and owls were mortal foes, locked in a battle that neither could win. Bumper stickers proclaimed "I like spotted owls... fried" and "Save a logger... eat a spotted owl." In spite of the venom and the vitriol, there were still enough spotted owls and ancient forests left in Oregon to rally a successful call among conservationists for protection and preservation of both the forests and the owls.

Across the border, in British Columbia, the situation for spotted owls was dire. There were just 100 pairs of these elusive owls lurking in

(*opposite*) The secretive northern spotted owl lives in the old-growth forests of the Pacific Northwest, which receives more than 100 inches (254 cm) of rain per year.

the shadowed coastal forests. As I write these words, 17 years later, only 6 pairs of spotted owls and 10 single birds are estimated to remain in British Columbia. In Canada, the owl is doomed—the result of greed and the irresponsible logging and decimation of old-growth forests. Humans have altered and despoiled the planet like no other creature in the history of life on Earth. The eminent biologist Edward O. Wilson calls humans "the serial killers of the biosphere."

HIPPO

The acronym HIPPO is commonly used by conservation biologists to identify the different threats posed by humans to the environment and biodiversity.

H: Habitat destruction
I: Introduced species
P: Pollution
P: Population growth
O: Overconsumption

The impact that each of these has had on owls varies greatly.

Habitat destruction is unquestionably the greatest threat to owls, and all other plants and animals, not only in North America but also worldwide. Most species of owls live in forests of one sort or another, and the loss of these to logging and human expansion has eliminated many tracts of forests where owls once lived. It's difficult, however, to accurately evaluate how owl numbers respond to such habitat losses. The population status of most species of owls in Canada and the United States is largely unknown simply because many of them are secretive, nocturnal, and inhabit tractless hinterlands where few people venture. Biologists have often relied on an annual Christmas Bird Count (CBC) to gain insight into population trends and alert them to declines. The Christmas Bird Counts are a continent-wide winter bird census that began on Christmas Day 1900 in response to the senseless slaughter of birds whose feathers were used to adorn women's fashionable hats. The value of this census is limited since many large areas are never surveyed. For example, the great northern forests of spruce, pine, and fir that cloak a third of Canada are home to uncounted numbers of great grays, boreal, barred, great horned, and northern hawk owls. Since most of these birds have never been censused, it's impossible to evaluate the numerical impact that widespread clear-cut logging has on the resident owls.

The sad, yet preventable, story of the northern spotted owl's demise in Canada is a good example of how inadequate census information allowed the population to be decimated by uncontrolled logging. Typically, natural resources, such as forestry, are managed by governments that demand hard cold facts before they will make decisions that might decrease profits or hinder economic growth, the two sacred cows of modern progress. Thus, in British Columbia, while biologists and conservationists scrambled to gather convincing population data on the declining status of the owls, the logging industry forged ahead at full speed, cutting

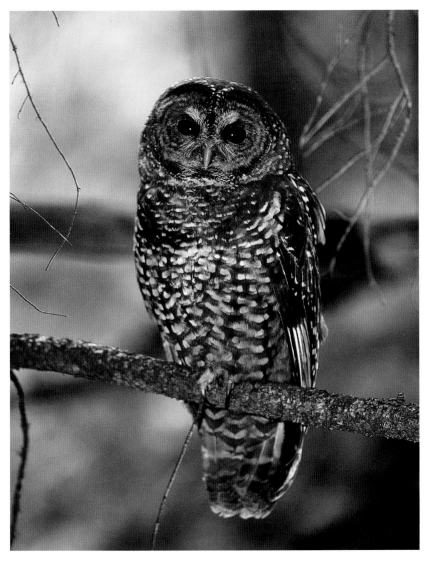

Because the northern spotted owl lives in mature forests that are coveted by loggers, it is one of the best studied owls in North America.

as much forest as fast as they could. A Vancouver newspaper headline from August 17, 2004, made the point quite movingly: "Spotted Owl Habitat Turned into Wood Chips." By the time biologists presented their discouraging population numbers to the government, the damage had been done, and the owl was on its irreversible slide to elimination.

Habitat loss is also incriminated in the decline of barn owls in southern Ontario and the precipitous slide of short-eared owls in the northeastern United States where the bird is a species of special concern, threatened, or endangered in 7 of 13 northeastern states. Farther west, in the Great Plains, burrowing owls have followed a similar disturbing downward trend. In most of the states bordering the eastern edge of the Great Plains, the range of the tiny owl has shrunk dramatically in recent decades. In Canada, the burrowing owl is now listed as endangered, and there may be fewer than 500 pairs remaining. The noted Nebraskan ornithologist Paul Johnsgard summarized the plight of the prairie burrowing owl: "In most western states the familiar 'howdy owl' is saying a long, sad farewell." Not surprisingly, the culprit in many of these instances is the loss of native prairies to croplands, recreation, housing, and resort development.

Spotted Owls and Logging

A logging truck headed for the lumber mill.

In the 1990s, the spotted owl, a secretive denizen of deep, shaded forests, was perhaps America's most controversial bird. Three subspecies are currently recognized: the northern spotted owl, which haunts the old-growth forests of the Pacific Northwest from coastal British Columbia to northern California; the California spotted owl, which lives in the Sierra Nevada and scattered mountain ranges in southern California; and the Mexican spotted owl, which inhabits the conifer and pine-oak forests and canyonlands of southern Utah and Colorado to central Mexico.

The reason for the controversy was simple. Spotted owls were disappearing at an alarming rate, and logging companies wanted the right to fell the forests despite the negative environmental impact. In June 1990, the northern spotted owl was listed as a threatened species under the U.S. Endangered Species Act. Two years later, as part of the protocol required when a species is listed, critical habitat was delineated to protect the old-growth forests used by the northern subspecies. In 1993, the Mexican spotted owl also became listed as a threatened species. Meanwhile, in the Pacific Northwest, the critical habitat legislation had basically stopped all logging in federally managed forests in Oregon, Washington, and northern California. The logging industry sounded the battle cry, and owls and loggers became mortal enemies. Eventually, a compromise was reached with the Northwest Forest Plan, which came into effect in April 1994. Since then, federal lands in Washington, Oregon, and northern California have been better managed to benefit the owls and the timber industry. Even so, old-growth forests continue to be felled on private and state lands and the owls continue to decline in numbers.

The fragmentation of habitat into smaller blocks is sometimes just as lethal to owls as is its total destruction. The case of barred owls versus great horned owls is a good example of this. Barred owls favor large continuous tracts of woodland, whereas the great horned owl thrives where forests are fragmented and tracts of trees are interrupted by open spaces. Fragmentation like this can occur when roads, pipelines, power lines, and seismic lines dissect a forest, or when an area is subjected to patchy clear-cut logging. When a forest becomes fragmented, the great horned

Fragmentation of forests, as seen here in the foot-
hills of the Canadian Rocky Mountains, changes
the ecology of the forest; many species, including
owls, disappear as a consequence.

owls that move in drive out the barred owls, or worse, kill them and eat them. Either way, barred owls are eliminated.

The *I* in HIPPO stands for introduced species. Worldwide, the accidental or purposeful introduction of invasive species has had tragic consequences. A few outstanding examples include the Pacific island of Guam where introduced brown tree snakes decimated the songbird population, driving most of the songbirds to extinction. In the Galápagos Islands, feral goats, pigs, burros, dogs, and cats, originally released into the islands by pirates and whalers, continue to threaten the islands' endemic species. The story repeats itself in the Hawaiian Islands where the introduction of rats, mongooses, and feral house cats has caused widespread bird declines. Additionally, it drove the Hawaiian rail to extinction and has endangered all of the surviving native Hawaiian water birds: the coot, moorhen, stilt, duck, and nene goose.

At first glance, the introduction of species would appear to be irrelevant, or at best, of minimal significance to the survival of owls in the United States and Canada. This was probably true until the summer of 1999 when the West Nile virus was first reported in New York City.

The featherless areas around a young boreal owl's eyes and beak are vulnerable sites where mosquitoes can bite them, as is happening here.

This potentially virulent virus has now spread into all 48 continental states, 7 Canadian provinces, and from Mexico to El Salvador. To date, at least 228 species of birds, 30 mammals, including humans, and two reptiles have been infected with the virus, which affects the brain and is potentially lethal. The virus is transmitted by the bite of a mosquito and 25 species of mosquitoes have been implicated so far in the virus's transmission, although the most important mosquito species seems to be *Culex pipiens*.

Mortality from the virus seems especially high in crows, blue jays, and hawks. Owls can also contract the disease. So far, the victims have included snowy owls, great horned owls, eastern screech-owls, a barred owl, and a short-eared owl. Researchers studying the *Culex pipiens* mosquito suggested that the reason why these particular birds are infected in relatively greater numbers is because of the mosquito's canopy-inhabiting behavior. Many of these birds perch, nest, or roost high in trees, which puts them at a greater risk from the virus-carrying mosquito that has a predilection for life in the treetops. It is still too early to predict what impact the arrival of West Nile virus will eventually have on populations of native wild owls, but it is certainly a threat that merits monitoring.

Third in the list, representing the first *P* in HIPPO, is pollution. Poisoning of the planet's air and water is a familiar topic in our chemically assisted world. Most people have heard the DDT story, although the memory of its tragic history is starting to dim with time. Dichlorodiphenyltrichloroethane (DDT) is a synthetic pesticide that was introduced in 1942, in the middle of the horrors of World War II. It was a bright moment in a dark time, for DDT killed the malarial mosquito, which was killing millions of people every year. The problem with DDT was that it didn't break down, and its toxic metabolites persisted in the

water and soil for years. It killed not only mosquitos but also whole food chains. Predators such as peregrine falcons, ospreys, bald eagles, and brown pelicans, which are at the top of the food chain, were especially hard hit because the toxins built up as they moved higher up the chain. The toxins not only killed the birds directly but also caused thinning of their eggshells, which resulted in reproductive failure, all of which resulted in population declines. The use of DDT was banned in Canada in 1971, in the United States in 1972, and finally in Mexico in 2000.

Owls were largely spared from the effects of the DDT crisis, but hundreds, if not thousands, of new potentially dangerous chemicals, including fungicides, herbicides, and pesticides, are sprayed on the planet every day in an effort to maximize the yield from crops. For most of these chemicals, we have no idea what the physiological repercussions will be if they eventually get into the bloodstream of wild birds and mammals. Predators, such as owls, at the top of their food chains, are at the greatest risk. For example, herbicides sprayed on crops are eaten by rodents that are then eaten by owls. At each stage, toxins, many of which accumulate in fat tissue, get more concentrated so that the deleterious effects are amplified the higher you go up the chain.

The effects of chemical pollutants have been well studied in wild burrowing owls. In Saskatchewan, when granular carbofuran, a broad-spectrum pesticide, was applied within 55 yards (50 m) of a burrowing owl nest, the breeding success of the owls declined by 50 percent. Carbofuran is highly toxic to birds. A single granule, which resembles a grain seed in size and shape, can kill a small songbird. Red-shouldered hawks have died after eating prey from carbofuran-treated fields. The application of granular carbofuran was banned in the United States in 1994 and in Canada in 1999, but liquid formulations of the pesticide are still allowed.

The sequence of events for monitoring the environmental impact of pesticides is always the same. All agricultural pests eventually evolve resistant strains that then require new and generally more toxic countermeasures, which then silently ripple through the food chain until we finally recognize their toxic effect, which then leads to a prohibition on use and ends with the search for a safer substitute and the wishful thought that the complications are reversible. There is reason to fear for the future chemical poisoning of owls by insidious toxins. But the fear should perhaps be no greater than the one we should have for the poisoning of humanity by these same chemicals.

The second *P* in HIPPO stands for population growth. More humans invariably means more of all the other HIPPO effects. The human population of the earth is now estimated to be roughly 6.6 billion. In the hour it took me to write these pages, the human burden on the planet increased by another 11,000 souls. And of course the hourly proliferation is even greater as the population increases. Our species, *Homo sapiens sapiens,* is not nearly as sapient as our name suggests when it comes to protecting and preserving the biosphere.

More people means a greater impact on the environment and a greater likelihood that owls will be affected. One of the major causes of

Farmers spray tons of pesticides on their crops to lessen the damage caused by insects such as grasshoppers. The poisoned grasshoppers concentrate the toxins, and if they are then eaten by owls, the birds may also die.

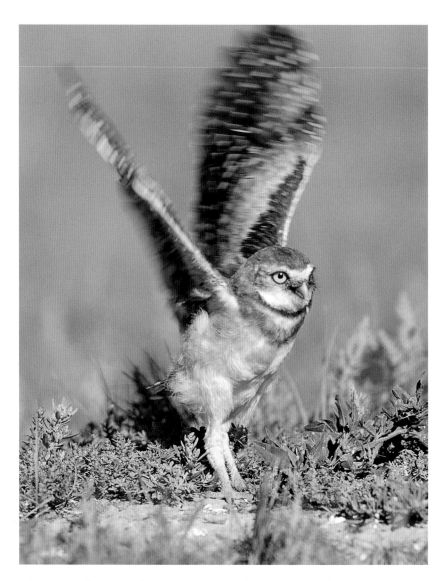

Burrowing owls are slowly disappearing from the prairies, and pesticides are one of the many reasons for their decline. Today, probably fewer than 400 to 500 burrowing owls remain in Canada.

adult mortality in owls are collisions with motor vehicles. In 1933, when a new highway opened through a swamp near New Orleans, Louisiana, 17 large owls, a combination of great horned and barred owls, were killed along a 10-mile (16-km) stretch of this road in the first few weeks of use. Today, more than 70 years after the Louisiana report, around 190 million motor vehicles sputter and spew along the highways of North America every day. By some estimates, nearly 300 million wild creatures are killed on the roads every year. That's nearly a million deaths a day. Owls are frequent victims. Gordon Court, an owl specialist with the Alberta government, estimates that several hundred road-killed owls are turned into his office every year, and he believes this represents just a small fraction of the total mortalities.

The best analysis of owl deaths from vehicle collisions was done in France, where Hugues Baudvin surveyed 161 miles (259 km) of roads traversing forests, cereal fields, sand pits, and meadows. During the course of his four-year study, dead animals were systematically collected three times a day. In that time, 1,625 road-kill mammals were recovered. Of these, 82.5 percent were carnivores, including domestic cats, European wild cats, red foxes, European badgers, ermines, least weasels,

and several species of martens. Baudvin also recovered 1,598 dead birds, of which 81.5 percent were owls and diurnal birds of prey. Barn owls and long-eared owls were the most frequent avian victims, totaling 974. Baudvin observed that predation on small mammals was the common behavior shared by the dead carnivores and raptors. He attributed the fatalities to the fact that the grassy roadsides in France provided an ideal habitat to support high numbers of voles, which, in turn, attracted the predators. The engineering of the roadway was also a contributing factor. In cases where the highway was level with or higher than the adjacent grassy roadsides, more owls were killed. There were many fewer victims when the highway was constructed below the surrounding terrain. He recommended that roadside vegetation be allowed to grow taller or that short bushes be planted beside roads. Either measure would make voles more difficult to catch and thus make roadsides a less attractive hunting habitat for owls.

The veteran owl researcher Robert Nero believes that great gray owls and barred owls are killed in such great numbers on the highways because of "focal concentration." Once an attacking owl locks onto a target it appears oblivious to anything else, such as a vehicle on a collision course with it. During such concentrated glides, great gray owls will sometimes fly directly into the side of cars, killing themselves instantly. Nero concludes that focal concentration may be a vital adaptation for successful hunting, but where roads and vehicles are involved, it may be a lethal handicap.

Owls can also collide with airplanes, although the incidence is relatively rare. In Canada, many snowy owls overwinter in the inhabited southern portions of the country and frequently settle around big city airports, such as in Calgary, Toronto, and Vancouver, where the open, treeless habitat is reminiscent of the owls' tundra breeding grounds. The owls may collide with planes during takeoffs and landings, get sucked into jet engines, or killed in back blasts. For the last 25 years, Norman Smith, with the Massachusetts Audubon Society, has been studying and banding wintering snowy owls at Logan International Airport in Boston. In some winters there were as many as 23 snowy owls on the airfield at one time, however, Smith knows of only a handful of instances when an owl collided with an aircraft or was killed in a back blast.

From 1990 to 1998, overall bird collisions cost the U.S. aviation industry more than $400 million per year. In 1999 alone, more than 5,000 bird strikes on American civil aircraft were reported, but industry experts estimated that 80 percent of all such strikes went unreported. Gulls and waterfowl, especially Canada geese, were the culprits in most of these collisions, although raptors, including owls, were involved in about 15 percent of them. To give you a sense of the damage potential of these collisions, consider a 4-pound (1.8-kg) snowy owl struck by a 737 jet traveling at 150 miles per hour on takeoff. The force of the owl's impact is equivalent to a 110-pound (50-kg) weight dropped from 10 feet (3 m).

Owls collide not only with planes, cars, and trucks but also with radio antennae, telephone lines, and barbed wire fences. I was surprised

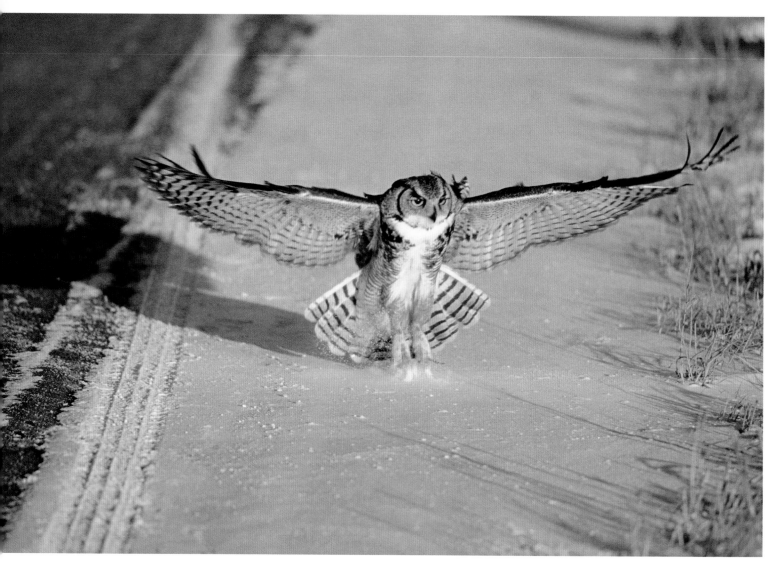

This great horned owl, hunting beside a rural highway, is completely focused on its targeted prey. In such circumstances, owls ignore everything around them, including oncoming traffic. As a result, it is not uncommon for owls to be killed in collisions with vehicles.

to learn that many owls are electrocuted on power lines. Various raptors, including hawks, eagles, falcons, and owls use poles and power lines to hunt, to survey their territories, or to rest and feed. These man-made perches are especially popular in the treeless habitats of the western prairies and badlands. When a raptor lands on a power pole if two fleshy parts of its body, such as its feet, wrists, or beak, simultaneously touch two electrified wires, the temporary connection acts as a conduit for electrical current and the bird is electrocuted instantly. Under wet conditions, waterlogged feathers may also conduct electricity. I have seen film footage of a turkey vulture bursting into flames when this happened. Cindy Platt studied the extent of raptor electrocutions in the aspen parklands and prairie grasslands of east-central Alberta. Within her 5,174-square-mile (13,400-sq-km) study area, she estimated that 542 to 2,762 raptors were electrocuted over a six-week period in the summer. The principal victims were great horned owls and red-tailed hawks, the owls outnumbering the hawks two to one.

The last of the HIPPO threats is overconsumption. Owls are a legally protected species in both the United States and Canada, so hunting them is illegal. Nonetheless, a small number of owls get shot every year

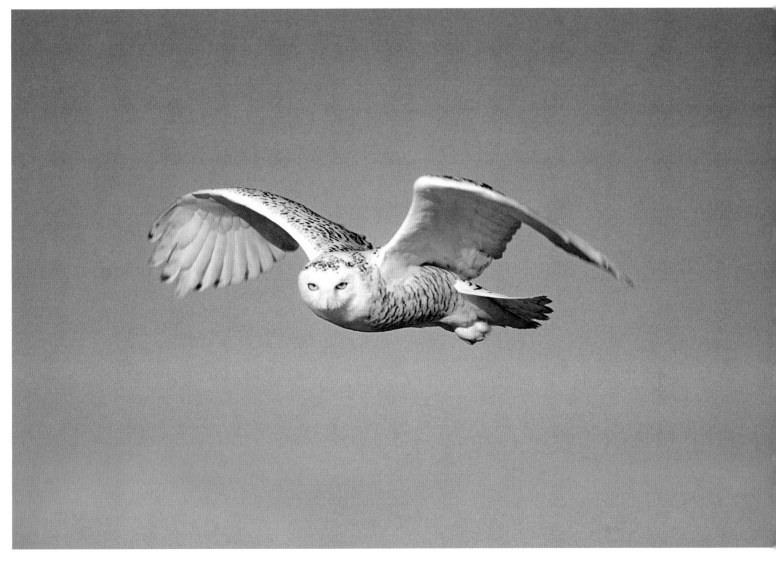

for target practice by a handful of hunters with more bullets than brains. Such mortalities, however, are probably minor and inconsequential to the survival of any owl population in North America.

The killing of owls by Native Americans is a separate issue. In Canada, the hunting rights of aboriginal people are controlled by the governments of the individual provinces. If a native hunter shoots an owl for food, he would probably not be charged with a crime. Such an action would be permissible on constitutional grounds, although such a case has never been challenged in court. It is illegal, however, for that same hunter to sell, trade, or barter the owl or its feathers, in other words, to traffic in animal parts.

In the United States, the federal Fish and Wildlife Service controls the management of nongame birds such as owls, under the protective umbrella of the Migratory Bird Treaty Act of 1918. With the passage of that act, all citizens, native and nonnative, were prohibited from killing or harming an owl. Native Americans, however, can obtain a permit to kill an owl if they are members of a federally recognized tribe and show the need, for religious or cultural reasons, to harvest an owl. Such permission is not granted lightly and few permits are issued.

This female snowy owl hunted in the fields near the Edmonton International Airport for several weeks one winter.

Decorative hand fans such as this one are used by native dancers in powwow competitions. It was made illegally from the tail feathers of a female snowy owl. The owner was charged in Alberta with trafficking in and illegal possession of wildlife.

With so much bad news about owls and humans, is there any good news? In a word, yes. The obvious first step in protecting owl populations is to establish where the owls are located and how many of them there are. Most species of nocturnal owls are poorly monitored by existing surveys such as Christmas Bird Counts and Breeding Bird Surveys. During the 1990s, volunteers from several regions of Canada and the United States developed nocturnal roadside surveys for breeding owls, but the survey methods were inconsistent, making it difficult to compare results from year to year, and from area to area. In response, a workshop was held in Winnipeg, Manitoba, in September 1999 to develop a standardized survey protocol that could be used continent-wide and one in which interannual variations and population trends could be more scientifically evaluated. Out of that meeting came "Guidelines for Nocturnal Owl Monitoring in North America." Currently, volunteer survey groups subscribing to the guidelines operate in all 10 provinces in Canada, as well as in the Yukon and Northwest Territories. The information collected goes into a national data base. Although many states have shown an interest in the protocol, only Montana and Minnesota presently have a volunteer owl monitoring program. Lead author of the protocol, Lisa Takats-Priestley, hopes that more states will eventually adopt the program once its value is recognized. Such coordinated survey data are vital for the development of sound conservation strategies and the understanding and tracking of population trends.

Another beneficial program, the North American Banding Program, which has been in operation since 1923, is jointly administered by the U.S. Fish and Wildlife Service and the Canadian Wildlife Service. The intent of the program is to place standardized aluminum bands around the legs of wild birds. A small clutch of owl chicks can be banded in a matter of minutes without harming the birds. Each band is inscribed

with a unique number and carries the abbreviated address of the U.S. Fish and Wildlife Service where the band can be sent if the bird is found dead or injured. Since the program began, several hundred million birds have been banded worldwide, including every species of owl in the United States and Canada.

When it comes to banding owls, no one has been more assiduous than Stuart Houston and his wife, Mary, in Saskatoon, Saskatchewan. Houston, a radiologist by profession, has been banding birds for 65 years. To date, he and Mary have banded roughly 132,000 birds rep-

(*top*) My wife, Aubrey Lang, and I originally found this family of great horned owls on a nocturnal owl census. This young chick had left the nest and was perched unwarily near the ground after a late spring snowstorm. (*bottom*) Bird bander Ray Cromie travels thousands of kilometers every winter searching for owls. He also builds nest boxes for northern saw-whet, boreal, and barred owls to encourage the birds to breed.

This is the tree stand I used to photograph the life cycle of a great horned owl family in Alberta. The nest was only 30 feet (9 m) away from me.

resenting 207 species. Included in these are 7 species of owls totaling 8,607 birds, of which 87 percent were great horned owls—a record for North America. Houston began banding as a youth during World War II when Ducks Unlimited paid him 10 cents for every duck he banded.

Despite Houston's climbing thousands of trees, it was not a fall from aloft that almost claimed his life, but an unexpected swim. One night in late May in the 1970s, Stuart was banding great horned owls when one of the owl chicks that was nearly full grown flew from the nest and landed in the middle of the South Saskatchewan River, which was swollen with the spring melt. Without thinking about it, he immediately stripped down to his undershorts and plunged into the river to rescue the owl, which had landed with a splash about 50 yards (46 m) offshore. The current was stronger than he expected and the water was freezing cold. By the time Stuart reached the chick he was numb all over. He was then faced with the daunting task of swimming back to shore clutching an owl chick in one hand before he succumbed to hypothermia. By the time he reached solid ground he was dangerously chilled, but happily he saved the owl and survived the ordeal.

The benefits of banding owls are many. It can provide information

on migration routes, destinations, distances, and speed of travel. Bands may also reveal whether a young bird returns to the location where it hatched, how long it lived, and perhaps even the cause of its death.

Another way that humans help owls is by erecting wooden nest boxes. This has become a common practice in rural woodlots, urban parks, and residential backyards throughout the United States and Canada. This practice can benefit a number of species, especially those that might be kept from breeding by a scarcity of suitable nesting cavities. For example, on Martha's Vineyard off the coast of Massachusetts, nest boxes were put up to encourage barn owls to breed. Over a 15-year period, the number of breeding pairs increased from 2 to 28.

Nest boxes work especially well with eastern screech-owls as well as barn owls because both species are tolerant of humans and readily settle in residential areas. In wilderness areas, nest boxes may attract whiskered and western screech-, northern saw-whet, boreal, northern pygmy-, flammulated, barred, and spotted owls. Since 1980, Alberta owl bander Ray Cromie has erected about 340 nest boxes for saw-whet owls, and he checks the boxes every spring. Ray estimates that an average of about 30 owl pairs use these boxes each year. One nest box was used for seven springs in a row by a different pair of owls every year.

The dimensions of the nest boxes and the size of the entrance holes vary with the different owl species. The height of the box and the habitat in which it is placed are also important. Such details are available on the U.S. Fish and Wildlife Service Web site (www.fws.gov). Commercially produced nest boxes can be purchased from numerous sources on the Internet.

Some owls will occupy platform nests built for them. A flat piece of plywood with some loose sticks on top can be fixed atop a pole or nailed to a tree. These nests are most often used by great gray owls, but also occasionally by long-eared owls and great horned owls.

Possibly the most effective way that humans can protect and preserve owls is by helping to change attitudes about these magnificent birds of prey. The caring concern of a single person can have a ripple effect that influences others. A school program where students see a tame owl and learn about the lives of these birds can have a lifelong impact on a child. A winter outing organized by a local nature club to see a roosting owl can turn a person into an ardent advocate for habitat and species preservation. Owls have that kind of power, just ask Bruce and Bonnie Caywood. The Caywoods live across the road from the Alberta woodlot where I spent three months photographing a family of great horned owls. Bruce and Bonnie had moved to the area the previous summer and had enjoyed hearing the owls but they had never seen one. In March 2002, when I traipsed into the woods to set up a tree stand, Bruce thought I might be a nest robber and he followed my tracks in the snow, ready to physically defend the owls if need be. After a few words of explanation, we immediately became friends, and he and Bonnie became the unofficial guardians of the owls. Throughout that summer, the family of great horned owls was all the Caywoods thought and talked about. They sent weekly e-mail reports about the owls to family members on the British

Tips for Finding Owls

At least one species of owl lives in every area of North America, and in most areas south of the arctic, there may be four or more. But finding them can be a challenge. Below are some of the ways that I have found useful in locating these elusive birds. The best book on the topic is *How to Spot an Owl*, written by Patricia and Clay Sutton, and I highly recommend it.

No. 1 Consult local nature clubs, birding hotlines, and Web sites.

Bird-watchers are generally friendly and helpful, and they will usually share information about the known owl-rich areas in your region. That's how I found out about the screech-owls in Ottawa that I showed my wife-to-be on one of our earliest dates. Many nature clubs also run weekend day-trips to locate winter owls. These outings are usually led by a local expert and visitors are welcome to tag along. Furthermore, every Christmas season, more than 1,500 natural history societies throughout North America conduct an annual bird count and the results are published by the National Audubon Society and Bird Studies Canada. By reviewing the census results from previous years you can learn where winter owls are commonly seen throughout the populated areas of the continent.

Birding hotlines are another good source of owl information. The telephone numbers are usually listed at local libraries and bird seed stores. The hotlines are taped messages listing recent rare or unusual bird sightings and their locations, and the messages are updated every week or so. The birding hotline in Ottawa was how I learned about the phenomenal "owlfest" that occurred on Amherst Island along the northern shore of Lake Ontario in the winter of 1977–78. That winter, there were at least 160 owls, including 6 different species, hunting on an island that is barely 15 miles (24 km) long! Owlers from as far away as Texas came to the island that winter.

With the proliferation of personal computers and the blooming of the Internet, regional

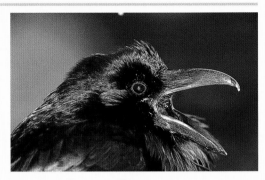

An agitated raven calling.

bird-watching Web sites offer the best information. Up-to-date postings from multiple contributors can quickly alert you to owls in your area. The Web site Alberta Bird (http://groups.yahoo.com/group/albertabird/) was how I learned about the exceptional 2005–6 winter aggregation of short-eared owls around Beaverhill Lake in central Alberta. I've also used such sites to find out where owls are located when I am planning a visit to a new area. I did this to locate barn owls in Florida and elf owls in Arizona. The participants on these Web sites were always extremely helpful, even offering to guide me to a location where I could observe the owls I wanted to see.

No. 2 Listen for bird calls.

During the day, many owls, especially the smaller ones such as northern saw-whets, boreals, pygmy-owls, and long-eared owls roost in thick shrubbery or bushy conifers. If foraging blue jays, chickadees, or redpolls locate one of these hidden owls, they chatter and chirp excitedly. These noisy calls summon other songbirds in the area, and together they mob the owl. I have found many owls by listening for these calls. It's not hard to recognize the agitated cawing of a mobbing crow or the screaming of a blue jay. Even an amateur bird-watcher can detect the excitement in the birds' voices.

No. 3 Prospect for pellets and poop.

Many owls use the same roost trees day after day. The branches and the ground underneath

them soon become soiled with conspicuous white droppings. In winter, long-eared owls commonly roost in groups, and several dozen owls may shelter in such roosts, making the droppings easy to spot.

Frequently, the ground below a roost site is also littered with pellets—those compact, cigar-shaped wads of undigested bones, teeth, and fur that owls regularly regurgitate.

No. 4 Cruise the roads.

The way I am most successful at finding owls is by driving slowly along highways and back roads, especially in winter when the leaves have fallen. Great gray owls, northern hawk owls, and snowy owls frequently hunt voles and mice in the ditches alongside roadways. These large conspicuous owls are fairly easy to locate. In some years, they literally flood into the forests and prairies of southern Canada and the northern United States, and they stay throughout the winter. This occurs roughly every three to five years when rodent populations in the boreal forest or the arctic crash, compelling the owls to move south. The winter of 1996–97 was one of those times. In February 1997, I attended a symposium on the biology and conservation of Northern Hemisphere owls in Winnipeg, Manitoba. During the conference, I joined a group of international owl scientists on a field trip to an area southeast of the city. In one afternoon, we saw 2 snowy owls, 19 great gray owls, and 32 hawk owls. On board our bus was a middle-aged Japanese biologist whose life dream it was to see just one northern hawk owl. She wore a smile for the rest of the day. Two weeks later, the local birder Rudolf Koes, while searching the same area, beat our one-day owl tally and found 4 snowy owls, 32 great gray owls, and 55 hawk owls, a world record for the hawk owl.

Riding the roads is also the best way I know to find nesting great horned owls. Where I live in southern Alberta, these large owls are the first birds to nest in spring, often starting to

A long-eared owl on a fencepost as seen from my car.

lay in the early days of March, long before the end of winter. Typically, great horned owls use the old stick nests of crows and hawks, and the owl's distinctive feathery ear tufts can be seen sticking above the rim of the nests from several hundred yards away. On a Sunday drive in March, armed with binoculars and a spotting scope, I can usually find 3 or 4 nesting great horned owls in the aspen woodlands around Calgary.

Sometimes a drive can yield unusual owl sightings. One afternoon, I found a long-eared owl in broad daylight sitting on a fencepost just 50 feet (15 m) from the edge of a gravel road. Long-eared owls are supposedly strictly nocturnal and highly secretive. I know that, but apparently the owl didn't. It was hunting voles in the ditch and I watched it at close range for more than an hour. It completely ignored my vehicle the whole time.

Columbia coast, who eagerly read the owl updates every Sunday. Bruce and Bonnie also shared owl stories with their rural neighbors and with dozens of visitors who dropped by their home. Most had never given much thought to owls before the Caywoods shared their excitement and interest with them. Four years later, Bruce and Bonnie continue to spread the word about the value and wonder of owls to anyone who will listen. How could such unbridled enthusiasm not have a beneficial ripple effect? As I write these words in the fall of 2006, I have just returned from a visit to the owl woods where I first met the Caywoods. The owl nest that collapsed in 2002 was rebuilt by another family of red-tailed hawks this past summer, and the Caywoods and I hope the owls will return again to nest in the spring. It has now been 22 years since I first began to follow the great horned owls living in these woods. With Bruce and Bonnie nearby, the future for the owls looks promising.

APPENDIX: Scientific Names of Plants and Animals

Common name (Scientific name)

acorn woodpecker (*Melanerpes formicivorus*)
adder (*Vipera berus*)
Adélie penguin (*Pygoscelis adeliae*)
African elephant (*Loxodonta africana*)
African lion (*Panthera leo*)
African white-backed vulture (*Gyps africanus*)
albatross (family Diomedeidae)
alligator (*Alligator mississippiensis*)
American bittern (*Botaurus lentiginosus*)
American coot (*Fulica americana*)
American kestrel (*Falco sparverius*)
American magpie (*Pica hudsonia*)
American robin (*Turdus migratorius*)
American wigeon (*Anas americana*)
amphipod (order Amphipoda)
Andean condor (*Vultur gryphus*)
Anna's hummingbird (*Calypte anna*)
aphid (family Aphidae)
arctic fox (*Alopex lagopus*)
arctic goose (*Anser* spp.)
arctic grayling (*Thymallus arcticus*)
arctic tern (*Sterna paradisaea*)
arctic wolf (*Canis lupus*)
ash-throated flycatcher (*Myiarchus cinerascens*)
auk (family Alcidae)
badger (*Taxidea taxus*)
bald eagle (*Haliaeetus leucocephalus*)
banana slug (*Ariolimax columbianus*)
barn owl (*Tyto alba*)
barred owl (*Strix varia*)
Barrow's goldeneye (*Bucephala islandica*)
bat (order Chiroptera)
bat falcon (*Falco rufigularis*)
bearded vulture (*Gypaetus barbatus*)
beaver (*Caster canadensis*)
bee hummingbird (*Mellisuga helenae*)
Bewick's wren (*Thryomanes bewickii*)
bird-of-paradise (family Paradisaeidae)
bittern (*Botaurus lentiginosus*)
black bear (*Ursus americanus*)
blackbird (family Icteridae)
black brant (*Branta bernicla*)
black-browed albatross (*Thalassarche melanophrys*)

black-capped chickadee (*Poecile atricapilla*)
black duck (*Anas rubripes*)
blackfly (family Simuliidae)
black rat snake (*Elaphe obsoleta obsoleta*)
black-tailed prairie dog (*Cynomys ludovicianus*)
bluebird (*Sialia* spp.)
blue jay (*Cyanocitta cristata*)
blue whale (*Balaenoptera musculus*)
bobcat (*Lynx rufus*)
bonobo (or pygmy chimpanzee) (*Pan paniscus*)
booby (family Sulidae; *Sula* spp.)
boreal chickadee (*Poecile hudsonica*)
boreal owl (*Aegolius funereus*)
broad-winged hawk (*Buteo platypterus*)
brown creeper (*Certhia americana*)
brown kiwi (*Apteryx australis*)
brown lemming (*Lemmus sibiricus*)
brown pelican (*Pelecanus occidentalis*)
brown tree snake (*Boiga irregularis*)
bufflehead (*Bucephala albeola*)
bumblebee (*Bombus polaris*)
burrowing owl (*Athene cunicularia*)
bushy-tailed woodrat (*Neotoma cinerea*)
California ground squirrel (*Spermophilus beecheyi*)
California spotted owl (*Strix occidentalis occidentalis*)
Canada goose (*Branta canadensis*)
Canada lynx (*Lynx canadensis*)
canyon wren (*Catherpes mexicanus*)
caracara (family Falconidae)
caribou (*Rangifer tarandus*)
Carolina chickadee (*Poecile carolinensis*)
Carolina wren (*Thryothorus ludovicianus*)
carpenter ant (*Camponotus* spp.)
carpet beetle (family Dermestidae)
caterpillar (order Lepidoptera)
centipede (class Chilopoda)
cheetah (*Acinonyx jubatus*)
chewing louse (order Mallophaga)
chipmunk (family Sciuridae)
Clark's nutcracker (*Nucifraga columbiana*)
cobra (*Naja* spp.)
cockroach (order Blattodea)
collared lemming (*Dicrostonyx groenlandicus*)
common eider (*Somateria mollissima*)
common goldeneye (*Bucephala clangula*)

common gray fox (*Urocyon cinereoargenteus*)
common loon (*Gavia immer*)
common raven (*Corvus corax*)
Cooper's hawk (*Accipiter cooperii*)
coot (*Fulica alai*)
coral snake (*Micrurus* spp.)
cormorant (family Phalacrocoracidae)
cottonmouth (*Agkistrodon piscivorus*)
courser (family Glareolidae)
coyote (*Canis latrans*)
crayfish (*Pacifastacus leniusculus*)
cricket (family Gryllidae)
crow (family Corvidae)
curled snow lichen (*Cetraria nivalis*)
curlew (*Numenius* spp.)
deer mouse (*Peromyscus maniculatus*)
Dolly Varden trout (*Salvelinus malma*)
Douglas fir (*Pseudotsuga menziesii*)
Douglas squirrel (*Tamiasciurus douglasii*)
downy woodpecker (*Picoides pubescens*)
duck (*Anas wyvilliana*)
dung beetle (family Scarabaeidae)
eastern cottontail rabbit (*Sylvilagus floridanus*)
eastern screech-owl (*Megascops asio*)
eel (*Anguilla rostrata*)
elegant trogon (*Euptilotis neoxenus*)
elephant bird (family Aepyornithidae)
elf owl (*Micrathene whitneyi*)
elk (*Cervus elaphus*)
emperor penguin (*Aptenodytes forsteri*)
emu (*Dromaius novaehollandiae*)
Engelmann spruce (*Picea engelmannii*)
ermine (*Mustela erminea*)
Eurasian capercaillie (*Tetrao urogallus*)
Eurasian eagle owl (*Bubo bubo*)
European badger (*Meles meles*)
European starling (*Sturnus vulgaris*)
European wild cat (*Felis sylvestris*)
falcon (family Falconidae)
ferruginous hawk (*Buteo regalis*)
ferruginous pygmy-owl (*Glaucidium brasilianum*)
finch (family Fringillidae)
fisher (*Martes pennanti*)
flamingo (family Phoenicopteridae)
flammulated owl (*Otus flammeolus*)
Florida panther (*Puma concolor*)
fly (*Carnus hemapterus*)
flycatcher (family Tyrannidae)
flying squirrel (*Glaucomys sabrinus*)
forest hawk (*Accipiter* spp.)
frigatebird (family Fregatidae)
frogmouth (order Caprimulgiformes)
Galapagos penguin (*Spheniscus mendiculus*)
giant anteater (*Myrmecophaga tridactyla*)
giant diving beetle (*Dysticus* spp.)
giant squid (*Architeuthis dux*)
gila woodpecker (*Melanerpes uropygialis*)

gilded flicker (*Colaptes chrysoides*)
godwit (*Limosa* spp.)
golden eagle (*Aquila chrysaetos*)
goose (family Anatidae)
gopher tortoise (*Gopherus polyphemus*)
grasshopper (order Orthoptera)
gray jay (*Perisoreus canadensis*)
gray partridge (*Perdix perdix*)
Great Basin spadefoot toad (*Spea intermontana*)
greater rhea (*Rhea americana*)
great gray owl (*Strix nebulosa*)
great horned owl (*Bubo virginianus*)
grebe (family Podicipedidae)
ground beetle (family Carabidae)
ground sloth (*Mesocnus* spp.)
grouse (family Phasianidae)
grouse (family Tetraonidae)
gull (family Laridae)
gyrfalcon (*Falco rusticolus*)
hairy lousewort (*Pedicularis lanata*)
hairy woodpecker (*Picoides villosus*)
Harris's hawk (*Parabuteo unicinctus*)
Hawaiian rail (*Porzana sandwichensis*)
hawk (*Buteogallus aequinoctialis*)
heron (family Ardeidae)
hoary redpoll (*Carduelis hornemanni*)
homing pigeon (*Columba livia*)
honey-buzzard (*Pernis* spp.)
hornbill (family Bucerotidae)
horsefly (family Tabanidae)
house cat (*Felis catus*)
house finch (*Carpodacus mexicanus*)
house mouse (*Mus musculus*)
house sparrow (*Passer domesticus*)
hoverfly (*Chrysotoxum* spp.)
Hudsonian godwit (*Limosa haemastica*)
Hume's owl (*Strix butleri*)
hummingbird (family Trochilidae)
humpback whale (*Megaptera novaeangliae*)
Hutton's vireo (*Vireo huttoni*)
isopod (order Isopoda)
jackal (*Canis* spp.)
jaegers (family Stercorariidae)
jay (family Corvidae)
Jerusalem cricket (*Stenopelmatus* spp.)
June beetle (order Coleoptera)
kangaroo rat (*Dipodomys* spp.)
king eider (*Somateria spectabilis*)
kingsnake (*Lampropeltis* spp.)
kite (*Rostrhamus sociabilis*)
kiwi (family Apterygidae)
lake trout (*Salvelinus namaycush*)
leafhopper (family Cicadellidae)
least weasel (*Mustela nivalis*)
leatherback sea turtle (*Dermochelys coriacea*)
leptodactylid frog (*Physalaemus nattereri*)
lily-trotter (family Jacanidae)

little owl (*Athene noctua*)
long-eared owl (*Asio otus*)
long-tailed duck (*Clangula hyemalis*)
long-tailed weasel (*Mustela frenata*)
loon (family Gaviidae)
mallard (*Anas platyrhynchos*)
manakin (family Pipridae)
marsh owl (*Asio capensis*)
marten (*Martes* spp.)
meadow vole (*Microtus pennsylvanicus*)
merlin (*Falco columbianus*)
Mexican chicken bug (*Haematosiphon inodorus*)
Mexican spotted owl (*Strix occidentalis lucida*)
mite (*Dermanyssus* spp.)
monarch butterfly (*Danaus plexippus*)
Montezuma quail (*Cyrtonyx montezumae*)
moorhen (*Gallinula chloropus*)
moose (*Alces alces*)
moth (family Noctuidae)
mountain bluebird (*Sialia currucoides*)
mountain chickadee (*Poecile gambeli*)
mountain whitefish (*Coregonus williamsonii*)
musk oxen (*Ovibos moschatus*)
muskrat (*Ondatra zibethicus*)
nene goose (*Branta sandvicensis*)
neotropical rattlesnake (*Crotalus durissus*)
New World vulture (family Cathartidae; *Antillovultur varonai*)
nightjar (family Caprimulgidae)
nine-banded armadillo (*Dasypus novemcinctus*)
northern bobwhite quail (*Colinus virginianus*)
northern cardinal (*Cardinalis cardinalis*)
northern flicker (*Colaptes auratus*)
northern flying squirrel (*Glaucomys sabrinus*)
northern goshawk (*Accipiter gentilis*)
northern harrier (*Circus cyaneus*)
northern hawk owl (*Surnia ulula*)
northern jacana (*Jacana spinosa*)
northern pintail (*Anas acuta*)
northern pocket gopher (*Thomomys talpoides*)
northern pygmy-owl (*Glaucidium gnoma*)
northern raccoon (*Procyon lotor*)
northern red-backed vole (*Clethrionomys rutilus*)
northern saw-whet owl (*Aegolius acadicus*)
northern spotted owl (*Strix occidentalis caurina*)
Norway rat (*Rattus norvegicus*)
oilbird (family Steatornithidae; *Steatornis caripensis*)
Old World vulture (family Accipitridae)
opossum (*Didelphis virginiana*)
osprey (family Pandionidae; *Pandion haliaetus*)
ostrich (*Struthio camelus*)
owlet moth (family Noctuidae)
oystercatcher (family Haematopodidae)
parasitic jaeger (*Stercorarius parasiticus*)
parrot (order Psittaciformes)
Patagonian hare (*Dolichotis patagonum*)
pelican (family Pelecanidae)

penguin (family Spheniscidae)
perch (family Percidae)
peregrine falcon (*Falco peregrinus*)
phalarope (*Phalaropus* spp.)
pheasant (family Phasianidae)
pigeon guillemot (*Cepphus columba*)
pileated woodpecker (*Dryocopus pileatus*)
pine grosbeak (*Pinicola enucleator*)
pine marten (*Martes americana*)
pine siskin (*Carduelis pinus*)
plains spadefoot toad (*Spea bombifrons*)
pocket gopher (*Thomomys* spp.)
polar bear (*Ursus maritimus*)
ponderosa pine (*Pinus ponderosa*)
porcupine (*Erethizon dorsatum*)
potoo (family Nyctibiidae)
prairie dog (*Cynomys* spp.)
praying mantid (order Mantodea)
puff adder (*Bitis arietans*)
pygmy chimpanzee (or bonobo) (*Pan paniscus*)
quail (family Phasianidae)
raccoon (*Procyon lotor*)
rail (family Rallidae)
rattlesnake (*Crotalus* spp.)
red-backed vole (*Clethrionomys rutilus*)
red-breasted nuthatch (*Sitta canadensis*)
red fox (*Vulpes vulpes*)
redpoll (*Carduelis* spp.)
red-shouldered hawk (*Buteo lineatus*)
red squirrel (*Tamiasciurus hudsonicus*)
red-tailed hawk (*Buteo jamaicensis*)
red-throated loon (*Gavia stellata*)
red-winged blackbird (*Agelaius phoeniceus*)
reindeer (*Rangifer tarandus tarandus*)
rhinoceros auklet (*Cerorhinca monocerata*)
Richardson's ground squirrel (*Spermophilus richardsonii*)
ringed seal (*Phoca hispida*)
ring-necked pheasant (*Phasianus colchicus*)
ringtail (*Bassariscus astutus*)
river otter (*Lontra canadensis*)
rough-legged hawk (*Buteo lagopus*)
ruffed grouse (*Bonasa umbellus*)
sandhill crane (*Grus canadensis*)
sandpiper (*Calidris* spp.)
seabird (order Procellariiformes)
sea turtle (*Dermochelys coriacea*)
secretarybird (*Sagittarius serpentarius*)
sharp-shinned hawk (*Accipiter striatus*)
shearwater (family Procellariidae)
shorebird (family Charadriidae)
short-eared owl (*Asio flammeus*)
shrew (family Soricidae)
shrike (family Laniidae)
skin beetle (family Trogidae)
skua (family Stercorariidae)
slender blind (or worm) snake (*Leptotyphlops dulcis*)

snow goose (*Chen caerulescens*)
snowshoe hare (*Lepus americanus*)
snowy owl (*Bubo scandiacus*)
songbird (order Passeriformes)
southern red-backed vole (*Clethrionomys gapperi*)
spider (class Arachnida)
spiny lizard (*Sceloporus* spp.)
spotted frog (*Rana pretiosa*)
spotted hyena (*Crocuta crocuta*)
spotted owl (*Strix occidentalis*)
spring peeper frog (*Pseudacris crucifer*)
springtail (order Collembola)
spruce (*Picea* spp.)
spruce grouse (*Falcipennis canadensis*)
starling (family Sturnidae)
Steller's jay (*Cyanocitta stelleri*)
stilt (*Himantopus knudseni*)
stone-curlew (family Burhinidae)
stork (family Ciconiidae)
storm petrel (*Oceanodroma tethys*)
striped skunk (*Mephitis mephitis*)
sunbird (family Nectariniidae)
sunbittern (*Eurypyga helias*)
sun spider (order Solpugida)
Swainson's hawk (*Buteo swainsoni*)
swallow (family Hirundinidae)
swift (family Apodidae)
swift fox (*Vulpes velox*)
tawny owl (*Strix aluco*)
tern (family Sturnidae)
thick-knee (family Burhinidae)
thrush (family Muscicapidae)
tidepool sculpin (*Oligocottus maculosus*)
toucan (family Ramphastidae)
tree swallow (*Tachycineta bicolor*)
tropicbird (*Phaethon aethereus*)
tufted titmouse (*Baeolophus bicolor*)
turkey vulture (*Cathartes aura*)
turtle (*Chrysemys picta*)
vampire bat (*Desmodus rotundus*)
varied thrush (*Ixoreus naevius*)
viceroy butterfly (*Limenitis archippus*)
vole (family Muridae; *Microtus* spp.)
vulture, New World (family Cathartidae; *Antillovultur varonai*)
vulture, Old World (family Accipitridae)
warbler (family Parulidae)
wasp (*Vespula* spp.)
waterfowl (family Anatidae)
western kingbird (*Tyrannus verticalis*)
western screech-owl (*Megascops kennicottii*)
western toad (*Bufo boreas*)
West Indian boa constrictor (*Tropidophis* spp.)
whip-poor-will (*Caprimulgus vociferus*)
whiskered screech-owl (*Megascops trichopsis*)
white-breasted nuthatch (*Sitta carolinensis*)

white-flowered prickly saxifrage (*Saxifraga tricuspidata*)
white-tailed deer (*Odocoileus virginianus*)
white-tailed jackrabbit (*Lepus townsendii*)
wild turkey (*Meleagris gallopavo*)
willow ptarmigan (*Lagopus lagopus*)
willow tit (*Parus montanus*)
winter wren (*Troglodytes troglodytes*)
wolverine (*Gulo gulo*)
woodpecker (family Picidae)
wood rat (*Neotoma* spp.)
worm (or blind) snake (*Leptotyphlops dulcis*)
wren (family Troglodytidae)
yellow oxytrope (*Oxytropis maydelliana*)

REFERENCES

General

del Hoya, J., A. Elliot, and J. Sargatal (eds.). 1999. *Handbook of the Birds of the World.* Vol. 5, *Barn-Owls to Hummingbirds.* Lynx Ediciones, Barcelona, Spain. 759 pp.

Duncan, J. 2003. *Owls of the World: Their Lives, Behavior, and Survival.* Firefly Books, Buffalo, NY. 319 pp.

Duncan, J. R., D. H. Nicholls, and H. Thomas (eds.). *Biology and Conservation of Owls of the Northern Hemisphere: 2nd International Symposium: 1997 February 5–9; Winnipeg, MB.* J. R. Duncan. P. 583. Gen. Tech. Rep. NC-190. St. Paul, MN: U.S. Department of Agriculture, Forest Service, North Central Research Station. 635 pp.

Gill, F. B. 1995. *Ornithology.* 2nd ed. W. H. Freeman, New York. 763 pp.

Johnsgard, P. 2002. *North American Owls: Biology and Natural History.* 2nd ed. Smithsonian Institution Press, Washington, DC. 298 pp.

Konig, C., F. Weick, and J. Becking. 1999. *Owls: A Guide to the Owls of the World.* Yale University Press, New Haven, CT. 462 pp.

Mikkola, H. 1983. *Owls of Europe.* Buteo Books, Vermillion, SD. 397 pp.

Nero, R. W., R. J. Clark, R. J. Knapton, and R. H. Hamre (eds.). 1987. *Biology and Conservation of Northern Forest Owls: Symposium Proceedings: 1987 February 3–7; Winnipeg, MB.* USDA Forest Service, Gen. Tech. Rep. RM-142. Fort Collins, CO. U.S. Dept. of Agriculture, Forest Service, Rocky Mountain Forest and Range Experiment Station. 309 pp.

Welty, J. C., and L. Baptista. 1988. *The Life of Birds.* 4th ed. Saunders College Publishing, New York. 581 pp.

Preface

Chauvet, J-M, E. B. Deschamps, and C. Hillaire. 1996. *Dawn of Art: The Chauvet Cave: The Oldest Known Paintings in the World.* Harry N. Abrams, New York. 135 pp.

Clottes, J. 2001. "Chauvet Cave." *National Geographic* August:104–21.

Holmgren, V. C. 1988. *Owls in Folklore and Natural History.* Capra Press, Santa Barbara, CA. 175 pp.

Marcot, B. C., and D. H. Johnson. 2003. "Owls in Mythology and Culture." In *Owls of the World: Their Lives, Behavior, and Survival.* J. R. Duncan. Pp. 88–105. Firefly Books, Buffalo, NY. 319 pp.

Mikkola, H. 1997. "World Distribution of Owlaholics." In *Biology and Conservation of Owls of the Northern Hemisphere: 2nd International Symposium: 1997 February 5–9; Winnipeg, MB.* J. R. Duncan, D. H. Nicholls, and H. Thomas (eds.). P. 583. Gen. Tech. Rep. NC-190. St. Paul, MN: U.S. Department of Agriculture, Forest Service, North Central Research Station. 635 pp.

Weinstein, K. 1985. *Owls, Owls, Fantastical Fowls.* Arco Publishing, New York. 144 pp.

Chapter 1 Anatomy of an Owl

Arredondo, O. 1976. "The Great Predatory Birds of the Pleistocene of Cuba." *Smithsonian Contributions to Paleobiology* 27:164–87.

Cade, T. J. 1952. "A Hawk Owl Bathing with Snow." *Condor* 54:360.

Coulombe, H. N. 1970. "Physiological and Physical Aspects of Temperature Regulation in the Burrowing Owl *Speotyto cunicularia.*" *Comp. Biochem. Physiol.* 35:307–37.

de la Torre, J., and A. Wolfe. 1990. *Owls: Their Life and Behavior.* Crown Publishers, New York. 214 pp.

Eckert, A., and K. E. Karalus. 1974. *The Owls of North America (North of Mexico).* Doubleday, Garden City, NY. 278 pp.

Feduccia, A. 1999. *The Origin and Evolution of Birds.* 2nd ed. Yale University Press, New Haven, CT. 466 pp.

Gehlbach, F. R. 1994. *The Eastern Screech Owl: Life History, Ecology, and Behavior in Suburbia and the Countryside.* Texas A&M Univ. Press, College Station. 302 pp.

———. 1995. "Eastern Screech-Owl (*Otus asio*)." In *The Birds of North America, No. 165.* A. Poole and F. Gill (eds.). Academy of Natural Sciences, Philadelphia, PA, and American Ornithologists' Union, Washington, DC.

Holt, D. W., R. Kline, and L. Sullivan-Holt. 1990. "A Description of 'Tufts' and Concealing Posture

in Northern Pygmy-Owls." *J. Raptor Res.* 34 (3):59–63.

Johnson, D. H. 1997. "Wing Loading in 15 Species of North American Owls." In *Biology and Conservation of Owls of the Northern Hemisphere: 2nd International Symposium: 1997 February 5–9; Winnipeg, MB.* J. R. Duncan, D. H. Nicholls, and H. Thomas (eds.). Pp. 553–61. Gen. Tech. Rep. NC-190. St. Paul, MN: U.S. Department of Agriculture, Forest Service, North Central Research Station. 635 pp.

Mosher, J. A., and C. J. Henry. 1976. "Thermal Adaptiveness of Plumage Color in Screech Owls." *Auk* 93:614–19.

Poole, E. L. 1938. "Weights and Wing Areas in North American Birds." *Auk* 55:511–17.

Proudfoot, G. A., R. L. Honeycutt, and R. D. Slack. 2006. "Mitochondrial DNA Variation and Phylogeography of the Ferruginous Pygmy-Owl (*Glaucidium brasilianum*)." *Conservation Genetics* 7 (1):1–12.

Roulin, A. 1999. "Nonrandom Pairing by Male Barn Owls (*Tyto alba*) with Respect to a Female Plumage Trait." *Behav. Ecol.* 10 (6):688–95.

Roulin, A., C. Riols, C. Dijkstra, and A. L. Ducrest. 2001. "Female Plumage Spottiness Signals Parasite Resistance in the Barn Owl (*Tyto alba*)." *Behav. Ecol.* 12 (1):103–10.

Sibley, C. G., and J. E. Ahlquist. 1990. *Distribution and Taxonomy of Birds of the World.* Yale University Press, New Haven, CT. 1136 pp.

———. 1991. *Phylogeny and Classification of Birds: A Study of Molecular Evolution.* Yale University Press, New Haven, CT. 1080 pp.

Wink, M., and P. Heinrich. 1999. "Molecular Evolution and Systematics of the Owls (Strigiformes)." In *Owls: A Guide to the Owls of the World.* C. Konig, F. Weick, and J. Becking. Pp. 39–57. Yale University Press, New Haven, CT. 462 pp.

Chapter 2 Son et Lumière

Barlow, H. B. 1981. "Critical Limiting Factors in the Design of the Eye and Visual Cortex." *Proc. R. Soc. Lond.* B. 212:1–34.

Bowmaker, J. K., and H. J. A. Darnell. 1980. "Visual Pigments of Rods and Cones in a Human Retina." *J. Physiol.* (Lond). 298:501–11.

Bowmaker, J. K., and G. R. Martin. 1978. "Visual Pigments and Colour Vision in a Nocturnal Bird, *Strix aluco* (Tawny Owl)." *Vision Res.* 18:1125–30.

Dice, D. L. 1945. "Minimum Intensities of Illumination under Which Owls Can Find Dead Prey by Sight." *Am. Nat.* 79:384–416.

Duncan, J. R., and P. A. Lane. 1988. "Great Horned Owl Observed 'Hawking' Insects." *J. Raptor Res.* 22 (3):93.

Eckert, A., and K. E. Karalus. 1974. *The Owls of North America (North of Mexico).* Doubleday, Garden City, NY. 278 pp.

Fite, K. V. 1973. "Anatomical and Behavioural Correlates of Visual Acuity in the Great Horned Owl." *Vision Res.* 13:219–30.

Gill, F. B. 1995. *Ornithology.* 2nd ed. W. H. Freeman, New York. 763 pp.

Goodman, S. M., and C. Glynn. 1988. "Comparative Rates of Natural Osteological Disorders in a Collection of Paraguayan Birds." *J. Zool. (Lond).* 214:167–77.

Hecht, S., and M. H. Pirenne. 1940. "The Sensitivity of the Nocturnal Long-eared Owl in the Spectrum." *J. Gen. Physiol.* 23:709–17.

Hilden, O., and P. Helo. 1981. "The Great Gray Owl *Strix nebulosa:* A Bird of the Northern Taiga." *Ornis Fennica* 58:159–66.

Hill, J. E., and J. D. Smith. 1992. *Bats: A Natural History.* University of Texas Press, Austin. 243 pp.

Kaufman, Kenn. 1991. *Owls Up Close.* Directed by Michael Godfrey. Nature Science Network. VHS.

Knudson, E. I., and M. Konishi. 1979. "Mechanisms of Sound Localization in the Barn Owl (*Tyto alba*)." *J. Comp. Physiol.* 133:12–21.

Konishi, M. 1973. "How the Owl Tracks Its Prey." *Am. Sci.* 61:414–24.

———. 1973. "Locatable and Nonlocatable Acoustic Signals for Barn Owls." *Am. Nat.* 107 (958):775–85.

Krebs, J. R., N. S. Clayton, S. D. Healy, D. A. Cristol, S. N. Patel, and A. R. Jolliffe. 1996. "The Ecology of the Avian Brain: Food-storing Memory and the Hippocampus." *Ibis* 138:34–46.

Lythgoe, J. N. 1979. *The Ecology of Vision.* Oxford University Press, Oxford. 244 pp.

Martin, G. R. 1977. "Absolute Visual Threshold and Scotopic Spectral Sensitivity in the Tawny Owl, *Strix aluco.*" *Nature* (Lond.) 268:636–38.

———. 1982. "An Owl's Eye: Schematic Optics and Visual Performance in *Strix aluco* L." *J. Comp. Physiol.* 145:341–49.

———. 1984. "The Visual Fields of the Tawny Owl, *Strix aluco* L." *Vision Res.* 24:1739–51.

———. 1986. "The Eye of a Passeriforme Bird, the European Starling (*Sturnus vulgaris*): Eye Movement Amplitude, Visual Fields, and Schematic Optics." *J. Comp. Physiol.* 159:545–57.

———. 1986. "Sensory Capacities and the Nocturnal Habit of Owls (Strigiformes)." *Ibis* 128:266–77.

———. 1986. "Total Panoramic Vision in the Mallard Duck (*Anas platyrhynchos*)." *Vision Res.* 26:1303–5.

———. 1990. *Birds by Night.* Poyser, London. 227 pp.

Moss, R., and I. Lockie. 1979. "Infrasonic Components in the Song of the Capercaillie *Tetrao urogallus.*" *Ibis* 121:95–97.

Motani, R., B. M. Rothschild, and W. Wahl Jr. 1999. "Large Eyeballs in Diving Ichthyosaurs." *Nature* 402:747.

Norberg, R. A. 1968. "Physical Factors in Directional Hearing in Aegolius Funereus (Strigiformes), with Special Reference to the Significance of the Asymmetry of the External Ears." *Ark. Zool.* 20:181–204.

———. 1977. "Occurrence and Independent Evolution of Bilateral Ear Asymmetry in Owls and Implications on Owl Taxonomy." *Phil. Trans. R. Soc. London.* 280:376–408.

———. 1978. Skull Asymmetry, Ear Structure and Function, and Auditory Localization in Tengmalm's Owl, *Aegolius funereus* (Linné)." *Phil. Trans. R. Soc. London.* B. 282:325–410.

———. 1987. "Evolution, Structure, and Ecology of Northern Forest Owls." In *Biology and Conservation of Northern Forest Owls: Symposium Proceedings: 1987 February 3–7; Winnipeg, MB.* R. W. Nero, R. J. Clark, R. J. Knapton, and R. H. Hamre (eds.). Pp. 9–43. USDA Forest Service, Gen. Tech. Rep. RM-142. Fort Collins, CO. U.S. Dept. of Agriculture, Forest Service, Rocky Mountain Forest and Range Experiment Station. 309 pp.

Ollivier, F. J., D. A. Samuelson, D. E. Brooks, P. A. Lewis, M. E. Kallberg, and A. M. Komáromy. 2004. "Comparative Morphology of the Tapetum Lucidum (among Selected Species)." *Veterinary Ophthalmology* 7 (1):11–22.

Payne, R. S. 1962. "How the Barn Owl Locates Prey by Hearing." *Living Bird* 1:151–59.

———. 1971. "Acoustic Location of Prey by Barn Owls (*Tyto alba*)." *J. Exp. Biol.* 54:535–73.

Poole, J. H., K. Payne, W. R. Langbauer, and C. J. Moss. 1988. "The Social Contexts of Some Very Low Frequency Calls of African Elephants." *Behav. Ecol. Sociobiol.* 22:385–92.

Roffler, S. K., and R. A. Butler. 1968. "Factors That Influence the Localization of Sound in the Vertical Plane." *J. Acoust. Soc. Am.* 43:1255–59.

Schmidt, P. H., A. H. Van Gemert, R. J. Der Vries, and J. W. Duyff. 1953. "Biaural Thresholds for Azimuth Difference." *Acta Physiol. et Pharmacol. Neer.* 3:2–18.

Sivian, L. J., and S. D. White. 1933. "On Minimal Audible Sound Fields." *J. Acoust. Soc. Am.* 4:288–321.

Snow, D. W. 1961. "The Natural History of the Oilbird, *Steatornis caripensis,* in Trinidad. 1. General Behaviour and Breeding Habits." *Zoologica* 46:27–48.

Street, T. H. 1870. "Remarks on the Cranium of an Owl." Proceedings of the Academy of Natural Sciences of Philadelphia 1870:73.

Vander Wall, S. B. 1990. *Food Hoarding in Animals.* University of Chicago Press, Chicago. 445 pp.

Walker, L. W. 1993. *The Book of Owls.* University of Texas Press, Austin. 256 pp.

Walls, G. L. 1942. *The Vertebrate Eye and Its Adaptive Radiation.* Cranbrook Institute of Science, Bloomfield Hills, MI. 785 pp.

Chapter 3 Haunts and Hideaways

Andrusiak, L.A., and K. M. Cheng. 1997. "Breeding Biology of the Barn Owl (*Tyto alba*) in the Lower Mainland of British Columbia." In *Biology and Conservation of Owls of the Northern Hemisphere: 2nd International Symposium: 1997 February 5–9; Winnipeg, MB.* J. R. Duncan, D. H. Nicholls, and H. Thomas (eds.). Pp. 38–46. Gen. Tech. Rep. NC-190. St. Paul, MN: U.S. Department of Agriculture, Forest Service, North Central Research Station. 635 pp.

Barrows, C., and K. Barrows. 1978. "Roost Characteristics and Behavioral Thermoregulation in the Spotted Owl." *West. Birds* 9:1–8.

Bent, A. C. 1961. *Life Histories of North American Birds of Prey: Hawks, Falcons, Caracaras, Owls.* Part 2. Dover Publications, New York. 482 pp.

Berthold, P. 1996. *Control of Bird Migration.* Chapman and Hall, New York. 355 pp.

Boxall, P. C., and M. R. Lein. 1982. "Territoriality and Habitat Selection of Female Snowy Owls (*Nyctea scandiaca*) in Winter." *Can. J. Zool.* 60:2344–50.

Bull, E. L., and J. R. Duncan. 1993. "Great Gray Owl (*Strix nebulosa*)." In *The Birds of North America, No. 41.* A. Poole and F. Gill (eds.). Academy of Natural Sciences, Philadelphia, PA, and, American Ornithologists' Union, Washington, DC.

Burt, W. H. 1943. "Territory and Home Range Concepts as Applied to Mammals." *J. Mamm.* 24:346–52.

Chaplin, S. B., D. A. Diesel, and J. A. Kasparie. 1984. "Body Temperature Regulation in Red-tailed Hawks and Great Horned Owls: Responses to Air Temperature and Food Deprivation." *Condor* 86:175–81.

Coulombe, H. N. 1970. "Physiological and Physical Aspects of Temperature Regulation in the Burrowing Owl *Speotyto cunicularia*." *Comp. Biochem. Physiol.* 35:307–37.

Gehlbach, F. R., and N. Y. Gehlbach. 2000. "Whiskered Screech-Owl (*Otus trichopsis*)." In *The Birds of North America, No. 507.* A. Poole and F. Gill (eds.). Academy of Natural Sciences, Philadelphia, PA, and American Ornithologists' Union, Washington, DC.

Gessaman, J. A. 1972. "Bioenergetics of the Snowy Owl (*Nyctea scandiaca*)." *Arctic and Alpine Research* 4 (3):223–38.

Gross, A. O. 1927. "The Snowy Owl Migration of 1926–27. *Auk* 44:479–93.

———. 1931. "Snowy Owl Migration of 1930–31." *Auk* 48:501–11.

———. 1947. "Cyclic Invasions of the Snowy Owl and the Migration of 1945–1946." *Auk* 64:584–601.

Gutierrez, R. J. 1989. "Hematozoa from the Spotted Owl." *J. Wildl. Dis.* 25:614–18.

Haug, E. A., B. A. Millsap, and M. S. Martell. 1993. "Burrowing Owl (*Speotyto cunicularia*)." In *The Birds of North America, No. 61.* A. Poole and F. Gill (eds.). Academy of Natural Sciences, Philadelphia, PA, and American Ornithologists' Union, Washington, DC.

Holt, D. W., and S. M. Leasure. 1993. "Short-eared Owl (*Asio flammeus*)." In *The Birds of North America, No. 62.* A. Poole and F. Gill (eds.). Academy of Natural Sciences, Philadelphia, PA, and American Ornithologists' Union, Washington, DC.

Holt, D. W., and J. L. Petersen. 2000. "Northern Pygmy-Owl (*Glaucidium gnoma*)." In *The Birds of North America, No. 494.* A. Poole and F. Gill (eds.). Academy of Natural Sciences, Philadelphia, PA, and American Ornithologists' Union, Washington, DC.

Houston, C. S., D. G. Smith, and C. Rohner. 1998. "Great Horned Owl (*Bubo virginianus*)." In *The Birds of North America, No. 372.* A. Poole and F. Gill (eds.). Academy of Natural Sciences, Philadelphia, PA, and American Ornithologists' Union, Washington, DC.

Hunter, D. B., C. Rohner, and D. C. Currie. 1997. "Mortality in Fledgling Great Horned Owls from Black Fly Hematophaga and Leucocytozoonosis." *J. Wildl. Dis.* 33:486–91.

Keith, L. B. 1964. "Territoriality among Wintering Snowy Owls." *Can. Field Nat.* 78:17–24.

Kerlinger, P., and M. R. Lein. 1986. "Differences in Winter Range among Age-Sex Classes of Snowy Owls, *Nyctea scandiaca,* in North America." *Ornis Scand.* 17:1–7.

Korpimäki, E. H., H. Hakkarainen, and G. F. Bennett. 1993. "Blood Parasites and Reproductive Success of Tengmalm's Owls: Detrimental Effects on Females but Not Males." *Funct. Ecol.* 7:420–26.

Ligon, J. D. 1968. "The Biology of the Elf Owl, *Micrathene whitneyi*." Miscellaneous Publications, Museum of Zoology, University of Michigan No. 136. Ann Arbor, MI. 70 pp.

———. 1969. "Some Aspects of Temperature Regulation in Small Owls." *Auk* 86:458–72.

Lynch, W. 1997. *Penguins of the World.* Firefly Books, Buffalo, NY. 143 pp.

Marks, J. S., D. L. Evans, and D. W. Holt. 1994. "Long-eared Owl (*Asio otus*)." In *The Birds of North America, No. 133.* A. Poole and F. Gill (eds.). Academy of Natural Sciences, Philadelphia, PA, and American Ornithologists' Union, Washington, DC.

McCallum, D. A. 1994. "Review of Technical Knowledge: Flammulated Owls." In *Flammulated, Boreal, and Great Gray Owls in the United States: A Technical Conservation Assessment.* G. D. Hayward and J. Verner (eds.). Pp. 14–46. Gen. Tech. Rep. RM-253. Fort Collins, CO. U.S. Department of Agriculture, Forest Service, Rocky Mountain Forest and Range Experiment Station. 214 pp.

Merritt, J. F. (ed). 1984. *Winter Ecology of Small Mammals.* Special Publication No. 10, Carnegie Museum of Natural History, Pittsburgh, PA. 380 pp.

Moulton, M. P., K. E. Miller, and E. A. Tillmer. 2001. "Patterns of Success among Introduced Birds in the Hawaiian Islands." *Studies in Avian Biology* 22:31–46.

Nero, R. W. 1980. *The Great Gray Owl: Phantom of the Northern Forest.* Smithsonian Institution Press, Washington, DC. 167 pp.

Priestley, L., and C. Priestley. 2007. "Discovery of a Short-eared Owl Invasion at Beaverhill Lake, Alberta." *Blue Jay.* In press.

Rohner, C., F. I. Doyle, and J. N. M. Smith. 2001. "Great Horned Owls (*Bubo virginianus*)." In *Ecosystem Dynamics of the Boreal Forest: The Kluane Project.* C. J. Krebs, S. Boutin, and R. Boonstra (eds.). Pp. 339–76. Oxford University Press, New York. 511 pp.

Rohner, C., C. J. Krebs, D. B. Hunter, and D. C. Currie. 2000. "Roost Site Selection of Great Horned Owls in Relation to Black Fly Activity: An Anti-parasite Behavior? *Condor* 102:950–55.

Ryder, R. A., D. A. Palmer, and J. J. Rawinski. 1987. "Distribution and Status of the Boreal Owl in Colorado." In *Biology and Conservation of Northern Forest Owls: Symposium Proceedings: 1987 February 3–7; Winnipeg, MB.* R. W. Nero, R. J. Clark, R. J. Knapton, and R. H. Hamre (eds.). Pp. 169–74. USDA Forest Service, Gen. Tech. Rep. RM-142. Fort Collins, CO. U.S. Dept. of Agriculture, Forest Service, Rocky Mountain Forest and Range Experiment Station. 309 pp.

Siegfried, W. R., R. L. Abraham, and V. B. Kuechle. 1975. "Daily Temperature Cycles in Barred, Great Horned, and Snowy Owls." *Condor* 77:502–6.

Soule, O. H. 1964. "The Saguaro Tree-Hole Microenvironment in Southern Arizona. II. Summer." M.Sc. thesis, Univ. of Arizona, Tucson.

Watson, A. 1957. "The Behaviour, Breeding, and Food Ecology of the Snowy Owl, *Nyctea scandiaca*." *Ibis* 99:419–62.

Chapter 4 The Owlish Appetite

Abbruzzese, C. M., and G. Ritchison. 1997. "The Hunting Behavior of Eastern Screech-Owls (*Otus asio*)." In *Biology and Conservation of Owls of the Northern Hemisphere: 2nd International Symposium: 1997 February 5–9; Winnipeg, MB.* J. R. Duncan,

D. H. Nicholls, and H. Thomas (eds.). Pp. 21–32. Gen. Tech. Rep. NC-190. St. Paul, MN: U.S. Department of Agriculture, Forest Service, North Central Research Station. 635 pp.

Baicich, P. J., and C. J. O. Harrison. 1997. *A Guide to the Nests, Eggs, and Nestlings of North American Birds.* 2nd ed. Academic Press, New York. 347 pp.

Bondrup-Nielsen, S. 1977. "Thawing of Frozen Prey by Boreal and Saw-whet Owls." *Can. J. Zool.* 55:595–601.

Boxall, P. C., and M. R. Lein. 1982. "Feeding Ecology of Snowy Owls (*Nyctea scandiaca*) Wintering in Southern Alberta." *Arctic* 35 (1): 282–90.

Bull, E. L., and J. R. Duncan. 1993. "Great Gray Owl (*Strix nebulosa*)." In *The Birds of North America, No. 41.* A. Poole and F. Gill (eds.). Academy of Natural Sciences, Philadelphia, PA, and American Ornithologists' Union, Washington, DC.

Bull, E. L., and M.G. Henjum. 1990. "The Neighborly Great Gray Owl." *Nat. Hist.* 9:32–41.

Cade, T. J., P. T. Redig, and H. B. Tordoff. 1989. "Peregrine Falcon Restoration: Expectation vs. Reality." *Loon* 61:160–62.

Cannings, R. J. 1993. "Northern Saw-whet Owl (*Aegolius acadicus*)." In *The Birds of North America, No. 42.* A. Poole and F. Gill (eds.). Academy of Natural Sciences, Philadelphia, PA, and American Ornithologists' Union, Washington, DC.

Collins, K. M. 1980. "Aspects of the Biology of the Great Gray Owl, *Strix nebulosa* Forster." M.Sc. thesis, University of Manitoba, Department of Zoology, Winnipeg, MB. 219 pp.

Collister, D. M. 1995. "Prey Caching by Non-breeding Northern Hawk Owls in Alberta." *Blue Jay* 53 (4):203–4.

Daoust, P-T., M. Elderkin, and J. Kennedy. 2005. "Fatal Encounter of a Great Horned Owl with a Porcupine." *Wildlife Health Centre Newsletter* 11 (1):4–5.

Duke, G. E., and D. D. Rhoades. 1977. "Factors Affecting Meal to Pellet Intervals in Great Horned Owls (*Bubo virginianus*)." *Comp. Biochem. Physiol.* 55A:283–86.

Duncan, J. R., and P. A. Duncan. 1998. "Northern Hawk Owl (*Surnia ulula*)." In *The Birds of North America, No. 356.* A. Poole and F. Gill (eds.). Academy of Natural Sciences, Philadelphia, PA, and American Ornithologists' Union, Washington, DC.

Duncan, J. R., and P. H. Hayward. 1994. "Review of Technical Knowledge: Great Gray Owls." In *Flammulated, Boreal, and Great Gray Owls in the United States: A Technical Conservation Assessment.* G. D. Hayward and J. Verner (eds.). Pp. 159–75. Gen. Tech. Rep. RM-253. Fort Collins, CO. U.S. Department of Agriculture, Forest Service, Rocky Mountain Forest and Range Experiment Station. 214 pp.

"Enteric Disease Associated with Animal Contact, Minnesota, 1999–2004." 2005. *Minn. Dept. Health* 33 (2):13–20.

Gehlbach, F. R. 1994. *The Eastern Screech Owl: Life History, Ecology, and Behavior in the Suburbs and Countryside.* Texas A&M University Press, College Station. 302 pp.

———. 1995. "Eastern Screech-Owl (*Otus asio*)." In *The Birds of North America, No. 165.* A. Poole and F. Gill (eds.). Academy of Natural Sciences, Philadelphia, PA, and American Ornithologists' Union, Washington, DC.

Gehlbach, F. R., and R. S. Baldridge. 1987. "Live Blind Snakes (*Leptotyphlops dulcis)* in Eastern Screech Owl *(Otus asio)* Nests: A Novel Commensalism." *Oecologica* 71:560–63.

George, W. G., and R. Sulski. 1984. "Thawing of Frozen Prey by a Great Horned Owl." *Can. J. Zool.* 62:314–15.

Grimm, R. J., and W. M. Whitehouse. 1963. "Pellet Formation in a Great Horned Owl: A Roentgenographic Study." *Auk* 80:301–6.

Gutiérrez, R. J., A. B. Franklin, and W. S. Lahaye. 1995. "Spotted Owl (*Strix occidentalis*)." In *The Birds of North America, No. 179.* A. Poole and F. Gill (eds.). Academy of Natural Sciences, Philadelphia, PA, and American Ornithologists' Union, Washington, DC.

Hannah, K. C. 1999. "Status of the Northern Pygmy-Owl (*Glaucidium gnoma californicum*) in Alberta." Alberta Environmental Protection, Fisheries and Wildlife Management Division, and Alberta Conservation Association, Wildlife Status Report No. 20, Edmonton, AB. 20 pp.

Hayward, G. D., P. H. Hayward, and E. O. Garton. 1987. "Movements and Home Range Use of Boreal Owls in Central Idaho." In *Biology and Conservation of Northern Forest Owls: Symposium Proceedings: 1987 February 3–7; Winnipeg, MB.* R. W. Nero, R. J. Clark, R. J. Knapton, and R. H. Hamre (eds.). Pp. 175–84. USDA Forest Service, Gen. Tech. Rep. RM-142. Fort Collins, CO. U.S. Dept. of Agriculture, Forest Service, Rocky Mountain Forest and Range Experiment Station. 309 pp.

Hayward, J. L., J. G. Galusha, and G. Frias. 1993. "Analysis of Great Horned Owl Pellets with Rhinoceros Auklet Remains." *Auk* 110:133–35.

Henry, S. G., and F. R. Gehlbach. 1999. "Elf Owl (*Micrathene whitneyi*)." In *The Birds of North America, No. 413.* A. Poole and F. Gill (eds.). Academy of Natural Sciences, Philadelphia, PA, and American Ornithologists' Union, Washington, DC.

Holt, D. W., and S. M. Leasure. 1993. "Short-eared Owl (*Asio flammeus*)." In *The Birds of North America, No. 62.* A. Poole and F. Gill (eds.). Academy of Natural Sciences, Philadelphia, PA, and American Ornithologists' Union, Washington, DC.

Houston, C. S., D. G. Smith, and C. Rohner. 1998. "Great Horned Owl (*Bubo virginianus*)." In *The Birds of North America, No. 372*. A. Poole and F. Gill (eds.). Academy of Natural Sciences, Philadelphia, PA, and American Ornithologists' Union, Washington, DC.

Johnsgard, P. 1988. *North American Owls: Biology and Natural History*. 1st ed. Smithsonian Institution Press, Washington, DC. 295 pp.

Kertell, K. 1986. "Reproductive Biology of Northern Hawk-Owls in Denali National Park, Alaska." *J. Raptor Res*. 20:91–101.

Klauber, L. M. 1972. *Rattlesnakes: Their Habits, Life Histories, and Influence on Mankind*. 2nd ed. Vols. 1 and 2. University of California Press, Los Angeles. 1533 pp.

Korpimäki, E. 1987. "Prey Caching of Breeding Tengmalm's Owls (*Aegolius funereus*) as a Buffer against Temporary Food Shortages." *Ibis* 129:499–510.

Ligon, J. D. 1968. "The Biology of the Elf Owl, *Micrathene whitneyi*." Miscellaneous Publications, Museum of Zoology, University of Michigan No. 136. Ann Arbor, MI. 70 pp.

Marks, J. S., D. L. Evans, and D. W. Holt. 1994. "Long-eared Owl (*Asio otus*)." In *The Birds of North America, No. 133*. A. Poole and F. Gill (eds.). Academy of Natural Sciences, Philadelphia, PA, and American Ornithologists' Union, Washington, DC.

Marti, C. D. 1973. "Food Consumption and Pellet Formation Rates in Four Owl Species." *Wilson Bull*. 85 (2):178–81.

McCallum, D. A. 1994. "Flammulated Owl (*Otus flammeolus*)." In *The Birds of North America, No. 93*. A. Poole and F. Gill (eds.). Academy of Natural Sciences, Philadelphia, PA, and American Ornithologists' Union, Washington, DC.

McInvaille, W. B., and L. B. Keith. 1974. "Predator-Prey Relations and Breeding Biology of the Great Horned Owl and Red-tailed Hawk in Central Alberta." *Can. Field-Nat*. 88:1–20.

McNair, D. B. 1994. "Caching by an Irruptive Hawk Owl." *Blue Jay* 52 (4):216–17.

Mikkola, H. *Owls of Europe*. Buteo Books, Vermillion, SD. 397 pp.

Murray, G. A. 1976. "Geographic Variation in the Clutch Sizes of Seven Owl Species." *Auk* 93:602–13.

Nero, R. W. 1980. *The Great Gray Owl: Phantom of the Northern Forest*. Smithsonian Institution Press, Washington, DC. 167 pp.

———. 1993. "Evidence of Snow-plunging by Boreal and Barred Owls." *Blue Jay* 51 (3):166–69.

Norberg, R. A. 1987. "Evolution, Structure, and Ecology of Northern Forest Owls." In *Biology and Conservation of Northern Forest Owls: Symposium Proceedings: 1987 February 3–7; Winnipeg, MB*.

R. W. Nero, R. J. Clark, R. J. Knapton, and R. H. Hamre (eds.). Pp. 9–43. USDA Forest Service, Gen. Tech. Rep. RM-142. Fort Collins, CO. U.S. Dept. of Agriculture, Forest Service, Rocky Mountain Forest and Range Experiment Station. 309 pp.

Perrone, M., Jr. 1981. "Adaptive Significance of Ear Tufts in Owls." *Condor* 83:383–84.

Proudfoot, G. A., and R. R. Johnson. 2000. "Ferruginous Pygmy-Owl (*Glaucidium brasilianum*)." In *The Birds of North America, No. 498*. A. Poole and F. Gill (eds.). Academy of Natural Sciences, Philadelphia, PA, and American Ornithologists' Union, Washington, DC.

Rohner, C., and F. I. Doyle. 1992. "Food-stressed Great Horned Owl Kills Adult Goshawk: Exceptional Observation or Community Process?" *J. Raptor Res*. 26 (4):261–63.

Siddle, C. 1984. "Raptor Mortality on Northeastern British Columbia Trapline." *Blue Jay* 42 (3):184.

Sonerud, G. A. 1992. "Search Tactics of a Pause-Travel Predator: Adaptive Adjustments of Perching Times and Move Distances by Hawk Owls (*Surnia ulula*)." *Behav. Ecol. Sociobiol*. 30:207–17.

Steidl, R. J., C. R. Griffin, L. J. Niles, and K. E. Clark. 1991. "Differential Reproductive Success of Ospreys in New Jersey." *J. Wildl. Manage*. 55:266–72.

Vander Wall, S. B. 1990. *Food Hoarding in Animals*. University of Chicago Press, Chicago. 445 pp.

Watson, A. 1957. "The Behaviour, Breeding, and Food Ecology of the Snowy Owl, *Nyctea scandiaca*." *Ibis* 99:419–62.

Weir, A., and A. Hanson. 1989. "Food Habits of Great Horned Owls, *Bubo virginianus*, in the Northern Taiga of the Yukon Territory and Alaska." *Can. Field Nat*. 103 (1):12–17.

Wotton, M. 1976. "Summer of the White Owl." *Audubon* 78 (4):32–41.

Yalden, D. W., and P. A. Morris. 1990. "The Analysis of Owl Pellets." Occasional Paper No. 13. Mammal Society, London. 24 pp.

Chapter 5 Family Life

Andersson, M. 1980. "Nomadism and Site Tenacity as Alternative Reproductive Tactics in Birds." *J. Animal Ecol*. 49:175–84.

Appleby, B. M., and S. M. Redpath. 1997. "Indicators of Male Quality in the Hoots of Tawny Owls (*Strix aluco*)." *J. Raptor Res*. 31 (1):65–70.

Bent, A. C. 1961. *Life Histories of North American Birds of Prey: Hawks, Falcons, Caracaras, Owls*. Part 2. Dover Publications, New York. 482 pp.

Cannings, R. J., and T. Angell. 2001. "Western Screech-Owl (*Otus kennicottii*)." In *The Birds of North America, No. 597*. A. Poole and F. Gill (eds.). Academy of Natural Sciences, Philadelphia, PA, and American Ornithologists' Union, Washington, DC.

Clark, K. A., and S. H. Anderson. 1997. "Temporal, Climatic, and Lunar Factors Affecting Owl Vocalizations of Western Wyoming." *J. Raptor Res.* 31 (4):358–63.

Dark, S. J., R. J. Gutiérrez, and G. I. Gould. 1998. "The Barred Owl (*Strix varia*) Invasion in California." *Auk* 115:50–56.

del Hoya, J., A. Elliot, and J. Sargatal (eds.). 1999. *Handbook of the Birds of the World.* Vol. 5, *Barn-Owls to Hummingbirds.* Lynx Ediciones, Barcelona, Spain. 759 pp.

Earhart, C. M., and N. K. Johnson. 1970. "Size Dimorphism and Food Habits of North American Owls." *Condor* 72:251–64.

Ford, N. L. 1983. "Variation in Mate Fidelity in Monogamous Birds." *Current Ornithol.* 1:329–56.

Forsman, E. D., E. C. Meslow, and H. M. Wright. 1984. "Distribution and Biology of the Spotted Owl in Oregon." *Wildl. Monogr.* 87:1–64.

Gehlbach, F. R. 1994. *The Eastern Screech Owl: Life History, Ecology, and Behavior in the Suburbs and Countryside.* Texas A&M University Press, College Station. 302 pp.

Gehlbach, F. R., and N. Y. Gehlbach. 2000. "Whiskered Screech-Owl (*Otus trichopsis*)." In *The Birds of North America, No. 507.* A. Poole and F. Gill (eds.). Academy of Natural Sciences, Philadelphia, PA, and American Ornithologists' Union, Washington, DC.

Gill, F. B. 1995. *Ornithology.* 2nd ed. W. H. Freeman, New York. 763 pp.

Gottfred, J., and A. Gottfred. 1996. "Copulatory Behavior in the Great Horned Owl." *Blue Jay* 54:180–84.

Grant, R. A. 1965. "The Burrowing Owl in Minnesota." *Loon* 37:2–17.

Green, G. A. 1983. "Ecology of Breeding Burrowing Owls in the Columbia Basin, Oregon." M.Sc. thesis, Oregon State University, Corvallis. 51 pp.

Green, G. A., and R. G. Anthony. 1989. "Nesting Success and Habitat Relationships of Burrowing Owls in the Columbia Basin, Oregon." *Condor* 91:347–54.

Gutiérrez, R. J., A. B. Franklin, and W. S. Lahaye. 1995. "Spotted Owl (*Strix occidentalis*)." In *The Birds of North America, No. 179.* A. Poole and F. Gill (eds.). Academy of Natural Sciences, Philadelphia, PA, and American Ornithologists' Union, Washington, DC.

Hamer, T. E., E. D. Forsman, A. D. Fuchs, and M. L. Walters. 1994. "Hybridization between Barred Owls and Spotted Owls." *Auk* 111 (2):487–92.

Haug, E. A., B. A. Millsap, and M. S. Martell. 1993. "Burrowing Owl (*Speotyto cunicularia*)." In *The Birds of North America, No. 61.* A. Poole and F. Gill (eds.). Academy of Natural Sciences, Philadelphia, PA, and American Ornithologists' Union, Washington, DC.

Hayward, G. D., and P. H. Hayward. 1993. "Boreal owl (*Aegolius funereus*)." In *The Birds of North America, No. 63.* A. Poole and F. Gill (eds.). Academy of Natural Sciences, Philadelphia, PA, and American Ornithologists' Union, Washington, DC.

Holt, D. W., and S. M. Leasure. 1993. "Short-eared Owl (*Asio flammeus*)." In *The Birds of North America, No. 62.* A. Poole and F. Gill (eds.). Academy of Natural Sciences, Philadelphia, PA, and American Ornithologists' Union, Washington, DC.

Houston, C. S. 1965. "Observation and Salvage of Great Horned Owl Nest." *Blue Jay* 23:164–65.

———. 1975. "Eggs of Other Species in Great Horned Owl Nests." *Auk* 92:377–78.

Houston, C. S., R. D. Crawford, and D. S. Houston. 1987. "Addled Eggs in Great Horned Owls Nests in Saskatchewan." In *Biology and Conservation of Northern Forest Owls: Symposium Proceedings: 1987 February 3–7; Winnipeg, MB.* R. W. Nero, R. J. Clark, R. J. Knapton, and R. H. Hamre (eds.). Pp. 225–28. USDA Forest Service, Gen. Tech. Rep. RM-142. Fort Collins, CO. U.S. Dept. of Agriculture, Forest Service, Rocky Mountain Forest and Range Experiment Station. 309 pp.

Houston, C. S., and K. J. McGowan. 1999. "Westward Spread of the Barred Owl." *Blue Jay* 57 (4): 190–95.

Johnsgard, P. 2002. *North American Owls: Biology and Natural History.* 2nd ed. Smithsonian Institution Press, Washington, DC. 298 pp.

Kelly, E. G., and E. D. Forsman. 2004. "Recent Records of Hybridization between Barred Owls (*Strix varia*) and Northern Spotted Owls (*S. occidentalis caurina*)." *Auk* 121 (3):806–10.

Kelly, E. G., E. D. Forsman, and R. G. Anthony. 2003. "Are Barred Owls Displacing Spotted Owls?" *Condor* 105:45–53

Korpimäki, E. 1985. "Clutch Size and Breeding Success in Relation to Nest-Box Size in Tengmalm's Owls, *Aegolius funereus.*" *Holarctic Ecol.* 8:175–80.

———. 1986. "Reversed Size Dimorphism in Birds of Prey, Especially in Tengmalm's Owl, *Aegolius funereus:* A Test of the 'Starvation Hypothesis.'" *Ornis Scand.* 17:326–32.

———. 1989. "Mating System and Mate Choice of Tengmalm's Owls, *Aegolius funereus.*" *Ibis* 131: 41–50.

Ligon, J. D. 1968. "The Biology of the Elf Owl, *Micrathene whitneyi.*" Miscellaneous Publications, Museum of Zoology, University of Michigan No. 136, Ann Arbor, MI. 70 pp.

Lippincott, J. W. 1917. "The Barn Owl's Voice." *Bird-Lore* 19:275.

Marks, J. S., and E. Yensen. 1980. "Nest Sites and Food Habits of Long-eared Owls in Southwestern Idaho." *Murrelet* 61:86–91.

Mazur, K. M., P. C. James, and S. D. Frith. 1997. "Barred Owl (*Strix varia*) Nest Site Characteristics in the Boreal Forest of Saskatchewan, Canada." In *Biology and Conservation of Owls of the Northern Hemisphere: 2nd International Symposium: 1997 February 5–9; Winnipeg, MB.* J. R. Duncan, D. H. Nicholls, and H. Thomas (eds.). Pp. 267–71. Gen. Tech. Rep. NC-190. St. Paul, MN: U.S. Department of Agriculture, Forest Service, North Central Research Station. 635 pp.

McCallum, D. A. 1994. "Flammulated Owl (*Otus flammeolus*)." In *The Birds of North America, No. 93.* A. Poole and F. Gill (eds.). Academy of Natural Sciences, Philadelphia, PA, and American Ornithologists' Union, Washington, DC.

Menyushina, I. E. 1997. "Snowy Owl (*Nyctea scandiaca*) Reproduction in Relation to Lemming Population Cycles in Wrangel Island." In *Biology and Conservation of Owls of the Northern Hemisphere: 2nd International Symposium: 1997 February 5–9; Winnipeg, MB.* J. R. Duncan, D. H. Nicholls, and H. Thomas (eds.). Pp. 572–82. Gen. Tech. Rep. NC-190. St. Paul, MN: U.S. Department of Agriculture, Forest Service, North Central Research Station. 635 pp.

Mikkola, H. 2003. "Strangers in the Dark: Hybridization between Owl Species." In *Owls of the World: Their Lives, Behavior, and Survival.* J. R. Duncan. Pp. 82–87. Firefly Books, Buffalo, NY. 319 pp.

Miller, A. H. 1947. "The Structural Basis of the Voice of the Flammulated Owl." *Auk* 64:133–35.

Millsap, B.A., and P. A. Millsap. 1987. "Burrow Nesting by Common Barn Owls in North Central Colorado." *Condor* 89:668–70.

Moskoll, W. 2001. "Why Some Female Birds Are Larger Than Males: The Meaning of Reversed Sexual Size Dimorphism." *Birding* June: 254–60.

Murray, G. A. 1976. "Geographic Variation in the Clutch Sizes of Seven Owl Species." *Auk* 93:602–13.

Nero, R. W. 1980. *The Great Gray Owl: Phantom of the Northern Forest.* Smithsonian Institution Press, Washington, DC. 167 pp.

Nicholls, T. H., and M. R. Fuller. 1987. "Territorial Aspects of Barred Owl Home Range and Behavior in Minnesota." In *Biology and Conservation of Northern Forest Owls: Symposium Proceedings: 1987 February 3–7; Winnipeg, MB.* R. W. Nero, R. J. Clark, R. J. Knapton, and R. H. Hamre (eds.). Pp. 121–28. USDA Forest Service, Gen. Tech. Rep. RM-142. Fort Collins, CO. U.S. Dept. of Agriculture, Forest Service, Rocky Mountain Forest and Range Experiment Station. 309 pp.

Norberg, R.A. 1987. "Evolution, Structure, and Ecology of Northern Forest Owls." In *Biology and Conservation of Northern Forest Owls: Symposium Proceedings: 1987 February 3–7; Winnipeg, MB.*

R. W. Nero, R. J. Clark, R. J. Knapton, and R. H. Hamre (eds.). Pp. 9–43. USDA Forest Service, Gen. Tech. Rep. RM-142. Fort Collins, CO. U.S. Dept. of Agriculture, Forest Service, Rocky Mountain Forest and Range Experiment Station. 309 pp.

Palmer, D. A. 1987. "Annual, Seasonal, and Nightly Variation in Calling Activity of Boreal and Northern Saw-whet Owls." In *Biology and Conservation of Northern Forest Owls: Symposium Proceedings: 1987 February 3–7; Winnipeg, MB.* R. W. Nero, R. J. Clark, R. J. Knapton, and R. H. Hamre (eds.). Pp. 162–68. USDA Forest Service, Gen. Tech. Rep. RM-142. Fort Collins, CO. U.S. Dept. of Agriculture, Forest Service, Rocky Mountain Forest and Range Experiment Station. 309 pp.

Parmelee, D. F. 1972. "Canada's Incredible Arctic Owls." *Beaver* (Summer):30–41.

Pearson, R. R., and K. B. Livezey. 2003. "Distribution, Numbers, and Site Characteristics of Spotted Owls and Barred Owls in the Cascade Mountains of Washington." *J. Raptor Res.* 37 (4):265–76.

Philips, J. R. 2000. "A Review and Checklist of the Parasitic Mites (Acarina) of the Falconiformes and Strigiformes." *J. Raptor Res.* 34 (3):210–31.

Philips, J. R., and D. L. Dindal. 1977. "Raptor Nests as a Habitat for Invertebrates: A Review." *J. Raptor Res.* 11 (4):86–96.

Pitelka, F. A., P. Q. Tomich, and G. W. Treichel. 1955. "Ecological Relations of Jaegers and Owls as Lemming Predators near Barrow, Alaska." *Ecol. Monogr.* 25:85–117.

Poulin, R. G. 2005. "Food Caching by Burrowing Owls on the Regina Plain, Saskatchewan." *Blue Jay* 63 (4):203–4.

Reichard, T. A. 1974. "Barred Owl Sightings in Washington." *Western Birds* 5:138–40.

Reynolds, R. T., and B. D. Linkhart. 1987. "The Nesting Biology of Flammulated Owls in Colorado." In *Biology and Conservation of Northern Forest Owls: Symposium Proceedings: 1987 February 3–7; Winnipeg, MB.* R. W. Nero, R. J. Clark, R. J. Knapton, and R. H. Hamre (eds.). Pp. 238–48. USDA Forest Service, Gen. Tech. Rep. RM-142. Fort Collins, CO. U.S. Dept. of Agriculture, Forest Service, Rocky Mountain Forest and Range Experiment Station. 309 pp.

———. 1990. "Extra-pair Copulation and Extra-range Movements in Flammulated Owls." *Ornis Scand.* 21:74–77.

Rich, T., and B. Trentlage. 1983. "Caching of Longhorned Beetles by the Burrowing Owl." *Murrelet* 64:25–26.

Rohner, C., F. I. Doyle, and J. N. M. Smith. 2001. "Great Horned Owls (*Bubo virginianus*)." In *Ecosystem Dynamics of the Boreal Forest: The Kluane Project.* C. J. Krebs, S. Boutin, and R. Boonstra (eds.). Pp. 339–76. Oxford University Press, New York. 511 pp.

Seamans, M. E. 1994. "Breeding Habitat Ecology of the Mexican Spotted Owl in the Tularosa Mountains, New Mexico." M.Sc. thesis, Humboldt State Univ., Arcata, CA. 64 pp.

Solheim, R. 1982. "Bigyny and Biandry in the Tengmalm's Owl, *Aegolius funereus.*" *Ornis Scand.* 14:51–57.

Sutton, G. M. 1932. "The Birds of Southhampton Island." *Mem. Carnegie Mus.* 12 (part 11, sec. 2): 3–267.

Takats, D. L., and G. L. Holroyd. 1997. "Owl Broadcast Surveys in the Foothills Model Forest, Alberta, Canada." In *Biology and Conservation of Owls of the Northern Hemisphere: 2nd International Symposium: 1997 February 5–9; Winnipeg, MB.* J. R. Duncan, D. H. Nicholls, and H. Thomas (eds.). Pp. 421–31. Gen. Tech. Rep. NC-190. St. Paul, MN: U.S. Department of Agriculture, Forest Service, North Central Research Station. 635 pp.

Taylor, A. L., and E. D. Forsman. 1976. "Recent Range Extensions of the Barred Owl in Western North America, Including the First Records for Oregon." *Condor* 78:560–61.

Todd, F. S. 1994. *10,001 Titillating Tidbits of Avian Trivia.* Ibis Publishing, Vista, CA. 630 pp.

Toops, C. 1990. *Discovering Owls.* Whitecap Books, Vancouver, BC. 128 pp.

Vander Wall, S. B 1990. *Food Hoarding in Animals.* University of Chicago Press, Chicago. 445 pp.

Watson, A. 1957. "The Behaviour, Breeding, and Food Ecology of the Snowy Owl, *Nyctea scandiaca.*" *Ibis* 99:419–62.

Chapter 6 The Next Generation

Belthoff, J. R., and A. M. Duffy Jr. 1997. "Corticosterone and Dispersal in Western Screech-Owls (*Otus kennicottii*)." In *Biology and Conservation of Owls of the Northern Hemisphere: 2nd International Symposium: 1997 February 5–9; Winnipeg, MB.* J. R. Duncan, D. H. Nicholls, and H. Thomas (eds.). Pp. 62–67. Gen. Tech. Rep. NC-190. St. Paul, MN: U.S. Department of Agriculture, Forest Service, North Central Research Station. 635 pp.

Duncan, J. R., and P. A. Duncan. 1998. "Northern Hawk Owl (*Surnia ulula*)." In *The Birds of North America, No. 356.* A. Poole and F. Gill (eds.). Academy of Natural Sciences, Philadelphia, PA, and American Ornithologists' Union, Washington, DC.

Gehlbach, F. R. 1995. "Eastern Screech-Owl (*Otus asio*)." In *The Birds of North America, No. 165.* A. Poole and F. Gill (eds.). Academy of Natural Sciences, Philadelphia, PA, and American Ornithologists' Union, Washington, DC.

Hannah, K. C. 1999. "Status of the Northern Pygmy-Owl (*Glaucidium gnoma californicum*) in Alberta." Alberta Environmental Protection, Fisheries and Wildlife Management Division, and Alberta Conservation Association, Wildlife Status Report No. 20, Edmonton, AB. 20 pp.

Houston, C. S. 1975. "Eggs of Other Species in Great Horned Owl Nests." *Auk* 92:377–78.

Ligon, J. D. 1968. "The Biology of the Elf Owl, *Micrathene whitneyi.*" Miscellaneous Publications, Museum of Zoology, University of Michigan No. 136. Ann Arbor MI. 70 pp.

Marks, J. S., D. L. Evans, and D. W. Holt. 1994. "Long-eared Owl (*Asio otus*)." In *The Birds of North America, No. 133.* A. Poole and F. Gill (eds.). Academy of Natural Sciences, Philadelphia, PA, and American Ornithologists' Union, Washington, DC.

Marr, T. G., and D. W. McWhirter. 1982. "Differential Hunting Success in a Group of Short-eared Owls." *Wilson Bull.* 94:82–83.

Mikkola, H. *Owls of Europe.* Buteo Books, Vermillion, SD. 397 pp.

Murphy, R. K. 1992. "Long-eared Owl Ingests Nestlings' Feces." *Wilson Bull.* 104 (1):192–93.

Parmelee, D. F. 1992. "Snowy Owl (*Nyctea scandiaca*)." In *The Birds of North America, No. 10.* A. Poole and F. Gill (eds.). Academy of Natural Sciences, Philadelphia, PA, and American Ornithologists' Union, Washington, DC.

Potter, J. K., and J. A. Gillespie. 1925. "Observations on the Domestic Behavior of the Barn Owl, *Tyto pratincola.*" *Auk* 42:177–92.

Rohner, C., F. I. Doyle, and J. N. M. Smith. 2001. "Great Horned Owls (*Bubo virginianus*)." In *Ecosystem Dynamics of the Boreal Forest: The Kluane Project.* C. J. Krebs, S. Boutin, and R. Boonstra (eds.). Pp. 339–76. Oxford University Press, New York. 511 pp.

Sealy, S. G., J. C. Duncan, and R. W. Nero. 2003. "Additional Notes on Manitoba's Long-lived Great Horned Owl (Band Number 568-17752)." *Blue Jay* 61 (1):27–30

Watson, A. 1957. "The Behaviour, Breeding, and Food Ecology of the Snowy Owl, *Nyctea scandiaca.*" *Ibis* 99:419–62.

Chapter 7 Predators, Pirates, and Pests

Bent, A. C. 1961. *Life Histories of North American Birds of Prey: Hawks, Falcons, Caracaras, Owls.* Part 2. Dover Publications, New York. 482 pp.

Boal, C. W. 1997. "Nest Defense and Mobbing Behavior of Elf Owls." *J. Raptor Res.* 31 (3):286–87.

Carter, J. D. 1925. "Behavior of the Barred Owl." *Auk* 42:443–44.

Cramp, S. (ed). 1985. *Handbook of the Birds of Europe, the Middle East, and North Africa: The Birds of the Western Palearctic.* Vol. 4. Oxford University Press, Oxford.

Deppe, C., D. Holt, J. Tewksbury, L. Broberg, J.

Petersen, and K. Wood. 2003. "Effect of Northern Pygmy-Owl (*Glaucidium gnoma*) Eyespots on Avian Mobbing." *Auk* 120 (3):765–71.

Desmond, M. J. 1991. "Ecological Aspects of Burrowing Owl Nesting Strategies in the Nebraska Panhandle." M.Sc. thesis, University of Nebraska, Lincoln. 114 pp.

Duffy, D. C. 1976. "Snowy Owl Steals Prey from Marsh Hawk." *Auk* 93: 839–40.

Duncan, J. R. 1987. "Movement Strategies, Mortality, and Behavior of Radio-marked Great Gray Owls in Southeastern Manitoba and Northern Minnesota." In *Biology and Conservation of Northern Forest Owls: Symposium Proceedings: 1987 February 3–7; Winnipeg, MB.* R. W. Nero, R. J. Clark, R. J. Knapton, and R. H. Hamre (eds.). Pp. 101–8. USDA Forest Service, Gen. Tech. Rep. RM-142. Fort Collins, CO. U.S. Dept. of Agriculture, Forest Service, Rocky Mountain Forest and Range Experiment Station. 309 pp.

Forsman, E. D., E. C. Meslow, and H. M. Wight. 1984. "Distribution and Biology of the Spotted Owl in Oregon." *Wildl. Monogr.* 87:1–64.

Gaston, A. J. 2004. *Seabirds: A Natural History.* Yale University Press, New Haven, CT. 222 pp.

Gehlbach, F. R. 1994. *The Eastern Screech Owl: Life History, Ecology, and Behavior in Suburbia and the Countryside.* Texas A&M Univ. Press, College Station. 302 pp.

Gehlbach, F. R., and N. Y. Gehlbach. 2000. "Whiskered Screech-Owl (*Otus trichopsis*)." In *The Birds of North America, No. 507.* A. Poole and F. Gill (eds.). Academy of Natural Sciences, Philadelphia, PA, and American Ornithologists' Union, Washington, DC.

Green, G. A. 1983. "Ecology of Breeding Burrowing Owls in the Columbia Basin, Oregon." M.Sc. thesis, Oregon State University, Corvallis. 51 pp.

Green, G. A., and R. G. Anthony. 1989. "Nesting Success and Habitat Relationships of Burrowing Owls in the Columbia Basin, Oregon." *Condor* 91:347–54.

Grinnell, J., J. Dixon, and J. M. Linsdale. 1930. *Vertebrate Natural History of a Section of Northern California through the Lassen Peak Region.* University of California Publications in Zoology 35:1–594.

Lein, M. R., and P. C. Boxall. 1979. "Interactions between Snowy and Short-eared Owls in Winter." *Can. Field Nat.* 93 (4):411–14.

Levin, S. A., J. E. Levin, and R. T. Paine. 1977. "Snowy Owl Predation on Short-eared Owls." *Condor* 79:395.

Marks, J. S. 1986. "Nest-site Characteristics and Reproductive Success of Long-eared Owls in Southwestern Idaho." *Wilson Bull.* 98:547–60.

Martin, D. J. 1973. "A Spectrographic Analysis of Burrowing Owl Vocalizations." *Auk* 90:564–78.

Menyushina, I. 2003. "The Snowy Owls of Wrangel Island." In *Owls of the World: Their Lives, Behavior, and Survival.* J. R. Duncan. Pp. 127–33. Firefly Books, Buffalo, NY. 319 pp.

Rowe, M. P., R. G. Coss, and D. H. Owings. 1986. "Rattlesnake Rattles and Burrowing Owl Hisses: A Case of Acoustic Batesian Mimicry." *Ethology* 72:53–71.

Tremblay, J-P., G. Gauthier, D. Lepage, and A. Desrochers. 1997. "Factors Affecting Nesting Success in Greater Snow Geese: Effects of Habitat and Association with Snowy Owls." *Wilson Bull.* 109 (3):449–61.

Chapter 8 Owls and Humans

Alberta Sustainable Resource Development and Alberta Conservation Association. 2005. "Status of the Burrowing Owl (*Athene cunicularia*) in Alberta: Update 2005." Alberta Sustainable Resource Development, Wildlife Status Report No. 11 (Update 2005), Edmonton, AB. 28 pp.

Anderson, J. F., T. G. Andreadis, A. J. Main, and D. L. Kline. 2004. "Prevalence of West Nile Virus in Tree Canopy–Inhabiting *Culex pipiens* and Associated Mosquitoes." *Am. J. Trop. Med. Hyg.* 71 (1):112–19.

Baudvin, H. 1997. "Barn Owl (*Tyto alba*) and Long-eared Owl (*Asio otus*) Mortality along Motorways in Bourgogne-Champagne: Report and Suggestions." In *Biology and Conservation of Owls of the Northern Hemisphere: 2nd International Symposium: 1997 February 5–9; Winnipeg, MB.* J. R. Duncan, D. H. Nicholls, and H. Thomas (eds.). Pp. 58–61. Gen. Tech. Rep. NC-190. St. Paul, MN: U.S. Department of Agriculture, Forest Service, North Central Research Station. 635 pp.

Follen, D. G., Sr. 1987. "Barred Owl: A Demonstration of Focal Concentration." *Passenger Pigeon* 48:73.

Holt, D. W., and S. M. Leasure. 1993. "Short-eared Owl (*Asio flammeus*)." In *The Birds of North America, No. 62.* A. Poole and F. Gill (eds.). Academy of Natural Sciences, Philadelphia, PA, and American Ornithologists' Union, Washington, DC.

Jackson, M. H. 1993. *Galapagos: A Natural History.* 2nd ed. University of Calgary Press, Calgary AB. 315 pp.

Jaffe, M. 1994. *And No Birds Sing: The Story of an Ecological Disaster in a Tropical Paradise.* Simon and Schuster, New York. 283 pp.

James, P. C., and G. A. Fox. 1987. "Effects of Some Pesticides on Productivity of Burrowing Owls." *Blue Jay* 45:65–71.

Johnsgard, P. 2002. *North American Owls: Biology and Natural History.* 2nd ed. Smithsonian Institution Press, Washington, DC. 298 pp.

Nero, R. W. 1991. "Focal Concentration: A Possible Cause of Mortality in the Great Gray Owl." *Blue Jay* 49 (1):28–30.

Platt, C. M. 2005. "Patterns of Raptor Electrocution Mortality on Distribution of Power Lines in Southeast Alberta." M.Sc. thesis, University of Alberta, Edmonton, AB. 183 pp.

Primack, R. B. 2004. *A Primer of Conservation Biology.* 3rd ed. Sinauer Associates, Sunderland, MA. 320 pp.

Smith, N. 2003. "Snowy Owl Migrants in New England." In *Owls of the World: Their Lives, Behavior, and Survival.* J. R. Duncan. Pp. 133–36. Firefly Books, Buffalo, NY. 319 pp.

Sutton, P., and C. Sutton. 1994. *How to Spot an Owl.* Chapters Publishing, Shelburne, VT. 143 pp.

Takats, D. L., C. M. Francis, G. L. Holroyd, J. R. Duncan. K. M. Mazur, R. J. Cannings, W. Harris, and D. Holt. 2001. "Guidelines for Nocturnal Owl Monitoring in North America." Beaverhill Bird Observatory and Bird Studies, Canada, Edmonton, AB. 32 pp.

Ward, W. B. 1934. "Owls on a Louisiana Highway." *Auk* 51:236.

Wilson, E. O. 2002. *The Future of Life.* Alfred A. Knopf, New York. 229 pp.

Identification Guide

Cannings, R. J. 1993. "Northern Saw-whet Owl (*Aegolius acadicus*)." In *The Birds of North America, No. 42.* A. Poole and F. Gill (eds.). Academy of Natural Sciences, Philadelphia, PA, and the American Ornithologists' Union, Washington, DC.

Duncan, J. R., and P. A. Duncan. 1998. "Northern Hawk Owl (*Surnia ulula*)." In *The Birds of North America, No. 356.* A. Poole and F. Gill (eds.). Academy of Natural Sciences, Philadelphia, PA, and the American Ornithologists' Union, Washington, DC.

Henry, S. G., and F. R. Gehlbach. 1999. "Elf Owl (*Micrathene whitneyi*)." In *The Birds of North America, No. 413.* A. Poole and F. Gill (eds.). Academy of Natural Sciences, Philadelphia, PA, and the American Ornithologists' Union, Washington, DC.

Johnsgard, P. 2002. *North American Owls: Biology and Natural History.* 2nd ed. Smithsonian Institution Press, Washington, DC. 298 pp.

Kirk, D. A., and C. Hyslop. 1998. "Population Status and Recent Trends in Canadian Raptors: A Review." *Biol. Conserv.* 83:92–118.

McCallum, D. A. 1994. "Flammulated Owl (*Otus flammeolus*)." In *The Birds of North America, No. 93.* A. Poole and F. Gill (eds.). Academy of Natural Sciences, Philadelphia, PA, and American Ornithologists' Union, Washington, DC.

INDEX

Bold type indicates photograph or illustration

Lein, Ross, 83, 117, 197
lemmings, 90, 157, 175
lice, 20
life span, 186–187
Ligon, David, 69, 72, 103
Linnaeus, Carolus, 2
logging, and impact on owls, 206–207
long-eared owl (*Asio otus*), 51, 54, 82, **142**, 176, **186**, **221**; chicks, **172**; clutch size, 157; courtship, 137; defensive behavior, 196–197; diet, 29, 97; dispersal, 185; distribution, **29**, 59; feather count, 22; hunting behavior, 113, **116**; identification, **29**; incubation period, 157; migration, 85; nests, 142; pellets, 108–109; polygamy, 139; roosts, 78, 81
loon, 12
Louisiana, 212
lower critical temperature, 76

Maine, 86
Manitoba, xx, 24, 87, 113, 190, 216
Martin, Graham, 41, 43, 51–54, 56
Massachusetts, 86, 150, 197, 213, 219
mating, 151–152
McCallum, Arch, 148
Megascops asio. See eastern screech-owl
Megascops kennicottii. See western screech-owl
Megascops trichopsis. See whiskered screech-owl
Menyushina, Irina, 160, 198
metabolic rate, 101
Mexico, 58, 82, 85, 101, 103, 185
Michigan, 65, 86, 87
Micrathene whitneyi. See elf owl
migratory behavior, 82–83
Migratory Bird Treaty Act, 215
migratory restlessness, 184
Mikkola, Heimo, xv, 118, 152, 155
Minnesota, 66, 69, 86, 87, 88, 113, 134, 216
mobbing by songbirds, 199–202, 220
molecular biology, 4
molting, 22–23
Montana, xi, 14, 61, 65, 82, 144, 169, 175, 216
mosquitoes, 210
Murphy, Robert, 176
Murray, Gale, 155
mythology, xvi–xix

Native Americans, and owl hunting, 215
Nebraska, 191
Nero, Robert, 97, 112, 137, 213

nest boxes, 219
nest parasites, 150
nests, 142, 144–146
nest site competition, 146, 148
New Brunswick, 65
New Mexico, xviii, 15, 76, 81, 142, 148, 184
New York State, 17, 60, 86
nightjars, 3, 8–9, 14, 48
nocturnal environment, 45–47
Norberg, Åke, 44, 113
North American Banding Program, 216
North Carolina, 86
northern flying squirrel, **95**
northern harrier, 197
northern hawk owl (*Surnia ulula*), 14, **24**, **38**, **59**, **89**, **98**, **158**, **163**, 221; caching surplus prey, 120; chicks, 181, **182**; clutch size, 155, 157; courtship, 137; defensive behavior, 189; diet, 29, 98–99; distribution, **29**, 59; hovering, **119**; hunting behavior, 93, **94**, 109, 110, 114; identification, **29**; incubation period, 157; mating, 151; mobbing by songbirds, 199; nests, 146; nest selection, 149; polygamy, 139
northern pocket gopher, **95**
northern pygmy-owl (*Glaucidium gnoma*), 14, **200**; chicks, 183; clutch size, 157; diet, 33, 98–99; distribution, **33**; false eyespots, 203; hatching, 175; hunting behavior, 109, 111; identification, **33**; incubation period, 157; mortality, 105; nest boxes, 219; nests, 146, 149; pellets, **109**; winter movements, 84
northern saw-whet owl (*Aegolius acadicus*), 13, **51**, 82, **83**, **102**, **139**; chicks, **172**, **174**, 183; clutch size, 157; diet, 32, 94–95; distribution, **32**; ear asymmetry, 44, 110; hunting behavior, 110; identification, **32**; incubation period, 157; lethal body temperature, 72; mobbing by songbirds, 200; nest boxes, 219; nests, 146, **147**; pellets, 108; polygamy, 139; vocalizations, 132
Norway, 54, 96, 110
Nova Scotia, 66, 113
Nunavut, 59–60, 66

Ohio, 17, 124
oilbird, **3**, 49
Ontario, xi, 85, 87, 88, 207
order Caprimulgiformes. See nightjars

order Strigiformes. See owls
Oregon, 61, 66, 84, 141, 150, 152, 205, 208
Otus flammeolus. See flammulated owl
owlaholics, xiv
owls: aircraft collisions, 213; banding, 216–219; bathing, 20–12; body temperature, 69; branching, 181; breeding age, 127; breeding season, 123–124; caching, 119–121; Canadian provincial emblems, xx; clutch size, 157; coloration, 14–17; courtship, 135–138; defensive behaviors, 196–197; diet, 96–101; eggs, 153–155; eyes, 50–52; floaters, 66–68; fossil record, 3; habitat destruction, 206–207; hatching, 169; hearing, 37–45; hunting behavior, 109–117; hunting success, 117–118; incubation, 159–162; iris color, 51; irruptions, 84, 85–91; lower critical temperature, 76; mating, 151–152; metabolic rate, 101–103; mobbing by songbirds, 199–202, 220; molting, 22–23; mythology, xvi–xix; nests, 142, 144–146; noiseless flight, 13–14; Paleolithic art, xv–xvi; pellets, 105–109; predators, 190–194; preening, 19–20; prey consumption, 115, 117; roosts, 78–82; skeleton, 12; spatial memory, 56; stomach acidity, 108; taxonomy, 3–6; weights and wingspans, 6; West Nile virus, 210; wing design, 10–12; world population, 6

Paleolithic art, xv–xvi
Palmer, David, 131
Parmelee, David, 145, 185
pellets, 105–109, 220
Pennsylvania, 124
peregrine falcon, as prey, 103–104
Philips, James, 150
photoperiod, 125, 184
pH scale, 108
pileated woodpecker, **148**
pine grosbeak, **95**
piracy. See kleptoparasitism
plains spadefoot toads, **95**
Platt, Cindy, 214
pollution impact, 210–211
polygamy, 139
porcupine, **104**, 105
Potter, Julian, 174
predators, 190–194
preening, 19–20
prey consumption, 115, 117
prolactin, 159

About the Author

In 1979, at the age of 31, Dr. Wayne Lynch left a career in emergency medicine to work full time as a science writer and photographer. Today, Lynch is recognized as one of North America's leading wildlife and natural history photographers. His photo credits include hundreds of magazine covers, thousands of calendar shots, and tens of thousands of images published in more than three dozen countries. Lynch is also an award-winning science writer and popular guest speaker. He is the author and photographer of a dozen highly acclaimed natural history books, including *Married to the Wind: A Study of the Prairie Grasslands; The Great Northern Kingdom: Life in the Boreal Forest; Wild Birds across the Prairies; Penguins of the World; Mountain Bears; Bears: Monarchs of the Northern Wilderness; A Is for Arctic: Natural Wonders of a Polar World;* and *Windswept: A Passionate View of the Prairie Grasslands.* He has written more than 30 books for children and young adults. His books have been described as "a magical combination of words and images."

Dr. Lynch has studied wildlife in more than 50 countries and is a fellow of the internationally recognized Explorers Club, headquartered in New York City. Fellows are those who have actively participated in exploration or have substantially enlarged the scope of human knowledge through scientific achievements and published reports, books, and articles. In 1997, Lynch was elected as a Fellow to the Arctic Institute of North America, in recognition of his contributions to the knowledge of polar and subpolar regions. He lives in Calgary with his wife of 33 years, Aubrey Lang.